The Complete Guide To

CAMERA ACCESSORIES

. . . . And How To Use Them

The Complete Guide To

CAMERA ACCESSORIES

. . . . And How To Use Them

By Robb Smith

Ziff-Davis Publishing Company
New York

Library of Congress Catalogue Card Number 79-66280
ISBN 0-87165-038-X

Printed in the United States of America
First Printing 1980

Ziff-Davis Publishing Company
One Park Avenue
New York, New York 10016

Book design by Virginia Tiso Gianakos.

To My Wife, Julie

Contents

Introduction

Rapid advances in photo technology have enriched the photographer's life with a spectacular variety of camera accessories—from autowinders to zoom lenses—that make picture-taking more exciting than ever. But the very profusion of accessories often leaves us confused and groping unsuccessfully for answers when it comes time to select equipment to complement a basic camera and lens.

What features should an electronic flash unit have? Is a macro lens a good investment or would a couple of less expensive close-up supplementary lenses do as well? Is a light box better than a viewer for editing slides? What features are important in a projector? Is a zoom lens really worth the price?

Involvement in photography creates a torrent of questions and up until now, getting answers has been a hit-or-miss affair, where missing data can lead to costly mistakes. This book handles that situation by providing condensed, accurate, easy-to-find information about all the most frequently purchased camera accessories. It provides detailed information about important features and explains what they are used for. It gives step-by-step guides to equipment operation, and offers hundreds of tips on equipment selection and photographic technique that can save money and produce better pictures.

This book fills a gap between the detailed articles found in photo magazines and the brief descriptive data found in the typical buying guide. It provides buying information, generalized operating instructions, and how-to-do-it guides all in one condensed package.

How to Use This Book

This is essentially a reference book, which means that each section is self-contained. If you want to find out about a particular accessory, such as a multiple-image lens or an automatic flash unit, look it up in the table of contents or the index and go directly to that section. If you feel you need additional information then read the introductory sections under each major heading. These provide overviews and general background information that supplement the detailed sections on specific accessories.

In general, using a reference book is easier if you look up the exact meanings of technical terms whenever you feel unsure about them. Going past a technical term you don't understand is a good way to get confused a few paragraphs later.

The emphasis throughout the book is on practice rather than theory. Here you find out how experienced photographers really go about selecting equipment, how it is actually used, and what kind of results you can reasonably expect to get when it comes down to taking real pictures of real subjects. Unlike most books on photography, this one also helps you evaluate the relative importance of information, so that you don't get bogged down in trivia. It brings you right to the heart of the matter to augment the adventure and pleasure of buying and using photo accessories. Have fun.

1
ACCESSORY BASICS

Shopping for accessories is part of the fun of photography, and while the more common ones, such as lenses, flash units, and gadget bags, are available at any camera outlet, some of the more exotic items may be a challenge to find. This section describes the various places you can go to buy both new and used accessories, and gives you a few tips on using each type to best advantage.

PHOTO SPECIALTY OUTLETS

Stores that specialize in photography have the largest selection of stock items. Browsing in a large photo store is one way to familiarize yourself with many of the smaller accessories, and asking questions puts you under no obligation to buy.

Before you put your money down on a major item like a lens, shop around. Look at the ads in the photo magazines to get a feel for some of the more important features of items from name-brand manufacturers. Remember too that stores will stock some brand lines in depth and carry little or nothing from other lines that are equally good.

If you want accessories made by the manufacturer of your camera, you will have to locate a dealer that handles your camera line. For example, there may be several good camera stores in your area, but only one Nikon dealer, and you will have to work through that outlet to special-order less common accessories for Nikon.

There is some competition between the camera specialty store and the photo section of a large discount department store, but they actually serve different functions. At the discount store you can generally get a good deal on film and sometimes a good price on a camera, lens or electronic flash, but the selection is usually limited and the sales personnel frequently lack a solid knowledge of photographic equipment. The camera specialty store is usually better stocked, carries more top-of-the-line items, and has a better trained staff.

When you buy good equipment, do not rely exclusively on sales personnel to give you product information. Even experienced persons make mistakes about the features and functions of specialized equipment. In the long run, learning to recognize what you want and knowing how to describe it will save time, money and frustration. If you want an ECT bulb, which is a 500-watt tungsten photo lamp for use indoors with Ektachrome 160 Tungsten, know enough not to settle for a No. 1 photoflood, which has a different color quality, or such exotica as a PAR (sealed beam movielight) bulb, which costs four times as much as an ECT.

If you have a feeling the person you are dealing with does not understand what you want, try to talk with someone else. The owner or manager of a camera specialty store is usually a good source for sound information on equipment.

Prices: To get an idea of prices in general, or to check out an advertised special and find out if it is really a good deal, check the mail-order ads in the back of magazines such as *Popular Photography*. You won't find lower prices anywhere.

Blister pack. Most shops that carry camera equipment now have a space devoted to hanging cards that contain small accessories such as synch cords, pocket tripods and air releases sealed in see-through plastic bubbles. This method of display is called blister pack, and it's useful when you want to get an idea of what is available without taking up the time of a busy clerk.

Shopping for low prices on blis-

ter-pack items is usually not worth the trouble. At best, you save only pennies. Most photographers buy these items on impulse and seldom regret it. New gadgets lead to new picture ideas, which lead to new gadgets, and so on. It's part of the fun.

Shopping by Mail

Catalogs from the major mail-order photo dealers carry more accessory items than you could hope to see in a lifetime of camera-store browsing, and the prices are among the lowest you can find anywhere.

Shopping by mail is convenient, wastes no gasoline, and provides the considerable pleasure of leafing at leisure through the latest catalogs from Porter, Spiratone, or 47th Street Photo and browsing among the thousands of items listed in the mail-order sections of major photo magazines.

For current addresses and catalog costs, look at the ads in the back of a recent issue of *Popular Photography* or one of the other photo magazines.

Credit-card offers: Occasionally credit-card companies will offer a special on photo equipment. The ad literature is appealing, but before you buy, check the prices elsewhere. The equipment is usually offered at close to full list price, and you can probably get the same outfit cheaper from a camera store or mail-order photo dealer.

Door-to-Door, Tent, and Motel-Room Sales

Forget it. These offers usually include both film and equipment.

Catalogs like these make shopping by mail a pleasure. Just browsing through them will give you new ideas for pictures and often as not the prices are as low as you will find anywhere.

You will end up paying more than you should and will have no recourse if something goes wrong.

Used Equipment

Most of the larger camera stores carry some used equipment and will often give you a limited 30 or 90 day guarantee with it. They are a good source, and you may be able to bargain over the price, something you would not normally do with new equipment.

Best buys in used equipment are lenses, tripods, and other sturdy items that are easy to test and have a low failure rate. Stay away from limited-life items such as NiCad batteries and electronic flash units, which you should buy new.

Buying from individuals is more risky. If you are unsure of what you may be getting, ask a more experienced photographer to take a look at the equipment before you buy and check the prices on new equipment that can do the same thing for you as the used item. You may be surprised. Used equipment is often overpriced.

Shutterbug Ads is a national monthly tabloid devoted entirely to ads for photo equipment. Its 60-to-70 pages of display and classified ads contain offers for professional, amateur and antique photo items. For a copy, write to *Shutterbug Ads*, P.O. Box F, Titusville, FL 32780. If nothing else, the ads can give you a feel for the prices being asked for used equipment.

Accessorizing a Camera

If you are just beginning to accessorize a camera, you may be wondering what things are really important to get first. The suggestions that follow are based on the assumption that you already have an SLR (single-lens reflex camera) with a normal lens and through-the-lens metering system.

Think first of lenses, then of electronic flash. A zoom in the moderate telephoto range, a 70–150mm or 100–200mm, with or without a matched 2x telephoto extender, and a 24mm or 28mm wide-angle lens will give you all the coverage you will probably ever need for general photography. (See Chapter 2.)

You can't go wrong with a small, low-power automatic (thyristor circuit) electronic flash. They are always useful, even if you later decide to buy a larger, more powerful unit, because the small ones fit neatly in your pocket or gadget bag. (See Chapter 8.)

From the start, experiment with different film types. Color print film is fine for family photos, but if you want to get a feel for color, use color slide film. You can view the slides with a cheap hand viewer or put them in vinyl pages and look at them with an 8X magnifier. A slide projector comes later, after you decide you want to work more seriously with slide film. Black-and-white film is used mainly by professionals and by photographers who do their own darkroom work. (See Chapters 5 and 11.)

As your collection of accessories builds, you will need a gadget bag to carry your equipment. A tripod will let you experiment with long exposures and perform routine photo tasks around the home such as photographing your valuables for insurance records. (See Chapter 7.)

Film, flash, lenses, a bag to keep them in and a tripod are the heart of an accessory system. Next on the list could be a cable release, a No. 3 or No. 4 close-up supplementary lens, a motor drive or autowinder if your camera will handle one, and an 80A conversion filter for your normal lens so you can use daylight color film in tungsten (standard photoflood or

household lightbulb) lighting. From then on, it's a matter of adding to what you have, building your array of lenses, experimenting with more film stocks, trying a special-effect device, working with filters, building your lighting system by getting another flash or some inexpensive flood lights, and above all, learning to use and enjoy the equipment you acquire.

Accessories: A Way of Seeing

The habit of looking through the viewfinder and seeing a finished scene in front of the camera is the biggest barrier to the effective use of lenses, film, special-effect attachments, flash and exposure meters. Mastery of these devices depends on the cultivated habit of looking at every subject as raw material that can be turned into a good photograph through the skilled application of equipment and technique.

Dull, commonplace photos are the result of a willingness to let the camera do its preprogrammed thing with a minimum of assistance from the photographer. This technique produces millions of adequately exposed shots every year. These simple records of whatever was in front of the lens more often than not fail totally to communicate the photographer's feelings and ideas about the subject.

Photographers who boast of never using a filter or other accessory are displaying a profound ignorance. Filters, lenses, and other accessories expand the visual possibilities of the medium. They are tools for visual thinking.

As you master the use of accessories, scenes that once seemed ordinary, hardly worth a second glance, one by one open up to the imagination and begin to glitter with picture-taking potential. Just as muscles develop through exercise, so too does the visual imagi-

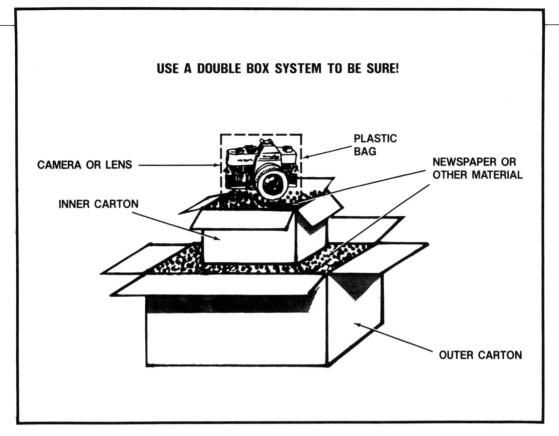

USE A DOUBLE BOX SYSTEM TO BE SURE!

CAMERA OR LENS

PLASTIC BAG

INNER CARTON

NEWSPAPER OR OTHER MATERIAL

OUTER CARTON

nation develop through intensive play with the tools and techniques of photography.

WARRANTIES AND REPAIRS

All the major photo equipment manufacturers and distributors are careful to honor warranties. In most cases, they will repair or replace within two or three weeks any camera or accessory sent to them for in-warranty service. They will also repair out-of-warranty equipment at reasonable cost.

Where you may run into problems is with old equipment that has been discontinued for many years. As with old cars, parts can be hard to come by or simply unavailable. A good independent repairperson is your best bet for equipment in this category. But always ask for an estimate before you authorize a repair. The labor may cost more than the item is worth.

If you have an established relationship with a camera specialty dealer, go there first for help in finding repairs. If you buy mail order, send the equipment to one

of the authorized service centers listed in the literature that accompanies the unit. Either way, get a price quote before you authorize a repair.

Warranty Rights
Always keep your sales receipt. The date on that receipt establishes your right to warranty service. Most new equipment also comes with a warranty card that you can fill out and send to the manufacturer. You do not have to fill out the personal data on the card. Those questions about age, number of cameras owned, and so on are market research and have nothing to do with warranty service. The only significant information is your name and the purchase date. So long as you have a receipt, it usually does not matter if you send the card in or not, but the receipt should specify by name the item bought. If you only get a register receipt, protect yourself by sending in the warranty card.

Loss of warranty: A product can be considered out of warranty and the existing warranty void, regardless of purchase date, if a

defect in workmanship or material is not present and the product shows evidence of water, sand, liquid or impact damage. In other words, you can't dunk your equipment in a lake or drop it on concrete and expect to get it repaired free.

Manufacturers are also quite strict about the time limits in warranties. So if you know there is something wrong with your equipment, do not delay sending it in for service. Once the warranty period has expired, you will have to pay for repairs.

Packaging for Survival
To be certain your camera, lens or other instrument arrives safely at the repair center, use the double-carton system, which is designed to minimize the effects of rough handling encountered in transit.

Put the item in a plastic bag first. Next, put it into its original box with its contour foam packing, if you happen to have it, or into any small box. Surround the item with crumpled newspaper or bits of foam if you do not have the original packing material. Now put the boxed accessory into a

larger box and surround it with plenty of crumpled paper or other packing material.

Put your name and address inside the box and include a note to the repair center explaining the problem and telling them where to send the cost estimate and repaired item.

Water Damage

If you dunk your camera in water or leave it out in a heavy rain, corrosion will set in. If the equipment has suffered only a short spray exposure, it can usually be repaired, provided it is sent to the repair center at once with a note saying "Water Damage: Repair Immediately."

Once equipment has been fully immersed, there is very little that can be done for it. Water damage affects rivets, springs and gear spindles. Rust will most likely begin to form on these parts within 24 hours after the accessory has been in contact with water. This type of corrosion may increase for more than a year, and there is no way of determining how severe it may ultimately get.

Occasionally you will hear of some photographer who dropped his equipment in a pond, then kept it immersed in a bucket or plastic bag of fresh water while he rushed it to a local repair shop. If you are fast and your repairperson is well equipped, this technique may actually work. If it falls into salt water, rinse it in fresh water immediately. In an emergency, you can try drying the equipment in an oven on the "warm" setting, although there is some danger with this technique that the setting could be too high for some plastic parts, which could warp or even melt. On the other hand, you have probably ruined your equipment anyway, so why not try to coax a little more life from it?

Although from a technical standpoint, repair of water-damaged equipment is often possible, it may not be feasible from an economic standpoint. If the repair will take more than seven hours for an SLR, the cost of repair and the cost of buying a new unit begin to work out about the same.

Even when equipment can be repaired at a reasonable cost, corrosion can develop again, requiring another repair.

The color of corroded parts makes the problem readily identifiable and is something you should watch for if you buy used equipment. Corrosion of reddish brown color occurs on iron or iron-based metals such as the winding base, screws, and other camera body parts. Green oxidation occurs on brass, copper and bronze, such as electrical connectors and other internal parts. White oxidation occurs mainly on the body die casting.

Rechargeable NiCad batteries in popular sizes from GE and Ray-O-Vac are widely distributed.

For motor drive and autowinder units, use alkaline or NiCad batteries. Old-fashioned carbon batteries just won't do the job.

BATTERIES

In today's high-technology world, a good percentage of all equipment is battery powered. As a result, batteries have become an im-

portant accessory in their own right, a sort of accessory for accessories. Unfortunately, batteries are not without their problems. They are sensitive to both high and low temperatures, their terminals corrode, and they have a limited life even when you do not use them.

In general, NiCad (Nickel-Cadmium), alkaline, and carbon batteries are used to power heavier devices such as autowinders, motor drives and flash units. The tiny silver and mercury batteries are used to power exposure meters and electronic shutters.

NiCad Batteries

Although initially expensive, rechargeable NiCad batteries quickly pay for themselves if your battery-powered equipment sees heavy usage. Manufacturers of electronic flash units and motorized cameras usually have NiCad battery packs and chargers designed specifically for use with their equipment. Standard AA, C, D, and 9.5V sizes are sold in most photo stores and can be used to replace alkaline batteries.

Whether you use them or not, NiCads have a limited life. A NiCad battery is good for at least 80 to 100 charges, and many will give you up to 1000, but the battery itself may have a maximum life of only three or four years, regardless of how often you recharge it. A ten-year life is about tops. This means that if a piece of equipment such as a battery pack or electronic flash has a built-in NiCad, it will go bad after a few years even if you do not use it.

If you have a choice between NiCad and alkaline cells, consider the amount of use the equipment will get. If you have an autowinder and run fewer than 30 or 40 rolls of film through your camera a year, the chances are alkaline cells will be a better value. On the other hand, NiCads are almost al-

Cross Reference Battery Guide

Mallory Number	Voltage	Type	Eveready	Ray-O-Vac	Japanese
MN1300	D 1.5	Alkaline	E95	813	AM1
MN1400	C 1.5	Alkaline	E93	814	AM2
MN1500	AA 1.5	Alkaline	E91	815	AM3
MN1604	9.0	Alkaline	—	—	—
MN2400	AAA 1.5	Alkaline	E92	824	AM4
MN9100	N 1.5	Alkaline	E90	810	AM5
MS76	1.5	Silver	S76	RS76	GM13
PX1	1.35	Mercury	EPX1	RPX1	HS-P
PX13	1.35	Mercury	EPX13	RPX13	HS-D/H-D
PX14	2.7	Mercury	EPX14	RPX14	HS-2D/H-2D
PX19	4.5	Alkaline	531	RPX19	—
PX21	4.5	Alkaline	523	RPX21	—
PX23	5.6	Mercury	EPX23	RPX23	—
PX24	3.0	Alkaline	532	RPX24	—
PX25	4.05	Mercury	EPX25	RPX25	—
PX27	5.6	Mercury	—	RPX27	—
PX28	6.0	Silver	544	RPX28	4G13
PX30	3.0	Alkaline	EPX30	RPX30	—
PX32	5.6	Mercury	—	—	HM-4N
PX625	1.35	Mercury	EPX625	RPX625	H-D
PX640	1.35	Mercury	EPX640	—	H-N
PX675	1.35	Mercury	EPX675	RPX675	HS-C/H-C
PX825	1.5	Alkaline	EPX825	RPX825	AMF
RM400R	1.35	Mercury	E400	T400	—
RM640	1.4	Mercury	E640	T640	—
SA13D	D 1.5	Rechargeable Alkaline	—	—	—
SA14C	C 1.5	Rechargeable Alkaline	—	—	—
SA15AA	AA 1.5	Rechargeable Alkaline	—	—	—
TR112R	2.7	Mercury	—	—	KM-2D
TR164	5.6	Mercury	E164	T164	KM-4N
7R31	K 4.0	Mercury	538	RPX31	—
7K67	Flat-Pak 6.0	Alkaline	—	—	—
M215	22½	Zinc	412	215	015
M504	15	Zinc	504	220	W10
M505	22½	Zinc	505	221	W15
PF489	225	Zinc	489	N150	—
PF491	240	Zinc	491	1010	0160
PF497	510	Zinc	497	1012	0320

ways a better bet for electronic flash units.

Recharging times vary with the design of the battery pack and the charger. It may take from 8 to 16 hours to build up a full charge with the slow-charging designs, although the batteries may take on enough charge to be usable within a couple of hours. Rapid rechargers, which deliver a full charge in anywhere from two hours to 15 minutes, should be used only with the battery packs for which they are designed. For example, the Charge 15 from Vivitar will recharge the Vivitar NC-3 battery pack in only 15 minutes, but the pack has a built-in thermostat that shuts the unit off if the batteries overheat. Other batteries could be ruined by a unit like this.

Both GE and Ray-O-Vac make rechargeable NiCads in standard AA, C, D, and 9.5V sizes. The bat-

teries and chargers are interchangeable between the two brands. The batteries go into a module that snaps onto a recharger that can be plugged into any standard household electric outlet. It takes about 14 hours to develop a full charge.

Do not overcharge NiCads. They can overheat and leak. Be particularly careful about recharging time in hot weather, when they discharge and recharge with extra speed. If the batteries are hot, let them cool down before you recharge them or put them to work. They will last longer.

NiCads hold charge best in cool weather. In hot weather they discharge spontaneously at about five per cent a day. In any case, if you haven't used them in more than a week, assume the charge is down and recharge before a long session. In extremely cold

weather, voltage may fluctuate and NiCad-powered exposure meters may give erratic readings. Under extremely low-temperature conditions, keep the batteries warm in an accessory battery pack.

If your NiCads do not seem to be delivering full power, try cleaning the terminals with a pencil eraser.

Alkaline Batteries

These widely advertised, long-life batteries really do deliver three to five times more power than their zinc-carbon counterparts. They also have a three-year shelf life so your chances are good that they will still pack plenty of power when you buy them. Keep a set in your gadget bag as a back-up for NiCads.

When only partly discharged, alkaline cells can spontaneously recharge themselves to a limited extent. But once they fail, the partial recharge will only give you a few extra flashes or a couple of feet of film driven through the camera before another failure.

There are rechargers designed to be used with special rechargeable alkaline cells, but most are not designed for recharging, and if you try, you do so at your own risk. If you want rechargeable batteries, go with NiCads.

Zinc-Carbon Batteries

These are the classic dry cells. The smaller AA, C, D, and 9.5V sizes are not recommended for use in photo equipment because they do not last long enough, although they will do in an emergency.

Do not mix carbon and alkaline batteries in the same unit. The extra power of the alkaline cells can partly recharge the carbon cells and cause them to overheat, leak, or explode.

Rechargeable carbon batteries are no longer made for use in photo equipment, although they were available at one time. If you still own equipment of this type, it is time to update it with NiCads.

High-voltage zinc-carbon battery packs are still being used for professional electronic flash units when rapid recycling time is a necessity, but even in this area, the newest high-voltage units are designed for use with high-voltage NiCad battery packs.

Silver-Oxide and Mercury Batteries

These small batteries are used to power camera electronics and exposure meters. They operate well from slightly below 0° F (−20° C) to a bit over 100° F (+40° C). If you are working at sub-zero temperatures, keep the equipment warm or use a remote battery pack, which you can keep in an inside pocket and attach by wire to your camera. These remote packs are available from the manufacturers of the better camera systems.

If the weather is extremely hot, keep the equipment in the shade or in a cooler when not in use. A picnic cooler with an ice pack in the bottom will do.

These batteries are not rechargeable, but most equipment that depends on them can operate for a long time on a single battery load. Camera batteries frequently last a year or more, provided you remember to turn off the exposure meter when you are not using it. If you are going on a trip, keep a spare battery set in your gadget bag.

Never let children get their hands on these batteries. Mercury in particular is a powerful poison. Throw dead batteries out with the garbage. Do not toss them into a fire, because they can explode.

Trouble-Shooting Batteries

Battery failure is not always due to discharge. One common problem is corrosion on the terminals, and many good batteries have been thrown away because the extra resistance caused by an invisible film of corrosion prevented them from delivering full power.

You can clean a battery terminal by rubbing it with an ordinary pencil eraser. For stubborn corrosion, use a bit of emery board, the type used to manicure fingernails, or a very fine sand or garnet paper. The contacts in the equipment should also be cleaned on occasion. The eraser on the end of a pencil is ideal because you can poke it into the smallest and deepest battery compartments. Use a blower to remove eraser dust from the compartment after cleaning.

Corrosion develops naturally, even when the batteries are new and unused, so always clean the terminals of new batteries by wiping them with a clean, coarse cloth. Do not touch the terminals with your fingers.

If you keep batteries in your equipment—most photographers do despite the advice of equipment makers—clean the battery terminals every few months and check for leakage. If the batteries begin to leak, throw them away. For long-term storage, remove the batteries from the equipment.

Store batteries in a cool, dry place. In hot weather, you can keep them in the refrigerator, but do not freeze them. Let a cold battery warm up to room temperature before you put it into your equipment.

In cold weather, choose heavy-duty batteries and always carry an extra set. Alternate batteries every two hours. One set of- batteries should always be warming inside your shirt pocket while the other set is in use.

If you buy extra batteries, write the date of purchase on the package, and try to use them within a year after purchase.

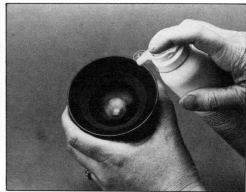

Your first line of defense against dirt is a blast of "canned air" or a blower brush.

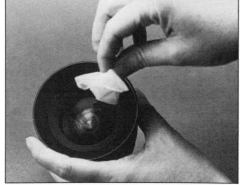

Equipment for cleaning lenses, filters and other accessories is essential. A can of gas is convenient, but a cheap blower brush will do as well, particularly if you are traveling. Lens cleaning fluid and tissue is the only way to remove oily pollution.

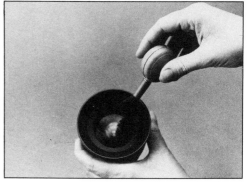

For more stubborn dirt, breathe moistly on the lens and wipe gently with a wadded-up lens tissue or piece of clean cloth. Do not use wool, which contains oils.

Fingerprints are tough. Put a drop of lens cleaning fluid on a piece of lens tissue and wipe gently.

HOW TO CLEAN EQUIPMENT

All camera equipment should be cleaned periodically. No matter how meticulous you are, lenses and other accessories are bound to collect dirt, if for no other reason than atmospheric pollution.

Every so often, wipe down all non-optical surfaces with a clean, dry cloth made of cotton or synthetic fiber to get rid of the dust. If the equipment gets dusty or dirty, clean it immediately.

To get dust and grit out of nooks and crannies and to remove it from optical surfaces, use a blower brush or a blast of inert gas from a can of Dust-Off.

To get rid of stubborn dirt on optical surfaces, try whisking it away using a bunched up lens tissue or lightly wadded non-wool cloth. If you need lubricant, breathe moistly on the glass surface. Do not use paper, which has fibers that can scratch the soft surface of a lens or filter, and do not use the treated tissues sold to clean eyeglasses, which can damage the lens coating. Do not scrub the surface. Just brush it lightly with the tissue or cloth.

For really sticky grime, use a drop of lens-cleaning fluid on a sheet of lens tissue and wipe gently with a circular motion. This is the best way to get rid of fingerprints on lenses, filters and viewfinder eyepieces.

The plastic filters sold for use with electronic flash can be washed in soapy, lukewarm water, rinsed, and dried with a soft, lint-free cloth. In general, filters that go over light sources do not need to be treated with the extreme care given to filters and lens surfaces that are used to make the image on the film.

2 LENSES

One of the keys to the creation of outstanding photos is the use of a system of interchangeable lenses. It is true that a good photographer can take good pictures using a simple pocket camera, but that's a trick you can only get away with occasionally. By using a variety of lenses and lens handling techniques, you can get a single subject to yield dozens of exciting images rather than just one.

Using different lenses can be exhilarating when you have an SLR because you can see the image change as you switch from one lens to another, and with each change, new worlds open up. With a normal or moderate tele lens you can capture medium-size subjects full frame and poke about to get details of nearby objects. Switch to a wide-angle lens and space seems to open up, taking on new depths and dimensions. If you then change to a long telephoto, space seems to flatten out and you can bring in distant details.

LENS BASICS

The modern photographic lens is a computer-designed marvel that should give you sharp, brilliant images. If you buy a lens that gives you soft fuzzy images, and it's not a soft-focus lens, return it. All modern lenses with a list price of more than $100 should give quality performance.

This is not to say that there are not differences in quality. You get what you pay for, and it pays to know what you are buying. For example, a top-of-the-line lens from Nikon, Canon, Minolta, Olympus, or one of the other makers of top-quality camera systems will go through significant quality control procedures before it gets into your hands, and once you have it, the lens should stand up to use day in and day out for years. Moreover, these great lenses will produce images of superior quality, But a glance at the test reports published in photography magazines reveals that you now can get good quality from most of the widely advertised lenses of independent manufacturers. Vivitar, Soligor, Tamron, and Sigma are just a few of the better known lens brands that enjoy a well-deserved popularity. There are many other less well-known brands that also deliver fine performance.

How To Test Your Lens

Fuzzy low-contrast images can have a variety of causes, including problems with a lens. Since you do not have sophisticated optical-test equipment, your best bet is to leave fancy optical-performance tests to the photo magazines. Those test reports on lenses are a good guide to the quality you can expect and provide all the information you need, and then some, about subtle differences among lenses.

On the other hand, there is a simple test that you should make with every new lens you get. Put the lens on your camera and take a few shots on color slide film of subjects with fine details and then take the same subjects using your normal lens. When you get the slides back, compare them using either your projector or a light box and one of the 8X magnifying glasses sold in photo stores. (Do not use color-print film for a lens test.)

A simple test like this will immediately reveal any severe problems with a lens, provided you do your part. If you hand-hold the camera, there is always the possibility, especially with telephoto lenses, that you will get some blur due to camera shake. If you must hand-hold, use a shutter speed at least twice as fast as the focal length of the lens. If you are testing a telephoto or long zoom lens, mount the camera on a tripod or

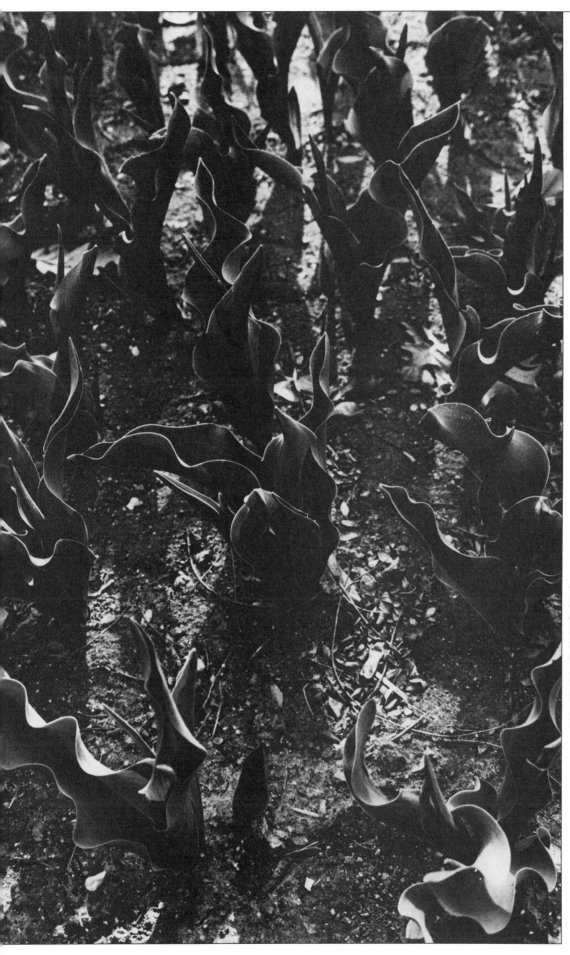

The combination of
backlighting plus slight
exaggeration of the distance
between foreground,
middleground and background
elements provided by a 35mm
lens on a 35mm SLR help make
this photo of plants in a
botanical garden something
more than just a snapshot.
Photo by Robb Smith.

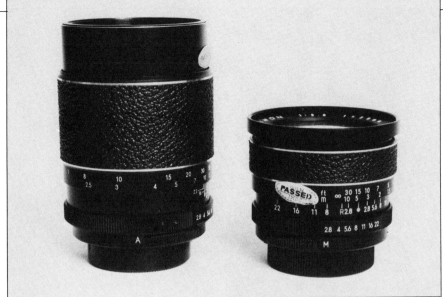

The "A" and "M" settings on these lenses allow you to use the lens with non-automatic cameras. The "A" setting is for use with automatic cameras. Use the "M" setting with a non-automatic camera. The new generation of bayonet-mount lenses do not have these settings because they are unnecessary with modern equipment.

The variations among lens-mount systems are obvious when you look at the rear of the lenses. These three automatic lenses are, from left to right, Minolta, Nikon and Universal Thread. Aside from the obvious mechanical differences, there are differences in flange focal length, which is the computed distance between the rear of the lens and the film plane. That's why switcheroo adapters that let you use lenses of one type with a body of another do not usually provide infinity focus.

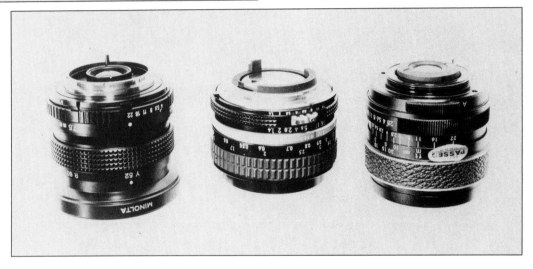

rest it on a solid table with something underneath the lens to keep it from moving.

If you are testing a zoom lens, test it at several different focal lengths. If it is a one-touch zoom, refocus at each setting.

If your normal-lens shots look fine and the shots taken on the same roll with your new lens seem unacceptably fuzzy, return the lens. The manufacturer will either repair it or send you a new one. Do not wait till the last minute to exercise warranty rights if you feel the lens needs service. Many dealers will simply take the lens back and give you a new one if you act within a few days of purchase. (See Chapter 1.)

In addition to delivering a sharp, contrasty image, a good lens should handle smoothly. As soon as you put a new lens on your camera, try working it. Focus and refocus; change f/stops; operate the zoom and close-focus controls if it has them. It should feel smooth and solid, with nothing gritty or extremely wobbly. The focus should work throughout its entire range without getting hung up at any point.

Finally, the lens should be complete. Some are supposed to come with a case, lens hood, or other accessories. These are listed either on the box or in the literature that comes with the lens.

Automatic, Preset, and Manual

Most contemporary lenses for 35mm SLRs are automatic. This means that the aperture will automatically close down to whatever you have the lens set on at the time you press the shutter. The rest of the time, the lens stays wide open, which is the best position for viewing and focusing.

A preset lens has an aperture ring that you can preset to stop at a particular aperture when you turn it. A quick twist with your fingers changes the lens from wide open for viewing to the preset stop for exposure.

A manual lens has an aperture that stays at whatever f/number is set on the f/stop ring. Today, only mirror lenses are manual, and manufacturers frequently refer to them as preset lenses, because they have only one, preset aperture.

Lens Mounts

Each camera system has a slightly different method of mounting a

lens. The most popular are bayonet mounts, which lock in place with a turn of the wrist and unlock when you push a button on the camera and give the lens a quarter turn in the opposite direction. The mount mechanism varies with the brand. You cannot ordinarily use a lens in a Minolta mount on a Canon or Pentax or Nikon; on the other hand, several cameras now share the Pentax K mount. The universal thread (Practica) mount is a screw-on lens system used on Chinon and Fujica cameras, and on older Pentax models such as the Spotmatic cameras.

Occasionally it is possible to adapt one lens-mount type for use with some other mount. For example, Konica has an adapter for the TC that lets you use universal thread, Nikon and Exakta lenses. When Pentax introduced a new line of cameras featuring a bayonet mount, they also brought out an adapter that let owners of Pentax screw-mount lenses use them with the new cameras. A special adapter of this type is also available for Leica system users. These adaptations were planned by the designers of the camera systems.

Switcheroo adapters let you attach a Pentax lens to a Nikon body, Nikon lens to a Pentax body, Minolta lens to a Nikon body, Pentax to Minolta body, and so on. Normally these adapters do not permit infinity focus and the focusing range is limited. They are the most useful for close-up work. If you use one of these adapters, watch out for lenses that have protruding rear elements which can get in the way of the mirror action in SLR cameras. Unless you are willing to tinker, you are better off sticking with lenses designed for use with your particular camera.

Independent lens manufacturers such as Sigma, Soligor, Tamron, Vivitar, and so on, offer the same lens in a number of different mounts. All you have to do is specify the camera on which you will use it. The most common mounts are Universal Thread, Minolta MD, Canon FL/FD, Nikon/Nikkormat AI and F, Konica Autoreflex, Olympus OM, Pentax K and M, Yashica SR, and Contax RTS.

T-mounts: The proliferation of camera systems with unique mounts led some independent lens manufacturers to develop lenses with interchangeable mounts. The first of these was the T-mount, which does not couple with the automatic exposure and aperture system of the camera.

Today, automatic T-mounts, such as the Vivitar TX-mounts are also available. These mounts are for use only with lenses designed specifically for them. Since the automatic features are quite important in contemporary SLR photography, lenses that use the automatic T-mount system offer an important advantage when compared to the standard T-mount.

The advantage to T-mounts, whether standard or automatic, is that the same lens can be used with different cameras. The mount and lens are separate units. You buy the basic lens and separate T-mount for each camera lens mount style that you want to use. For example, if you happen to have an old Pentax Spotmatic with a universal thread mount and a new Nikon FM, you could buy a single 80–210mm zoom lens designed for use with T-mounts and two T-mounts, one for each camera. Then you could use the lens on either camera. The mounts are relatively inexpensive and you need only one per camera.

The disadvantage to the T-mount system is that it adds

Focal Length Comparison Chart—35mm Format

	Focusing Distance		
Focal Length	One Head, Vertical	Two Heads, Horizontal	Three Standing Adults, Horizontal
20mm	1 ft. (.3m)	1.2 ft. (.37m)	4 ft. (1.2m)
24mm	1.12 ft. (.35m)	1.5 ft. (.45m)	5 ft. (1.5m)
28mm	2 ft. (.6m)	2 ft. (.6m)	5.5 ft. (1.7m)
35mm	1.7 ft. (.5m)	2 ft. (.6m)	7 ft. (2.1m)
50mm	2.25 ft. (.7m)	3 ft. (.9m)	10 ft. (3m)
55mm	2.3 ft. (.7m)	3.3 ft. (1m)	11 ft. (3.1m)
85mm	4 ft. (1.2m)	5 ft. (1.5m)	17 ft. (5.2m)
105mm	5 ft. (1.5m)	6.3 ft. (1.9m)	21 ft. (6.4m)
120mm	5.6 ft. (1.7m)	7.3 ft. (2.2m)	24 ft. (7.3m)
135mm	6.5 ft. (2m)	8 ft. (2.4m)	27 ft. (8.2m)
200mm	9.5 ft. (2.9m)	12 ft. (3.7m)	40 ft. (12.2m)
300mm	14.5 ft. (4.4m)	18 ft. (5.5m)	60 ft. (18.3m)
400mm	19 ft. (5.8m)	24 ft. (7.4m)	80 ft. (24.4m)
500mm	23.8 ft. (7.3m)	30 ft. (9.2m)	100 ft. (30.5m)
1000mm	48 ft. (11.6m)	60 ft. (18.3m)	200 ft. (61m)

adapters to the load in your gadget bag and is just one more item that can get lost or misplaced.

Lens conversions: It is possible to have some older lenses updated for use on newer model cameras. This allows you to buy new bodies with advanced features and enjoy the advantages of full-aperture exposure automation with older lenses from the same manufacturer. Not all lenses can be updated and not all manufacturers have a program for this conversion. To find out if the older lenses in your collection can be updated for use with newer bodies, contact the lens manufacturer's customer service department.

Even when a manufacturer will not update old lenses, you may find some independent repair person who can do the job for you at a reasonable cost.

Coverage

Lenses are designed to cover a particular format without vignetting (darkening). If you contrive to use a lens designed for a small-format camera on a larger-format camera, chances are there will be darkening at the edges of the film and in extreme cases, the image will project as a circle. It is possible, however to go in the other direction and use a lens for a medium-format camera on a 35mm SLR, and you may occasionally run across adapters that let you do this.

Comparing Lenses

In their enthusiasm for new telephoto lenses, photographers occasionally resort to hyperbole, swearing that they can photograph the eye of a bird with their latest optical monster. In fact, very few photographers use tele lenses longer than 600mm, and

with a lens of that length, you must be quite close, working out of a blind, or with a remote set-up, before you can fill the frame with the eye of a condor, much less that of a budgie. Similar misunderstandings occur on the other end of the focal-length range with wide-angle lenses.

One way to visualize what lenses of different focal length will do is to think of them in terms of the camera-to-subject distance required to fill the frame with a vertical head or the distance needed to fill the horizontal format with three standing adults. The accompanying chart gives a rundown on these focusing distances for a typical selection of 35mm camera lenses, ranging from 20mm through 1000mm.

For example, to fill the frame with three standing adults, the difference in focusing distance between a 50mm lens and a 200mm lens is 30 feet. A 1000mm

lens would put you 200 feet from the same subject.

Lens Handling

Here are some basic do's and don't's for lens handling:

1. Most modern lenses have coupling pins on the rear and some have protruding rear elements. If you have to put the lens down without the rear lens cap, place its front element down. If the lens has a protruding front element as well, use your lens case or gadget bag as a holder. Laying a lens down on its side is asking for trouble, because it can roll.

2. Clean your lenses regularly. (See Chapter 1 for detailed instructions.) No matter how careful you are, the lens will inevitably get dirty, if only from air pollution. A dirty lens degrades sharpness and contrast.

3. Try not to touch the front or rear element. If you do, wipe the fingerprint off immediately with a

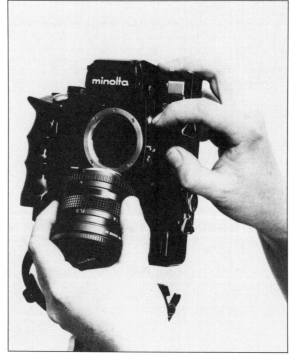

To interchange lenses on bayonet-mount cameras, press the lens-lock button on the camera body, give the lens a quarter turn, and lift it out. The exact method used to attach a lens varies. Some have a dot that aligns with a dot on the camera body. Some must engage a meter coupling pin. Others have to be set to a particular aperture range. And some you could put on blindfolded and never go wrong. If you run into problems, consult your camera instruction book or get help from someone familiar with your camera model.

soft cloth or lens tissue. Finger-prints contain acid that after a period of time can etch the surface of the glass.

4. Keep the lens in its case with front and rear lens caps on when not in use. If you have the slip-on type cap that always seems to get lost, then buy the type that screws or bayonets into the lens accessory mount. You can get a lens-cap protector that keeps the lens cap attached by cord to the camera, but a dangling lens cap can interfere with camera handling.

5. Develop a procedure for lens interchange so that you do not have to hold two lenses in your hand at the same time. The usual method is to remove the first lens, put on the front and rear lens caps, and place the lens in its case or in a lens compartment in your gadget bag. Then pick up the second lens, remove the front and rear caps and place them in the lens case or gadget bag compartment, and finally attach the lens to the camera. Lens interchange is safest when you have the camera on a strap around your neck or on a table.

6. When you keep lenses in a gadget bag, make sure they are well protected from accidental bumps and do not knock against one another. The best way is to keep them in individual cases or use a gadget bag that has individual padded compartments for accessory lenses. If you keep lenses on a shelf in your studio, wrapping them in a plastic sandwich bag will keep dust from settling into the mechanisms.

TECHNICAL FACTS

This section provides working definitions for some of the more commonly used and misused technical terms. It's here to help clean up some of the more frequent misunderstandings that photographers seem to pick up as a result of reading jargon-filled photo literature.

Focal Length

Focal-length numbers function like names. They are a simple way of telling one lens from another. After a while you get to know what certain focal-length lenses will do for you and the technical meaning of the term *focal length* becomes unimportant. Most photographers think of it as the distance between the film and the center of the lens. Actually, it's a measurement in millimeters from the film plane to an optical point called the node of emission. When this node falls behind the lens, it's a retrofocus design which is used for wide-angle lenses. If it falls in front of the lens, the design is a telephoto, which usually means that the lens is physically shorter than its focal length. Today, most long focal-length lenses are actually telephotos, and in this book the term telephoto is used to refer to any long lens. But in fact there are also long-focus lens designs in which the lens is as long as its focal length. These lenses are monsters —big, heavy, and hard to hold. Stay away from them.

F/Stops

Lenses for SLR cameras have a diaphragm with a variable aperture in the middle that opens and closes as you turn the f/stop (aperture) ring. The size of the opening is given in f/stops (f/numbers), which are fractions that tell you

Focal-Length/Angle-of-View Equivalents
(approximate values)

Angle of View (approx.)	Nominal Picture Size / Diameter	35mm	2¼x2¼ 6x6cm	2¼x2¾ 6x7cm	2¼x3¼ 6x9cm	4"x5"	5"x7"	8"x10"
		43mm	80mm	90mm	100mm	150mm	210mm	300mm
76°		28mm	50mm		65mm	100mm	135mm	185mm
69°		31mm	55mm	65mm		110mm	150mm	220mm
68°		32mm	60mm		75mm	115mm	160mm	225mm
62°		36mm	65mm	75mm		125mm	175mm	245mm
58°		39mm	70mm		90mm	135mm	190mm	265mm
53°		43mm	80mm	90mm		150mm	210mm	305mm
51°		45mm	85mm		105mm	160mm	220mm	330mm
46°		50mm	90mm	105mm		170mm	240mm	355mm
45°		52mm	95mm		120mm	180mm	250mm	360mm
41°		57mm	105mm	120mm		200mm	280mm	400mm
37°		65mm	120mm		150mm	220mm	310mm	450mm
33°		72mm	135mm	150mm		250mm	350mm	500mm
32°		78mm	145mm		180mm	270mm	380mm	505mm
28°		85mm	155mm	180mm		300mm	420mm	605mm
27°		90mm	165mm		210mm	320mm	440mm	615mm
24°		100mm	180mm	210mm		350mm	490mm	690mm
21°		115mm	210mm		270mm	400mm	560mm	810mm
19°		130mm	240mm	270mm		450mm	630mm	865mm

how many times the focal length of the lens can be divided by the diameter of the aperture. The numbers on the f/stop (aperture) ring give you the bottom half of the fraction, so instead of 1/5.6, it shows "5.6". The smaller the number the larger the opening.

The scale is based on the progression of the square root of 2 (1.4147 × 1.4147 × 1.4147. . . .). As you go up the scale, each number represents twice the amount of light of the preceding number. Unless you have some special interest in math, there is no need to work through the logic of the scale. Once you take enough pictures, you learn to use the relationships between the numbers without thinking about them. After a while you just know that opening up, say, two stops from f/11 will bring you to f/5.6.

Depth of Field
When you focus a lens, there is always some area in front and behind the focus point that will also appear sharp. This region of apparent sharpness is called the depth of field. It is largest at small apertures. The depth-of-field information you get from a table or the scale on your lens is generally reliable for enlargements up to 8″ x 10″ when viewed at a distance of 10″ or more and for color slides and giant blowups when viewed from a minimum distance equal to the diagonal of the enlarged image. Small prints, such as the popular 3″ x 5″ size, give you greater depth of field than the scales would indicate and an enlargement from a small area of the negative can produce a slight reduction in the apparent depth of field. Most of the time the scales work fine.

The wider the angle of view of the lens, the greater the depth of field at any given camera-to-subject distance. A super-wide-angle lens at small f/stops will have a

depth of field that extends from a few inches to infinity. A super-telephoto lens has a comparatively small depth of field, sometimes no more than a few inches at close focusing distances. To increase depth of field, switch to a wide-angle lens. To narrow it down for selective focus effects, use a tele lens.

How to use the depth-of-field scale on a lens: The scale has a central index mark that shows the exact distance to which the lens is focused. On either side of this mark are lines that indicate f/stops. The lines may be numbered, or they may be colored to match correspondingly colored f/numbers on the diaphragm ring. To use the scale, find the marks for the f/stop you are using. The distance bracketed by the marks is the depth of field.

Angle of View
The angle of view tells you how wide or narrow a view you will get on the film. It is a combination of film format and focal length. In 35mm photography, a normal 50mm lens has a 46° angle of view, a 28mm wide angle has a 75° angle of view, and a 135mm

moderate telephoto has an 18° angle of view. The accompanying chart compares angles of view for lenses of similar focal length when used with various film formats and tells whether they are wide angle, normal, or telephoto.

You can figure out the angle of view of any lens by drawing a triangle. Make the base the same

The depth-of-field scale on the lens at left is coded by colored lines that correspond to colored f/numbers. The lens on the right has a duplicate set of f/numbers to show depth of field.

length as the diagonal of your negative (43.2 mm for the standard 35mm format). Make the height of the triangle the focal length of the lens. The angle at the top (apex) of the triangle is the angle of view for the lens/film-format combination.

The shorter the lens, the wider its angle of view. Most photographers think of a lens in terms of the category in which the focal length falls, such as super-wide angle, wide angle, normal, and so on, and do not worry about the actual angle, which is never printed on the lens.

Speed

The speed of a lens is its widest opening. On the lens it is usually printed as a ratio such as 1:1.4, which means that the diameter of the widest opening you can get

with the diaphragm inside the lens can be divided into the focal length 1.4 times.

Curvature of Field

When you focus a lens, you are technically bringing all the points from one plane to a common focus on the film. In most lens designs, the plane is curved, so that the region you image most sharply is a big, sweeping arc. This is called curvature of field.

For close-up and macro photography, a flat field lens is preferred. Macro lenses and some close-focusing zooms are flat-field designs. In macro photography, you can get a flatter field with a normal lens by reversing it. There are also special-purpose, wide-angle lenses that provide variable-field curvature.

A 28mm is a good, general-purpose focal-length for wide-angle work with a 35mm camera. Its field of view adds emotional impact to shots of interiors with the extreme exaggeration of depth that you get with lenses 24mm and shorter. Photo by Robb Smith.

Aberrations

Aberrations are flaws in a lens that can be seen in the image. All lenses have some aberrations, but good ones have very few and these would not normally be noticeable.

The only aberrations over which the photographer can exert any control are spherical aberration, which is a slight unsharpness caused by a difference in focus from the center to the edge of the lens, and coma, which is a variation in size of the image projected by various parts of the lens. Stopping down partially corrects both spherical aberration and coma.

There is nothing much you can do about other types of aberration except change lenses. Distortion occurs when the image magnification is not the same over the entire image field but varies from the center out. In pincushion distortion, straight lines tend to curve inward. In barrel distortion, straight lines bow outward. Distortion is a problem with some zoom lenses, particularly at the longest and shortest focal lengths.

Chromatic aberration is a failure of all wave lengths of light to come to the same focus on the film plane. All lenses used in photography are color-corrected to some extent, and all the better ones are free of any obvious color fringing. If you work professionally with ultraviolet or infrared radiation, then you may want to consider one of the very expensive super-corrected lenses with fluorite and quartz elements or one of the new mirror lenses.

Microscope and telescope eyepiece lenses designed strictly for viewing are often not color-corrected sufficiently for good photographic use. The best telescope ocular for photographic work is an orthoscopic eyepiece. For photomicroscopy, use an apochromat.

A lens has astigmatism when it images some points of light as two little lines at right angles to each other. You should not have this problem with a modern photographic lens.

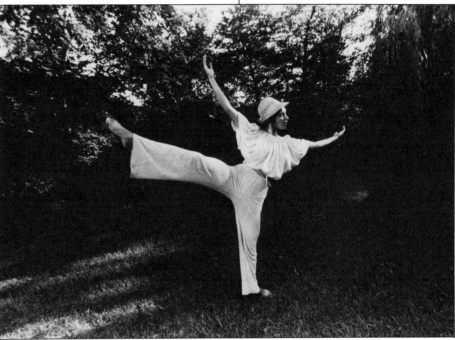

When there are no clear-cut straight lines in a photo, it is often difficult to tell exactly what type of lens was used. This shot was taken with a 16mm fish-eye. Note how the proportions of the dancer's right foot and leg are exaggerated in comparison with her head and torso. Photo by Robb Smith.

Aspheric Lenses

An aspheric lens has one or more elements with nonspherical surfaces that are shaped to reduce spherical and other aberrations. Computer technology and advances in lens manufacturing have given rise to a new generation of extremely fast aspheric lenses in both the wide-angle and moderate telephoto classes. These costly lenses should produce images of superior quality.

Perspective

Perspective in photography refers to the point of view of the lens and is specifically concerned with the way a lens images straight lines and with differences in the size of objects separated in depth.

Good photographic lenses from about 18mm (super-wide-angle) on up in 35mm photography are rectilinear, which means that they render straight lines as straight lines. If straight lines are distorted by the lens, then it has an uncorrected aberration. Fish-eye lenses are curvilinear, which means that they render straight lines as curves. The only other type of projection you may encounter in photographic equipment is cylindrical perspective, in which a moving camera lens projects its image onto a curved film plane to produce an image that looks like it was printed on the surface of a cylinder.

The way objects separated in depth are imaged has to do with the lens-to-subject distance. Consider a full-frame shot of a dancer with her hand outstretched toward the lens. If you use a normal lens, you will be standing about 10 feet from your subject and her hand will be about 8 feet from your lens, or 20 percent closer. At this distance, the hand will seem just a little too large in proportion

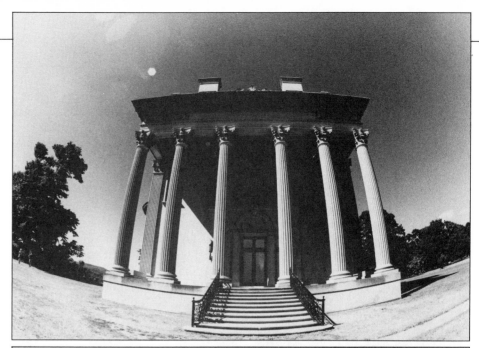

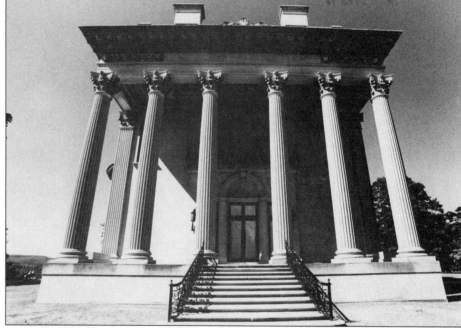

What a difference two millimeters makes! The photo on the top was taken with a Sigma 16mm fish-eye lens. The white dot in the sky is flare caused by the sun striking the surface of the protruding front element. Note how the pillars seem to curve outward. The photo on the bottom was taken with a Sigma 18 mm wide-angle lens that gives standard rectilinear perspective. The pillars are relatively straight. Both lenses feature a built-in red filter, which was used in both shots to create better separation between the white stone buildings and the patch of blue sky behind it.

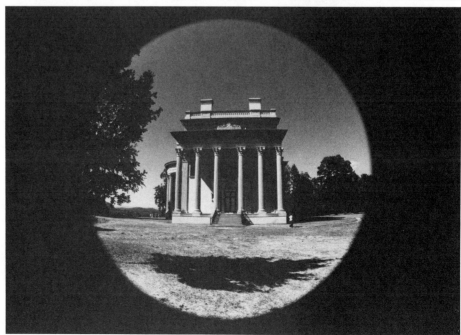

This photo of the Vanderbilt mansion in Hyde Park was taken with a Sigma 16mm fish-eye lens and a circular adapter supplied with the lens. The result is a cropped image covering an angle of view of about 100°, similar to that of an 18mm lens. The perspective is still spherical, but with a distant subject, the slight outward bow of verticals is barely apparent. Fish-eye adapters used with normal and wide-angle lenses produce similarly restricted angles of view. Compare this effect with those in any of the 7.5mm fish-eye shots, which provide a true 180° angle of view in all directions.

to the body. If you used a 135mm moderate-telephoto lens, you would be about 25 feet from your subject and the 2-foot extension of her arm toward the camera would produce no significant change in size relationship. If you go in the other direction and use a 20mm wide-angle lens, the dancer will fill the frame at about 4 feet from the lens and her extended hand would be only 2 feet from the lens. In this case, the hand would look enormous in proportion to the rest of her body. This effect is sometimes called "wide-angle distortion," although technically it is perfectly correct perspective.

You can deliberately use these perspective effects by changing lenses to either decrease or increase the distance between you and your subject. If your subject is a person and you fill the frame using a wide-angle lens, you will be right on top of your subject and every gesture will be exaggerated. A still subject, such as the branches of a tree, will seem to expand as nearby branches are imaged large and those further back are rendered comparatively tiny. By using a telephoto lens you can compress the apparent distance between objects separated in depth because the tele lens puts so much more working distance between you and your subject.

In general, telephoto lenses are

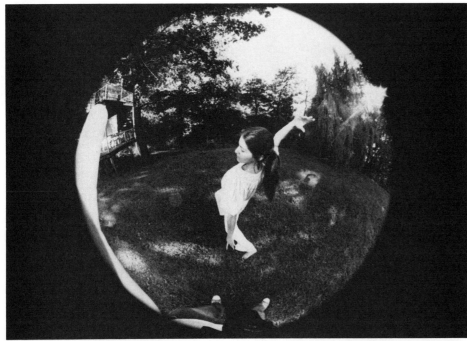

It's easy to go wrong with a 7.5mm fish-eye, which gives a true 180° picture of the world. This photo contains three of the most common errors. At 2 o'clock the sun creates flare. At 6 o'clock, the photographer's feet and second camera appear. And from 7 to 10 o'clock the photographer's finger becomes part of the picture.

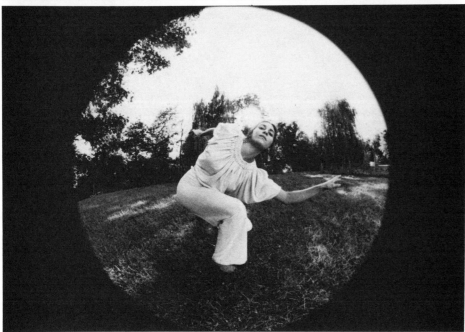

The distortion produced by a fish-eye lens is in part a function of camera to subject distance. In this photo dancer Karen Abram was about 3 feet from the camera and the exaggeration of gesture and form is quite apparent. One of the trickiest parts of fish-eye lens work is learning to use distance as a means of controlling distortion.

used to control middleground/background size relationships. Wide-angle lenses are used to control foreground/middleground relationships. Normal lenses are used to give normal size relationships as they would be perceived by an observer standing in the same position as the camera.

NORMAL LENSES

The normal lenses supplied by the top-brand camera manufacturers for their best SLRs are some of the sharpest, fastest lenses ever made. If you own a Nikon, you just can't find a better optic for your camera than a 50mm Nikkor lens. The same can be said of a 50mm Rokkor-X lens for a Minolta, a 50mm FD for a Canon, and so on.

If you are still in the market for a normal lens, buy the best you can afford. An $f/1.4$ or 1.8 lens will give you the speed you need for low-light, hand-held camera work. If cost is a consideration, then buy the slightly slower, less expensive normal lens, a 1.7 rather than a 1.2, for example. The extra half stop or less delivered by the faster lens will seldom be significant.

The angle of view provided by a normal lens is something of a compromise. The traditional rationalization is that it covers about the same field as your eyes when you casually scan a subject without moving your head. But when you look closely at something, an 85mm lens more closely approximates the angle of view involved, and if you include peripheral vision and a widely roving eyeball, then you need a very wide-angle lens to cover the same field. One reason the 50mm lens is "normal" is that when the 35mm Leica camera with its 24 x 36mm format was first designed,

that focal length turned out to be the one that could be designed to deliver optimum optical performance.

Photographers with a need to get close to their subjects will occasionally opt for a comparatively slow 50mm or 55mm macro lens over the faster standard lens. Unless you plan to do a great deal of close-up work, you are better off with a regular, high-speed normal lens and accessories for occasional close-up work.

Some photographers prefer to use a slightly longer or wider lens as their standard. A 35mm lens can be used as a normal lens for black-and-white work and is especially useful when you photograph people indoors or when you find yourself interested in scenic photography. An 85mm or 105mm lens is technically a moderate telephoto, but some photographers standardize on this focal-length area for color-slide work because the slightly longer lens lets you poke around and isolate parts of a scene more efficiently than a 50mm. The longer focal length also puts more working distance between yourself and portrait subjects, which creates better proportions, particularly in head-and-shoulder shots.

If you feel the slightly longer lenses are "normal" for your way of seeing, then check out some of the new zoom lenses that cover that range before you plunk your money down on a single-focal-length (unifocal) optic. You may find that a 70–150mm zoom, or something similar, is just what the doctor ordered.

WIDE-ANGLE TO FISH-EYE

Wide-Angle Lenses
In 35mm photography the wide-angle group usually covers lenses from 24mm through 35mm.

The 35mm lens is either a mod-

erate wide-angle or a wide normal-angle lens. It is a favorite of photojournalists who like to work close to their subjects yet want to avoid the apparent distortion produced by wider lenses at closer working distances. It is particularly useful for full-figure shots of people indoors. It is also a useful lens for scenic photography. By and large, this is a lens for black-and-white work. Photographers working in color generally prefer the close cropping that longer lenses permit or the drama and style provided by a true wide-angle or super-wide-angle lens.

The 28mm lens is a true wide-angle. It provides great depth of field even at close focusing distances and gives plenty of coverage when you want to photograph large objects in small rooms or get in a complete building without moving back too far. If you work with subjects in the near and middle ground, it provides an exaggerated sense of depth. If you tilt the lens in relation to an architectural subject, there will be an exaggerated sense of converging verticals or horizontals.

The 28mm lens is very popular among amateur photographers, and it has the widest angle of view that a portable flash unit with a wide-angle attachment will normally cover.

Among professionals, the 24mm lens with its exceptional ability to cover interiors is probably more popular than the 28mm. The 24mm lens still provides a straight-line rendering of architectural subjects, even at the edges of the frame. With it you can photograph most buildings without stepping off the property or backing into the street. You can use its exaggerated rendition of the separation of foreground and middleground subjects to produce endless stylistic effects. Depth of field with a 24mm lens is enormous.

Super-Wide-Angle Lenses

Lenses shorter than 24mm are in the super-wide-angle category. The good ones, which may be as short as 17mm or 18mm, provide rectilinear perspective, in which straight lines are straight, as opposed to the curvilinear rendition of a fish-eye. Modern lenses in the 17mm to 24mm class are of a retrofocus design that permits through-the-lens viewing. Older designs had protruding rear elements and often had to be used with the mirror locked up.

Another feature to look for in lenses from this group is a floating element system that ensures sharp images at close-focusing distances.

Because of the very wide angle of view, flare is a special problem with these lenses. The only solution is to be aware of potential difficulty and hold your camera so that strong light does not spill across the front element.

Lenses in this category produce extreme separation of objects in the near- and middleground and depth of field that can extend from inches to infinity at small $f/$ stops. With an 18mm lens, you can actually hold an object up in front of the lens with your hand and have both it and a distant building sharply imaged. This leads to the possibility of making unusual combinations—a foot over a skyscraper, and so on. These lenses are also useful for photographing architectural interiors and for working in restricted spaces such as the cockpit of an aircraft.

Fish-Eye Lenses

The modern fish-eye lens has a 180° angle of view and gives a curvilinear rendition of straight lines. This is spherical perspective. It looks as though you were imaging the world on the outside half of a ball.

There are two types of fish-eye.

One produces a circular, 180° image in the middle of the frame. Lenses of this type are usually 7.5mm or 8mm focal length. In the older designs, you had to lock up the mirror to use these lenses because of the protruding rear elements. Modern designs, such as the 7.5mm Nikon, Canon, and Minolta lenses, permit through-the-lens viewing and focusing.

The second type of fish-eye is a 15mm or 16mm lens that produces a full-frame image. It's as though you cut a rectangle out of the full circular image. The angle of view at the diagonal of the film format is 180°. It is less when computed for horizontal and vertical sides of the frame. The newest designs permit through-the-lens viewing. Older designs required mirror lock-up.

The 7.5mm lenses have a fixed focus because depth of field extends from a few inches to infinity, even at fairly wide apertures. This focal length was designed originally for scientists needing hemispherical photos of changing cloud patterns and other phenomena. It can also be used for special visual effects.

The 15mm or 16mm fish-eye is used primarily for industrial photography and pictorial effects in commercial, advertising, and fine arts work.

TELEPHOTO LENSES

Moderate Telephotos

This group contains lenses from about 85mm through 135mm with 105mm and 135mm lenses being the most popular.

The moderate telephoto lens is ideal for portraiture, particularly three-quarter figure and head-and-shoulder shots, because it puts just enough distance between camera and subject to provide pleasing perspective. It can be used for sports and fashion

photography. In the studio it is useful for small-object photography.

A 105mm lens provides about twice the image size of a 50mm lens at the same focusing distance. It is a favorite for candid portraits in towns and cities where camera-to-subject distance is restricted by buildings, parked cars, and traffic. You can use it at a fair to get close-ups of craft demonstrations or in an industrial setting to record a work operation without interfering with the activity. No other lens does these jobs as well as the moderate tele, which probably accounts for its great popularity. If this focal-length range interests you, then consider a zoom lens as a possible alternative to the restrictions imposed by a unifocal optic.

Telephoto Lenses

The conventional wisdom is that the true telephoto lens has a focal length of at least 200mm, although 150mm or even 135mm might be a more convenient break point.

The primary use for a telephoto is to get a satisfactorily large image of a distant subject such as a wild animal or a parachute demonstration. Sports photographers are particularly fond of the 200mm lens because with it you can stand on the sidelines and get tight shots of a quarterback get-

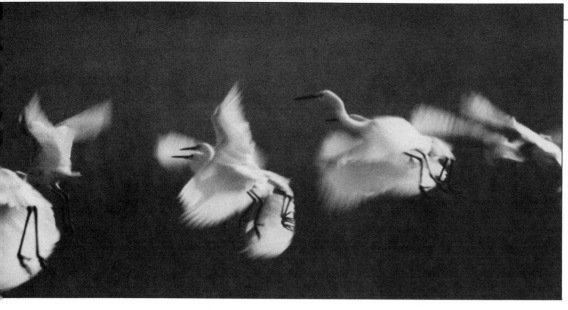

This photo of snow egrets by Morris Guariglia was taken through a 300 mm lens on a 35mm SLR. The first amateur photo to be used in the giant Kodak Colorama in Grand Central Terminal, New York City, its execution took patience and planning. The photographer had to move into position unobserved by the birds, prefocus, then wait for the birds to take flight. Film: Kodachrome 64.

ting tackled halfway across the field or of a baseball player sliding into second base. It is also good for picking out architectural details. But it is not the super-long lens that some like to think it is. Surveillance photos are often taken with a 300mm lens. Nature shots are often taken with a 400mm or 500mm lens, particularly if you want to get full-frame shots of medium-size wild animals.

You need a very high shutter speed to hand-hold a telephoto lens and get sharp photos. Use at least 1/500 sec. for a 200mm or 300mm lens. For a longer lens, use 1/1000 or 1/2000 sec. To get shutter speeds this fast, you need fast film and wide apertures, even on a bright day.

Telephoto lenses seem to compress the space that separates objects or parts of a subject at different distances for the camera. This flattening effect is not flattering for portraits, but it is interesting when used to create color compositions. When the lens is focused on a nearby subject and set to a wide aperture, backgrounds will be thrown way out of focus, making an interesting pattern of blended tones or colors against which you can image your main subject.

Super-Telephoto Lenses

The super-telephoto lens, with a focal length of 400mm or more for the 35mm format, has two primary uses. The first is to obtain an enlarged image of a distant sub-

On the bottom is a diagram showing the elements of a 200mm f/2.8 MD Tele-Rokkor-X lens, a typical 200mm telephoto, with positive and negative elements, variable aperture, and a straight light path. Above it is a diagram of the Minolta 250mm f/5.6 RF Rokkor-X mirror telephoto, which uses a lens-mirror combination to fold the light path. The result is a lens that is less than half the size and weight of a standard 200mm lens, a big advantage when you are traveling. The disadvantage is the fixed aperture.

A set screw on the mount allows you to rotate the camera body when you have this 500mm Sigma lens mounted on a tripod. The lens itself has been attached to an accessory quick shoe, which is a big help when you want to remove the lens quickly from the tripod. Some lenses have a tripod mount on a collar so that you can rotate the entire camera-lens assembly.

ject. The second is to use increased camera-to-subject distance as a means of controlling the relative sizes of objects separated in depth.

Fast lenses in this category are a rarity, because of the enormous front elements that long, fast lenses must have. In lenses of 500mm or more, *f*/5.6 would be considered fairly fast and *f*/8 is common, particularly among mirror lenses.

When you use a very long lens, such as a 500mm or 600mm to photograph action that flows toward and away from the camera, you can either try to follow focus or use a zone focus technique. (See Chapter 4.)

Mirror Telephotos

The modern mirror lens is a light-weight, sharp telephoto available in focal lengths from 250mm to 2000mm, although for general telephoto work, the 400mm, 500mm, and 600mm lenses are probably the most useful. The new mirror lenses are based on a modified mirror design pioneered by Nikon engineers. That they are relatively inexpensive is a tribute to optical production improvements and the wide use of the laser for measurement and control.

The mirror lens solves the problem of chromatic aberration with very long telephoto lenses without recourse to costly fluorite elements. But the big advantage to a mirror lens is its compact design and light weight. For example, the 250mm Minolta is as small and lightweight as a normal 50mm lens, and lenses recently introduced by other manufacturers show comparable weight and size reductions. Just pick up a mirror lens and compare it to a refracting (standard) lens of the same focal length. With lenses this light, you can easily hand-hold a 600mm lens. These lenses

are ideal for photo safaris, back-packers, and touring when you want to travel light yet retain long-lens capability.

The disadvantage to mirror lenses is that you get only one aperture. To vary exposure, you must change shutter speed or film speed, or use a neutral density filter. When you hand-hold your camera, you will be using at least 1/1000 sec. with most mirror lenses, which doesn't give you much to work with, because that's the top speed for most cameras. On a sunny day with your subject illuminated by a combination of sunlight and skylight you can use an *f*/8 lens at 1/1000 sec. with Plus-X or Ektachrome 200. If a thin cloud obscures the sun, you will need a fast 400 ASA film, and on a dull day you will need high-speed recording film.

If you have an automatic camera and a choice of modes, the camera should be used in the aperture priority mode. But watch the shutter speed. Unless the camera is tripod-mounted or supported in some other way, you are almost sure to get a fuzzy image if the shutter speed number falls below the focal-length number of the lens.

To get maximum flexibility, use an automatic camera which will give you continuously variable intermediate shutter speeds and push-process an ISO/ASA 400 film to ASA 800. (See Chapter 5 for a discussion of film speed.) If you don't mind a grainy effect, you could also try high-speed recording film at ASA 1000 to 2000.

Some mirror lenses have a filter holder built in at the rear of the lens. You can use this for neutral-density filters. Rear-mount contrast filters may also be available from the manufacturer.

Telescopes specifically designed for photography as well as viewing, such as the Celestron 90, can also be classed as mirror tele-

photos.

If you are in the market for a mirror lens, compare weight and size before you buy. The newer designs are significantly lighter and smaller than older designs and you may find that an older 500mm mirror lens can be larger and heavier than a newly introduced 600mm mirror lens from the same manufacturer.

Telephoto Extenders

When they were first introduced, telephoto extenders produced only so-so quality. Today's versions are considerably improved and you can feel reasonably confident using them. They are compact, lightweight, and ideal for travel photography when you want to carry fewer lenses.

The telephoto extender is a supplementary lens that fits between your prime lens and the camera body. It doubles (2X) or triples (3X) the focal length of your lens. You can combine tele-extenders for additional focal-length extension.

The tele-extender reduces the amount of light that reaches the film. If you use through-the-lens metering, compensation will be automatic. If you use some other exposure-measurement technique, compensate for the light loss by multiplying the *f*/stop set on the lens by the power of the extender to get the effective stop, then adjust your shutter speed accordingly. For example, if your prime lens is set at *f*/8 and you use a 2X extender, the effective stop is *f*/16. With a 3X extender, it would be *f*/22, which is the next full stop down. With two 2X extenders, it would be *f*/32.

Matched tele-extenders are offered by some manufacturers. A matched extender gives excellent optical performance when used with the lens to which it is matched, even when the prime optic is used wide open. A gen-

Tele extenders are also available for medium-format SLRs. These fully automatic 2X converters from Vivitar are available in mounts to fit Bronica 6x6, Hasselblad, Mamiya RB67, Mamiya 645 and Pentax 6x7 cameras.

eral-purpose extender will usually give adequate performance if you stop down at least one full stop from wide open.

General-use tele-extenders with removable elements are also available. When you remove the lens elements, the extender becomes an extension tube for extreme close-up photography. (See Chapter 10.)

When you shop for a telephoto extender, look for the automatic type that lets you retain the automatic features of the lens.

Telephoto Techniques

Here is a grab bag of techniques for using telephoto lenses to their best advantage.

Sunsets are natural subjects for ultra-long tele lenses in the 400mm plus range. Short of some very fancy work in the darkroom, the only way to get those great glowing orange balls that hang suspended between silhouettes of trees, buildings or couples hand-in-hand is to use a very long lens.

The disc of the sun as imaged by a normal lens is hardly more than an orange dot in the 35mm frame. Even a 200mm lens produces a small image. If you use a 400mm lens, or a 2X tele-extender

on your 80mm to 200mm zoom, you get a small but respectable orange ball. For a really dramatic sun, you need to get at least a 500mm focal length and 1000mm is not too much. A 3X tele-extender with your 200mm focal-length lens will do the trick. To fill the 35mm frame edge-to-edge with the ball of the sun, you need a 2300mm lens, but that size is just too big to do much with in terms of composition.

The sun moves very rapidly, so timing is crucial, and because you are using long lenses, camera placement is also crucial. To control the relative size of your tree, building or couple silhouette in relation to the size of the sun, you need to put considerable distance between yourself and your subject, anywhere from a few hundred yards to several miles or more and a period of optimum alignment may last only a half minute or so. There is very little time to correct camera placement. Really good sunset shots require experience and luck.

A through-the-lens exposure reading will produce a deep orange sky and sun on daylight-type film. Bracket exposure one or more stops over and under to give

yourself a choice of color quality ranging from deep orange-red to yellow. For a different quality, try Ektachrome 160 Tungsten.

Even if the exact placement of the sun eludes you, shooting after the sun goes down can produce some fine landscapes and city scapes in the afterglow.

Supports: Unless you possess one of the new breed of ultra-lightweight teles, your lenses of 400mm and more will all have their own tripod mount. Very long lenses, particularly the heavier ones, can put excessive torque on the camera lens mount and may warp it, so always use a support for long, heavy lenses. Putting the camera itself on a tripod without a support for one of these lenses is asking for trouble. On the other hand, don't worry about the weight of the camera. It is light enough not to need support when attached to a tripod-mounted lens.

Hand-held camera work is extremely difficult with lenses longer than 300mm. Just to eliminate camera shake due to normal body vibrations, you need shutter speeds of 1/1000 sec. or more. A shoulder pod will let you use lenses up to about 600mm, pro-

vided you are very steady, and you can get additional stability by leaning against some convenient post or wall. (For additional support methods, see Chapter 7.)

Distant subjects: As the distance between camera and subject increases, the effect of pollution and other particulate matter in the atmosphere begins to appear as haze or aerial perspective. In black-and-white photography, this effect can be sharply reduced by using contrast filters. For an effect that approximates the haze-penetrating effect of your own sight, try an Orange No. 15. For increased haze penetration, use a Red No. 25. A slight improvement with color films can be gained by using a Haze or UV (ultraviolet) filter or a pale yellow filter such as the Aero No. 3. For maximum haze penetration, use infrared film with the recommended filters.

Image distortion due to air turbulence caused by heat waves cannot be corrected.

Nature photographers rely almost exclusively on telephoto lenses. Since the equipment must often be carried long distances through rough country, weight is an important factor in lens selection. If you plan on doing photography of this type, consider the new, lightweight-mirror lenses in the 400mm to 600mm group. One of these lenses with a 2X tele-extender will give you plenty of magnification to play with, provided there is sufficient light. If you plan to shoot in twilight or in dense forests, you might consider one of the fast 200mm lenses with variable aperture and a long-distance flash.

ZOOM LENSES

Advances in the art of making zoom lenses have resulted in zooms that provide all the advantages of continuously-variable focal length plus high performance. What's more, zooms are now available in every focal-length category from wide-angle through telephoto.

Pros and Cons
A zoom lens lets you change composition without changing camera position; change focal length without changing lenses; create special effects by zooming during long exposures; and carry one lens instead of several in your gadget bag. Some zooms even have close-focusing ("macro") capability, and in the tele range, this close-focus option cannot be matched by unifocal optics.

On the negative side, zooms are slower, heavier, and more expensive than unifocal lenses. A few zooms have linear distortion at the shortest and longest focal lengths. Vignetting of the corners is a problem with some wide-angle zooms at shortest focal lengths.

Flare is a special problem with zooms that dip into the wide-angle range. The glass/air interfaces of the many elements create multiple reflections that can degrade image quality. Multiple coating really helps with these lenses.

In general, the advantages of zoom lenses outweigh the disadvantages, and if you buy the right lens, you probably will never regret it. Look particularly at the zooms that cover the moderate telephoto area, the 70–150mm or 100–200 mm lenses, and the possibility of using these with a 2X tele-converter for extended telephoto coverage.

Zoom Lens Features
Among the features you should be aware of when you shop for a zoom is the difference between a varifocal and a zoom lens. Once focused, a zoom lens will maintain that focus during a zoom. A varifocal lens must be refocused at each focal length. The convenience of a true zoom is indisputable. On the other hand, a varifocal lens—there are only a handful on the market—is lighter, has fewer glass/air interfaces, which means less flare, and tends to be sharper than a zoom of similar range.

One touch vs. two touch: A two-touch zoom lens has separate zoom and focus controls. A one-touch zoom has a single zoom-focus collar that you turn to focus and push in or out to zoom. One-touch zooms are slightly heavier than two-touch designs.

Zoom range: The biggest consideration in buying a zoom lens is to find a zoom range that gives you the kind of subject coverage you like at the working distances you prefer. If you find one lens that does this for you, you can probably cover most of your other needs with single-focal length optics, or at most with one other zoom and a tele-extender.

For example, a 70–150mm zoom with 2X tele-extender will cover the entire range from 70mm to 300mm. You could combine that with a 24mm or 28mm lens for wide-angle work and a fast normal lens for available light and general picture-taking. Or you could get a second zoom to cover the wide-angle-to-normal range, such as a 24- or 28-to-50mm zoom.

If you are familiar with motion-picture cameras, you may be accustomed to thinking in terms of a zoom ratio, which is found by dividing the shortest focal length into the longest. Zoom ratios of 8:1 and even 12:1 are not uncommon in amateur motion-picture equipment. These dramatic ratios are not found in zooms for 35mm still cameras because the lenses would be too big to hand-hold. The longest you are likely to encounter for an SLR is about 4:1,

A close-focusing zoom lens, such as the Vivitar 100-200mm used to photograph these mushrooms, is ideal for nature photography because you can tripod-mount the camera and then zoom to compose. A piece of white cardboard was used to isolate the mushrooms in the bottom shot.

and a lens with this ratio, such as a 70–300mm, is a monster. You are better off with a lightweight 2:1 zoom, such as a 100–200mm, and a matched tele-extender to get the extra focal length coverage.

As a rule, the longer the zoom range, the heavier the lens. When you first try out a zoom, the long zooms are impressive, but that extra weight can be a problem if you have to lug it around for a day. This is why some photographers are turning away from the popular 80–210mm zooms and looking toward lighter lenses with shorter zoom ratios.

Lenses that cover the moderate-telephoto-to-telephoto range are the most useful for general photography because they can be used for portraiture, candid work, fashion, sports, and coverage of special events such as air shows

and circuses.

Lenses that cover the normal range, 39–85mm for example, are popular for reasons that may have more to do with beginners' conservatism than anything else. If this range matches your way of seeing the world, then it's the range for you. But a normal-range zoom doesn't replace a fast normal lens and the front elements are usually large, requiring big, expensive filters and other accessories. What's more, the normal-range zoom does not get you down into the true wide-angle category or up into the moderate-telephoto range.

Wide-angle zooms can be as useful in their way as the mid-tele-range zooms. Of particular interest are those that start at 24mm or 25mm and zoom to 40, 48, or 50mm. These give you flexibility when you photograph in small spaces, such as an engineer's booth in a sound studio, or when you work close to your subjects and become involved in dance, play, or other activities as you photograph.

Close-focusing (macro) zooms: The macro or close-focusing zoom is not a true macro lens. It will not give you life-size (1:1) reproduction, but it will give you plenty of close-up capability. (The term *macro* was probably applied to these lenses by some advertising copy writer who thought it sounded good. For the sake of clarity, they are referred to in this book as close-focusing zooms.)

There are three types of close-focusing zoom designs, and they

This Canon FD 300mm lens has a removable collar on the tripod mount so that the lens can be hand held. With traditional telephoto lens designs, a 300mm is about the longest lens that can be hand held.

The popularity of zoom lenses has led to a new way of thinking about focal length when it comes time to buy accessory lenses. Rather than picking out a handful of unifocal optics, photographers are considering focal-length ranges. This three-lens package (left) from Samigon, for example, covers the entire range from 28mm to 400mm with a 28–80mm automatic varifocal lens, and 80–200mm zoom lens, and a 2X telephoto converter.

The large lens on top is a 70–310mm zoom. Its companion is a Sigma 500mm mirror lens, more powerful yet smaller and considerably lighter.

require slightly different handling procedures. In the compensator focusing design, you lock one set of zoom elements in place by turning a "macro ring". This locks the zoom in place and allows you to close-focus by moving a set of compensator elements inside the lens. This design gives you a smaller, lighter lens but you lose the zoom feature at close-focusing distances.

A second type uses a helical extension system at the back, which moves the entire lens away from the film for close-focusing. This extension design is generally more bulky than the compensator type but frequently lets you choose your focal length at close-focusing distances.

A third type has an extended focusing barrel that gives you continuous focusing from infinity to close-up and zoom capability at all distance settings. Although slightly longer than some other designs, these lenses are easy to use and give great flexibility.

Focusing Technique

Some photographers like to focus a zoom lens at its longest setting and then zoom out to get wider-angle views with the sharp focus provided at the longest focal-length setting. This technique works only when the distance between you and your subject is not changing. It is easiest to do with two-touch zooms. With a one-touch you never know if you changed the focus slightly when you zoomed. For action photography, focus a zoom at the focal length you intend to use, just as you would any unifocal lens.

Since some zooms provide depth-of-field scales only for the shortest and longest focal lengths, and even more have no depth-of-field scale at all, a bit of guess work is involved when you want to use a zone-focus technique. In theory you could stop down to

the taking aperture and preview the scene on the groundglass, but this is a very rough technique. A better bet is to use one of the focal-length–f/stop combinations given in Chapter 4.

SPECIAL-PURPOSE OPTICS

Supplementary Lenses

Wide-angle and telephoto supplementary lenses attach to the front of your lens. The telephoto attachments are intended primarily for

This one-touch Sigma 75–250mm macro zoom has two scales on the lens barrel, one to indicate focal length, the other to show focusing distance and depth of field. The depth-of-field scale is a big plus for the one-touch design in which you slide the front portion of the lens in toward the camera body to zoom to longer focal lengths and turn the same collar to focus.

Independent lens manufacturers have recently begun to introduce ultra-compact zoom lenses for use with the new generation of compact 35mm SLRs. This Sigma 21–35mm ultra-wide-angle zoom compares favorably in size with a 35mm film magazine, yet it provides all the wide-angle coverage you are ever likely to need.

non-interchangeable lens cameras and generally yield a moderate-telephoto effect. Those lenses that are designed for use with one specific camera, such as the Polaroid Tele Lens for use with Polaroid SX-70 cameras, produce the best quality.

A wide-angle attachment can be a simple negative lens such as the Tiffen minus diopter lenses, or a complex, multi-element device such as the Samigon Auxiliary 180° Fish-Eye. These attachments are available in various strengths

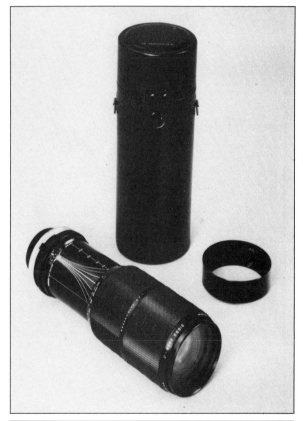

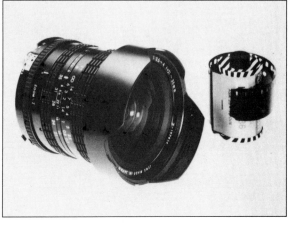

that give you everything from moderate-wide-angle to fish-eye effects. The image quality varies depending on the lens, but for occasional non-critical applications they are an inexpensive alternative to a more costly wide-angle lens.

The results you get with an extreme wide-angle supplementary lens depend on the lens you put it on. For example, the Spiratone Curvatar semi-fish-eye will double the angle of view of a lens, giving a 150° circular image with a 28mm lens and a 100° full-frame image with a normal 50mm lens. An auxiliary fish-eye is usually computed for use with a normal lens and effects will vary when you use it with other focal lengths.

The zoom converter is a variable conversion lens that attaches to the front of a unifocal lens to give you a modest zoom capabilility that can aid in composition. For example, the Samigon Deluxe Vari-Zoom attaches to your lens with a Series 7 adapter and will give you a range of 100mm to 170mm when you use it with a 135mm lens.

Multi-purpose converters give you more than one function. For example, Samigon offers an extra-wide macro lens that converts a 50mm lens to a 30mm wide angle. If you remove the front portion of the attachment lens, you get a +8 close-up lens.

(For information on supplementary close-up lenses, see Chapter 10.)

Professional Lenses

In this category are a variety of special-purpose lenses that offer unique quality and special features of interest to professional photographers. The group includes macro lenses, aspherical lenses, ultra-color-corrected lenses, and perspective correcting (shift or tilt-and-shift) lenses.

Macro lenses: The typical macro lens focuses from infinity down to ½ life-size (1:2) on the negative without any accessories. It is generally sold with an extension tube that permits focusing down to 1:1 (life-size). A flat-field design makes these lenses ideal for copy work. When used with additional extension tubes or bellows for magnifications greater than 1X, these lenses can be reversed.

Scales on the lens and extension tube show magnification and can be used to determine exposure factors when through-the-lens metering is not used.

There are two common focal lengths available, a normal 50mm or 55mm length and a moderate-telephoto 100mm length. The 100mm lens provides twice as much distance between lens and subject as the 50mm lens, which facilitates lighting of three-dimensional subjects. Outdoors, the extra working distance provided by the 100mm lens may prove very useful because it is often dif-

For moderate telephoto work, Polaroid offers this unique tele-lens attachment in a frame that holds it securely to the SX-70 camera.

ficult to get close to subjects in the field. On the other hand, the smaller, lighter 50mm lens may be more useful for general copy work or when used in the reverse position on a bellows.

The bellows lens is a non-focusing lens designed to be used with a bellows between it and the camera body. Although designed specifically for macro work, the 85mm and 100mm types can usually be focused to infinity at minimum-bellows extension with the bellows for which the lens is designed. Never popular, these lenses have now been dropped from the current lines of most manufacturers.

Short-focal-length bellows lenses, such as the Olympus Zuiko MC Macro 20mm and 38mm lenses, are designed only for bigger than life-size magnifications. They are intended for scientific, technical, and industrial applications.

Ultra-color-corrected lenses combine quartz or fluorite elements to provide a high degree of correction against chromatic aberration. Sometimes referred to as apochromats, they are the most expensive lenses you can buy and are used almost exclusively for scientific, industrial, surveillance, journalism, and forensic work. Some are specially corrected for photography with ultraviolet or infrared radiation in addition to the visible spectrum.

Perspective-correcting (shift) lenses shift off center and rotate so that you can get straight vertical or horizontal lines and tight composition without tilting the camera or changing its position.

Let's say you were photographing a building and did not want a large amount of foreground in the picture. You could tilt the camera upward to get all of the building in and eliminate the foreground, which would produce the converging-vertical look called key-

stoning. With a perspective-correcting lens you could align the camera in parallel with the building, which would produce straight lines, and then shift the lens upward to crop out the foreground and get all of the building in the frame.

Lateral and diagonal shifts are generally used to avoid imaging intruding foreground elements such as cars, shrubs or telephone poles. You can also shift to eliminate undesirable reflections.

In the Minolta, Canon, Olympus, and Nikon systems, perspective-correcting lenses are 35mm focal length. In the Pentax system, there is a 28mm shift lens. The Minolta lens also offers variable field-curvature control that allows you to adjust the plane of sharpness from concave through flat to convex.

Binoculars, Monoculars and Spotting Scopes

You can attach your 35mm SLR camera body to just about any spotting scope, monocular, or other long-distance viewing device and take photographs through it as though it were a telephoto lens. The results will vary from excellent to poor, depending on the design of the telescopic device. Some, such as the Celestron 90, are made specifically for photography, and it shows in the high quality of the final photo. Others, such as the typical refracting-type spotting scope, are designed specifically for viewing and tend to produce aberrations such as curvature of field, chromatic aberration, and pincushion distortion when used on a camera.

Telescope attachments for lenses: If you have only occasional need for a telescopic viewing device, you might consider a device such as the Portertown Telescoper, which is a right-angle eyepiece that converts any telephoto or zoom lens into a tele-

scope. This device produces an image that is right side up, correct left to right, and is about 2.7 times larger than when the lens is used on the camera. For example, a 400mm lens used with this converter provides 22X magnification for viewing. It is available for a variety of different lens mounts.

Binoculars: For viewing at magnifications from 6 to 10X, binoculars are the most convenient. A binocular is essentially a pair of monoculars that can be individually focused for each eye. In the past, adapters were available that allowed you to use a pair of binoculars with a twin-lens reflex camera. The arrangement was clumsy, but it worked. You can attach any camera lens to one of the eyepieces of a binocular using an eyepiece adapter and a bracket that holds the camera to the binocular. The arrangement is more a curiosity than a serious option for modern SLR users.

Monoculars: There are still monoculars on the market that are designed for both viewing and photography. These attach by adapter ring to the accessory mount on your normal camera lens, and usually have front focusing, rather than the eyepiece focusing typical of monoculars designed strictly for viewing. Some require special adapters, so be sure the unit comes with an adapter for your lens before you buy it. Monoculars for photography can provide very high magnifications. For example, the Ercona Telescopic Zoom Monocular goes from 8X (400mm) to 20X (1000mm) when you use it with your normal 50mm lens.

Prismatic telescopes are giant-size monoculars designed to be tripod-mounted and used for everything from surveillance to long-distance observation of sporting events and animals in the wild. If you intend to photograph through a spotting scope of

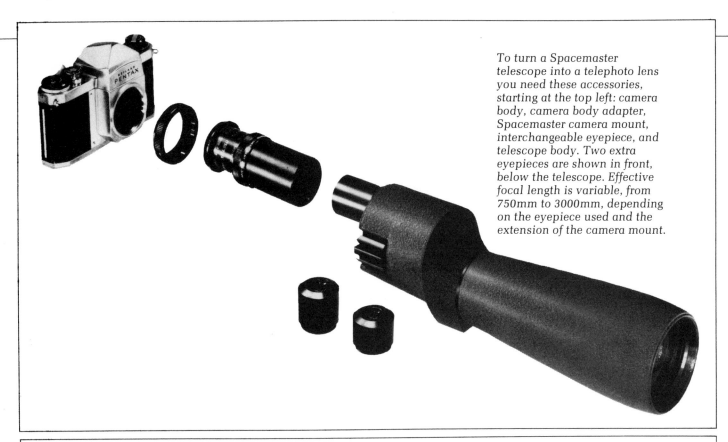

To turn a Spacemaster telescope into a telephoto lens you need these accessories, starting at the top left: camera body, camera body adapter, Spacemaster camera mount, interchangeable eyepiece, and telescope body. Two extra eyepieces are shown in front, below the telescope. Effective focal length is variable, from 750mm to 3000mm, depending on the eyepiece used and the extension of the camera mount.

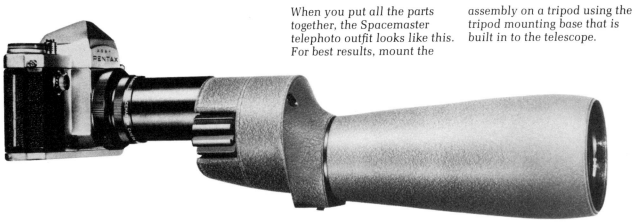

When you put all the parts together, the Spacemaster telephoto outfit looks like this. For best results, mount the assembly on a tripod using the tripod mounting base that is built in to the telescope.

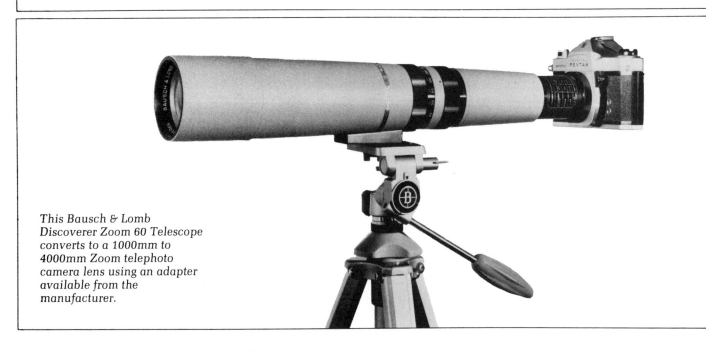

This Bausch & Lomb Discoverer Zoom 60 Telescope converts to a 1000mm to 4000mm Zoom telephoto camera lens using an adapter available from the manufacturer.

this type, be sure the manufacturer makes a camera mount and body adapter for the model telescope you buy. For example, Bushnell provides a camera adapter system for its Fixed Power Spacemaster but not for its 45° and Zoom Spacemaster models.

With some telescopic devices, including the Fixed Power Spacemaster, variable magnification for photography is achieved by using the eyepiece as a projection lens. To do this, remove the camera lens. A draw-tube camera mount with a T-type camera-body adapter is attached over the eyepiece. The camera, without lens, is attached to the T-adapter.

This arrangement is compatible with most SLRs. The draw tube allows you to vary the size of the projected image within a magnification range determined by the power of the eyepiece. For example, in the Bushnell system, the 15-power eyepiece provides the effect of a 750 to 1500mm tele lens; the 20-power eyepiece gives you a 1500 to 2160mm range; and the 25-power eyepiece lets you work in the 2160 to 3000mm range.

Exposure: Use through-the-lens exposure readings. To compute by formula, multiply the focal length of the camera lens by the power of the monocular to find the combined focal length. For example, a 50mm lens used with an 8X35 monocular gives a telephoto effect of 400mm. Next, divide the combined focal length (400mm) by the diameter of the monocular objective (35). The result is 11.4 or, for all practical purposes, $f/11$. So long as your prime camera lens is set for $f/11$ or wider, $f/11$ will be the working f/stop for the camera-lens/monocular combination. This formula can also be used for computing exposure with telescopes.

Telescopes

For terrestrial photography through telescopes, you generally need nothing more than a T-mount camera adapter for the telescope and a T-ring for your camera-lens mount. Most telescope makers offer camera adapters for their units.

For planetary photography, a draw tube or extension over the eyepiece is used. The magnification that you get depends on the focal length of the ocular (eyepiece) you use. The shorter the ocular, the larger the image magnification. For best photographic results, use an orthoscopic ocular.

Deep-sky photography: Making time exposures of deep-sky objects requires guiding, a technique in which the astrophotographer makes fine adjustments in telescope point during the course of the exposure. Even when you have an electric equitorial drive that tracks the stars as the earth rotates, guiding is necessary because there is always a slight movement of the image in the field of view, and this movement produces fuzzy images unless corrected.

Wide-field piggyback photography is done with the camera mounted piggyback on the telescope to record a swath of night sky using a normal lens. Celestron offers three accessories that permit successful piggyback photos with a camera mounted on a telescope with an electric drive mount. The piggyback adapter is used to attach the camera to the telescope. The drive corrector speeds up and slows down the drive on the telescope. The illuminated reticle, which is an orthoscopic (color-corrected) ocular, allows you to select a star as a reference point as you guide while looking through the main

optics of the telescope. Exposures using this technique may last from one minute to a full hour. The wide-field technique is used to photograph star clouds of the Milky Way, long comet tails, and meteor showers. Learning to guide a camera with normal lens during timed exposures is a first step to mastering narrow-field, deep-sky photography.

Narrow-field photography is the way to get those mind-boggling photos of deep-sky subjects that you see in textbooks and astronomy magazines. It requires precise mastery of guiding technique and an accessory such as the Celestron Off-Axis Guider Body that permits you to guide and photograph through the main optics of the telescope at the same time. Exposures may range anywhere from five minutes for very bright subjects to an hour or longer for faint galaxies.

Cold cameras: For very faint objects that are just too dim to be recorded on normal film, you can replace your 35mm SLR with a cold camera, which has an ice chamber that allows you to chill the film using dry ice. At sub-zero temperature during exposure, film sensitivity increases 3 to 6 times for color film and up to 15 times for black-and-white film. Ektachrome 200 and Tri-X are recommended for use with the Celestron-Williams cold camera, which accepts only short pieces of 35mm film. If you use this system, you will either have to process the film yourself or find a commercial lab that routinely does test clips for professional photographers.

For more complete information on photographic accessory systems for small and medium-size telescopes, write to manufacturers such as Celestron, Questar, and Unitron to get their current catalogs.

3 LENS ACCESSORIES

Lens accessories are all too easy to ignore, and the cost to you is often a photo that disappears into unwanted flare, nonexistant contrast control, or the commonplace. Often, the real difference between good and bad photos is found not in equipment or composition, but in the skilled use of lens hoods, filters, and special-effect attachments that alter quality, mood, or even the shape of the image.

An enormous range of specialty attachments is available, and there is no need to restrict yourself to the few offered as part of most camera systems. There are dozens of manufacturers producing top-quality accessories in mounts to fit almost any lens. What's more, these accessories really do work. They open up new and exciting ways of seeing images and using equipment.

ATTACHMENT OPERATIONS

Most lenses for 35mm, medium-format, and interchangeable-lens 110 cameras have an accessory mount on the front of the lens. The most common type is a screw mount in which the outer rim of the lens has interior threads into which you can screw filters and other accessories. Most twin-lens reflex cameras and some 35mm lenses require bayonet-mount accessories. Polaroid cameras and a variety of cameras with lenses that do not have an accessory mount will accept accessories in mounts that fit over the outside rim of the lens.

Most lenses for 35mm and medium-format cameras with accessory mounts ranging in diameter from 43–82mm accept the standard, medium-thread, .75-pitch, screw-in accessories. However, some lenses with small diameter accessory mounts, such as 39mm or 40.5mm, accept only fine-thread, .5-pitch-threaded accessories. If you are in doubt, bring your lens to the store and try the attachment on before you buy it.

Cross threading: Attachments should be screwed in gently. There is nothing more frustrating than finding that your polarizer or filter won't come off because it has been cross threaded. Be slow and careful as you screw in accessories and it will never happen to you.

If you do find yourself with a stuck accessory, try using a jar opener with padded jaws or one of the pad-type openers. But be gentle. Too much pressure could damage the filter mount. Some-

times cooling the accessory helps. Put the lens in a plastic bag, seal it, and put it in the refrigerator for 15 minutes or so. When you take it out, the accessory may have loosened up through shrinkage.

Metal accessories are most prone to cross threading. Filters in plastic mounts do not seem to have this problem.

easier to use than those that call for an adapter, buying duplicate accessories in different-size mounts is a waste of money when the mounts are fairly close to one another in size.

Most camera systems have a standard-size filter mount that will be used with the more popular lenses. Nikon, for example, of-

A No. 25 (red) filter darkened the blue sky to create a dramatic backdrop for this shot of clear-cut logging in Oregon. Photo by Robb Smith.

Adapter Rings
An adapter ring allows you to use an accessory on a lens that it does not fit exactly. Although direct-fitting accessories that are a perfect match for the lens are always

fers a large number of their lenses in the 28mm through 135mm range with 52mm accessory mounts. Other popular accessory-mount sizes for the mid-range lenses are 49mm and 55mm. Stan-

dard lenses for medium-format SLR's and many tele- and slower-zoom lenses for 35mm systems accept 58mm or 62mm accessories. Fast tele and wide-angle lenses and very long-range zooms generally require larger accessories.

Since accessories are used primarily with normal and moderate telephoto lenses, and with mid-range (35–105mm) zooms, you can usually find a size that will fit your most frequently used lens and adapters that will let you use the same accessory on many of your other lenses.

As a rule, it's better to use a large accessory on a small-lens accessory mount. Going the other way and using a small accessory with a larger mount can result in vignetting if the accessory itself gets into the field of view of the lens.

Step-up rings have external threads of one size and internal threads of the next larger size. They let you use large accessories on lenses with smaller accessory mounts. For example, a 52–55mm direct fitting step-up ring allows you to use 55mm accessories with lenses that have a 52mm accessory mount.

Step-down rings have external threads of one size and internal threads of a smaller size. For example, a 58–55mm step-down ring would allow you to use 55mm accessories with lenses that have a 58mm accessory mount. Vignetting at the corners of the image is a real problem whenever you step down, and the bigger the step, the greater the vignette. A 58–49mm step down will almost always produce some vignetting. Stepping down works best with telephoto lenses that have a very narrow angle of view.

Series Sizes
The series-size system is based entirely on the use of adapter rings. To use a series-size filter,

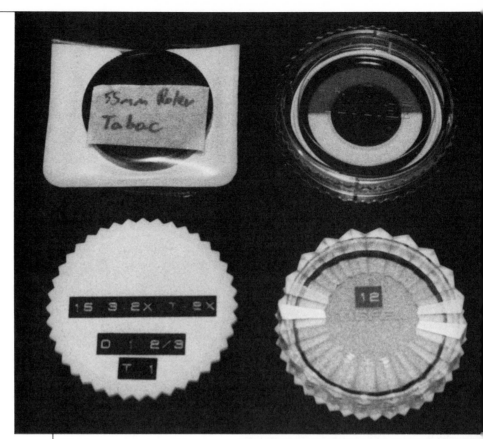

The best way to keep filters straight is to label the pouch or case for each one. You can use a piece of white masking tape for the label. Write on it with a pen. Then cover the writing with a piece of Scotch Magic Transparent Tape so that the ink does not rub off. The label should include filter type and factor, if any.

You can use gelatin and square glass filters in a professional filter holder such as this, which attaches to the lens via series size adapters.

A filter pouch is a big help in organizing your filters. A typical wallet holds four filters. Label each pouch so that you know the filter type and factor at a glance.

The gelatin filter is inexpensive but fragile. The filter comes wrapped in a foil pouch and is further protected by a cardboard folder and tissue paper wrapper. Handle the filter only by the tissue paper or by the edges. Water and fingerprints ruin these filters. Do not purchase one of these filters if the seal on the package has been broken.

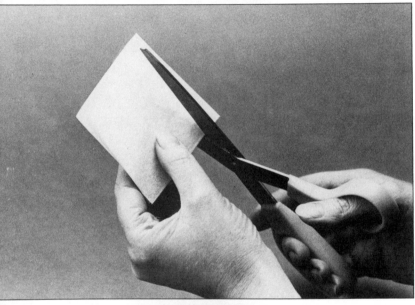

To cut a gelatin filter to fit a holder, hold it by the tissue paper wrapper and cut through both paper and filter.

A bit of tape will hold a gel filter onto your lens in an emergency. Any piece of colored plastic can be taped over a flash head for colored light effects, but optically clear gelatin filters should be used over the lens.

Direct screw-on or series size? The screw-on filter (left) is simple. The series size is a three-part affair consisting of series adapter, filter, and retaining ring. Series sizes can be used with more lenses but the adapters are a hassle, especially in cold weather.

you need an adapter that fits on the lens, the series filter, which is a round disc of glass bound by a metal ring, and a retaining ring that screws into the adapter ring and holds the filter in place.

There are six commonly available series sizes ranging from the 1³⁄₁₆″ diameter Series 5 through the 3¼″ diameter Series 9. Series 5, 5.5, and 6 are generally used with 110, instant-loading, Polaroid cameras and Kodak Instant cameras. Series 7 is a popular choice for 35mm camera users and can be used effectively with lenses that have 49mm, 52mm, and 55mm filter mounts. Series 8 is a useful size for medium-format SLR's and mid-range zooms used in 35mm camera work. Although considerably more expensive than Series 7, the Series 8 filters can be used with lenses having 49mm through 62mm filter-mount diameters. Series 9 is reserved for lenses that have extra large front elements, such as fast tele and zoom lenses.

To use a series-size filter, put the adapter ring on the lens, then put the filter into the retaining ring and screw the retaining ring into the adapter. Other series-size accessories, such as matt boxes and lens hoods, are either held in place with a retaining ring or screw directly into the adapter ring.

Screw-in adapter rings are custom threaded to match the exact lens thread pitch and diameter. Bayonet adapter rings are designed for cameras having bayonet-type lens mounts such as twin-lens reflex cameras. Set-screw adapter rings lock on the outside of the lens mount by means of a precision set screw. A slight turn of the screw locks the ring in place.

Slip-on adapter rings have a slotted, pronged back that slips over the lens mount. You can adjust it to fit a lens of slightly

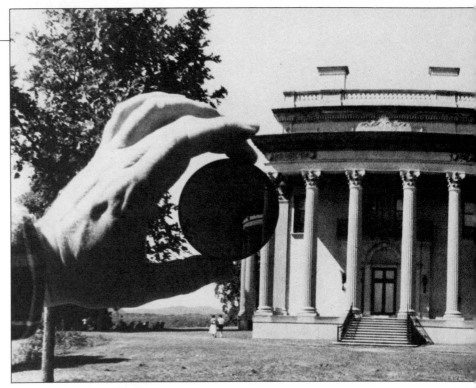

A red filter passes about 15 percent of the light that hits it. The rest is absorbed. Unless you compensate for the light absorbed by the filter, you will be underexposed by about 3 f/stops. The photo on the top is exposed for the unfiltered scene; the one on the bottom is correct for the filtered portion of the image. The sky seen through the filter still appears grey because a red filter darkens a blue sky, but the tone value is now correct.

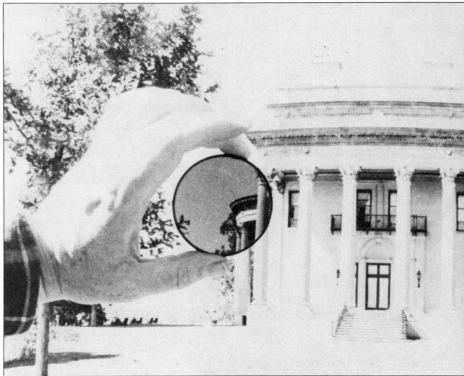

smaller or larger diameter by bending the prongs. To bend the prongs outward, use a pair of pliers. You can avoid scratching the ring by putting a rag over the plier jaws. To bend the prongs inward, roll them along the edge of a table as you gently press down. If something on the lens mount gets in the way, break off one or two of the prongs to make space for the protrusion.

Slip-on adapters are most often used with lenses that have a relatively small outside diameter, somewhere between 24mm and 43mm for Series 5 and 6 accessories. The set-screw type is used for larger lenses, with outside diameters ranging from 38mm to 81mm, and are for use with Series 6, 7, 8, and 9 accessories.

Professional Filter Holders

A professional filter holder is used to hold Series 8 or 9 series-size filters and square glass or gelatin filters. It is usually attached to the lens with a series-size adapter. The filters go into slots in the top of the holder; the holder rotates so that the filters can't drop out when you turn the camera from horizontal to vertical.

FILTERS

A filter is a piece of colored glass, plastic or gelatin, that either changes the quality of light or selectively holds back some colors while passing others. The energy from colors that are absorbed is dissipated as heat. The light that gets through is used to make the exposure.

In theory, any piece of colored acetate will work as a filter, but in practice you pay for optically-flat filters with even-dye dispersal that will not distort the image. Acetate, cellophane, and colored glassware are all suitable for spe-

cial effects, but they also introduce optical aberrations into your lens system. There is no substitute for a good filter when you want a standard filter effect and intend to keep your images sharp.

Filter Series Sizes

5	5.5	6	7	8	9
1³⁄₁₆″	1⁷⁄₁₆″	1⁵⁄₈″	2″	2½″	3¼″
27.6mm	35.9mm	41.3mm	50.8mm	63.5mm	82.6mm

Exposure Through Filters

Both colored filters and polarizers absorb some of the light that would ordinarily be used to make an exposure. If you are using an automatic camera that makes exposure readings through the lens, then in most cases you can depend on the built-in exposure system to compensate for the filter.

Deep red filters may trick red-sensitive CdS (Cadmium Sulfide) and Blue Silicone meters into underexposing slightly, but you can compensate by setting the camera meter to an ISO/ASA number about 25 percent lower than the rated speed of the film. For example, with Tri-X (ISO/ASA 400) and a Red No. 25 filter, you might set the meter at ASA 300. This is only a starting point. Try bracketing to find a percentage that seems to work best for you.

Beam splitters and pellicle mirrors will throw off a through-the-lens reading when a polarizer is put on the lens. Since these arrangements are found primarily in Super 8 cameras, and a few highly-specialized 35mm SLR bodies, it should not be a problem. Most automatic cameras compensate precisely for polarizers.

If you take hand-held meter readings, then you will need to employ a filter factor to compensate for light absorbed by the filter. The factor is an exposure multiple, such as 1.5X, 2X, and so on. To use the factor, divide either the shutter speed or the ASA rating of the film by the factor number to get a compensated exposure.

Most photographers prefer to translate factors into exposure increases in *f*/stops and think of

their filters as half-stop (1.5X), one-stop (2X), two-stop (4X), three-stop (8X), and so on. When considered in this way, a polarizer or an orange filter is a stop-and-a-half filter, and a tungsten-to-daylight conversion filter (80A) is a two-stop filter. A No. 25 is a three-stop filter.

When you combine filters, multiply exposure factors or add compensation in numbers of *f*/stops to get the new exposure factor. For example, if you combine a polarizer (3X or 1½ stops) with an 80A conversion filter (4X or 2 stops) the resulting factor is 12X or 3½ stops exposure compensation.

The factor supplied by the filter manufacturer is an average. In tungsten light, reddish filters require slightly less compensation and blue filters may require more. The effect will also vary with the spectral sensitivity of the film. Use the factors, but adjust them if it looks like you are not getting what you want.

Filters for Black and White

There are two reasons to filter black-and-white shots. One is to correct tonal relationships thrown off by the excess sensitivity to blue that is characteristic of most films; the other is to change contrast and improve detail rendition.

Correction filters: Most general-purpose black-and-white films, including such all-time favorites as Panatomic-X, Plus-X, Tri-X, HP4, and HP5, are more sensitive to blue than the eye is. That is why a sky that looks blue to you comes out white in an unfiltered photo. A tonally correct rendition would make it a pale

grey. To get this correct effect, use a Yellow No. 8 correction filter, which requires one *f*/stop exposure increase.

General-purpose films also tend to give slightly distorted tonal renditions of skin, lips, and foliage. For full correction in tungsten light, use the Green No. 11 correction filter. It has a factor of 4X (two *f*/stops). This same filter can be used to lighten foliage outdoors, but the effect is subtle. Some photographers feel that the No. 11 filter works better than the No. 8 for outdoor portraits, but most viewers looking at prints and comparing the two could not tell the difference.

Contrast filters: These filters are most often used to improve separation between subject and background by darkening one or the other. The most frequent use is to darken a blue sky more than can be done with a No. 8 correction filter.

There are really only two important filters in this group, the Orange No. 15 and the Red No. 25. Although the exact nomenclature varies from brand to brand, with some manufacturers referring to their Orange filter as a Dark Yel-

Most Used Filter Factors

Factor	Increase in *f*/Stops
1.5X	½
2X	1
3X	1½
4X	2
6X	2½
8X	3

Expanded Filter Factor Conversion Chart

Density	Percent Transmission	Exposure Increase In f/Stops	Factor
.05	90	⅛	1.1
.06	87.5	¼	1.2
.07	85	⅓	1.25
.08	84	⅓	1.3
.10	80	½	1.4
.12	75	½	1.5
.15	70	⅔	1.55
.17	68	⅔	1.6
.19	65	¾	1.65
.21	62	¾	1.7
.22	60	⅞	1.75
.25	55	⅞	1.8
.30	50	1	2.
.35	45	1¼	2.5
.36	44	1¼	2.6
.38	42	1⅓	2.7
.40	40	1⅓	2.9
.43	35.7	1½	3.
.45	35	1½	3.2
.47	34	1⅔	3.3
.49	32	1¾	3.5
.50	30	1¾	3.6
.60	25	2	4.
.65	22	2⅛	4.5
.66	21.8	2¼	5.
.70	20	2⅜	5.5
.73	18.7	2½	6.
.75	18	2⅝	6.5
.81	15.6	2¾	7.
.82	15	2⅞	7.4
.90	12.5	3	8.
.96	10.9	3¼	10.
1.00	10	3⅜	11.
1.03	9.4	3½	12.
1.11	7.8	3¾	14.
1.20	6.25	4	16.
1.27	5.4	4¼	20.
1.30	5	4⅜	22.
1.34	4.6	4½	24.
1.40	4	4¾	27.
1.41	3.9	4⅞	28.
1.47	3.4	5	32.
1.50	3.2	5¼	40.
1.52	3	5⅜	44.
1.59	2.6	5½	48.
1.68	2.1	5¾	56.
1.70	2	5⅞	60.
1.77	1.7	6	64.
2.00	1		

low or Yellow and to their No. 25 as a Red or Medium Red, the effects and filter factors are standard.

The No. 15 (3X or 1½ f/stops) provides moderate sky darkening. It improves the contrast of whitecaps on a sunny day, brings out cloud formations in a blue sky, and at high altitudes or in unpolluted atmospheres, it provides all the sky darkening you need to make dramatic shots. It darkens green foliage significantly. Lips may look a bit chalky, so this filter is not recommended for portraiture. If you want to pose a model against the sky, use a No. 8.

The No. 25 (8X or 3 f/stops) is actually a color separation filter, but in pictorial photography it is used for dramatically darkened skies. In a correctly exposed scene, pine trees come out almost black when taken through this filter; grass is quite dark, although its infrared reflectivity diminishes the effect somewhat; and blue sky is a medium gray.

Contrast filters can also be used to improve detail rendition with monochromatic subjects, such as an incised terra cotta vase. Choose a filter the same color as the subject, but slightly darker. Use uncompensated through-the-lens-and-filter-metering or use a slightly lower filter factor.

Narrow-cut filters are designed for use in the graphic arts, but some landscape photographers have put them to work creating scenic effects. Technically, a narrow-cut filter passes a very narrow band of light and absorbs all other colors. Among the more common are the Dark Red No. 29, the No. 25, the Green No. 58, and the Blue Nos. 47 and 47B filters.

The blue filters have been effective in separating subtle tonal differences in desert scenery when used after sunset. The rocks tend to reflect the blue of the sky while foliage absorbs it. The filter emphasizes the difference. In daylight, a similar scene might best be photographed through a narrow-cut green or red filter to increase contrast between pale green and tan.

Other filters: Manufacturers carry dozens of other filters for black-and-white work, most of which are designed for specialized scientific uses. The variations may be crucial for some research applications, but they are unimportant for general picture-taking. Ignore these filters unless you have some specialized need, such as improved color separation of selected dyes in photomicros-

Starter Filter Set For Black-and-White Photography

Filter Color and Wratten No.	Other Designations
Medium Yellow (8)	Yellow; K2; Y48
Yellow Green (11)	Green; X1; Light Yellow-Green
Dark Yellow (15)	Orange; G; Y52; O2
Medium Red (25)	Red; A; Tricolor Red; R60; R2

Haze Penetration Effects

Filter Color	Wratten Filter Number	Film Type	Degree of Clarity Change	Effect on Foliage
Yellow	8, 15	Pan	Slight	Slight
Red	25	Pan	Moderate	Darkens
Red	25	IR	Great	Lightens
Visibly Opaque	89B	IR	Very Great	Lightens Considerably

Exposure Increase With Orthochromatic Films

Filter No.	Color or Name	f/Stop Increase Day-light	Tung-sten
6	Yellow 1	1	2/3
8	Yellow 2	1 1/3	1
9	Yellow 3	1 1/3	1
12	Yellow	1 2/3	1 1/3
15	Deep Yellow	2 1/3	1 2/3
47B	Dark Blue	2 2/3	3
58	Dark Green	3	2 1/3

Note: Orthochromatic films are generally used only for copying and in the graphic arts.

Filters for Black-and-White Panchromatic Film

Filter No.	Color	Suggested Uses	f/Stop Increase Day-light	Tung-sten
3	Pale Yellow	Aerial photography, haze penetration.	2/3	—
6	Yellow	For all black-and-white films, absorbs excess blue, outdoors, thereby darkening sky slightly, emphasizing the clouds.	2/3	2/3
8	Yellow	For all black-and-white films, most accurate tonal correction outdoors with panchromatic films. Produces greater contrast in clouds against blue skies, and lightens foliage.	1	2/3
9	Yellow	Deep Yellow for stronger cloud contrast.	1	2/3
11	Green	Ideal outdoor filter where more pleasing flesh tones are desired in portraits against the sky than can be obtained with yellow filter. Also renders beautiful black-and-white photos of landscapes, flowers, blossoms, and natural sky appearance.	2	1 2/3
12	Yellow	"Minus blue" cuts haze in aerial work, excess blue of full moon in astrophotography. Recommended as basic filter for use with Kodak Aero Ektachrome Infrared.	1	2/3
13	Green	For male portraits in tungsten light, renders flesh tones deep, swarthy. Lightens foliage, with pan film only.	2 1/3	2
15	Deep Yellow	For all black-and-white films. Renders dramatic dark skies, marine scenes; aerial photography. Contrast in copying.	1 2/3	1
16	Orange	Deeper than No. 15. With pan film only.	1 2/3	1 2/3
21	Orange	Absorbs blues and blue-greens. Renders blue tones darker such as marine scenes. With pan film only.	2 1/3	2
23A	Light Red	Contrast effects, darkens sky and water, architectural photography. Not recommended for flesh tones. With pan film only.	2 2/3	1 2/3
25A	Red	Used to create dramatic sky effects, simulated "moonlight" scenes in mid-day (by slight underexposure). Excellent copying filter for blueprints. Use with infrared film for extreme contrast in sky, turns foliage white, cuts through fog, haze and mist. Used in scientific photography.	3	2 2/3
29	Dark Red	For strong contrasts; copying blueprints.	4 1/3	2
47	Dark Blue	Accentuates haze and fog. Used for dye transfer and contrast effects.	2 1/3	3
47B	Dark Blue	Lightens same color for detail.	3	4
56	Light Green	Darkens sky, good flesh tones. With pan film only.	2 2/3	2 2/3
58	Dark Green	Contrast effects in microscopy, produces very light foliage.	3	3
61	Dark Green	Extreme lightening of foliage.	3 1/3	3 1/3

The amount of sky darkening that you get with a filter varies, depending on how blue the sky is, and the results are often difficult to predict on the spot. The white Space Needle in Seattle needed some sky darkening to make it stand out. But how much? The photo on the left was taken through a No. 8 (light Yellow) correction filter. The other was made through a No. 25 (Red) contrast filter.

Filter Comparison Chart
Black-and-White Contrast Filters

Filter Color and Wratten No.	Aetna Rokunar	B & W	Cannon	Hoya	Harrison & Harrison	Ilford
Light Yellow (6)		Light Yellow (021)			YL-1	Light Yellow (K1)
Medium Yellow (8)	Yellow (Y2)	Medium Yellow (022)	Yellow 2	K2	YL-3	Medium Yellow (K2)
Dark Yellow (9)		Dark Yellow (023)			YL-4	
Yellow-Green (11)	G53	Yellow-Green (060)	Green 11	XI	GR-4	Light Yellow-Green (X1)
Yellow-Green (13)					GR-5	
Dark Yellow (12)						
Dark Yellow (15)			Orange 15	G	YL-6	Dark Yellow (G)
Orange (16)	O56	Yellow-Orange (040)				
Dark Orange (21)		Red Orange (041)				
Light Red (23)		Light Red (090)			RD-4	
Medium Red (25)	R60	Dark Red (091)	Red	25A	RD-5	Tricolor Red (A)
Dark Red (29)		Deep Dark Red (092)			RD-8	
Blue (47)						Tricolor Blue (C5)
Green (58)						Tricolor Green (B)

A No. 15 (dark yellow) filter was used to bring out the clouds and provide a darker background against which the white parts of the helicopter are clearly imaged.

Minolta	Nikon	Pentax	Rolev	Tiffen	Vivitar	Discontinued Kodak Designations	f/Stop Increase (Daylight)
	Y44	Y1		6 (Yellow 1)		K1	⅔
Yellow	Y48	Y2	8 Yellow	8 (Yellow 2)	K2	K2	1
				9 (Yellow 3)		K3	1
Green	XO	YG	11 Green	11 (Green 1)	X1	X1	2
	X1			13 (Green 2)		X2	2⅓
				12 (Yellow)			1
Orange	Y52	O2	15 Orange	15 (Deep Yellow)	G15	G	1½
				16 (Orange)	O2		1⅔
	O56			21 (Orange)			2
				23A (Light Red)			2½
Red	R60	R2	25 Red	25A (Red)	25 (A)	A	3
				29 (Dark Red)		F	4½
				47 (Blue)			3
				58 (Green)			3

copy. For detailed information on filters for scientific use, read *Kodak Filters for Scientific and Technical Use.*

Filters for Color Photography
Color film is designed to be used in a standard light source. For daylight films, this is a mixture of hazy sunlight and skylight. For tungsten films, it is a studio flood (tungsten) bulb. And for most motion-picture films as well as Kodachrome 40, it's a photoflood light. All other light sources will produce a color shift.

The amount of color shift depends on how far off from the standard the light source is. If you have a portrait subject standing in the open shade, where the illumination is blue skylight, skin tones will take on a distinctly bluish cast, even with daylight film. If

The superabundance of blue and ultraviolet radiation at high altitudes makes filtration mandatory when you take shots through the window of a commercial air liner and want to get details of the ground. The shot on the bottom was made without filter. The one on the top was taken through a No. 25 (Red) filter. Lens: 35mm on a 35mm SLR. Film: Tri-X. The white specks on the surface of the water are sailboats.

you use a daylight film such as Kodachrome 400 in tungsten light, everything will take on a yellow-orange cast. These, and thousands of other color casts can all be predicted and corrected by using filters.

The only filters you actually need for color photography are conversion filters. All other filters simply fine-tune your color.

Color temperature: For many years color was described in terms of color temperature (degrees Kelvin, or K), which is based on the relative proportions of red and blue in the light. Since most of the light sources that give us trouble in photography also contain green, the color temperature scale is not very useful, but there are five points on the scale worth taking note of.

The color temperature of standard daylight is 5500 K. A blue sky is anywhere from 10,000 K up. A photoflood is 3400 K and studio flood (tungsten light) is 3200 K. A standard 100-watt household light bulb is about 2900 K when new. The standard lightbox for viewing transparencies and the standard source for looking at color prints is a 5000 K light, about the same color temperature as a 500-watt blue photoflood.

Color temperature meters: The color temperature meter measures the red and blue components of light and provides a suggested filter compensation. These meters were originally developed for use with tungsten floodlights that changed color temperature as they aged. The advent of quartz lights for motion picture, television and still photography work virtually eliminated the need for these meters. They do not work accurately with fluorescents or daylight, the two major sources that require special filtration.

Three-color meters: There are only two three-color meters avail-

able, the Minolta 3-Color Meter and the Spectra Tri-Color Meter. They measure all three components of light—red, green and, blue—and provide filter recommendations based on scale readouts. Both work well and both are expensive. They are professional tools that virtually guarantee standard color with any lighting situation, provided all parts of the scene are illuminated with the same type of light. (There is no correct filtration for a mixed lighting situation where half the scene is daylight and half warm white fluorescents.)

Three-color meters give readings that translate into either light-balancing or color-compensating filter recommendations or a combination of both. Although the scales on the Minolta and Spectra meters are different, the result is standard color. The Minolta meter is more compact and has a chart on the back that explains the scale values. The meter also features a rotating head so that you can read from a variety of angles without color kickback from your own clothing. It will read either incident or reflected light.

Conversion Filters
These filters are used to make major changes in the quality of light, such as converting studio floods to daylight quality.

Use an 80A (4X or two f/stops) with daylight film and 3200 K studio floods when you want accurate, daylight-type color saturation. This is the right combination for product photos, copying in color, and close-up photography of small objects. It will provide partial correction for portraits made by available tungsten lighting such as the 100-watt and 75-watt bulbs found in most household lamps. The results are a bit warm, but the color still seems natural.

Use an 80B (3.5X or 1⅔ f/stops) with daylight film and 3400 K photofloods or movie lights. Since most motion-picture film is balanced for 3400 K illumination, this filter is used when you make stills on an artificially lighted movie set.

Use an 85B filter to balance a tungsten-type film, such as Ektachrome 160 Tungsten with daylight. An 85 filter balances Kodachrome 40 (formerly called Type A) with daylight.

Light-balancing filters can be used in conjunction with conversion filters to provide additional fine-tuning.

Light-balancing filters are used to make minor changes in the quality of light striking the film. Although originally designed for use with tungsten lights, they are used today mostly for warming and cooling effects in daylight.

The 81 series of warming filters have a salmon or pale amber color. Outdoors, they add warmth in cloudy, or open shade situations and are used primarily to produce pleasing flesh tones, which, unfiltered, would have a bluish cast. They are seldom used for scenic shots, which seem to come out better unfiltered. Under an overcast sky, an 81C produces adequate correction with most films, although personal preference may dictate more or less correction.

The 82 series of cooling filters are all pale blue. The 82A is frequently sold as a correction filter for use in early-morning or late-afternoon sunlight, but is seldom used for that purpose because it corrects only those portions of the scene hit directly by the sun, squelching the rich golden color objects take on in that light, and it overcorrects the skylighted portions of the scene, which are bluish to begin with. It is much more useful as additional correction in conjunction with an 80A

A No. 25 (red) filter helped darken the pine trees in the background and bring out the unique forms of these weeds.

This is the Spectra Tricolor Meter, an instrument widely used by motion-picture, television and commercial photographers. Both the Spectra and Minolta meters are beyond the reach of amateur pocket books, but if accurate color rendition is important to you professionally and you frequently work on location, then a three-color meter is a good investment.

This Minolta 3-Color meter gives a numerical readout on the meter dial (left). To get a filter combination, refer to the chart on the back of the meter (right). Readouts are given in either light-balancing or CC filter combinations.

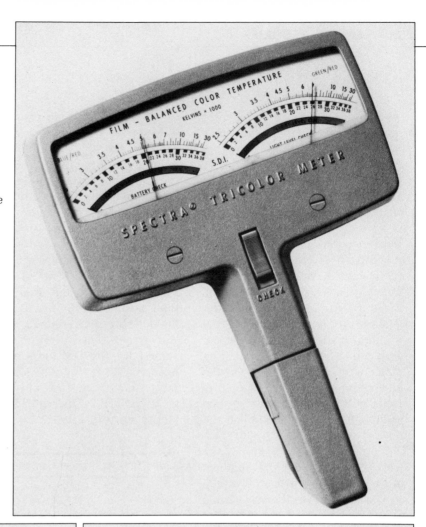

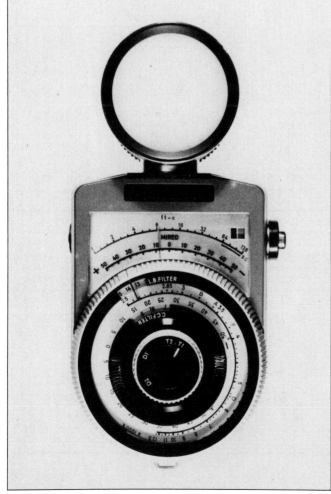

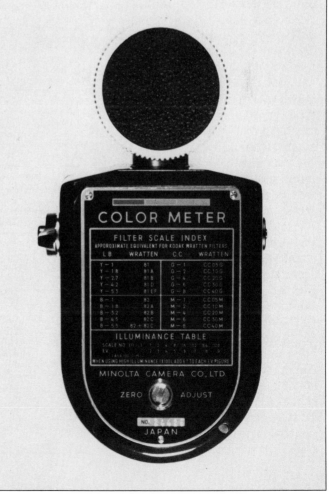

when you want to get good color rendition on daylight film with household bulbs. With new 100-watt bulbs, an 82B plus and 80A and 2½ f/stops compensation will give good color for copying and small object photography.

Decamired Filters

A standard set of Decamired (DM) filters consists of four reddish and four bluish filters that do the job of both light-balancing and conversion filters. In this system, the number of the filter tells you exactly what the warming or cooling effect will be. It is based on the conversion of color temperature into units called mireds. The smaller the number, the bluer the light.

The big disadvantage to the Kelvin scale is that the numbers are not uniform, so a shift of 200 K at one point on the scale has a very different effect at some other point on the scale. It is confusing and cumbersome.

The Mired scale accurately indicates the warming or cooling effect of a filter using only one number—its decamired value. A decamired is ten mireds. The larger unit was chosen because you can't really see a color shift of less than ten mireds.

The Tiffen DM Filter set contains four reddish (warming) filters—R1½, R3, R6, R12—and four bluish (cooling) filters—B1½, B3, B6, B12. The B12 is for use with daylight film in tungsten light. The R3 is a good starting point for correcting flesh tones on heavily overcast days. The R12 is for use with tungsten film in daylight.

The filters can be used singly or in combination as long as you stick to one color or the other. Do not mix R and B filters if you want predictable results.

The accompanying chart gives DM values for standard light sources. To find the DM filter required to raise or lower the quality of the light to standard daylight or standard tungsten, subtract the DM value of your light source from the DM value of the film. For daylight films, the DM value is 18; for tungsten films, it's 31, and for Kodachrome 40, it's 29.

For example, say the light was an overcast sky. Subtract 15 from 18. The result is 3DM, so use an R3. Working in the other direction, assume the light was photoflood. Subtract 29 from 18. The result is −11. As a rule, if you cannot hit the DM value on the nose, then go for less filtration rather than more. It would be better to use a B3 plus a B6 and possibly even adding a B1½ to get the equivalent of B10½ rather than use a B12. That is the rule for color quality. Unfortunately, using three filters is likely to create some flare. You might be better off with an undercorrected B9 equivalent or a slightly overcorrected B12, depending on the lighting situation.

Once you get the hang of it, the

Starter Set For Color Photography

Filter Type	Filter No.
Skylight	1A or 1B
Light-balancing (warming)	81A, 81C
Light-balancing (cooling)	82A
Polarizer	
Fluorescent light, daylight	(FLD or FD or CC30M)

Color Temperature of Common Light Sources

Source	Color Temperature (Kelvin Units)	Approximate Decamired Value
Clear blue northern skylight	15,000-27,000	6-4
Subject in shade, illuminated by blue skylight	10,000-12,000	9
Hazy skylight	7500-8400	12
Overcast sky	6700-7000	15
Electronic flash	6200-6800	16-15
Blue flashbulb	6000	17
Hazy sunlight	5800	17
Average daylight	5500-6000	18-17
Morning or afternoon sunlight	5000-5500	19
500-watt blue photoflood	4800-5400	21-19
Clear zirconium foil-filled flashbulbs	4200	24
Clear aluminum foil-filled flashbulbs	3800	26
500-watt amateur photoflood lamps	3400	29
500-watt studioflood lamps	3200	31
100-watt general-service lightbulb	2900	35
75-watt general-service lightbulb	2820	35
40-watt general-service lightbulb	2650	38

Conversion Filters For Color Films

Filter Color	Filter Number	Exposure Increase in f/stops	Application	Lighting Conversion in Kelvin Units	Decamired Shift Value
Blue	80A	2	Balances daylight film with studio floods. Also used for general-service household bulb.	3200K to 5500K	−13.1
Blue	80B	1⅔	Balances daylight film with photofloods.	3400K to 5500K	−11.2
Amber	85	⅔	Balances Type A (Kodachrome 40) film with daylight.	5500K to 3400K	11.2
Amber	85B	⅔	Balances Tungsten film with daylight.	5500K to 3200K	13.1

Typical Color Problems and Corrective Procedures

Problem	Problem Cause	Correction
Bluish color cast	Tungsten-type or Type A film used in daylight or with flash without filter	Use appropriate conversion filter
	Photograph made on daylight-type film in open shade, at twilight, or under overcast skies	Use Skylight 1A for general correction. Use 81 series of light-balancing filters for greater correction
Dense cyan cast on film	Faulty processing or photograph made through a cyan filter	None: try another lab.
Reddish or yellow color cast	Daylight-type film exposed by tungsten light or clear flash	Use appropriate conversion filter
	Film balanced or converted to 3400K or 3200K light exposed by general household light bulb	Use 82C or B3
Green or blue-green color cast	Film exposed by fluorescent lights	Use FLD filter for daylight films; use FLB filter for tungsten films; or use suggested CC filter
	Local color cast due to green foliage	Use Color Compensating filter as required
	Film correctly exposed; no local color cast	Improperly aged film; processing error. Color Compensating filters may be tested as possible means for correction
	Reciprocity failure due to exposures longer than those for which film is designed	Expose according to manufacturer's recommendations; use filters recommended by manufacturer to compensate for reciprocity failure
	Film subjected to heat or chemical vapors during storage	Store film according to manufacturer's recommendations.

Light-Balancing Filters

Filter Color	Filter Number	Exposure Increase in f/Stops*	To obtain 3200K from	To obtain 3400K from	Decamired Shift Value
Bluish	82C + 82C	1⅓	2490K	2610K	−8.9
	82C + 82B	1⅓	2570K	2700K	−7.7
	82C + 82A	1	2650K	2780K	−6.5
	82C + 82	1	2720K	2870K	−5.5
	82C	⅔	2800K	2950K	−4.5
	82B	⅔	2900K	3060K	−3.2
	82A	⅓	3000K	3180K	−2.1
	82	⅓	3100K	3290K	−1.0
No Filter Necessary			3200K	3400K	—
Yellowish	81	⅓	3300K	3510K	.9
	81A	⅓	3400K	3630K	1.8
	81B	⅓	3500K	3740K	2.7
	81C	⅓	3600K	3850K	3.5
	81D	⅔	3700K	3970K	4.2
	81EF	⅔	3850K	4140K	5.2

*These values are approximate. For critical work, they should be checked by practical test, especially if more than one filter is used.

DM system is very easy to use. If you would like to use light-balancing (LB) filters according to this system, the accompanying chart gives approximate DM equivalents for these filters. By assigning DM values to LB filters, their effect used singly and in combination becomes readily predictable.

Color-Compensating Filters

Not everyone likes the color quality imparted by LB and DM filters. For total color control, color-compensating (CC) filters are the only answer. A complete set of these filters is an expensive professional tool costing hundreds of dollars in fragile gelatin and hundreds more in glass, but fortunately there is almost never a need for a complete set.

The only CC filter that has any widespread application outside of professional fine-tuning of color quality is the CC30M. This filter can be used with daylight film as a correction filter underwater in shallow depths, as a correction filter for the green-tinted glass found on some touring buses, and as a general correction filter for fluorescent lights. You can also use it to get better color quality with Polacolor 2 when you overdevelop this film to increase color saturation.

CC filters are identified by density and color. In the CC30M designation, for example, CC stands for color compensating, 30 stands for a density of 0.30, and M stands for magenta. The accompanying chart shows the standard range of CC filters and the exposure compensation required for each.

To correct for batch-to-batch variations in the color quality of film emulsions, you can usually make do with R, Y, and M filters in densities of .1 (10) and .2 (20). The chart on the Minolta color-temperature meter makes do with four CC filters—CC10M, CC20M,

CC10G, and CC20G—plus a set of light-balancing filters for almost all color lighting situations.

Fluorescent Lighting and Color Casts

The fluorescent lights found in most offices, stores, and home kitchens are missing some colors normally found in both daylight and tungsten light. As a result, unfiltered shots taken under these lights usually have a blue-green or yellow-green cast.

If there is only one type of fluorescent in the scene, the color cast can be controlled using CC filters, but getting the right combination can be tricky. A three-color meter will do it for you. Alternatively, you can take test shots and view these through different CC filters on a light box or under a standard 5000 K light till you find a combination that looks right. If you use this method, do not lay the filter on the slide or print. Hold the filter up to your eye. Use a standard 5000 K light box or print viewing light. You can also project a slide and hold the filters in front of the lens. The accompanying chart gives filter recommendations for standard

A No. 11 (green) correction filter was used to lighten the foliage, keeping it in tune with the lightness of the subject.

fluorescents, and these combinations will work if there is only one type of fluorescent in the scene. Unfortunately most offices and stores have acquired mixed bulb types over the years, and getting the right combination can be tricky.

A number of filter manufacturers make filters for general correction of fluorescents. These filters give partial correction, but are seldom precise. They are a useful expedient when you do not want to take the time to test and do not have a three-color meter. Fluorescent filters have designations such as FLD or FD for daylight films and FLB or FB for tungsten films.

There are continuous-spectrum fluorescents on the market. These lights are a good source for color photography and do not require filtration.

Decimired Filter Selector Chart*

Film Type	Lighting	Filter	Exposure Increase In f/Stops
DAYLIGHT	Bluish daylight, open shade, slight overcast, blue flashbulbs	R1½	¼
	Electronic flash	R3	⅓
	Average sunlight plus skylight	None	—
	Early morning or late afternoon sunlight	B1½	¼
	Clear flashbulbs	B6 + B1½	1¼
	3400K photofloods	B3 + B6 + B1½	2
	3200K studiofloods	B12	2
	100-watt lightbulb	B12 + B3	2½
TYPE A (BALANCED FOR 3400K LAMPS)	Bluish daylight, open shade, slight overcast	R12 + R3	1⅓
	Electronic flash and blue flashbulbs	R12	1
	Average sunlight plus skylight	R3 + R6 + R1½	1
	Late afternoon or early morning sunlight	R3 + R6	¾
	Clear flashbulbs	R3	⅓
	3400K photofloods	None	—
	3200K studiofloods	B1½	¼
	100-watt lightbulb	B6	1
EKTACHROME 160 TUNGSTEN (BALANCED FOR 3200K)	Bluish daylight, open shade, slight overcast	R12 + R3 + R1½	1½
	Electronic flash and blue flashbulb	R12 + R3	1⅓
	Average sunlight plus skylight	R12	1
	Late afternoon or early morning sunlight	R1½ + R3 + R6	1
	Clear flashbulbs	R3 + R1½	½
	3400K photofloods	R1½	¼
	3200K photofloods	None	—
	100-watt lightbulb	B3	½

*Filter suggestions given here should be considered as starting points for correction only. More or less filtration may be required to suit personal tastes.

Decamired Exposure Increase

R Series	Exposure Increase in f/Stops
R1½	¼
R3	⅓
R6	½
R3 + R6 = R9	¾
R12	1
R12 + R3 = R15	1⅓
R12 + R6 = R18	1½

B Series	Exposure Increase in f/Stops
B1½	¼
B3	½
B6	1
B3 + B6 = B9	1½
B12	2
B12 + B3 = B15	2½
B12 + B6 = B18	3

Skylight and Ultraviolet (UV) Filters

The Skylight or 1A is probably the first filter most photographers buy, and in the days before single- and multi-coated lenses, it was useful. It requires no exposure compensation and now functions most often as a transparent lens cap.

All color films are excessively sensitive to blue and invisible ultraviolet radiation. The Skylight filter holds back the unwanted portion of blue and UV light, so in theory it eliminates the blue cast that this radiation could produce with photos taken on a sunny day at the beach or in the mountains. On the other hand, the coating on your lenses does much the same thing.

These filters do add a little warmth to shots taken in open shade or on cloudy days, but their effect is unnoticeable on sunny days. So it never hurts to use one. But decide for yourself whether it really does any good.

UV and haze filters are pale yellowish filters designed to give greater cutoff of UV and blue radiation than is provided by a Skylight filter. They are most useful

Kodak Color Compensating Filters

Peak Density	Yellow (Absorbs Blue)	Exposure Increase in Stops*	Magenta (Absorbs Green)	Exposure Increase in Stops*	Cyan (Absorbs Red)	Exposure Increase in Stops*
.025	CC 025Y	—	CC 025M	—	CC 626C	—
.05	CC 05Y	—	CC 05M	1/3	CC 05C	1/3
.10	CC 10Y	1/3	CC 10M	1/3	CC 10C	1/3
.20	CC 20Y	1/3	CC 20M	1/3	CC 20C	1/3
.30	CC 30Y	1/3	CC 30M	2/3	CC 30C	2/3
.40	CC 40Y	1/3	CC 40M	2/3	CC 40C	2/3
.50	CC 50Y	2/3	CC 50M	2/3	CC 50C	1

Peak Density	Red (Absorbs Blue and Green)	Exposure Increase in Stops*	Green (Absorbs Blue and Red)	Exposure Increase in Stops*	Blue (Absorbs Red and Green)	Exposure Increase in Stops*
.025	CC 025R	—		—	CC 05B	—
.05	CC 05R	1/3	CC 05G	1/3	CC 10B	1/3
.10	CC 10R	1/3	CC 10G	1/3	CC 20B	1/3
.20	CC 20R	1/3	CC 20G	1/3	CC 30B	2/3
.30	CC 30R	2/3	CC 30G	2/3	CC 40B	2/3
.40	CC 40R	2/3	CC 40G	2/3	CC 50B	1
.50	CC 50R	1	CC 50G	1		1 1/3

*These values are approximate. For critical work, they should be checked by practical test, especially if more than one filter is used.

**Kodak CC filters are gelatin. You can purchase glass CC filters from Tiffen and other full-line filter manufacturers.

Fluorescent Light Starting Correction Filter Table

Film Type	Type of Fluorescent Light					
	Wm Wht Del	Warm White	White	Cool Wht Del	Cool White	Daylight
	Filter	Filter	Filter	Filter	Filter	Filter
Daylight*	60C+30M	40C+40M	20C+30M	30C+20M	30M	40M+30Y
	+1⅔S	+1⅓S	+1S	+1S	+⅔S	+1S
Type A (3400K)	None	30M+10Y	40M+30Y	10M+20Y	50M+50Y	85+30M +10Y
	—	+1S	+1S	+⅔S	+1⅓S	+1⅔S
Tungsten (3200K)	+10Y	30M+20Y	40M+40Y	10M+30Y	50M+60Y	85B+30M +10Y
	+⅓S	+1S	+1S	+⅔S	+1⅓S	+1⅔S

*Includes KODAK Type S Films and KODACOLOR Films.

NOTE: Increase the meter-calculated exposure by the amount indicated in the table. If the exposure times require, make the necessary additional corrections for reciprocity effect, both in exposure and filtration. With transparency films, run a filter test series up to ±CC20 from the given values (usually in the M ⟷ G and Y ⟷ B directions) under each lighting condition.
Filters specified above are KODAK Color Compensating Filters and KODAK WRATTEN Filters. Exposure increases for filters with the same designations from other manufacturers may differ.

in telephoto work and aerial photography where there is a need to penetrate the haze barrier created by scattered UV and blue light.

If you get slides or prints back with a dense cyan cast, the fault is most likely in the processing, a worn-out bleach-fix for example. No amount of filtration will correct it.

Polarizers

The primary function of a polarizer is to reduce or eliminate glare, which improves detail rendition and, in color photography, can improve color saturation as well. It will also darken that arc of blue sky at a right angle to the sun, and short of using a special-effect filter, it is the only way to darken a blue sky without affecting color quality.

Most polarizers are today sold in rotating mounts, which are most useful with SLR cameras. To use the polarizer with an SLR, mount it on the lens, then look through the viewfinder and rotate the filter to observe the effect of glare reduction.

With non-SLRs, hold the filter up to your eye, rotate it until you see the effect you want, note the position of the data inscribed on the rim, then mount the filter on the lens, turning it until the data is at the same angle it was when you looked through the filter.

Greatest glare reduction occurs with light bouncing off a smooth surface such as glass or water at a 30° angle. At this angle you can reduce or eliminate glare in photos of the contents of store windows and penetrate the surface glare of ponds to photograph fish and other shallow-swimming subjects.

To find the arc of sky that will be darkened by a polarizer, make a right angle between your thumb and index finger, point your thumb at the sun and your finger will point to the area of sky that will respond most strongly to your polarizing filter. This arc is close to the horizon at midday and high in the sky in the early morning and late afternoon.

The polarized area of the sky makes a good background for portraits and color studies of sculpture or buildings.

The polarizer affects all colors equally and unless there is polarized light in the scene, it will simply act as a neutral-density filter requiring an exposure compensa-

tion of 1½ to 2 f/stops.

Polarized light vibrates in one plane only. Normally light vibrates in all directions, but when it strikes a smooth surface such as still water or glass, and glances off as glare rather than passing through, it becomes polarized. Light passed through a polarizing filter will also be polarized. The filter has a special microstructure aligned to stop light vibrating at right angles to it and pass light vibrating in other directions. By rotating the filter, you can allow polarized light to pass freely or you can stop it.

A polarizer is hardly a necessary filter, but it is useful for scenic photography and for copying work where glare is often a problem. (See Chapter 9.)

Neutral-Density (ND) Filters

Gray neutral-density filters are used to control exposure. They can be used singly or in combination, and the numbering system used to identify the density of each filter also functions as a rough guide to the exposure increases needed.

The numbering system is logarithmic, which means that each 0.3 increase in density is equivalent to approximately one f/stop increase in the required exposure. This is a rough guide only, but it is adequate when you do not have more exact data, such as the accompanying table.

An ND 0.3 is a one-stop filter, an ND 0.6 is a 2-stop filter, an ND 0.9 a 3-stop filter, and so on. When you use ND filters in combination, add their numbers to get the combined-density value and divide by .3 to get the exposure increase in f/stops.

ND filters have no affect on color. Their primary use is in motion-picture work where they allow all scenes to be shot at the same aperture. In black-and-white work, they allow you to use wide

Ultraviolet, Skylight, and Haze Filters

Filter No.	Film Type	Lighting	f/Stop Increase	Suggested Uses
SKY 1A	Daylight	Daylight	—	Use at all times, outdoors, to reduce blue and add warmth to scene. Also in open shade
HAZE 1	Daylight	Daylight	—	Reduce excess blue caused by haze and ultraviolet rays. Ideal for mountain, aerial, and marine scenes
HAZE 2A	Daylight	Daylight	—	Greater ultraviolet correction than Haze No. 1 filter and adds some warmth to the visible colors
UV15	Daylight	Daylight	—	Haze filter, also for 3200K film with photofloods
UV16	Daylight	Electronic flash Daylight	—	Reduces excessive blue in electronic flash, also may be used for haze correction
UV17	Daylight	Daylight	—	Greater haze correction, reduces blue in shade
3(Aero 1)	Daylight	Daylight	⅔	Aerial photography for haze penetration

apertures, slower shutter speeds, or both in bright sunlight with fast films. The 3X factor of a polarizer gives you all the neutral density you are likely to need in most situations.

ND filters come into their own in still photography only in the studio where they are used in conjunction with Polaroid film to make exact previews of exposure effects. (See Chapter 8.)

SPECIAL-EFFECT ATTACHMENTS

The effective use of special-effect attachments is a challenge. It is often more difficult to get a good split filter, fog filter, or multiple-image lens shot than it is to get a good straight photo of the same subject. As in any other area of photography, a good special effect is the result of a happy combination of subject and technique, and finding the right combination often calls for putting your visual imagination into high gear.

Every attachment creates its own limitations and potential, and no sooner do you learn some rules that seem to make an attach-

ment work for you than you seem to find ways to break them. A multi-image prism gives the most distinct, separate images when a subject is imaged against a plain background; yet a recent award-winning photo by an industrial photographer was made using a multi-image prism to simulate the fragmented vision of a drunk watching a police officer approach his car, and the background was complex.

Unless you have an interesting subject to begin with, the chances are that no special-effect attachment will produce an interesting shot. These devices are not an easy way to avoid difficult creative visual thinking. On the contrary, their effective use demands a consistently high level of creative thought. The result can be photos that communicate a mood, feeling, or idea more intensly than any straight shot.

Diffusion

There are a variety of devices designed to disperse light so that the image is softened. Effects are slightly different, depending on the device used, but all tend to

disperse highlights into shadow regions, which softens edge contrasts and lowers color saturation.

Soft-focus attachments, also called *diffusion filters,* have etched lines on the surface that soften image definition. The type with etched concentric circles produces overlapping regions of sharpness and unsharpness similar to spherical aberration present in old-fashioned portrait lenses and in contemporary soft-focus lenses such as the Minolta Varisoft or the Spiratone Portagon, which can be used with most 35mm SLR's. Diffusion filters are available in different strengths to give you a choice of light to heavy diffusion.

Fog filters are designed to simulate the effect of fog by producing a whitish veil over the entire image. They are available in various strengths ranging from a just noticeable lightening of the image through a dense diffusion in which everything seems to be enveloped in a whitish mist. When a true fog effect is desired, low-contrast, flatly lighted scenes are best. These filters are also used to create misty, romantic effects in pictorial and advertising photography and to symbolize a mood of nostalgia in shots of models or actors in period dress.

Fog filters can be used singly or in combination to produce a variety of effects. As the density of the filter increases a slight exposure compensation is required. Tiffen recommends no compensation for their No. 1 and No. 2 filters, 1/3 f/ stop for their No. 3 and No. 4 filters, and a full stop for their No. 5.

These filters do not produce color casts. In backlighted scenes, they increase the halo effect of light coming through hair or diaphanous clothing and sharp spikes of light from point sources are turned into glowing balls.

Clear center-spot diffusers have a clear center surrounded by a doughnut of ground or pebbled glass. They are used to lead the eye toward the center of interest by softening the outside edges of the image area. Effects range from barely noticeable to fairly strong, depending on the filter, and cannot always be predicted by looking at the filter itself. To find out what it really does, put it on the camera and test. These filters can also be used to enhance backlight-halo effects while maintaining a sharp central image that has good color contrast and brilliance.

Translucent matts of varying densities are sold for use with the matt boxes and compendium (bellows) lens hoods which are covered in detail on page 75.

Do-It-Yourself Diffusion

Your own warm, moist breath is the most convenient diffuser of all. If you have an SLR and want to get a misty effect, just breathe wetly on the lens and watch your subject through the lens as the moisture evaporates. Press the shutter when you see the effect you want. But a word of warning: the effects tend to be stronger on the film than they look to the eye and unless you are using through-the-lens metering, the shot may also be underexposed. It takes some practice to develop a feel for the amount of misting that produces the most satisfactory effects.

A bit of vaseline will turn any clear or Skylight filter into a diffuser. Smear it on with your finger. The degree of diffusion depends on how much jelly you put on. You can try leaving a clear center spot or oval for combination sharp and diffuse effects. You can even add watercolor, the kind that comes in tubes, to the jelly for colored effects.

Any material can be drafted into service as a diffuser, including rumpled plastic wrap, tissue paper, and tracing paper. If you

Neutral Density Filter Specifications		
TIFFEN Type	**Percent Light Transmission**	**Increase in f/Stops**
ND .1	80	½
ND .2	63	¾
ND .3	50	1
ND .4	40	1¼
ND .5	32	1¾
ND .6	25	2
ND .7	20	2¼
ND .8	16	2¾
ND .9	13	3
ND 1.0	10	3¼
ND 1.2	6.3	3¾
ND 1.5	3.2	4¼
ND 2.0	1.0	6⅔
ND 3.0	0.10	10
ND 4.0	0.001	13⅓

want a clear central image, just cut a hole in the paper or plastic. To hold the material in place in front of your lens, use a professional filter holder for square gelatin filters, a Tiffen Rotoadapter, or any matt box or bellows lens hood.

Low-Contrast Filters

Low-contrast filters are designed to reduce contrast without creating flare in the highlights or diffusion. In theory, you could lower contrast to the point where the greyish blacks merge into the whites and the image gets lost. They provide a means of controlling tone scale without exposure and development variations, although both techniques can be used for additional control. They are available from Tiffen and Harrison & Harrison in grades 1 through 5, with grade 5 producing the greatest contrast reduction. They can be combined for heightened effects. No exposure compensation is required for grades 1 through 3. For higher grades, a slight increase in exposure may be required, although just the opposite, a slight exposure reduction, may be called for with some black-and-white scenes. The effect depends on the contrast of the scene and some experimentation may be required to get the effect you want.

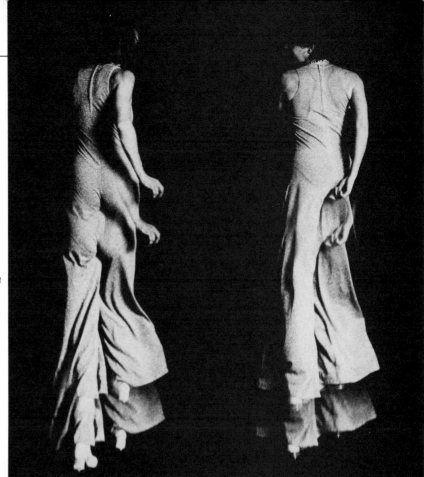

Tap dancers Brenda Bufalino and Pat Giordano were photographed through a Tiffen 6L multiple-image lens to achieve a visual symbol of the kinetic and formal qualities of tap. Photo by Robb Smith.

The exuberance of this four-year-old was amplified by using a Tiffen 5P multiple-image lens. The side light was provided by a Metz 45CT-1 automatic flash mounted on a Siegelite flash extension bracket. Photo by Robb Smith.

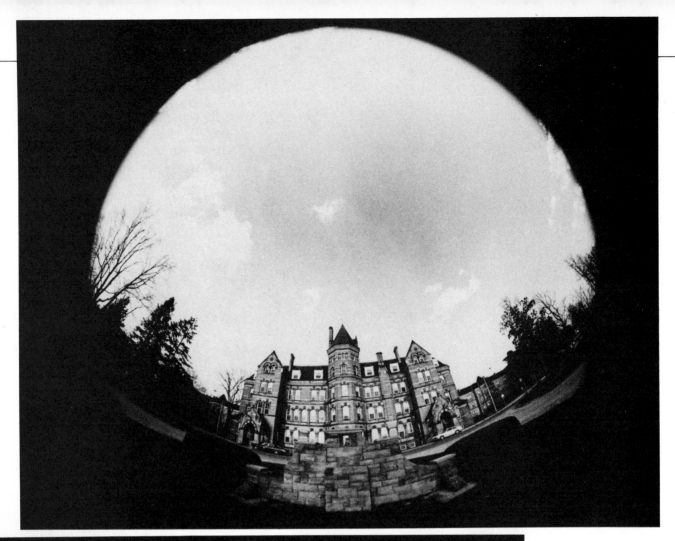

Use of the red filter built-in to a
Minolta 7.5mm fisheye lens
helped add dramatic impact to
these landscape photos.

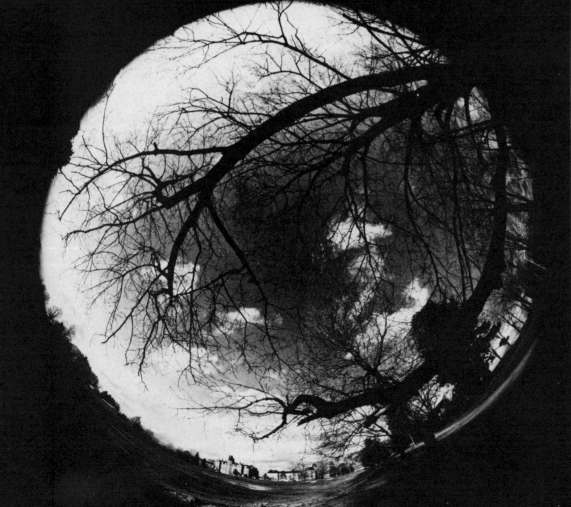

As you combine attachments, the results become more visually complex. This shot was taken through a Tiffen 6L multiple-image lens (half clear, with six parallel facets in the other half) crossed with a 3P (three parallel facets) lens mounted on a variable-color red/yellow filter with the polarizer rotated for red. Exposure was metered through the lens and bracketed.

Here a three-parallel facet multiple-image lens was combined with a holographic-diffraction filter. The attachment sequence was lens, multi-image lens, star-burst filter. The complex streaks of colored light were created by the diffracted light from the star-burst filter bouncing around the facets of the multi-image lens.

The shot on the top left was done by combining a variable-color filter with a holographic-diffraction filter. The star-burst filter bounced light into the polarizing material of the red/yellow filter, producing a yellow star against a red background. You cannot get this effect if you use a standard red No. 25 filter, which turns everything red.

This (top right) is a relatively simple effect. A Hoya four-beam star filter was the only attachment used on a normal lens. The pattern of light echoing the pattern of pipes on a jetty was created by the sun striking the star filter at an angle.

A six-facet, radial pattern filter (Tiffen 6R) helped turn this ordinary ferris wheel into something special. Ektachrome 160 tungsten film emphasized the blue lights.

The new generation of holographic-diffraction filters is extremely sensitive to light. The prismatic overlay of color in this photo of a rocking chair was produced by a Tiffen Vari-Burst filter, which diffracted rays of sunlight coming through a porch screen.

Variable-color filters give you extended control over false-color effects. These two photos of a backlighted cloud formation were taken through the same red/blue Tiffen Vari-Color filter.

This photo of a backlighted model was taken through a variable-color red/yellow filter. Fill light was provided by an on-camera Vivitar automatic flash.

The matte box is a favorite tool of wedding and portrait photographers because it lets you integrate subject and background with color and diffusion. These two photos of dancer Karen Abrams were taken using a Multi-E-Fects lens hood from Darkroom Products limited. The misty effect was done with a matt acetate of neutral color slipped into the box. A clear hole in the center of the matt gave a sharp rendition of the subject's head. The second photo was taken through a green matt to emphasize the color of the foliage in the background while the hole in the center gave a natural rendition of flesh tones.

Landscapes take on unusual aspects when you start to play with split filters. This sequence begins with a straight shot, which only hints at the emotional impact of the original scene. The second photo combines a split Vivitar yellow with a split green in the lower half. The third photo, in sequence, combines a normal lens with a split blue, split yellow and Tiffen Vari-Burst holographic-diffraction filter to create a shimmer of color that blends the scene.

One of the few times a polarizer is really useful is when you take scenic photos in wet areas and want to eliminate the glare. This photo was taken at Yellowstone National Park. A polarizer helped bring out the detail that was hidden under a sheet of glare from sunlight on wet rock.

Diffusion and fog filters are both used to give a hazy, romantic quality to an image. The fog filter used here gave a slight whitish veil to the image.

This was taken with a Vivitar split filter, half clear, half orange. The subject is a chair draped with a blue blanket to create a color contrast with the orange sky. It was intended to be strange and evocative, unlike the combination series of trees and a pool, which are variations on a theme.

The effect of ice on branches against a blue sky is visually interesting, but why be satisfied with a straight shot when you have filters to play with? This moody, deep blue photo was deliberately created by using a blue No. 47B color separation filter. A No. 80A conversion filter would have produced similar results.

A polarizer has its strongest effect on the area of sky roughly opposite to the sun. On a clear day, the polarized area appears as a darker blue to the unaided eye. When you use a polarizer, you can turn that area of the sky nearly black.

For studies like this, a 105mm
lens is ideal. Bringing the
camera down to the child's
level also helps.

Diffraction Attachments

These devices cause bright high-lights and point sources of light to break up into shimmering bands of color or brilliant spikes of light. The group includes star filters, and a variety of filters containing laser produced prisms that are the latest contribution from the emerging technology of holography.

Star filters are engraved with cross-hatched lines that produce four- six- or eight-point needles of light radiating from specular highlights and point sources of light such as streetlights and candles. These filters also produce mild diffusion, the strength of which depends on the distance between the grid lines. The 1mm and 2mm grids produce the greatest diffusion but softer star effects; 3mm and 4mm grids produce less diffusion and more brilliant stars. For glittering, romantic effects, select the smaller grid sizes.

These filters can be used with all lenses. For the best star effects, use apertures in the $f/4$ to $f/8$ range. Effects diminish at smaller apertures and wide apertures may give a slightly out-of-focus effect.

Star filters in rotating mounts allow you to change the orientation of the points for better composition. Variable star filters have two rotating mounts so that you can change either the orientation of the points or the angles made by the beams.

The strongest star effects are achieved when brilliant, point sources of light are imaged against a dark background. Changing camera-to-subject distance or changing image size by switching lenses will change the effect. To get the best results, experiment.

Star filters are used in fashion photography to achieve diffuse, glittery effects with metallic clothing and jewelry and they have become standard equipment for motion-picture and TV coverage of disco and pop concerts.

If you do your own printing, or work with a custom professional printer, star effects can be added after the photo is taken by double-printing techniques. All you need is a stock of negatives with stars on them and you can select any effect you want. This technique is frequently used by advertising photographers, who find it much easier to get the effect in the lab than to try and coax it out of a

A Tiffen Center Spot filter, which has a clear central spot surrounded by a diffusion collar, was used on the camera to diffuse the edges of this photo and direct attention to the central subject.

box of cigars or a wristwatch by fiddling with spotlights and bits of mylar reflector.

Star-burst filters: These filters are so new there is no standard name for them, but the star-burst effect is unmistakable. They are a modern version of the old diffraction grating, which caused very strong sources of light to break up into a rainbow of colors. This new version, produced by laser technology, contains a film of holographic prisms that break up any point light source into spectacular bursts of color and create shimmering rainbow hazes from broad highlight areas.

Star-burst filters are now available in a variety of patterns. Tif-

fen's Variburst breaks light up into ten radiating lines of prismatic color with a shimmer of color between the lines. Hoya offers four versions: the Andromeda yields a line of colored ghost images from each point source; the Pulsator is similar to the Variburst; the Nebula turns a point source into a whirl of radiating lines; the Rainbow-spot is actually a diffraction grating that turns point sources into a prismatic haze of color. Samigon Kolor-trix diffraction filters are available in four patterns: a radial diffraction pattern, a linear pattern, a multi-image linear pattern, and a unique circular-diffraction pattern that creates multiple

The use of an 8-point star filter gave added sparkle to this shot. Still photos of circus acts often fail to convey the excitement of the actual performance. A star filter helps because it turns the lights into visual symbols that convey the emotional impact of the event. Film: Tri-X; 50mm lens on a 35mm camera. Photo by Robb Smith.

bands of intense color. Vivitar now has a line of these filters. Other brands are B+W and Cokin.

Color-Filter Effects

You can use any brightly colored filter to create monochromatic or color-elimination effects with color film. When you use the deep color contrast filters, such as the Red No. 25, the result is a monochrome. This technique is often effective with subjects that work well as silhouettes.

Yellow and orange filters produce more coloration because these filters pass both red and green light. Magenta filters produce colors in the red to purple range.

You can buy colored special-effect filters designed to yield exotic colors. The aqua, rose, and purple Vibracolor filters from Spiratone are of this type.

Variable-Color Filters

Variable-color filters work in conjunction with a polarizer. They give you either variable density of one color or a complete switch from one color to another just by turning the polarizer. The result is combined polarization and color filtration.

These filters are best used with through-the-lens metering SLR's. As you change the relationship between filter and polarizer, you can see the color of the scene change.

The most dramatic color shifts are produced by the filters that switch from one primary color to another, such as red to green or red to blue. These filters also produce intermediate color values. For example, at one point, a red/blue filter will yield magenta. The single-color filters yield variable densities of a single color.

These are basically special-effect filters for use with color film, although you can use them as contrast filters with black-and-

white film. Some photographers are attracted by the dual function, but these filters have a very big disadvantage: they must be used with a polarizer. The resulting filter factor ranges from three to six *f*/stops, with a factor of four to five stops being about average. This means you must meter through the filter and even with fast film will be forced to use large *f*/stops if you hand-hold your camera. There may be only a handful of times in your life that the combination of a polarizer and a color filter will make or break a picture, but you could miss out on hundreds of good shots because of the big filter factor.

The variable-color filter contains colored polarizing material. To be effective, it must be mounted so that you can change its orientation with the polarizer. If you have a variable-color filter in a non-rotating mount and a rotating-mount polarizer, then you should attach the variable-color filter to the lens and screw the rotating polarizer into the filter. If you do it the other way around and screw the filter into the polarizer, then rotating the polarizer will also rotate the variable-color filter and you will not get a color change.

Variable-color density filters can be used in place of light-balancing and color-compensating filters. Those filters with settings inscribed on the lens, such as the Spiratone Colorflow Filters, can produce repeatable effects.

Clear Center-Spot Filters

Clear center-spot filters have become popular recently for use in portraiture and with centrally located still-life subjects. These filters have a clear central spot surrounded by a color or by some specially treated area that produces diffusion or diffraction.

The filters with a colored surrounding field are effective with

isolated subjects that can be enhanced by a spotlight effect. The diffraction field, found in the Vivitar Color-Halo Filter, breaks up point-light sources into a starburst pattern, yet leaves the center spot clear of the diffusion produced by the diffraction field.

No exposure compensation is required with these filters when the main subject is in the clear center spot. Any type of metering will do with diffraction types. Those filters with a colored field will cause through-the-lens meters to overcompensate. To correct, close down about one stop, or double the ASA setting, or if your camera has an exposure-compensation dial, set it for minus one stop.

Wide *f*/stops will diffuse the line separating the center spot from the surrounding field. Small *f*/stops will sharpen the line.

You can make your own center-spot filter by smearing vase-

A stereo adapter makes two identical images, side-by-side, on a single frame of 35mm film. To view the resulting slide, use a 35mm stereo viewer. The 3-D effect is strongest when your principal subject is 10 to 15 feet from the camera and isolated against a more distant background.

line on all but the center portion of a clear or Skylight filter. You can also use a piece of matte or colored acetate, or tissue paper, cut a hole in it, and tape it over the front of your lens hood. (For more on clear center effects, see the section on the special-effects box.)

Graduated and Split Filters

A split filter is half clear and half grey or colored. A graduated (attenuated) filter is similar, but the colored or neutral-density portion is feathered where it joins the clear portion. This provides a gradual transition between the two parts.

When you use filters with a sharp split between colored and clear areas, you can alter the effect by changing the distance between lens and filter. Screwing the filter directly into the lens accessory mount produces a graduated effect with the upper third of the frame most strongly affected. Bringing the filter out so that

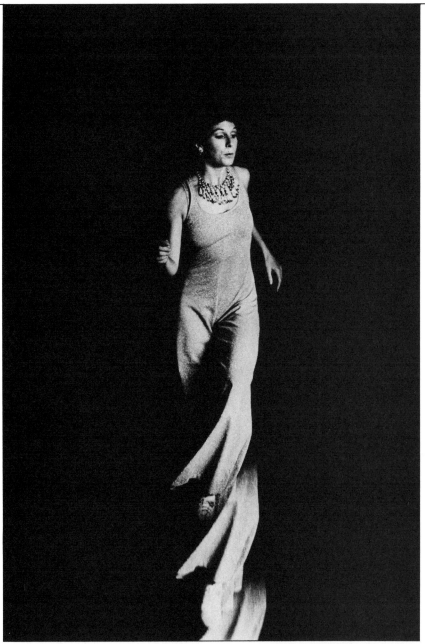

This group of photos by Robb Smith taken with Tiffen Multi-Image lenses demonstrate some of the many uses to which multiple-image attachments can be put. Similar lenses are available from Vivitar, Samigon, Prinz and other distributors.

Five parallel facets. The dancer, Pat Giordano, was on black seamless background paper and lighted by a single Ascor flash bounced from a 32-inch Reflectasol umbrella. Two additional images that appear above the dancer's head in the negative were burned in to black when the print was made.

The augmented ferris wheel was taken with a 5R lens that has four repeater facets surrounding a clear central facet. A dark yellow No. 15 filter was used to darken the sky and lighten the yellow wheel. In this photo, the repeat pattern helps suggest the dizzy, centrifugal spin of the wheel.

(Top) This was taken with a 6D lens in which six facets radiate from the center. Light was provided by a Metz 45-CT1 handlemount flash on a Sieglite Flash extension bracket.

A 3D prism consisting of three facets radiating from the center of the lens was used to amplify the motion of this antique, steam-driven hopper.

there is about one-half focal-length distance between filter and lens will increase the image area affected and still give a graduated transition. If you extend the lens-to-filter distance even further, you begin to get a sharp image of the split, which is usually undesirable.

Large f/stops soften the line between clear and colored halves. Small f/stops sharpen the line. When filters are mounted directly on the lens accessory mount, small f/stops increase the area affected by the colored portion of the filter.

In general, mid-range f/stops produce the most satisfying results, so you are best off using a medium-speed film, which also has the best contrast characteristics for special effects.

If you use through-the-lens metering with split filters, the meter will compensate for the filter, and this compensation is usually unwanted. To correct, close down about one f/stop from the indicated reading. If you use automatic exposure, use twice the normal ASA setting or use the exposure-compensation dial to get minus one stop. This is rough compensation only. If you have a good subject, try bracketing exposures to get a wider range of shots from which to choose.

Exposure readings taken with hand-held meters or using the 1/ASA method (see Chapter 9) require no compensation.

Split and graduated filters are available in different densities in a rainbow of colors. One manufacturer may offer the same color in several densities. The denser the color, the more obvious the effect. For subtle, naturalistic effects, use the weaker densities. For eye-stopping, deep-color effects, use the denser colors.

Skilled use of these filters is an art, particularly with colored subjects, because the filter color will

(Above) Three parallel facets. Natural daylight.

(Left) This was done with a 6R lens that contains five repeater facets surrounding a clear central facet.

combine with the subject color to produce a new color. For example, a light-red split filter used with light-green foliage turns the leaves dark yellow.

The split or graduated ND filter is often referred to as a "Sky Filter" (no relationship to the Skylight filter) and is available in one- two- and three-stop densities. It can be used to darken down any sky or any broad highlight area, such as an overcast sky or a bank of fluorescent lights in a commercial building.

When used for sky darkening, the split is usually positioned along the horizon line. It is the only filter that will darken over- cast skies. To darken ceiling lights, position the split where the ceiling and wall join, or just down the wall a bit.

You can use two split filters together for a multi-color effect and by changing the orientation of the filters create a variety of color blendings. For added color effects, use one of the star-burst type diffraction filters, and for image break-up, try adding one or two multiple-images lenses to the combination.

Multi-Color Devices
There are a variety of devices on the market that will give you multi-color effects. Most common

This was taken with two multiple-images lenses, a 6D plus a 3P. The result is an abstraction that communicates the visual complexity of New York City in a way that no straight shot can.

are the two-color filters in various color combinations, such as green/red, red/blue, blue/orange, and so on. Three-color filters and multiple-image lenses with different colors for each lens facet are also available.

Multi-color effects can be striking, but good shots with these devices require an eye for subject.

Since you are working with false-color effects, no precise rules can be given for exposure. Your best bet is to use through-the-lens metering and bracket when you find a good subject. Uncorrected hand-held meter readings will produce shots that are on the dark side, although the deep-color saturation may be visually satisfying. Ordinarily, a factor of one to two f/stops will put you in the ballpark.

Multiple-Image Lenses

These attachments create repeating-image patterns in a number of different configurations, the most popular of which are shown in the accompanying illustrations.

Multiple-image devices are computed for use with normal lenses. If you use them with long lenses, part of the image pattern will be lost. If you use them with wide-angle lenses, you will get a reduced pattern and vignetting.

No exposure compensation is required when you use multiple-image lenses, and you can use them in combination to create a wide variety of unique effects. For example, crossed parallel filters create a Mondrian pattern out of cityscapes, and the pattern can be further broken up by adding a radial filter such as the 6D, which breaks up the scene into six pie-shaped wedges.

The pattern you get with a normal lens and a multiple-image lens will depend on the size of the subject and the lens-to-subject distance. To increase separation between repeat images, increase your working distance.

Plain black or white backgrounds produce the strongest effects because the secondary images, which are always fainter than the primary image, remain clearly defined. If the background is complex, multiple images of the primary subject get confused with the background.

These devices will reflect and refract strong lights just outside the field of view of the lens. A lens hood combats the problem. You can also use your hand as a shade for the front of the lens.

If you are thinking about buying one or more of these multiple-image devices, your best bet will be the 6L, 5P, and 6D configurations. The radial configurations, in which a central image is surrounded by four or five repeat images, offer more limited possibilities for image interpretation. The effects with the 3D and 3P configurations tend to be less dramatic than 6D and 5P effects.

Spy Scopes

A spy scope is a right-angle mirror device that attaches to the front of a lens and looks like part of the lens itself. It allows you to point the camera in one direction and take pictures of people and things at right angles to the direction the camera is pointing.

There are two models commonly available, one for use with a normal lens and the other for a telephoto lens.

Special-Effects Box

The special-effects box has long been standard in motion-picture photography, and professional portrait and wedding photographers have used them for years to create vignette and misty effects. This accessory is also called a *matt box* or *compendium lens hood*. It is used to hold *matts*, also called *masks*, that either block out part of the image or create a vignette, and it may also hold filters.

There are two basic styles of matt box available for SLR cameras, The most convenient for 35mm camera users is a plastic or metal housing that holds the mattes. The housing, which is essentially a modified lens hood, attaches to the lens by adapter ring.

The second style is the compendium lens hood, which has a bellows that moves in or out on a rail. The hood attaches by adapter to the lens and the rail is usually marked with settings for standard focal lengths. The front of the compendium hood accepts mattes and the back usually accepts square gelatin filters. A typical shade of this type is the Ambico Shade+, which has adapters to fit most 35mm- and medium-format SLR's. Hasselblad has a bellows hood in its system, and both the Bronica ETR and Mamiya 645 have bellows hoods for the 4.5 x 6cm format.

A typical effect-housing unit is the Mult-E-Effect from Darkroom Products Limited. It has a two slots in the housing that accept specially shaped masks with a variety of cutouts in different shapes and sizes. The manufacturer also sells a do-it-yourself kit so you can make your own masks for this system. When you use a translucent matte mask, colors and broad shadowy shapes come through the matte area but there are no clearly defined images. You can use colored masks for colored vignettes, black masks, and combinations of masks.

The H L Effects housing has a circular front with 12 notches and a small lip around its edge. It uses special lids that snap onto the front of the housing. The lids can be rotated so that an off-center cutout will be imaged in a circular pattern through a series of exposures on the same frame. By using lids in various combinations, a

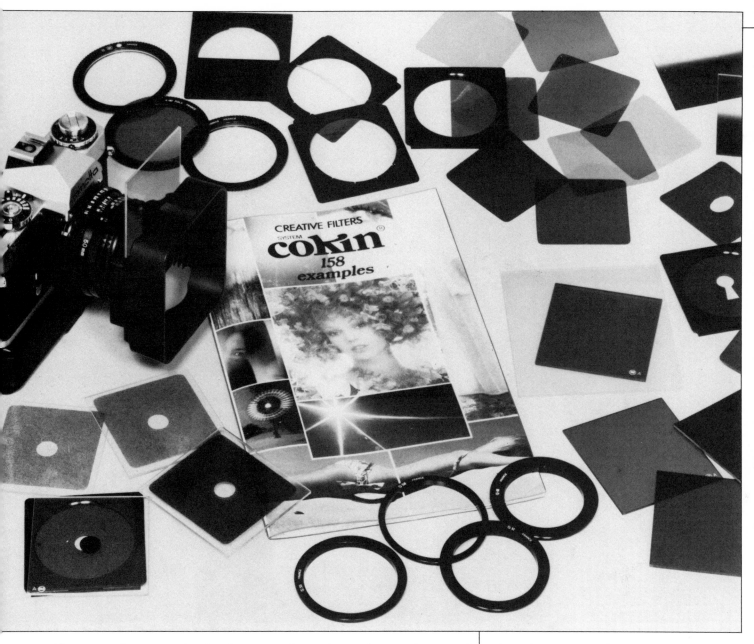

wide range of montage (multiple-image) effects can be achieved. For example, you could put a grandparent in an oval surrounded by individual shots of family members.

You can make your own masks by cutting out any shape from the center of a square of colored or matte acetate or tracing paper. You can hold the matte up in front of your lens or attach it by tape to the lens or the lens hood. You can make your own effects box out of construction paper by fashioning a cone to slip over the rim of your lens. A piece of tape will hold the cone in place and a slot in the cone will hold the mask.

Other special-effects units cur-

rently on the market are the Bag of Tricks, Bodnart Basic, Curtis Combo, Lindhal Montager, and Perfecto Mat.

Effect boxes are designed for use with normal and moderate telephoto lenses and with normal-range zooms. An ideal focal length for most units with 35mm cameras is about 85mm, although any lens in the 50 to 105mm range will do. Use a medium-speed film such as Kodachrome II, Ektachrome 64 or Plus-X to get optimum effects.

You can change the diffusion along the edge of a cutout by changing the matte-to-lens distance or by changing the aperture. The rule of thumb for cutouts is

The Cokin Creative Filter System, adaptable to all 35mm SLR cameras, is made up of more than 75 filters, masks, frames and lens attachments. These devices slip into a special filter holder that attaches to the accessory mount of your lens.

The Mult-E-Fect unit consists of a metal lens hood with slots for the masks. Shown here are a set of precut masks and a template being used to make a do-it-yourself mask. Precut masks, acetate blanks, template and mask cutting guide are all available from the manufacturer.

A sunshade such as this may be a bit awkward, but when you shoot with the sun just out of view of the lens, its portable shade is even better than a lens hood, which can generate some internal reflections.

This bellows lens hood from Bronica can be used with most 35mm and medium format cameras. It attaches to the lens via a series size adapter. In addition to providing adjustable shading, it will hold gelatin filters and any acetate mask you might want to make.

If you use a square or rectangular hood, make sure it is oriented with the frame. If you get it on wrong, you could get a darkening of the corners of your picture. Circular hoods provide a hair less protection from flare, but you don't need to worry about orientation, which is why they are generally chosen for use with 35mm SLR lenses.

the smaller the aperture, the sharper and smaller the effect. If you have a black shape in the middle of a clear matte, the opposite occurs: the smaller the aperture, the larger and softer the effect.

If you combine mattes for montage effects, then you will need to balance the size of the positive and negative shapes by aperture selection. Let's say you have a black matte with a star shape cutout, which you use for your first exposure, and a clear matte with a black star in the middle, which you use for your second exposure. To get a double image in which the two parts blend, you may have to shoot each at a different aperture. To make the star cutout appear smaller, close down the aperture. To make it larger, open up. To make the black area larger, close down the aperture; to make it smaller, open up. A couple of test shots with your equipment will reveal the ideal relationship.

Lens Hoods

Lens hoods help prevent flare caused by light outside the field of view of the lens. This light strikes the surface of the lens and can be reflected internally by the elements. Flare degrades image quality by reducing contrast, by creating an irregular fogging of the film, and by producing ghost images.

Multiple coating of modern lenses greatly reduces flare, and photographers accustomed to contemporary equipment regularly ignore the use of lens hoods. But there are still times when even with today's coated optics the presence of strong lights just out of view of the lens can ruin an otherwise perfect shot.

If you find that you are getting slightly degraded images when using a filter or close-up lens, try using a lens hood and see if that doesn't correct the problem. Filters and close-up lenses stick out in front of the lens, are often uncoated, and are particularly prone to flare problems.

Circular lens hoods are the most common type and are the easiest to use with hand-held cameras because you do not have to worry about the orientation of the hood. They are more than adequate in most situations, although hoods that match the shape of the format can provide slightly better shading. When a hood is the right length for a lens, it cuts off just before it would enter the field of view of the lens. Hoods that are too long vignette by darkening the corners of the image. Hoods that are too short do not give maximum protection, but are always better than nothing.

When a hood is made to match the rectangular or square shape of the format, it can be made slightly longer than a circular hood and provide slightly greater protection. The disadvantage to square and rectangular hoods is that they must be oriented to align with the film format. If the hood is knocked askew, it can vignette.

Hoods for wide-angle lenses are shallow. Square and rectangular types may have cutouts at the corners. This contoured design gives maximum flare prevention at all points. Telephoto lenses often have the hood built in. This is convenient, but if you are using a filter, you may need an auxiliary hood that screws into the filter.

Bellows and compendium hoods were originally developed for use with technical (view) cameras. They could be twisted and adjusted just as the bellows of the camera could be manipulated. Bellows hoods for medium-format SLRs and 35mm cameras generally have a rail with engraved markings for different focal-length lenses used with various formats. To use the hood with maximum effect, set it to the mark for the lens/format you are using. Alternatively, rack it out as you look through the lens. When it begins to vignette, pull it back a bit. These hoods are most useful in studio photography. Outdoors or in action-photography situations, they are clumsy to use.

A sun shade is a small black shade that attaches to the lens. You can angle the shade to block the sun or any strong light source so that it does not strike the surface of the lens.

If you are worried about flare and do not have a lens hood, you can use your hand or a piece of dark paper or cardboard as a sun shade. Outdoors, you might also change your position so that the lens is in the shade.

Lens Caps

A lens cap that screws or bayonets into the accessory mount is the most convenient because it will not slip off as you take the lens out of a gadget bag or case. Slip-on types are easier to lose.

A lens-cap holder is a cord with a clip on one end that attaches to the D-ring on your camera. On the other end is a small plate that sticks to your lens cap. If you change lenses frequently or move the camera around a lot as you photograph, the dangling cap gets in the way.

A clear lens cap is just a clear filter or a Skylight filter that you can photograph through. Clear caps increase problems with flare and get scratched easily, so they have to be changed regularly. If the atmosphere is so corrosive or so filled with flying spray, sand or dust that you need to protect the front of the lens, then you should probably protect the entire camera by using a plastic bag with a hole cut out for the lens and tape the bag to the rim of the clear lens cap. Alternatively, you could use one of the flexible plastic aqua housings described in Chapter 7.

4
VIEWING AND FOCUSING AIDS

This shot was taken at night on Panatomic-X using automatic electronic flash. The moderately high contrast of the film emphasized the effect of light fall-off and added to the total variation.

In recent years the very real problems of viewing and focusing have taken a back seat to ballyhoo about lenses and electronic exposure systems. It is true that a good lens and the right exposure are crucial to obtaining sharp pictures, but if you can't compose or focus properly, you might as well not be taking pictures.

The SLR solves the problem of composition because it lets you see exactly what the lens is imaging on the film. Focus is something else again. Wide-angle lenses are especially difficult to focus, and poor focusing technique, such as the use of finicky fine-focusing movements, exacerbates the problem. If you are having difficulty focusing an SLR, read the sections that follow on *Viewing Screens* and, especially, *Focusing Technique.*

Manufacturers of the more sophisticated SLR camera bodies also offer interchangeable viewfinders. Whether these finders are a real advantage is a matter of some debate, and most camera makers also offer low- and medium-priced models without this option. The section on finders covers advantages, disadvantages and special features of various finders.

If a rangefinder-focusing camera is giving you problems, or you are interested in a distance finder for use with old cameras that utilize scale-focusing systems, read the following section on rangefinders.

The section on eyepiece accessories includes data on angle finders, magnifiers, and diopter lenses that can be a real help to any photographer.

Rangefinders

There are two types of rangefinder. One employs a split-image system that depends on the photographer's ability to line up two vertical lines in the finder. The other is a coincidence-type that requires you to match two images of the scene so that they merge and become one image.

Some photographers argue that a good rangefinder camera can't be beat for low-light and wide-angle photography. Since the interchangeable-lens rangefinder camera is rapidly becoming part of history, the argument seems unimportant.

The typical rangefinder camera of today is a 35mm camera with a 38mm or 40mm non-interchangeable lens that is designed for general family and travel photography. Some of these cameras even feature built-in flash. The finders usually have two sets of frame lines, one for normal distances, one for close distances. The second set is required to compensate for the distance between the viewing window and the lens. (For information on close-up photography with a rangefinder camera, see the section on Close-up Lenses in Chapter 9.)

In 35mm photography, the built-in rangefinder system works well with lenses from about 24mm through 105mm. It does not work as well with longer lenses because of design limitations.

Distance finders: The typical distance finder or "optical tape measure" is a hand-held rangefinding device. It is most often used in survey, construction, military, land buying, and other applications where quick and moderately accurate measurements are required. The distance finder is not often thought of as a photographic accessory, but it can be quite useful if you are working with cameras that employ scale-focusing systems, and it can help in lens selection when you scout a scene to which you will later return with more equipment.

Distance finders are sold through general tool and hardware channels that supply the construction trades and through specialty supply houses such as Edmund Scientific. The finder depends on two beams of light. One is fixed to beam directly into your eye. The other enters the finder through a second window and is optically bent to coincide with the first beam. The accuracy of the finder depends on the base distance between the two beams. The bigger the distance, the greater the accuracy. This is why distance finders are sometimes sold in different sizes, with the larger models providing greater accuracy at long distances.

As a rule, accuracy decreases as the distance measured increases. In photography, this error factor is compensated by depth of field, but in non-photographic applications it may be significant.

Optical Finders

The optical finder is simply a lens that provides a field of view to match the lens on the camera. Sometimes these finders will include several frame lines to indicate the framing of lenses of different focal length.

The accessory optical finder is most often used with wide-angle lenses designed for medium-format press cameras that employ rangefinder-focusing systems. They are used when the viewing system built into the camera has a field of view that is smaller than that of the lens. An optical finder may also be required when a Polaroid back with a format different from that of the standard camera back is being used.

The optical finder slips into an accessory shoe on top of the camera. Focusing is usually done by a scale on the lens, although in some camera systems, the lens couples with the rangefinder.

If you are buying a wide-angle lens or Polaroid back for a non-SLR press camera, check to see if you need an optical finder for it. You probably will have to buy the finder separately, and if you are accessorizing a discontinued camera model, the right one may be hard to locate.

Wireframe (Sports) Finders

The wireframe finder is a rapid-framing device used for action photography with medium-format cameras. The typical sportsfinder has two or more wire frames that show the format for normal and telephoto lenses in the system. A peep sight in the center of the field of view helps keep your eye aligned properly.

To use a sportsfinder, look through the peep sight and keep it centered in the wire frame. The scene will be correctly framed at medium and long distances. At close-focusing distances, you can make a rough compensation for vertical parallax by tilting the camera upward until you see about ten percent more area at the top of the view finder than you intend to include in the picture.

A wireframe finder is useful for action, candid, and aerial photography.

An openframe finder is built into the focusing hood of most twin-lens reflex cameras. It is needed because the image on the viewing screen is reversed from left to right, and trying to follow action with a reversed image is very tricky.

The openframe finder is not really useful for 35mm work, because the cameras are so light and small that finding a moving subject in the viewfinder is seldom a problem.

Focusing Screens

Interchangeable focusing screens allow you to tailor the screen to fit the special requirements of telephoto, astro, macro, copy, and architectural photography.

Most of the sophisticated SLR cameras sold today come with a jack-of-all-optics screen designed to provide optimum focusing and

This wire-frame sports finder for a medium format SLR permits fast framing of rapid action. It's usually used in conjunction with a zone-focus technique. There are several collapsible wire frames on the finder, each showing the field of view for a different focal-length lens.

viewing characteristics over the entire wide-angle to moderate-telephoto range of lenses. This standard screen consists of a groundglass type field with Fresnel lens. In the center is a microprism or split-prism rangefinder or some combination of the two, such as a split-prism rangefinder surrounded by a microprism collar which may in turn be surrounded by a fine groundglass focusing collar.

Each of the three focusing systems—rangefinder, microprism, and groundglass—have advantages and disadvantages. The split-image rangefinder works well only when there are straight lines in the subject. It is adequate for wide-angle and normal lenses. It is not particularly accurate with lenses longer than 135mm; moreover, small-aperture lenses will black out half the prism. The split is usually horizontal. There is no practical advantage to a diagonal split, although some photographers prefer it.

The microprism is made up of very tiny split-image prisms that create a shimmering effect with out-of-focus images. It works well with wide-angle, normal, and moderate telephoto lenses, but it is not particularly accurate with long lenses. On the other hand, when a small-aperture telephoto lens causes half the prisms to black out, then the microprism area functions as a very coarse groundglass, which facilitates focusing.

The groundglass focusing area is most useful in telephoto and macrophotography. If you are uncertain about using the groundglass for focusing, read the section on focusing technique. Groundglass focusing can be precise when it's done right.

If you have a standard screen in your camera and buy a long telephoto, you will see that the edges of the screen seem to darken. This

is normal and does not indicate that the lens is vignetting. In addition to the focusing devices, standard screens incorporate a Fresnel lens, which provides a consistently bright image over the entire screen. Without the lens, the screen would appear dark at the edges. The Fresnel lens works well with lenses from wide-angle through moderate telephoto. With very long lenses, and in macrophotography at extreme bellows extensions, the angle of view becomes so small it is no longer compatible with the Fresnel lens and the lens darkens, making it hard to see the edges of the screen.

For macro and telephoto photography, an all-matte screen is your best buy. A variation on this screen is one with etched lines that form a grid across the surface of the screen. These lines are useful for aligning verticals and horizontals in architectural photography and in copy work when you have the camera on a tripod rather than a copy stand. Another variation on the matte screen is one with engraved scales that you can use to determine magnification with bellows and microscopes. A matte-focusing screen with a clear central area containing cross hairs is used for photomicrography, astrophotography, and macrophotography at extreme bellows extensions.

Most other screens are variations on the basic screen features covered here. For general work, select some general configuration with a microprism, split-prism rangefinder, or both. If you do architectural or copy work, or want to work with a perspective-correcting lens, then a screen with an etched grid and a matte surface that incorporates a Fresnel lens is the way to go. For extreme telephoto and macrophotography, an all-matte screen without Fresnel lens will let you work with the

small apertures and narrow angles of view involved. For photomicroscopy and astrophotography, a cross-hair screen or one with engraved scales may help. Focusing screens today are usually made of plastic, not glass, and are easily damaged. Never touch the surface of one with your fingers and do not wipe it with a coarse cloth. Keep it clean by using a blower.

Eyepiece Accessories

Eyepiece accessories attach to the eyepiece of your camera either by slipping on over the outside of the eyepiece or screwing into it. Some of these accessories are quite useful.

Diopter lenses: When you look into the viewfinder of an SLR, it seems as though you are looking out through the lens. In fact, you are looking through a prism at a flat screen only an inch or so from your eye. A negative lens in the eyepiece lets you see the screen as though it were a scenic poster about three feet away. If you see well at three feet, or wear contact lenses while looking into the finder, then SLR focusing should present no serious problems for you. If you have difficulty seeing clearly at this distance and would like to use your camera without wearing glasses or contact lenses, then you can select a dioptric adjustment lens for your viewfinder that will let you tailor the viewfinder for your eyesight.

If there are dioptric lenses for your camera, your best bet is to find a dealer that carries them, bring your camera to the store, and try out corrective lenses on the viewfinder until you find the one through which you can see most clearly. Although manufacturers give these corrective lenses diopter numbers, the numbers assigned may or may not take into account the negative lens built into the finder, so the diopter of your glasses prescription may not correspond to the number of the correction lens that will do you the most good. Some camera makers supply dealers with charts that let you select an eyepiece based on your glasses prescription.

The right-angle viewer is a viewfinder attachment that can be rotated so that you can look down into the finder from above when the camera is below your eye level or when you have the camera mounted on a copy stand. This is a useful accessory for nature photography and copy work.

There are two common types of angle finder. The least expensive is a simple mirror arrangement that allows you to view the image

Interchangeable viewing screens (bottom), such as these for the RB 67, are an advantage for industrial, architectural and scientific photography. A general-purpose screen really is best for most picture-taking situations and with most lenses from wide angle through telephoto, so if your camera does not offer this option, don't worry about it. When the time comes that you actually need interchangeable screens, it will probably be for professional reasons, and you will be writing the equipment off as a tax deduction or charging it to a departmental budget.

(Top) Never put your fingers on a focusing screen. For Pentax MX and ME cameras, a special pincette is supplied with each screen. Other systems that feature drop-in focusing screens have the screen bound in a metal or plastic rim. The screen should be handled by the rim only.

upright but reversed left to right. A more sophisticated design incorporates a pentaprism that gives a correct image left to right.

The better finders also incorporate a variable dioptric adjustment ring so that you can match the finder to your eyesight. This is a useful feature if you ordinarily use an eyepiece correction lens, because with most cameras you have to remove the correction lens before you can attach the finder.

A periscope attachment such as the one available from Spiratone is an extended angle finder that puts up to a foot of extension between you and your camera. You can use it to photograph subjects that are close to the ground or to get your camera up over the heads of a crowd and compose accurately.

The periscope attaches to the eyepiece of the viewfinder and the camera mounts on a height-adjustable platform attached to the scope. Unless you have unusually long arms, you will need to use the periscope in conjunction with a cable release. Use as high a shutter speed as possible to minimize the effects of camera movement.

Magnifiers: A magnifier that attaches to the viewfinder eyepiece is useful for close-up, macro- and wide-angle photography. The typical magnifier provides about 2.5X magnification of the center of the field of view and is mounted on a hinged frame so that you can swing it up out of the way when you want to check composition on the full viewing screen.

The finder eyecup aids in focus-ing and viewing by closing the gap between eyepiece and eye to prevent glare on the eyepiece lens. This is probably the first accessory most photographers lose, and unless you find that glare is a problem, you probably will not bother to replace it if you do lose it. It is most useful in macrophotography when you use through-the-lens metering, because light coming in through the finder eyepiece can cause the meter to underexpose slightly when you have a long bellows extension.

Interchangeable Finders for SLRs

Given the variety of eyepiece accessories available, there is some question about how desirable viewfinder interchangeability really is. If your camera does not

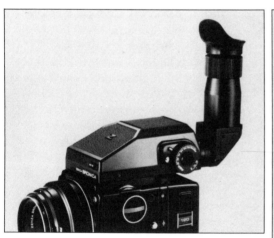

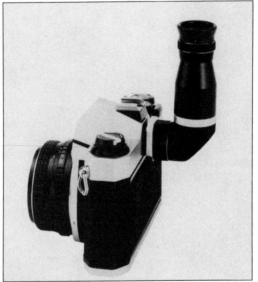

A right-angle finder is useful for studio photography, copy work, and outdoor photography with a tripod-mounted camera. The prism type is best because it gives you a laterally correct image. Mirror types reverse the image from left to right. Left, finder for a Bronica ETR; right, finder for a Pentax.

An eyepiece magnifier is particularly useful in close-up photography where depth of field is extremely shallow. If you use proper focusing technique, you should never have to use one of these for general photography.

have this feature, you are not losing out on much. It is found only in the heavy-duty professional cameras such as the Nikon F2, Canon F-1, and Minolta XK, among 35mm SLRs and in the Bronica, Hasselblad and RB 67, among medium-format SLRs.

One of the least expensive finders you can get for these cameras is a simple pentaprism, which provides an easy-to-see, laterally-correct image for eye-level viewing. But if you can afford it, you are better off buying a finder that provides exposure measurement, if not incorporated into the camera body. Some systems have finders that provide exposure automation as well, a convenience found more often in

cameras with sealed-pentaprism (non-interchangeable) finders.

Some systems still offer a waist-level finder that opens up to give you a direct view of the groundglass. This type usually incorporates a magnifier so that you can see the central portion of the focusing screen more clearly. The image is reversed left to right, which makes tracking moving subjects difficult.

The rotating angle finder with built-in prism offers most of the advantages of a waist-level finder and none of the disadvantages. You can use it when you have the camera on a copy stand or in a very low position and want to see the image while looking down on the camera. The image is laterally

Street performers always draw a crowd, and unless you are willing and able to muscle your way to the front, part of the view is going to be cut off. One solution is to raise the camera over your head as high as your arms will go, aim the camera in the general direction of the action, and take your shot. That's the way the photo on the right was done. A periscope viewing attachment could also have been used, but arms are free and if you use a normal or moderate wide-angle lens, your aim will probably be close enough.

correct, so you can track moving subjects. The typical finder of this type is adjustable so that you can either look down into it or turn it at a right angle to the camera and use it as an eye-level finder.

Other specialized finders are also available, such as the Nikon Action Sportsfinder, or the Canon Speedfinder, which is basically a right-angle finder. These finders let you see the entire field of view even though your eye may be up to 60mm behind the eyepiece. This lets you wear protective eye goggles or other protective eye gear and can be a help when you flip the camera up to your eye and want to locate a moving subject in a hurry. It is also helpful when you have the camera on a long tripod-mounted lens to follow sports action, or when the camera is in an underwater housing.

The magnifying hood is used for macrophotography and other specialized applications. It usually provides a magnification of about 6X. Eyepiece magnifiers are less expensive and may provide all the magnification you need.

Focusing Technique

There is no special trick to using a split-prism rangefinder, a microprism, or the distance scale on the lens. The two sides of a vertical line either match or they do not; the microprism either shimmers or looks sharp; and you either know the distance to your subject, or you ballpark it and guess. But there are some tricky techniques that most instruction books leave out or gloss over, and these are covered in this section.

Groundglass focusing: Even if your eyesight is poor, you can focus on the groundglass with surprising accuracy. But it works only if you do not make fine-focusing movements. Any tendency on your part to make minor focusing adjustments while you look at the groundglass image will intro-

duce significant focusing variations into your shots, because your eye automatically adjusts to a slightly out-of-focus image. Fine-focusing movements can make a whole range of focus points look as though they are correct.

The right way to get a sharp image on the groundglass is to

make large, sweeping focusing movements that give you a clear comparison between sharp and unsharp. Sweep past the point of sharp focus into the obviously unsharp region, then sweep back and stop just as the image seems to pop into sharp relief.

To practice this technique, choose some object, focus, and

A finder illuminator makes it possible to see the finder in extremely low-light situations. This is another one of those accessories in the professional category.

An interchangeable viewfinder is a feature found only on SLRs designed for professional, laboratory and industrial photographic use. Finders have to be correctly coupled to the metering mechanism, so check your instruction book for the right procedure before you try fiddling with finder interchange. The components are among the most delicate in any camera system. If you do not have an instruction book, write the customer service department of the camera manufacturer. You can probably get instructions over the phone if you are in a rush.

A speed finder, also called a sports finder, lets you view the entire focusing screen when you are using protective eyegear. This professional finder is used mainly by sports photographers, photojournalists, and underwater photographers.

note the distance on the distance scale. Try focusing again and again until you are getting approximately the same distance reading every time. It will be easiest with normal and long lenses. Using wide-angle lenses at distances of four to ten feet will be toughest.

As you look at the screen, watch

for either optimum resolution of fine detail or optimum contrast, which means a minimum of fuzziness along a sharp line separating a light and dark area.

When you photograph people, focus on the eyes in a head and shoulder shot or on the eye and hair region in a three-quarter or full-figure shot. Shells, clouds, and diffusely lighted subjects in general are naturally soft. In these cases, look for the focus that seems to resolve the most detail.

Groundglass focusing is fast enough for you to use telephoto lenses in the 400–600mm range to follow moving objects, such as airplanes or parachutists at an air show, and follow focus. Forget about the split-prism rangefinder with long lenses. It is not accurate enough and will probably darken anyway. With some of your very long lenses, you may be able to use the microprism as a rough groundglass.

The waist-level finder shown here on a Minolta XG is useful when a low, high, or unusual camera position makes it difficult or impossible to use the standard eye-level prism finder. In most applications a right-angle finder will serve the same function.

Cross-hair focusing screens: To use the central cross hairs, focus the image as sharply as possible on the groundglass area. Next, look at the relationship between the image and the cross hairs. Move your eye slightly to the right or left. If the image is focused precisely, the relationship between the cross hairs and the image will not change. If the cross is displaced slightly, continue to make slight focusing adjustments until the image no longer moves. At that point the aerial image is located precisely on the plane of the cross hairs. Cross-hair focusing is the only technique in normal photography that requires fine-focusing motions.

Zone focusing: In the zone-focus technique, you preselect a region in which you want everything sharp and preset your lens to an f/stop and focusing distance that covers the region. This is a very common technique in sports

photography and is frequently used by photographers doing candid photos, journalists using a hidden camera, and anyone trying to photograph in very low-available-light situations where the focusing screen and the dials on the lens are hard to see.

Photographers who make frequent use of this technique often put a big piece of white tape on the focusing ring opposite favorite distance settings so they can see them at a glance and learn to count click stops with a favorite lens so that in low light they can set the f/stop by feel.

When an entire shooting session will occur in one distance zone, then you can use a piece of masking tape to keep the focusing ring on the lens from moving once you have preset the focus. Take the tape off as soon as the session is over to avoid gumming up the lens. This technique can be used for candid and wedding photographs and in sports photography.

Maximum depth of field occurs when the lens is set to the hyperfocal distance. That is a point where everything is in focus from half that distance all the way to infinity. You find it by using the depth-of-field scale on your lens. Turn the focusing ring until the scale indicator for the f/stop you are using is aligned with the infinity sign. The second f/stop indicator on the scale will give you the near limit of the depth of field. Your lens is now set to the hyperfocal distance. If you are using a camera that does not have a depth-of-field scale, you will have to work from tables to find the right distance.

Zoom lenses frequently do not have depth-of-field scales, nor do many of the lenses for medium-format cameras. The accompanying table gives depth of field for 35mm camera lenses at some of the more popular focal-length/distance/aperture combinations. If you have a zoom lens, you can write several focal-length/aperture/depth-of-field combinations on a card to keep in your gadget bag or in waterproof ink on a piece of tape that you can stick to the large focusing collar of the lens. The information is given here for 35mm camera lenses because it is frequently not available from the lens makers. If you own a medium-format camera, you can get depth-of-field tables from the manufacturer.

How to estimate depth of field: At normal focusing distances, depth of field extends about two-thirds behind the point to which

Some subjects are naturally soft. Clouds are one, shells another. To focus accurately, look for a sharply defined edge between dark and light, or look for some other object with fine detail in roughly the same plane as the principal subject and focus on that.

you are focused and about one-third in front of it. If you want to get two objects in sharp focus and do not have a depth-of-field scale or table, you will have to estimate. The easiest way is to focus on the point you guess is about one-third of the way from the nearest to the farthest object you want in sharp focus. Then use the smallest f/stop you can get away with.

If you want to be a little more accurate, focus on the near object, note the distance, then focus on the far object and note the distance. Next, subtract the near from the far distance, divide the result by three, and add that number to the distance of the near object to get an optimum-focusing distance. Use a small f/stop.

The so called "depth-of-field preview" that you get with most SLRs is a very rough method of determining depth of field, particularly at the smaller apertures, which make the screen dim and hard to see when you stop down. For best results, use it in conjunction with the 1/3–2/3 rule of thumb or a depth-of-field scale

At very close focusing distances, the 1/3-2/3 rule breaks down and depth of field extends roughly half in front and half behind the point to which the lens is focused.

Close-focusing technique: In close-up and macrophotography, it is usually easiest to determine the magnification you want, say 1/2 life-size or life-size on the negative, then move the camera back and forth to get the subject sharp. Alternatively, move the subject toward or away from the lens. Trying to focus by using the focusing mount on the lens is tricky at high magnifications, although it is sometimes useful for fine focus after you have found the right lens-to-subject distance.

Depth of Field Tables in Meters for 35mm Camera Lenses

These tables cover focal lengths to which many zoom lenses can be set. If your zoom lens does not have a depth-of-field scale, you can use these tables to find depth of field at selected focal length and distance settings.

28mm lens

dist. ᶠ	3.5	4.0	5.6	8.0	11.0	16.0
0.40	0.38 / 0.42	0.38 / 0.42	0.38 / 0.43	0.37 / 0.44	0.36 / 0.46	0.34 / 0.50
0.45	0.43 / 0.47	0.43 / 0.48	0.42 / 0.49	0.41 / 0.51	0.39 / 0.53	0.37 / 0.58
0.50	0.47 / 0.53	0.47 / 0.53	0.46 / 0.55	0.44 / 0.57	0.43 / 0.61	0.40 / 0.68
0.60	0.56 / 0.65	0.56 / 0.65	0.54 / 0.68	0.52 / 0.72	0.49 / 0.78	0.46 / 0.90
0.80	0.73 / 0.89	0.72 / 0.90	0.69 / 0.96	0.65 / 1.04	0.61 / 1.18	0.55 / 1.53
1.00	0.89 / 1.15	0.87 / 1.18	0.83 / 1.27	0.77 / 1.44	0.71 / 1.73	0.63 / 2.62
1.20	1.03 / 1.43	1.02 / 1.47	0.96 / 1.62	0.88 / 1.92	0.80 / 2.49	0.70 / 5.03
1.50	1.25 / 1.89	1.22 / 1.97	1.13 / 2.25	1.03 / 2.88	0.92 / 4.46	0.79 / 62.58
2.00	1.56 / 2.79	1.52 / 2.96	1.38 / 3.67	1.23 / 5.79	1.07 / 21.36	0.89 / ∞
3.00	2.10 / 5.31	2.01 / 5.98	1.78 / 10.00	1.52 / ∞	1.29 / ∞	1.03 / ∞
7.50	3.57 / ∞	3.32 / ∞	2.72 / ∞	2.15 / ∞	1.70 / ∞	1.27 / ∞
∞	6.66 / ∞	5.83 / ∞	4.17 / ∞	2.93 / ∞	2.14 / ∞	1.48 / ∞

Photographers who do a lot of photographing in dim light or who cover sports and rely on zone focusing sometimes put a piece of white tape on the lens and mark off key focusing distances with big, easy-to-read numbers and lines.

100mm lens

dist. \ f	4.0	5.6	8.0	11.0	16.0	22.0
1.00	0.99 / 1.01	0.99 / 1.01	0.98 / 1.02	0.97 / 1.03	0.96 / 1.04	0.95 / 1.06
1.10	1.09 / 1.11	1.08 / 1.12	1.08 / 1.13	1.07 / 1.14	1.05 / 1.15	1.04 / 1.17
1.20	1.19 / 1.22	1.18 / 1.22	1.17 / 1.23	1.16 / 1.24	1.14 / 1.26	1.12 / 1.29
1.30	1.28 / 1.32	1.28 / 1.33	1.26 / 1.34	1.25 / 1.35	1.23 / 1.38	1.21 / 1.41
1.50	1.48 / 1.53	1.47 / 1.54	1.45 / 1.55	1.43 / 1.57	1.41 / 1.61	1.37 / 1.65
1.70	1.67 / 1.73	1.65 / 1.75	1.64 / 1.77	1.61 / 1.80	1.58 / 1.85	1.54 / 1.91
2.00	1.95 / 2.05	1.94 / 2.07	1.91 / 2.10	1.88 / 2.14	1.83 / 2.21	1.77 / 2.30
2.50	2.43 / 2.58	2.40 / 2.61	2.36 / 2.66	2.31 / 2.73	2.23 / 2.85	2.14 / 3.02
3.00	2.89 / 3.12	2.85 / 3.17	2.79 / 3.25	2.72 / 3.35	2.61 / 3.54	2.49 / 3.80
4.00	3.80 / 4.22	3.73 / 4.31	3.62 / 4.47	3.50 / 4.67	3.32 / 5.06	3.12 / 5.62
5.00	4.69 / 5.35	4.58 / 5.51	4.42 / 5.76	4.23 / 6.11	3.96 / 6.81	3.68 / 7.88
8.00	7.22 / 8.97	6.95 / 9.43	6.58 / 10.21	6.17 / 11.40	5.59 / 14.16	5.03 / 19.96
15.00	12.44 / 18.91	11.64 / 21.22	10.63 / 25.60	9.58 / 34.87	8.24 / 88.44	7.05 / ∞
∞	71.30 / ∞	50.96 / ∞	35.70 / ∞	25.99 / ∞	17.90 / ∞	13.05 / ∞

150mm lens

dist. \ f	4.0	5.6	8.0	11.0	16.0	22.0
1.80	1.79 / 1.81	1.78 / 1.82	1.77 / 1.83	1.76 / 1.84	1.75 / 1.86	1.73 / 1.88
2.00	1.98 / 2.02	1.97 / 2.03	1.96 / 2.04	1.95 / 2.05	1.93 / 2.08	1.91 / 2.11
2.25	2.23 / 2.27	2.22 / 2.28	2.20 / 2.30	2.19 / 2.32	2.16 / 2.35	2.13 / 2.39
2.50	2.47 / 2.53	2.46 / 2.54	2.44 / 2.56	2.42 / 2.59	2.38 / 2.63	2.34 / 2.60
3.00	2.95 / 3.05	2.94 / 3.07	2.91 / 3.09	2.88 / 3.13	2.83 / 3.20	2.77 / 3.28
4.00	3.92 / 4.09	3.88 / 4.12	3.84 / 4.18	3.78 / 4.25	3.69 / 4.38	3.58 / 4.54
5.00	4.87 / 5.14	4.81 / 5.20	4.74 / 5.29	4.65 / 5.41	4.50 / 5.63	4.34 / 5.91
7.00	6.73 / 7.29	6.63 / 7.42	6.48 / 7.61	6.31 / 7.87	6.04 / 8.35	5.74 / 9.00
10.00	9.45 / 10.63	9.24 / 10.90	8.95 / 11.34	8.61 / 11.94	8.10 / 13.09	7.57 / 14.83
15.00	13.76 / 16.48	13.33 / 17.16	12.72 / 18.30	12.04 / 19.95	11.05 / 23.49	10.06 / 29.87
30.00	25.36 / 36.74	23.88 / 40.37	21.97 / 47.42	19.97 / 60.68	17.35 / 113.87	14.99 / ∞
∞	160.73 / ∞	114.95 / ∞	80.51 / ∞	58.59 / ∞	40.33 / ∞	29.37 / ∞

200mm lens

dist. \ f	4.0	4.5	5.6	8.0	11.0
∞	∞ / 299	∞ / 268	∞ / 212	∞ / 150	∞ / 106
30	33 / 27	34 / 27	35 / 26	37 / 25	42 / 24
15	15.8 / 14.3	15.8 / 14.2	16.1 / 14.0	16.6 / 13.7	17.4 / 13.2
10	10.3 / 9.7	10.4 / 9.7	10.5 / 9.6	10.7 / 9.4	11.0 / 9.2
7	7.2 / 6.9	7.2 / 6.8	7.2 / 6.8	7.3 / 6.7	7.5 / 6.6
5	5.1 / 4.9	5.1 / 4.9	5.1 / 4.9	5.2 / 4.8	5.2 / 4.8
4	4.1 / 3.96	4.1 / 3.95	4.1 / 3.94	4.1 / 3.91	4.1 / 3.88
3	3.02 / 2.98	3.03 / 2.97	3.03 / 2.97	3.05 / 2.95	3.07 / 2.93
2.5	2.52 / 2.48	2.52 / 2.48	2.52 / 2.48	2.53 / 2.47	2.54 / 2.46

300mm lens

dist. \ f	4.0	5.6	8.0	11.0
5.50	5.4609 / 5.5396	5.4455 / 5.5556	5.4225 / 5.5799	5.3941 / 5.6105
6.00	5.9525 / 6.0482	5.9337 / 6.0678	5.9058 / 6.0974	5.8714 / 6.1348
6.50	6.4432 / 6.5578	6.4209 / 6.5812	6.3876 / 6.6167	6.3465 / 6.6616
7.00	6.9332 / 7.0681	6.9069 / 7.0958	6.8678 / 7.1377	6.8196 / 7.1909
8.00	7.9107 / 8.0914	7.8755 / 8.1286	7.8235 / 8.1851	7.7594 / 8.2570
9.00	8.8849 / 9.1182	8.8398 / 9.1664	8.7729 / 9.2397	8.6909 / 9.3332
10.00	9.8560 / 10.1484	9.7996 / 10.2091	9.7163 / 10.3016	9.6143 / 10.4197
12.00	11.7886 / 12.2194	11.7062 / 12.3095	11.5849 / 12.4473	11.4368 / 12.6241
15.00	14.6639 / 15.3523	14.5339 / 15.4980	14.3431 / 15.7221	14.1119 / 16.0118
20.00	19.3944 / 20.6456	19.1625 / 20.9160	18.8252 / 21.3354	18.4203 / 21.8846
30.00	28.6299 / 31.5102	28.1168 / 32.1584	27.3814 / 33.1832	26.5153 / 34.5613
50.00	46.2484 / 54.4213	44.9023 / 56.4191	43.0253 / 59.7095	40.8908 / 64.4100
100.00	85.8898 / 119.6945	81.3059 / 129.9423	75.2838 / 149.1064	68.9105 / 182.8511
∞	601.1879 / ∞	429.5554 / ∞	300.8310 / ∞	218.9155 / ∞

16.0	22.0
∞	∞
75	53
50	68
22	19
18.6	20.6
12.6	11.8
11.4	12.2
8.9	8.5
7.7	8.0
6.5	6.3
5.3	5.5
4.7	4.6
4.2	4.2
3.83	3.76
3.10	3.14
2.91	2.87
2.56	2.59
2.44	2.42

16.0	22.0
5.3474	5.2926
5.6624	5.7261
5.8149	5.7486
6.1984	6.2765
6.2793	6.2007
6.7380	6.8322
6.7408	6.6489
7.2815	7.3934
7.6551	7.5338
8.3797	8.5322
8.5577	8.4035
9.4934	9.6935
9.4491	9.2586
10.6229	10.8781
11.1986	10.9262
12.9308	13.3198
13.7432	13.3262
16.5198	17.1751
17.7838	17.0772
22.8670	24.1719
25.1895	23.7664
37.1358	40.7898
37.7726	34.6120
74.1548	90.6473
60.4015	52.6211
293.8698	1089.0609
150.6525	109.6947
∞	∞

400mm lens

m	f 5.6	8.0	11.0	16.0	22.0	Magnification
5	4.98-5.02	4.97-5.03	4.96-5.05	4.93-5.07	4.91-5.09	1/11
5.5	5.47-5.53	5.46-5.54	5.44-5.56	5.42-5.58	5.39-5.62	1/12
6	5.97-6.04	5.95-6.05	5.93-6.07	5.90-6.10	5.83-6.14	1/13
6.5	6.46-6.54	6.44-6.56	6.42-6.58	6.38-6.62	6.34-6.67	1/14
7	6.95-7.05	6.93-7.07	6.91-7.10	6.86-7.14	6.81-7.20	1/16
8	7.94-8.07	7.91-8.09	7.87-8.13	7.82-8.19	7.75-8.27	1/18
9	8.92-9.09	8.88-9.12	8.84-9.17	8.77-9.25	8.68-9.34	1/21
10	9.90-10.1	9.85-10.2	9.80-10.2	9.71-10.3	9.60-10.4	1/23
12	11.9-12.2	11.8-12.2	11.7-12.3	11.6-12.5	11.4-12.6	1/28
15	14.8-15.3	14.7-15.4	14.5-15.5	14.3-15.7	14.1-16.0	1/36
20	19.6-20.5	19.4-20.7	19.2-20.9	18.8-21.4	18.4-21.9	1/48
30	29.0-31.1	28.6-31.5	28.1-32.1	27.4-33.2	26.5-34.6	1/73
50	47.3-53.0	46.2-54.5	45.0-56.3	43.0-59.8	40.8-64.5	1/123
100	89.6-113	85.8-120	81.5-129	75.2-149	68.8-183	1/248
∞	857 -∞	600 -∞	436 -∞	300 -∞	218 -∞	1/∞

50mm lens

m	f 1.4	2.0	2.8	4.0	5.6	8.0	11.0	16.0
0.6	0.595-0.605	0.593-0.607	0.591-0.610	0.587-0.614	0.582-0.620	0.574-0.628	0.564-0.641	0.551-0.660
0.7	0.693-0.707	0.691-0.710	0.687-0.714	0.681-0.720	0.674-0.728	0.664-0.741	0.650-0.760	0.631-0.788
0.8	0.791-0 809	0.787-0.813	0.782-0.819	0.775-0.827	0.765-0.839	0.751-0.856	0.733-0.882	0.709-0.921
0.9	0.888-0.912	0.883-0.917	0.877-0.925	0.868-0.935	0.855-0.951	0.837-0.974	0.814-1.01	0.784-1.06
1	0.985-1.02	0.979-1.02	0.971-1.03	0.959-1.04	0.943-1.06	0.922-1.09	0.893-1.14	0.856-1.21
1.2	1.18- 1.22	1.17 -1.23	1.16 -1.25	1.14 -1.27	1.12 -1.30	1.09 -1.34	1.05 -1.41	0.994-1.52
1.5	1.47 -1.54	1.45 -1.55	1.43 -1.58	1.41 -1.61	1.37 -1.66	1.32 -1.74	1.26 -1.86	1.18 -2.06
1.7	1.66 -1.75	1.64 -1.77	1.61 -1.80	1.58 -1.84	1.53 -1.91	1.47 -2.01	1.40 -2.18	1.30 -2.48
2	1.94 -2.07	1.91 -2.10	1.88 -2.14	1.83 -2.20	1.77 -2.30	1.69 -2.46	1.59 -2.72	1.46 -3.20
3	2.86 -3.16	2.80 -3.23	2.73 -3.34	2.63 -3.50	2.50 -3.76	2.34 -4.21	2.14 -5.06	1.92 -7.10
5	4.61 -5.46	4.46 -5.69	4.27 -6.04	4.03 -6.61	3.73 -7.63	3.37 -9.77	2.98 -16.2	2.55 -∞
10	8.53 -12.1	8.03 -13.3	7.42 -15.4	6.71 -19.8	5.90 -33.3	5.05 -∞	4.20 -∞	3.39 -∞
∞	57.2 -∞	40.1 -∞	28.4 -∞	20.1 -∞	14.2 -∞	10.1 -∞	7.16 -∞	5.09 -∞

5 FILM

Film is the lifeblood of a camera system, and although film is treated as an accessory in this book, it could be argued that the camera is simply an accessory for the film. Your selection of film makes a crucial difference in the results you get and the information in this chapter can help you make the best choice for each of your needs.

Film is either conventional or instant. Conventional film requires darkroom processing. In this group you find such familiar names as Kodacolor, Tri-X, HP5, Agfachrome, and dozens more. Instant films have the processing chemistry built into the film pack. In the peel-apart type, the print is peeled away from a negative sheet after processing. In the SX-70 and PR-10 types, the chemistry remains an integral part of the image. Both conventional and instant films are detailed in this chapter, along with suggestions on storage, handling, and processing. (Information on accessories such as film loaders and bulk film backs is given in Chapter 6.)

All the standard forms in which film is available are covered here, including 135mm magazines, 110 and 126 cartridges for pocket- and instant-loading cameras, 120 and 220 rolls for medium-format cameras, instant sheet, roll and pack films, sheet film for view cameras, and long rolls in various widths.

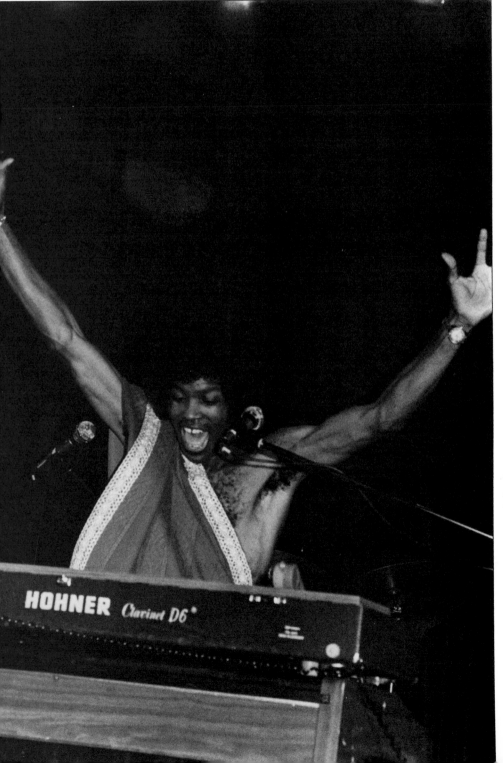

Tri-X and automatic flash are an ideal combination when you want to photograph nightclub acts. This shot was one of a series taken during a special performance to introduce a new record by the disco band, Gary Tom's Empire.

Brand Names

As are most mass-market products, film is generally taken for granted; yet in the entire world there are only a handful of companies capable of manufacturing film to today's standards. The following rundown of manufacturers and the brands they make is provided to help you weed your way through the tangle of names and select those few films that may actually be of interest to you.

The Eastman Kodak Company manufactures most of the conventional film sold in the U.S. and offers a wide range of general and special-purpose films packaged in yellow boxes. Kodak makes two color print films for amateurs—Kodacolor II and Kodacolor 400—and one professional color print film—Vericolor II. The company makes three different Kodachrome slide films and offers its Ektachrome color slide film in four different speeds. Among the more popular Kodak black-and-white films are Panatomic-X, Plus-X, Verichrome, Tri-X, Royal-X Pan, Recording Film 2475, and High Contrast Copy Film 6059. Kodak also makes PR-10 instant film.

Polaroid manufactures most of the instant film used in the world today, including SX–70 film, Polacolor II film in sheets and packs, a variety of black-and-white films in sheets and packs and rolls, a positive/negative film in sheets and packs, and a black-and-white transparency film in rolls.

Ilford manufactures and distributes four popular black-and-white films—PanF, FP4, HP4 and HP5 in white boxes.

The 3M Company makes 3M Brand Color Print Film and 3M Brand Color Slide Film, which is packaged in boxes identified by a rainbow bar of color. This film is sold through theme parks and grocery and drug chains.

Fuji markets Fujichrome color slide film and Fujicolor color print film in green boxes. This major Japanese manufacturer makes a variety of other films that are not sold in the U.S.

Agfa is the largest film manufacturer in Europe, where it markets a wide range of high-quality color and black-and-white films. Agfa transparency films are Agfachrome 80 and Agfachrome 100.

Other brands of black-and-white film distributed in the U.S. are EFKE (Adox), Orwo, and FSC.

The once well-known Ansco brand has not been around since the mid-1960s, when the name Ansco was dropped in favor of the company trade name GAF. In 1977, GAF stopped making film for general photography.

The proliferation of private labels gives the impression that there are more types of film on the market than is actually the case. A private label is a film sold under a brand name owned by a retail organization, which contracts with a manufacturer to make the film for it. These are standard films that are available elsewhere, though not always in the U.S., under the manufacturer's own brand name.

Among the many private labels that you may run across are Fotomat, Focal, Picture Pack, Thrifty, Viking, Carls, Dart, Fay's, Sears; Border Free, and Rite Aid.

Private label film is often significantly less expensive than nationally advertised brands, particularly when purchased with processing mailers included in the box. It offers an inexpensive way for an amateur to take more snapshots.

The 3M Company makes a large percentage of the private label film sold in the U.S. Sakura, a Japanese manufacturer, also makes private label films. Kodak does not manufacture private label film; however, some camera manufacturers offer respooled Kodak film to fit cameras that take special film sizes. Before it dropped out of the film business in 1977, GAF Corporation also made a large amount of private label film.

FILM QUALITY

The first thing most users expect from a film is a well-defined image of the subject and the second, if it's a color film, is good color. Definition, sometimes loosely called sharpness, is actually a composite effect involving graininess, resolving power, and sharpness. Other characteristics important in selecting a film are speed, contrast, latitude, and spectral sensitivity or color balance.

Grain

The sandy or granular effect that is sometimes noticeable in the lighter middle tones of a picture and in large, uniformly toned areas such as the sky or a smooth wall is called grain. Depending on how you consider the photo, grain can enhance a shot, harm it, or be unimportant. Technically, graininess is the result of a random clumping together of silver grains in black-and-white films and of dye particles in color films.

As a rule of thumb, the faster the film, the greater the grain, although the difference becomes less each year as new technology results in ever finer grain in fast films. If you push film speed by overdeveloping, grain will increase. This can lead to interesting pictorial results.

If you want the finest possible grain, select one of the slower films. There is a definite limit to the fineness of grain that you can get with any particular film. With color films, the finest possible grain is achieved by standard processing. With black-and-white negatives, there are fine-grain de-

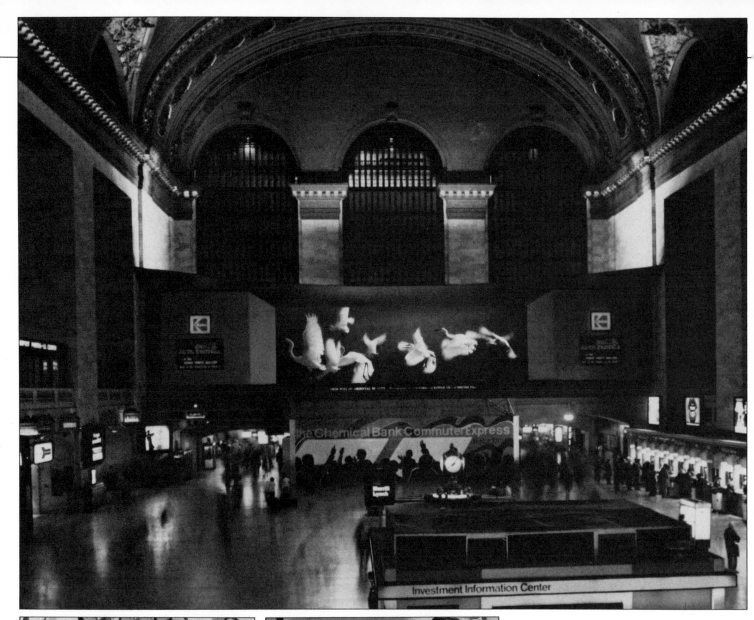

In the past, you could say with some certainty that the faster the film, the larger the silver halide grains in the emulsion and therefore the larger the grain patterns in the final image. But improvements in photo technology are rapidly reducing grain size. This composite of two electron micrographs at a magnification of 10,000X shows a comparison of silver halide grains of Kodak instant print film PR10 (right) and new, improved Kodak instant color film (left). Both sets of silver halide grains are symmetrical octahedrals that are uniform in size; however, the ones on the left are smaller, which contributes to faster developing time and other beneficial photographic characteristics. The speed of both is the same—EI 150.

How big can an enlargement be? This one, cropped from a 35mm transparency on Kodachrome 64 film, was 18 x 60 feet. The grain was not objectionable. For a closer look at this winner of the 1978 Kodak International Newspaper Snapshot Awards, see page 30.

There are two one-step, no-waste instant films available. Kodak instant color film PR10 provides a horizontal format. The image starts to show about 30 seconds after ejection from the camera at room temperature and judgment of exposure can be estimated after about a minute and a half. Polaroid SX-70 film has a vertical format and features metallic dyes with long-term fade resistance.

velopers, such as Microdol-X, that will yield slightly finer grain coupled with some loss of film speed.

Among the conventional films, the finest grain is found in Panatomic-X and PanF. H&W Control also provides extremely fine grain. Kodachrome offers the finest grain structure in a general-purpose transparency film. Original instant prints are almost grainless. For giant blow-ups, use a fine grain film such as Kodachrome in 35mm cameras or Ektachrome 64, Kodacolor II or Vericolor 2 in medium-format cameras.

To experiment with effects using a coarse-grain film, try Kodak Recording Film 2475.

Recent advances in color emulsion technology have created medium- and high-speed color films with very fine grain, so to deliberately create grainy effects, you will have to make arrangements with a lab to push process these films at least two f/stops and shoot the film at 1600 ASA. If the grain still is not coarse enough, try duplicating a small area from the resulting slides using any standard slide duplicating technique. If you know beforehand that you will be using this technique, try shooting with a wide-angle lens and composing so that your main subject fills only a small portion of the image area.

Resolving Power
Resolving power is the ability of a film to record fine detail. Manufacturers determine it for you by photographing a chart made up of fine lines, examing the processed film under a microscope, and counting the number of lines per millimeter the film is capable of recording. Resolving power decreases if the film is overexposed, underexposed, overdeveloped or underdeveloped.

A film with low resolving power can ordinarily be enlarged only a few diameters before lack of quality becomes noticeable. On the other hand, a film with very high resolving power, such as the negative provided in the Polaroid P/N film pack can be enlarged up to 25X. Unless you are documenting subjects with extremely fine detail, resolving power will not significantly affect your choice of film. If resolution is important, try Panatomic-X, PanF or Kodachrome 25.

Sharpness
The sharpness of a film is its ability to record a sharp edge between lighter and darker details in a photograph. It used to be determined by photographing the edge of a knife, and we still think of some photos as being razor sharp.

In practice, no film is perfectly sharp. There will always be some bleed over of dark areas of the negative image into light areas because of light scatter in the emulsion. The effect varies from film to film, but in general, thin emulsion films such as those used for 35mm photography tend to be sharpest.

Sharpness is significant only as it meshes with other factors to create overall image quality. For example, a 400 ASA color slide film may be slightly grainier yet appear sharper than a slower, finer grain film with higher resolving power.

In general, the sharpness of black-and-white films tends to be slightly higher than the sharpness of color films with the same ASA rating.

Speed
Speed is one of the most important factors in film selection. The faster the film, the more sensitive it is to light. In practice this means that fast films let you use smaller f/stops or higher shutter speeds and still get good exposures.

For several decades, film companies in the U.S. and many other countries used ASA speed designations. ASA stood for American Standards Association. Then the name was changed to the American National Standards Organization, which is abbreviated ANSI, but the old abbreviation ASA continued to be used by photographers and film makers.

In 1979, film manufacturers began to adopt ISO (International Standards Organization) speed numbers, which are essentially the same as the ASA and German DIN (Deutsche Industrie Norm) numbers used on most light meters.

Throughout this book, the term ISO/ASA is used to indicate that the speed number is the same in both systems.

Technically, the ISO number has two parts. The first half is the ASA standard and the second is the DIN standard. So a film such as Kodacolor II, with a rating of ASA 100 or DIN 21, now has an ISO 100/21° rating. All three numbers appear on the film box.

ISO/ASA numbers, or DIN numbers if you prefer, are the ones to set on your exposure meter. They produce optimum results with average subjects when the film is developed according to the manufacturer's instructions.

Sometimes photographers refer to a film's exposure index (EI). This means that the speed number is not derived according to a procedure specified by a national or international standards organization. For example, when you push Ektachrome 400 one stop, you technically are using EI 800, not ISO/ASA 800. But the numbers are the same. It's trivia like this that can turn a photography club meeting room into a battle zone. Other speed numbering systems, such as GOST (Russia) and DIN are covered in Chapter 8.

ASA numbers, and the first half of the ISO rating, are arithmetic, which means that each time the ISO/ASA number is doubled, the indicated speed doubles. In other words, an ISO/ASA 200 film is exactly twice as fast as an ISO/ASA 100 film. Another way of thinking about the difference is that the ASA 200 film is one stop faster. An ASA 400 film is two stops faster than an ASA 100 film, so if you need f/8 at 1/250 sec. with the

Simplified Color Film Reciprocity Guide

Exposure Time	Exposure Increase
1 sec.	1 f/stop
10 sec.	2 f/stops

These corrections are for use with most general-purpose color slide and color print films from ISO/ASA 25-400. For more accurate corrections, see the Color Film Reciprocity guides.

Reciprocity-Effect Adjustment for Black-and-White Films

Indicated Exposure Time	USE		Development Time Change
	EITHER This Aperture Change	OR This Adjusted Exposure Time	
1/100,000 sec	+1 stop	Use Aperture Change	+20%
1/10,000 sec	+½ stop	Use Aperture Change	+15%
1/1,000 sec	None	No Adjustment	+10%
1/100 sec	None	No Adjustment	None
1/10 sec	None	No Adjustment	None
1 sec	+1 stop	2 sec	−10%
10 sec	+2 stops	50 sec	−20%
100 sec	+3 stops	1200 sec	−30%

Reciprocity Characteristics of Kodak Color Films

Kodak Film Name and Type	Exposure Compensation (Stops) and Filter for Reciprocity Characteristics When Used With Type of Light for Which Film is Balanced					
	Exposure Time in Seconds					
	1/10,000	1/1000 to 1/100	1/10	1	10	100
Vericolor II Professional S	None NF	None NF	None NF	NR	NR	NR
Vericolor II Professional L	NR	NR	None NF	+⅓ NF	+⅔ NF (5 sec)	+1⅔ NF (60 sec)
Kodacolor II	None NF	None NF	None NF	+½ NF	+1½ CC10C	+2½ CC10C + CC10G
Kodacolor 400	None NF	None NF	None NF	+½ NF	+1 NF	+2 NF
Ektachrome 64 Professional (Daylight)	+½ NF	None NF	None NF	+½ NF	+1½ NF	NR
Ektachrome 200 Professional (Daylight)	+½ NF	None NF	None NF	+½ CC10R	NR	NR
Ektachrome 50 Professional (Tungsten)	—	None CC10C	None NF	None NF	+½ NF	+1½ NF
Ektachrome 160 Professional (Tungsten)	+½ NF	None NF	None NF	+½ CC10R	+1 CC10R	NR
Ektachrome 64 (Daylight)	+½ NF	None NF	None NF	+½ CC10B	+1 CC15B	NR
Ektachrome 200 (Daylight)	+½ NF	None NF	None NF	+½ CC10R	NR	NR
Ektachrome 400 (Daylight)	None NF	None NF	None NF	+1 NF	+1½ CC10C	+2½ CC10C
Ektachrome 160 (Tungsten)	+½ NF	None NF	None NF	+½ CC10R	+1 CC10R	NR
Kodachrome 25 (Daylight)	None NF	None NF	None NF	+1 CC10M	+1½ CC10M	+2½ CC10M
Kodachrome 64 (Daylight)	None NF	None NF	None NF	+1 CC10R	NR	NR
Kodachrome 40 Film 5070	—	None NF	+½ NF	+½ NF	NR	NR

Fujicolor F-II 400 Reciprocity Characteristics

Exposure Time (in sec.)	1/1000—1/10	1	10	100
Exposure Compensation	None	+1 stop	+2 stops	+3 stops
CC Filters	None	None	None	None

Fujichrome 100 Reciprocity Characteristics

Exposure Time (in sec.)	1/1000—1	4	16	64
Exposure Compensation	None	+⅓ stop	+1 stop	+1⅓ stop
CC Filters	None	None	CC5C	CC10C

Low-Light-Level Reciprocity-Failure Correction for Polaroid Land Black-and-White Films

Any exposure longer than 2 sec. will require correction to compensate for a fall off in film sensitivity at low light levels.

Metered Time in Seconds	Corrected Exposure Times in Seconds						
	Film Type						
	51	32 42 52	55P/N	47 57 107	105	46L	146L
2	3	2	2	2	2	2	2
4	9	6	6	4	5	4	5
8	20	15	15	12	10	8	11
16	60	45	30	30	30	25	30
32	120	90	70	90	75	45	70
64	—	300	150	240	200	120	150

A characteristic curve shows graphically how exposure relates to density. This one is for Ilford HP5 developed in ID-11 (D-76) at 20° C (68° F) with intermittent agitation. Mathematical data of this type is for use by lab technicians. Most photographers find such graphs confusing and without value for day-to-day picture taking.

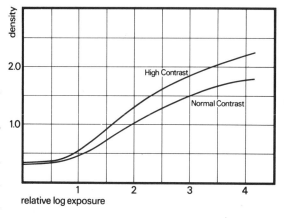

slower film, the last film would let you use f/16 at 1/250 sec.

A standard shutter speed for hand-held camera work with normal and moderate telephoto lenses is 1/250 sec. If you keep this speed constant and adjust aperture according to film, filter and lighting, the differences in speed become quickly apparent. Kodachrome 25 or Panatomic X (ISO/ASA 32) will be used at f/5.6 in direct sunlight. If you add a polarizer, which requires an additional two stops exposure, you will be working at f/2.8, which gives very shallow depth of field and is faster than many zoom lenses. The alternative is to use a slower shutter speed and possibly some type of camera support. A serious photographer who wants slow-film quality will use a tripod for most situations.

ASA 64 film provides an additional stop to work with, and ASA 100 or 125 film will give two more stops. Thus with Kodacolor II, Fujicolor 100, or Plus-X, you can shoot at f/11 on a sunny day with 1/250 sec. shutter speed and find plenty of room on your f/stop scale to use standard color and black-and-white filters. Since these films deliver top image quality, at a flexible speed, they are extremely popular.

The fast ASA 400 films such as Tri-X, HP5, Ektachrome 400, Kodacolor 400, and Fujicolor 400 provide a standard sunlight exposure of 1/500 sec. at f/16, four stops faster than Kodachrome. This speed lets you work with slow telephoto lenses, such as a 500mm f/8 mirror lens and use high 1/1000 or 1/2000 sec. shutter speeds to stop fast sports action.

They also let you photograph under very low light conditions without the need for a tripod.

Four stops from slow to fast may not seem like much, but in practice it makes an enormous difference in hand-held camera work where it can mean working at 1/30 sec. shutter speed, which will often produce blur due to camera shake, or working at 1/250 sec., which totally eliminates the effect of camera shake with normal lenses. Since the quality of fast films is excellent, many photographers now standardize on ASA 400 films for all but the most critical scenic and still-life photography. The exception is portraiture and wedding photography, which is done with electronic flash on ASA 100 color print film, such as Kodacolor II or Vericolor 2, which permit good 16″ x 20″ enlargements.

Speed Changes

The speed of black-and-white film can be manipulated in processing, but the variations also change the character of the film. For example, by increasing development time or by using a more energetic de-

veloper, you can raise film speed one or more stops, but you also increase contrast and grain.

There is a limit to the amount by which you can underexpose and compensate by overdeveloping. It takes a certain minimal amount of light just to trigger the film's response, and no amount of development will bring out a latent image that is not there.

The speed of color films can also be manipulated, in some cases with excellent results. Kodak sells a Special Processing Envelope ESP-1 for forced processing of Ektachrome films. This processing doubles the normal film speed so that Ektachrome 400 has an exposure index of ASA 800, Ektachrome 200 can be shot at ASA 400, and so on.

Custom labs can make additional adjustments that will per-

mit you to shoot Ektachrome 400 at speeds up to 1600 ASA for extremely low-light-level photography.

Using film at extremely slow or extremely high speeds also produces an effective change in film speed. General purpose films are designed to be exposed at speeds from about 1/10 sec. to 1/1000 sec. At these speeds, the relationship between increased or decreased amounts of light remains consistent. Halving the light produces half the exposure, doubling the light doubles the exposure and so on. But with very long exposures, effective speed tends to slow down, so additional exposure has to be given, and sometimes with very short exposures such as the 1/50000 sec. that some of the automatic flash units are capable of delivering, a similar slowing

down of film speed may be apparent. The effect is called *reciprocity failure*.

With color films, reciprocity failure may also produce changes in color balance that can be corrected using light-balancing or color-compensating filters. The color shift varies from film to film.

The accompanying charts show typical speed changes and color shifts with popular color and black-and-white films.

Contrast and Latitude

Contrast is simply the difference between dark and light, but the word takes on added meaning when applied to film. The brightness range that any film can handle is easiest to think of in terms of a textured white and a textured black with a range of middle tones in between. A textured white

Kodak High Speed Recording Film has a coarse grain structure that gives this photo a peppery effect. In sports action shots, the result is not only acceptable, but sometimes desirable. Compare this photo with the motorized sequence photos on pages 120–121, which were taken on Tri-X.

The toplight provided by midday sun cast shadows that combined with the shape of steel mesh used as concrete reinforcement to create this unusual composition. Film: Agfa Isopan 24; normal lens on a 4" x 5" view camera. The photo could have as easily been made with an SLR and any ASA 125 film. It's the light that makes the picture. Photo by Robb Smith.

could be a white sweater or a patch of concrete in the sun. It differs from a specular highlight or totally overexposed area of the subject in that it carries some detail. A textured black could be a dark skirt or patch of grass in deep shade. It differs from pure black in that it carries some recognizable detail.

What comes out as a textured white or black depends on both the subject and the film. If you have a contrasty film, then the brightness range between portions of the subject rendered as black and those rendered as white will be only a few f/stops. If you use a low-contrast film, then the range between the two could be a dozen or more f/stops.

Between the extremes of textured white and black lie the middle tones. Rendition of these tones and their relationships to one another will vary, depending on the design of the film, developing procedures, and, in black-and-white photography, on the contrast grade of the print paper.

The concept of contrast is fairly straightforward when applied to black-and-white film. When color is added, terminology gets confused because the word "contrast" is also used to apply to differences in hue, such as the contrast between blue and yellow. This use of the word has nothing to do with the effect on color of under- or overexposure. As you overexpose a color, it gets paler and paler until it disappears into a white. Underexpose a color and it appears to get more and more saturated, then darker until it is no longer recognizable as anything but a grey or dark brown, depending on the film. In practice, you will find that some color slide films reproduce texture in the blacks long after all sense of true color rendition has been lost.

So with color films, it is often easier to think in terms of latitude, which is the degree to which you can under- or overexpose a general scene and still get acceptable colors. With most color films, this range is only a few stops. It is longest with Kodachrome and with color print films. It is shortest with high-speed slide films. If you want to get optimum rendition of colors, an exposure reading of important colors should show no more than a one- to two-stop difference between them.

If you find that fast-color films are giving you burned-out highlights or large, ugly dark areas, then select a slower film for the type of photography you are doing, or learn to compose within the exposure limitations of the film. (See also Chapter 8.)

The contrast of a film and its rendition of middle tones is described graphically by a characteristic curve, which shows math-

ematically how the film responds to a carefully controlled series of exposures. While something can be learned through the study of these curves, most photographers prefer to experiment with a film stock and then observe the results.

A characteristic curve has three components. The toe shows how the film responds to low levels of light. The straight-line portion shows how the film responds over its useful range of exposures. The shoulder shows what happens as exposure is increased beyond what the film can handle. The slope of the straight-line portion of the curve gives an indication of the contrast of the film.

Films with a long toe are designed for studio lighting where flare is not a problem. The long toe provides detail in shadows and is suitable for portraiture. A typical film with a long toe is Tri-X Pan Professional, a 120 roll film. Films with a short toe are designed for outdoor work. A typical film in this category is Plus-X.

As a rule of thumb, slow black-and-white and color negative films are more contrasty and therefore have less latitude than faster films. Slow transparency films, on the other hand, have more latitude than fast transparency films.

Negative films, whether color or black and white, can be overexposed by several stops without significant loss of quality, so are said to have plenty of latitude on the overexposure side. They have very little tolerance for underexposure.

Today's black-and-white films are capable of handling extreme overexposure, up to 12 stops with a film such as Tri-X, but more than 3 stops of overexposure begins to produce excess graininess and a visible degradation of quality. Color-slide films generally tolerate slight underexposure fairly well, but have almost no tolerance

for overexposure.

Spectral Sensitivity

The spectral sensitivity of a film is its response to the various colors of light, both visible and invisible. A general purpose film, such as an Ektacolor, Kodacolor or panchromatic black-and-white film, matches the response of the eye fairly closely, though it is somewhat more sensitive to blue and will also record invisible ultraviolet light. This means blue skies tend to come out a bit light with most films. The effect can be corrected with filters (Chapter 3).

There are also films designed to record some wave lengths of light and eliminate others. Orthochromatic films such as Tri-X Ortho are used for copying in the graphic arts. They record blue and green but not red. These films were also popular years ago for black-and-white portraits of men. Blue sensitive or litho (lithographic) film is used in making printing plates. Infrared film is sensitive to both blue and invisible infrared radiation.

Among general purpose films slight differences exist in their sensitivity to specific colors. These differences are seldom important, although some black-and-white films may become a bit slower or faster in tungsten light, and this should be taken into account when using zone-system exposure techniques (Chapter 8).

Storage and Handling

Like fruits or vegetables, film is an organic product and can be damaged if improperly stored.

Films for amateurs are designed to be stored at normal room temperatures (up to 75° F) before use. By the time these films are shipped from the factory they are relatively stable and they will remain capable of giving good results until the expiration date stamped on the package. As the

film ages, subtle changes occur in speed, color balance and contrast of color films, and in speed, contrast and fog level of black-and-white films. These changes are normal and are taken into account in the design of the film. High temperatures, high relative humidity and harmful gases all accelerate aging and should be avoided.

Film is packaged in water-vaportight containers or foil pouches and it should remain sealed until ready for use. The cans or pouches keep it safe from humidity.

In hot summer weather or in tropical areas film stored in air-conditioned areas should be all right. But if the temperature in your storage area is likely to rise above 75° F (24° C), put the film in a plastic bag in your refrigerator. (Do not freeze it.) After taking it out of the refrigerator, give it an hour or so to warm up before using it.

If you buy film by the batch and find that it reaches a point where the color is exactly what you like, then you can slow down the aging process at that point by refrigerating or even freezing the film.

Film for professional use, such as Ektachrome 160 Professional, is like a bunch of ripe bananas. Professional emulsions are at their performance peak when you buy them and must be refrigerated to keep them fresh. If allowed to sit on a shelf under average room conditions, they deteriorate in quality.

Professional black-and-white films should be stored in a cool, dry place. Professional color films should be refrigerated at temperatures of 55° F (13° C) or less. Kodak High Speed Infrared black-and-white film and Kodak Ektachrome Slide Duplicating Film should also be refrigerated. Ektachrome Infrared Film should be kept frozen at 0 to −10° F (−18°

to −23° C).

Polaroid SX-70 films and Kodak PR-10 can be refrigerated in hot weather but should not be frozen.

Storing black-and-white film: The following storage conditions are recommended by Kodak for its black-and-white films. Under normal room temperatures that do not exceed 75° F (24° C) you can keep the film for two months without any problem. When stored up to six months, keep the storage temperature below 60° F (16° C) and for a year's storage, keep the film refrigerated at 50° F (10° C) or below. It should be safe to follow these same recommendations with films made by other manufacturers such as Ilford and Agfa.

Warm-up time: Once film has been refrigerated or frozen, adequate warm-up time must be allowed before the film is used. If you bring cold film into a warm environment without a warm-up period, moisture can condense on the film and ruin your photographs. The accompanying chart gives standard warm-up times. As a rule of thumb, allow one to two hours for refrigerated film, four hours for frozen film of the conventional type, and 24 hours for frozen instant print films.

When you travel during hot summer weather, storage can be a problem. Temperatures in a closed car parked in the sun can rapidly rise as high as 140° F (60° C). Temperatures this high can kill pets left in the car and ruin film. If you must leave film in the car, keep it in a picnic cooler along with some ice or a cold pack if available. Inexpensive foam coolers work just fine. If you use ice, keep your film above the melting ice water so that it does not get wet.

Film stored at room temperatures should be exposed before the expiration date on the package. If you have refrigerated or

| Film Size | Warm-Up Times (hours) | |
	For 14 C (25 F) Rise—From Refrigerator	For 56 C (100 F) Rise—From Freezer
Roll film, including 828 135 magazines;	½	1
110 and 126 cartridges	1	1½
10-sheet box	1	1½
50-sheet box	2	3
35 mm long rolls	3	5
70 mm long rolls	5	10

Film Warm-Up Table

frozen the film, then it will remain usable months or even years after the stamped date.

Handling opened film: Once film has been removed from its vaportight packaging, it should be used and processed quickly. Amateur films have preservatives that permit a delay between exposure and processing. Professional films should be processed immediately or placed inside a jar or plastic bag, and refrigerated.

Do not store opened packages of film under the damp conditions found in some basements and refrigerators. High relative humidity can damage film. Ideal RH for storage of opened film is between 40 and 60 percent.

To store opened film in a refrigerator or freezer, put the opened packages in a can or jar that you can seal tightly or in a tightly sealed plastic bag. Under tropical conditions, silica gel in a jar can be used to dry out film before storage.

Keep opened film away from motor exhausts, industrial gases, mothball vapors, formaldehyde, paint, solvents, insect sprays, cleaners, and mildew or fungus preventatives. Closets may have mothballs in them so check before storing film in them. Perfumes may contain formaldehyde, so avoid storing open film in a purse that also contains a bottle of perfume or spray cologne. Do not store film or cameras in the drawers of new furniture where the

glue may give off fumes.

Static marks: Indoors in winter and at other times when relative humidity is low, advancing film rapidly through the camera or rewinding it too quickly can produce static electricity. Marks created by static can appear as small dots, fogging, or lightning-like streaks.

Cold Weather Tips

Here are some things you can do to optimize results with black-and-white and color films in cold and even very cold weather.

• Store films in original, sealed packages and at recommended temperatures until time to use.

• To conserve space in the photographer's vest, skier's belt or parka in which supplies are carried, remove each roll of film from its carton but not from its vaportight package, which maintains correct relative humidity until it's opened. Put an identifying mark on packages if you're carrying more than one type of film.

• Carry film, cameras, extra lenses and especially extra batteries inside your outerwear where they will be warmed by body heat and protected from wind and snow.

• Load and unload film outdoors (but within the protection of your outerwear) to avoid tackiness that can occur due to condensation when film is loaded in a 70° F area and then taken directly into a cold, dry outdoor condition.

• Whether it's 40° F and melting

or −40° F and bone-dry, reduce the very real potential for static marks of either moist or dry origin by advancing film from one exposure to the next with a slow, steady motion and by rotating the rewind knob very slowly. Rapid film rewinding is the major cause of most static marks on 35mm films. Battery-operated, motor-driven cameras naturally tend to slow down a bit in extreme cold, but pay extra attention to the exposure counter at very low temperatures where film can become brittle and camera mechanisms sluggish. Plan to slow your rate of exposures toward the end of each roll to help prevent torn sprocket holes at very low temperatures.

• Winterize your camera by asking the original manufacturer or a competent camera service organization to replace the original lubricants with one of the newer, broad-range lubricants (Teflon® or silicone) that will not thicken when the camera is exposed to extreme cold. Unlike powdered graphite, still used by some for winterizing, the newer lubricants can be left in the camera permanently. Whatever the lubricant, the winterizing operation facilitates detection and replacement of weakened and damaged parts that might fail under the extra stress of extreme cold.

• Shoot a test roll, and whenever conditions change, shoot another. At very low temperatures, film may lose as much as a third of a stop in speed while a cold, sluggish shutter may provide a comparable amount of additional exposure. Even though the condition can be self-correcting, it is no more predictable than the weather.

• Keep your camera as dry as possible. Shake, don't blow, snow from camera. Whenever you must take a cold camera into a warm building, wrap it in an airtight plastic bag. Condensation forms on the outside of the bag instead of on the camera.

• If you process your own film, use the same slow, deliberate movements in unrolling the film and handling it during processing as you did in exposing it.

Processing

With the exception of Kodachrome, which can only be processed using special equipment, color print and slide films can be processed by the user or by a professional laboratory.

Prepaid processing mailers are a convenient way to get your film processed. You can buy them packaged with your film or separately. Some films such as Agfachrome and private label brands are normally sold with processing mailers included in the box because it can be difficult for the user to find independent labs that will process them.

Most mailers are for processing of one brand of film only. For example, Kodak's familiar yellow mailers are for use only with the film in the yellow box. If you send Kodak another brand in one of their mailers, the company will return the film to you unprocessed.

Any Kodak film with "P" appearing at the end of the film type, such as KR 135-36P, does not need a prepaid mailer. The "P" indicates that processing has already been paid for and the film can be mailed in any envelope to a Kodak processing laboratory.

When you use a prepaid mailer, make sure it is well sealed before you mail it. Each year the Post Office ends up with thousands of rolls of film that have fallen out of processing mailers. If there is one large processing lab in the town, the Post Office will deliver the film to that lab and the lab will process it as a customer courtesy in hopes of finding out who the film belongs to, but the chances of your ever seeing your film again once it becomes separated from its mailer is small. If the mailer you have is sealed with a gummed flap, then reinforce the flap seal with a piece of tape. If the envelope has a metal fastener, use it.

In hot weather, dropping your film into a mailbox standing in the sun is asking for trouble. Temperatures inside that metal box get very high. Instead, take the time to mail it directly inside the Post Office or mail it late in the day at a box where a collection will be made before sun hits it.

If you are traveling, you can mail your film as you shoot it. This eliminates the problem of carrying many rolls of exposed film with you, and if you are traveling by plane and making many stops, helps avoid cumulative damage from airport X-ray machines.

Processing labs run regular delivery routes that stop at kiosks and film counters, in most cases daily, so that when you leave your film with a retailer for processing, you will get it back in most cases more quickly than when you use a mailer.

Custom-processing labs such as those advertised in Popular Photography and other photo magazines offer a variety of services, often at a quite reasonable price.

Black-and-white: Today most black-and-white film is processed by the user because processing is easy—on the order of cooking ready-mix pancakes—and inexpensive. Many professional labs will also process black-and-white film. These labs can be found by looking in the yellow pages or asking at local photo stores.

Professional photographers will generally process film themselves or send it to a local professional lab. Professional labs tend to be more expensive but offer fast service, sometimes even same-day service, and consistent quality.

The pro lab can also take care of special problems including push processing (overdevelopment), and pulled processing (deliberate underdevelopment).

Test clips: A custom pro lab will also process test clips for you. A test clip is a short length of film at the beginning of the roll, usually just a few frames, that is snipped off by the lab and processed. The photographer then comes in and evaluates the results before having the remainder of the roll processed, along with other rolls shot at the same time under the same lighting conditions. By varying processing time, the lab can compensate for under- or overexposure. The lab can also make minor color corrections with color slide film.

Sheet films can be given to the lab in the film holders. If you wish, films on one side of the holder can be processed, the results evaluated, and then the other side processed with any minor corrections required. The lab will return the holders to you along with the film.

Special effects: Some labs can also provide a range of special effects, such as printing a portrait inside a heart or wine glass shape, making color posterizations from slides, mounting of prints on foam-core material, canvas mounting, and texturizing.

CONVENTIONAL FILM

This section provides a description of the most popular conventional films and offers suggestions about using them.

Color Print Film
This is far and away the most popular film type. Amateurs rely on it for snapshots and professionals use it almost exclusively for portrait and wedding photography.

Once processed, the film contains a negative image, often with an orange mask, that must be printed onto color paper. Pros like it because color can be corrected during the printing phase. Amateurs who do not care about critical color quality like it because the prints are easy to handle and prices for mass-production photofinishing are low.

Between these two groups falls the serious photographer who wants good color but does not want to pay for custom processing. If you fall into this group, you will probably never be satisfied with low-cost prints because they are made by machines that are programmed to give standard prints of standard subjects. If your shots tend to nonstandard colors, then the color quality of the print will be wrong. Moreover, the machines themselves may not always be properly adjusted, which can result in color casts and blur.

One solution is to get an intermediate quality color print, possibly one that is video-analyzed. These prints are offered by mail-order processing labs advertised in photo magazines. They are not always perfect, but they tend to be better than the prints delivered by super-cheap processors.

To get high quality prints for exhibition, have your negatives custom printed. These "C" prints are expensive, but the results are usually worth the extra cost.

Surface: Silk surface prints are quite popular, especially with users of small cameras, because the textured surface obscures defects in image quality. On the other hand, it also hides detail. The most brilliant prints with the best detail are done on glossy paper.

ISO/ASA 100 color print films: These films provide an extremely fine-grain negative capable of yielding sharp images and excellent color quality, particularly with flash. They are considered all-around films, suited to vacation, family, portrait, and wedding photography. Kodacolor II and Fujicolor F-II are the best known films in this group. There is also an ASA 100 3M Color Print Film. Sakuracolor is available only as private label in the U.S., but is available elsewhere. These films are all processed in the same chemistry, although not all labs will handle every brand.

Agfacolor is widely distributed throughout Europe and the Middle East and is an excellent film; however, it requires processing in Agfa chemistry, which is not readily available in the U.S.

Professional photographers often use Vericolor 2, the professional film version of Kodacolor II. Vericolor 2 is designed to give optimum results with electronic flash.

ISO/ASA 400 films: These films have been on the market for only a few years, but they have already proven their worth for available-light and action photography as well as for general picture taking. They offer very fine grain, though not quite as fine as Tri-X or HP5, and the speed is ideal for telephoto and close-up photography, where high-shutter speed and small-aperture techniques require a fast film.

Kodacolor 400 is balanced for daylight, electronic flash, or blue flash. It also has special sensitizing characteristics that let you obtain pleasing pictures under the light from household light bulbs and many types of fluorescent lamp without using filters on the camera. This film also handles mixed lighting situations, such as daylight plus fluorescents remarkably well.

Fujicolor F-II 400 also provides very fine grain, good color and special sensitizing characteristics.

3M makes its own 3M brand ASA 400 color print film and a variety of private label films in this speed category.

Color-Slide Films

Color-slide film is most often chosen for commercial color and serious amateur photography because color rendition can be extremely accurate when the slide is viewed on a light-box. Slides are frequently used for sales presentations, instruction, and other audio-visual situations. They are also ideal as originals for commercial four-color printing of postcards, advertising brochures, magazine illustrations, and posters.

Although slides can be viewed on a small hand viewer, to get the most from them, you will need a projector (Chapter 10). For color evaluation, use either a projector, which is a fairly warm light (3200 K), or a light box designed for transparency viewing. For critical color evaluation, use a light box with a color-rendering index (CRI) of 90 and a color temperature of 5000 K, and view the slides through a magnifier.

Prints from slides: Prints can also be made from color slides. The quality can be excellent, and with a film such as Kodachrome, which is virtually grainless, enormous blowups are possible. On the other hand, making prints from slides tends to be more expensive than having them made from negatives.

There are two types of print that you can get made from slides. The Cibachrome print is made directly from the slide onto Cibachrome paper. It can produce highly saturated colors and it offers good fade resistance. Prints can also be made by copying the slide onto negative film and printing this internegative onto standard color print paper. This method is used by most photofinishers, including Kodak.

Kodachrome: This film is in a class by itself. Available only in 35mm magazines, it provides greater latitude and finer grain than any other slide film. There are two daylight versions, Kodachrome 25, which is frequently used in conjunction with a tripod-mounted camera, and the slightly faster Kodachrome 64.

Kodachrome 25 is still the standard by which other films are judged. Unfortunately, both ISO/ASA 25 and ISO/ASA 64 speeds are relatively slow, which limits their usefulness for hand-held camera work; and they must be processed by Kodak or some other lab with special equipment.

Kodachrome 40 is designed for use with photoflood lighting. It is a good choice for close-up photography and for documenting photoflood-lighted interiors. Formerly called "Type A" film or simply indoor film, it also produces excellent results with standard motion-picture lighting.

ISO/ASA 64-100 slide films: This group contains the classic general-purpose slide films. They offer good quality and plenty of latitude. Ektachrome 64 provides very fine grain, high resolving power, and high sharpness. Fujichrome 100 is another excellent film in this group. Agfachrome, available in both ASA 80 and ASA 100 versions, offers exceptionally high resolving power, wide latitude, and generally pleasing rendition of natural colors. 3M also makes a ASA 100 color slide film.

Although films in this group have been the workhorses of color-slide photography, the recent development of faster slide films with fine grain is a siren call that many photographers are finding hard to resist.

Ektachrome 160: This is a tungsten-type film, which means that it is balanced for use with studio floods (3200 K). It is widely used in both professional and amateur versions for close-up photography, photomicroscopy, and studio photography in general. It can be used to photograph products, paintings, glassware, interiors, or people. This film produces good results with general household lighting and is a good choice for general photography under existing artificial lights. It produces late evening scenes with deep blue skies that make a dramatic contrast with lighted signs and windows. You can use it to take pictures in daylight or with electronic flash by using a No. 85B filter over your lens, which reduces its effective speed to ASA 100. Kodak offers special processing envelope ESP-1 if you want to shoot this film at ASA 320 and record candid nighttime scenes using a hand-held camera or stop action with a slow tele lens.

Ektachrome 200: This general-purpose slide film is an improved version of the old High-Speed Ektachrome. Its graininess is very fine, coming close to Ektachrome 64 in quality, yet Ektachrome 200 gives an extra stop and a half working speed, which can make all the difference when you want to use a fast shutter speed to stop action or eliminate camera shake with telephoto lenses. With ESP-1 processing, you can expose the film at EI 400. The ISO/ASA 200/400 option results in significant flexibility. You can handle low-light situations, stop down for increased depth of field, use a polarizer with slow telephoto lenses, and utilize techniques that require both fast shutter speeds and small working apertures.

Ektachrome 400: This high-speed film is for photographing dimly lighted subjects, fast action, and subjects that require both good depth of field and higher shutter speeds. It lets you take flash pictures at greater distances than slower films. It yields surprisingly fine grain and excellent sharpness. It is a good choice for telephoto and close-up photogra-

Mathew Brady had to coat each glass plate himself and take the photo while it was still wet. In the field, that meant a portable darkroom for plate coating. It was easier in the studio, where this shot of General Custer was probably taken. Photo courtesy of GAF Corporation.

flash fill. For low contrast scenes, you can obtain good negatives by setting your meter for speeds up to ASA 2000 with normal development and up to 4000 if you increase development 50 percent.

Kodak Recording Film 2475: This is an extremely high-speed ISO/ASA 1000 panchromatic film for 35mm cameras. It has extended red sensitivity, which makes it particularly effective in tungsten lighting, and a coarse grain. Use this film in situations where the highest film speed is essential and fine grain is not important. It can be used for candid photography at night or in dim light, for surveillance work and nature photography, and with extremely slow telephoto lenses when fast shutter speeds are required.

The grainy effect can add dramatic impact to sports and other action situations.

In low-contrast situations, you can use this wide-latitude, low-contrast film at speeds up to 1600 with normal development and at speeds up to 4000 if you increase development 50 percent.

Special Purpose Films

Films in this group were originally designed for industrial, commercial, and scientific applications, but are now widely used by amateurs to create special effects or to make copies of slides and prints.

Kodak High-Speed Infrared Film: This is a moderately fast high-contrast, medium speed film that is sensitive to blue, red and infrared light. To gain the full advantage of its infrared sensitivity, it must be used in conjunction with an infrared or red filter that absorbs blue and green light. It can produce striking and unusual effects because infrared reflecting subjects, such as healthy foliage and grass, are rendered very light in the print while blue skies and most inanimate subjects come out dark. The effect can be eerie.

For general photography, a Red No. 25 filter is recommended. You can also use a No. 29 or No. 70 filter. When you want to record only the infrared radiation, use a No. 89B, No. 88A, No. 87, or No. 87C filter.

At night, you can cover a flash unit with a No. 87 or 87C filter, which makes the flash practically invisible, and record subjects using only infrared light. If you filter both camera and flash, try ISO/ASA 25 as a starting point and bracket widely. Or use the flash to stop action and use a shutter speed slow enough to record part of the scene with ambient light.

It is not possible to give exact speeds for this film because the ratio of infrared to visible light is variable and exposure meters do not usually respond to invisible light; on the other hand, the sensors of most electronic flash units do (see Chapter 8). With on-camera filter No's. 25, 29, 70, or 89B, and a hand-held meter, try ASA 50 in daylight and 125 in tungsten. With filter No's. 87 and 88A try 25 in daylight, 64 in tungsten. With a No. 87C filter try 10 in daylight, 25 in tungsten. With no filter, try ASA 80 in daylight, 200 in tungsten. These speed settings are for hand-held meters. With cameras that have built-in exposure meter that reads through the lens, take the reading before you put the filter on the camera, and set the metered aperture-*f*/stop combination manually.

Infrared film is frequently used in aerial and long distance photography because haze effects, which are produced by scattered blue and ultraviolet light, are virtually eliminated.

Camera lenses do not focus infrared rays in the same plane as

phy and is ideal for photographing sports. With ESP-1 processing, you can shoot this film at ASA 800 with excellent results.

Take this film with you to the circus or ice show, where you can stop the action of spot-lighted acts using 1/250 sec. at f/2.8 with normal processing or f/5.6 if you shoot at ASA 800 (or ESP-1 processing). Carbon arc light used for these events produces natural color. Stage shows are lighted by tungsten lamps which produce a yellow/red cast, but you can photograph the average scene using 1/60 sec. at f/2.8.

If you use an 80A filter, you can get correct color with tungsten studio lighting and fairly natural color with standard household lighting as well, but the effective speed is reduced by two stops. Consider filtration an expedient that lets you use the same roll of film under various conditions without having to remove it from the camera. But if you have a choice, Ektachrome 160 is a better bet for tungsten light.

Black-and-White Films
Black-and-white photography is primarily a professional medium today, although students and a small group of serious amateurs also find satisfaction in working with it.

Most amateur and small-volume commercial photographers who use black-and-white process and print it themselves; however, you can almost always find a lab that can handle it for you. Black-and-white is the least expensive way to go when you make photos for public relations, advertising, and journalism, since the newspapers and magazines that will print them use mostly black-and-white anyway.

If you need a large number of copies of the same print, look for a lab that offers a special bulk price for 5" x 7" or 8" x 10" contact prints. To use this service, supply the lab with a negative or good print. The lab will copy the print or negative onto large format film and use the resulting internegative in an automated contact printer capable of turning out hundreds of prints an hour. This method is significantly less expensive than having enlargements made by hand.

When a custom lab processes the film for you, the lab usually returns the film with a contact sheet that contains a print of all the images on the roll. Some labs that handle amateur black-and-white will return small, individual prints of each printable negative, just as they do with color prints.

ISO/ASA 25-32 films: Films in this category are all moderately contrasty, very fine-grain films that are an excellent choice when you want to make prints larger than 16" x 20" and minimize graininess. They can be manipulated in development to alter the tone scale, which means that the precise worker can control the shade of grey for any given object in a scene. They are also tricky films to work with because of the narrow contrast range. In sunlight scenes, for example, areas of shadow may come out completely black in the print, although they seemed quite luminous to the eye when the photo was taken. Moreover, the slow speed limits the amount of hand-held camera work possible with these films.

The two best known films in this category are Panatomic-X and PanF, both ASA 32 films that offer top quality. You may occasionally run into some imported films in this category which are also outstanding.

ISO/ASA 100-125 films: These films are popular for general photography because they provide very fine grain, comfortable latitude, and adequate speed for hand-held camera work.

Kodak Plus-X, Ilford HP4 and Agfapan 100 are widely used by 35mm and medium-format camera persons, particularly for outdoor work under standard daylight conditions. For the roll film user, Kodak also offers Plus-X Pan Professional, which has a special retouching surface.

For users of 120 and 620 roll film or, 110 (pocket) and 126 (Instamatic) cameras, Kodak offers Verichrome, an extremely fine grain ASA 125 film with wide exposure latitude.

ISO/ASA 400 films: Tri-X, with its fine grain, very high sharpness, and wide latitude has long been the film of choice for photojournalism, sports, public relations, telephoto, and candid photography. Ilford's HP5 and Agfapan 400 also yield top quality.

These films are extremely flexible. To push process them, add about 50 percent more development time for each doubling of ASA speed. This increases contrast and can be used to add snap to low-contrast scenes taken on overcast days. Tri-X can be pushed to ASA 800 with no significant loss of quality.

To lower contrast in extremely contrasty situations, such as photographing an interior and the details of a view out the window in the same frame, or taking pictures on a stage or TV set, you can overexpose by one stop and underdevelop about 30 percent.

Kodak Royal-X Pan Film: This ISO/ASA 1250 film is available only in 120 rolls. Although this is a medium-grain film, the large image area provided by medium-format cameras requires no more than 5X enlargement for 8" x 10" prints, and at these magnifications, the grain is not noticeable. Its extremely wide latitude makes it possible to get luminous, detail-filled shadows in sunlit scenes without using reflectors

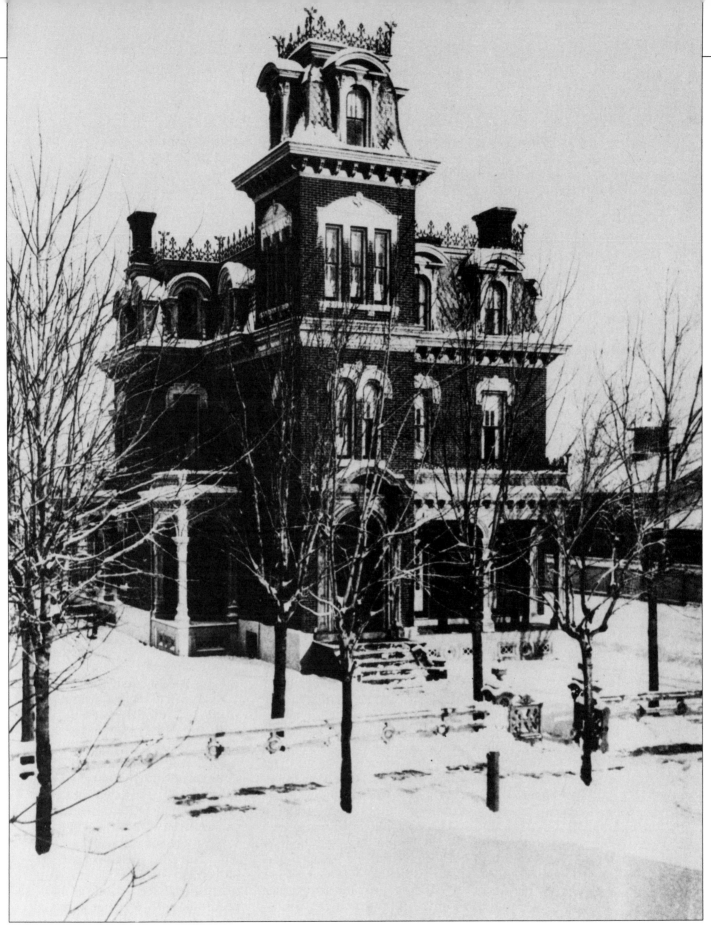

The do-it-yourself method of film coating went out when the dry plate was invented. George Eastman experimented with dry plates and went on to mass produce them, introducing the American public to the first truly portable camera and film system. This is one of Eastman's early experimental dry plate snapshots.

visible light rays. Some cameras have index marks on their focusing scales for taking infrared pictures, and if your camera lens has one, use it. Focus normally, note the distance indicated by the regular index mark on the focusing scale, and then adjust the focus so that the noted distance is opposite the infrared mark, usually a small "R" or a red line on the scale.

If your camera has no infrared mark, focus on the near side of the region of interest. With SLR's, shift focus back and forth across the sharp-focus position and stop the movement just as the image goes slightly unsharp while your focusing motion is bringing the plane of sharp focus closer to the camera. If you are capable of laboratory precision, you can focus on the subject and then move the entire camera away from the subject by 0.25 percent of the subject-to-lens distance. This technique is most feasible for close-up and macrophotography where depth of field is extremely shallow.

Infrared film is extremely sensitive to fogging and should be handled only in darkness when out of the cans. Load and unload your camera in a dark room and keep the film stored at 55° F or lower.

Ektachrome Infrared Film: Originally developed for camouflage detection, color infrared film is widely used today in aerial studies of crops, pollution, and forests. Amateur and commercial photographers frequently use it for the unusual color effects it produces. This is a false-color film, which means that colors in the original scene are falsified by dyes in the emulsion so that infrared reflectivity is clearly visible.

Ektachrome Infrared Film is designed for daylight quality illumination with a No. 12 (pure yellow) or No. 15 (deep yellow or orange) filter over the camera lens. The yellow or orange filter absorbs blue, to which this film is excessively sensitive. It does not impart a yellow cast to the image.

The normal infrared color image contains blue skies and red foliage and grass. Skin takes on a greenish hue. Green paint that does not reflect infrared turns out blue. Pine trees and other conifers appear almost black because they do not reflect infrared.

Using a No. 25 (red) filter turns blue skies green and green grass orange. Clouds become yellow and there is a general color shift toward yellow/orange.

With a hand-held meter, try a setting of 100 with a No. 12 or 15 filter. Use ASA 50 with 3400 K photofloods and a No. 12 or 15 filter. For "correct" color (daylight quality) use a No. 12 plus a CC50C in tungsten light. With through-the-lens metering cameras take exposure readings before you put the filter on the lens and set exposure manually.

High-Contrast Copy Film 5069: This panchromatic film is designed for making 35mm copy negatives of printed matter, such as books, newspapers, maps, engineering drawings, and similar items. The film has extremely fine grain, ultra-high resolving power and very high sharpness. It produces good quality copies of originals that contain both line and halftone material, such as magazine pages, and can be used for extremely low-contrast subjects, such as water color paintings.

Its speed in tungsten light is ISO/ASA 64 when developed normally. Although designed for use in standard copying setups (see Chapter 10), this film can also be used to produce high-contrast effects in daylight. The effect varies, depending on the speed selected and the contrast of the original scene, so try a starting speed of ISO/ASA 64 for your first shot, and then bracket the exposure, shooting at one stop less and one stop more than the metered exposure.

Kodak recommends developing this film in D-19; however, you could also try using a standard developer such as D-76 if you would like to try decreasing the contrast.

Kodalith Ortho Film 6556, Type 3: This extremely high-contrast orthochromatic film is available in 35mm x 100-foot rolls for photographers who load their own magazines. It can be used to make high-contrast copies, for posterization effects, audio-visual title slides, and other graphic applications. It is rated at ASA 6 in tungsten light.

Ektachrome Slide Duplicating Film 5071: This film is for making duplicate color slides from original slides made on color-slide films. This is a tungsten-type film; however, excellent results are also possible with daylight or electronic flash illumination when appropriate filtration is used. Filtration will vary, depending on the film type of the original. It is available in 135-36 exposure size. (See Chapter 10 for more information and suggested filtration.)

Kodak SE (Short-Exposure) Duplicating Film SO-366 is for use with electronic flash or daylight. Try ASA 8 as a starting point for determining exposure index.

Direct Positive Panchromatic Film, 5246: Available only in 35mm x 100-foot rolls for photographers who load their own magazines, this is a reversal transparency film used for making black-and-white slides with reversal processing. It has a daylight speed of ASA 80 and a tungsten speed of 64. Kodak sells a direct positive film developing outfit for use with this film.

Film Sizes

35mm film: This is one of the few film sizes in which the nomenclature is logical: the film width is 35mm. When sold in magazines, it is usually designated 135 film. When sold in 50- or 100-foot rolls, it is simply 35mm film.

Pre-loaded magazines are available in 12, 20, 24, and 36 exposure lengths. These exposure designations refer to the standard 24 x 36mm format. Other formats will produce a different number of exposures. The half-frame 18 x 24mm format will give twice the number of exposures. The unique 24 x 59mm format of the Widelux gives about half.

In addition to size and number of standard exposures, most boxes of 35mm film will carry an expiration date and an emulsion batch number. If you are finicky about color control and find a batch you like, then consider buying a quantity of the same batch number film and keeping it stored in a refrigerator or freezer until ready for use. This technique helps you avoid the problems associated with batch-to-batch variations. On the other hand, variations are seldom great and most photographers do not find them a problem.

If you shoot slide film, non-standard formats such as the half-frame may present some problems, because most labs are not equipped to mount them. The labs that do mount this size generally have an extra charge for the service. (For more information on slide mounting, see Chapter 11.)

Roll film: Medium-format cameras are designed to accept 120 or 220 roll film, which is loaded directly into the camera, into a detachable back, or onto a film carrier insert, depending on the camera system.

The 120 roll consists of a strip of film approximately 32 inches long and 2⁷⁄₁₆ inches wide taped at one end to a strip of opaque paper backing that is just slightly wider than the film itself. The backing paper is black on one side and colored with printed numbers on the other.

The longer 220 rolls are the same width and spool size as 120 but do not have a paper backing over the film itself. Only the leader is paper. Because of the need for adjustments in the pressure plate to compensate for the lack of paper backing and the complex frame-counter mechanism that must be incorporated into a camera or back that accepts 220, this film can only be used in systems specially designed for it. There are only a few emulsions currently available in the 220 size.

The now obsolete 620 size is similar to 120 but has a slightly larger spool. Cameras that take 620 can generally handle 120.

The emulsions available in roll-film size are similar to 35mm emulsions with the same name. Missing from the lineup is Kodachrome, which is available only in 35mm. Added are two black-and-white films with special retouching surfaces, Tri-X Pan Professional, an ASA 320 film

Kodak Film Codes

The letter code appears on film boxes, 35mm magazines, and the foil pouches in which some film is sealed. The edge numbers appear on the edge of processed negative and transparency films.

Film Type	Letter Code	Edge Numbers
Kodacolor II	C	5035 for sizes 135, 110, 126, 828 6014 for sizes 120, 127, 620, 616, 116
Kodacolor 400	CG	5075 for size 135, 110 6075 for size 120
Instant Print Film PR10	PR	None
Kodachrome 25	KM	5073, size 135 only
Kodachrome 64	KR	5032, sizes 135, 110, 126
Ektachrome 64	ER	5031 for sizes 135, 110, 126 6031 for size 127
Kodachrome 40 Film 5070 (Type A)	KPA	5070, size 135 only
Ektachrome 200	ED	5076, sizes 135, 126
Ektachrome 400	EL	5074 for size 135 6074 for size 120
Ektachrome 160 (Tungsten)	ET	5077, size 135
Ektachrome Infrared	IE	2236, size 135
Ektachrome Slide Duplicating Film 5071		5071, size 135
Vericolor II Professional S (for short exposures)	VPS	4107
Vericolor II Professional L (for long exposures)	VPL	4108
Ektachrome 64 Professional	EPR	6117
Ektachrome 200 Professional	EPD	—
Ektachrome 50 Professional (Tungsten)	EPY	6118

Black-and-White Films		
Verichrome	VP	7042 for size 110 8041 for size 126 6041 for sizes 120, 127, 620
Plus-X	PX	5062, size 135
Plus-X Pan Professional	PXP	—
Tri-X	TX	5063 for size 135 6043 for size 120
Tri-X Pan Professional	TXP	—
Panatomic-X	FX	5060 for size 135
Panatomic-X Professional	FXP	6040 for size 120
Royal-X	RX	6046 for size 120
Recording Film 2475	RE	2475 fpr size 135
High-Speed Infrared	HIE	2481 for size 135
High-Contrast Copy Film	HC	5069 for size 135

Note: This chart lists only those films generally available as stock items in larger photo stores. It does not include sheet films or the wide range of special films made by Kodak.

with a long toe designed for use in low-flare studio conditions, and Plus-X Pan Professional, a 125 ASA film with characteristics similar to Plus-X Pan. High-speed Royal-X Pan is also a 120 film.

Roll film is frequently sold in five-roll pro packs. Each roll in the box is sealed in its own foil pouch and identified by code. The code letter/edge number chart gives a rundown of current roll film codes and regular users of these films will find it to their advantage to become familiar with them. It saves having to unseal rolls to find out what you have lying loose in your gadget bag after a day's shooting.

70mm film is available in 50- and 100-foot rolls for use in special film backs and aerial cameras. It is the medium-format equivalent of bulk film and is particularly useful when a large number of photos must be taken in rapid sequence. It is frequently used in conjunction with a motorized camera. School photographers who must photograph every person in a high school graduating class, aerial photographers, and industrial photographers are the most frequent users of this film. A variety of general and special purpose color and black-and-white emulsions are available through dealers that service professional photographers.

INSTANT FILMS

More than half the amateur photos taken today are made on instant print film. Professionals also rely heavily on instant photography to make both test shots and high-quality originals.

Instant photography is essentially medium-format photography. Although Nikon at one time offered the Speed Magny back for use with Polaroid pack and sheet films, the medium has never been successfully adapted for convenient use with 35mm cameras.

If you want to get involved with instant photography, you can either buy an instant camera, some of which are fairly sophisticated, or use an adapter back in conjunction with a medium-format camera or viewcamera.

There are four types of Polaroid film available today—roll, sheet, pack, and SX-70. Among them you can find at least one type that will fit any Polaroid camera ever made, so in theory no Polaroid camera or adapter back is obsolete. On the other hand, older Polaroid cameras take only roll film, which is usually not carried at film counters. Complete instructions for using Polaroid film are packed with the film.

In the roll-film system, you pull a large tab sticking out of the camera back. This breaks the developer pod and mates the negative material with the positive print or receiver material. After 30 seconds to two minutes, depending on the film type, you open the camera back, peel off the print and tear off the waste material. Close the back and you are ready for the next exposure. Today, Polaroid still makes roll-film backs for use with its MP-4 copy camera system. Although the roster of roll films includes only black-and-white films, it does include two transparency films that are unavailable in any other format.

Pack films are also peel-apart films, but the material is packed into a plastic magazine. There are two pack sizes available, one with a 3¼″ x 4¼″ format and one with a square 3¼″ x 3¼″ format. Load the pack into the camera back with the cut-out side facing the lens. Close the back and pull the black tab (safety cover) all the way out of the camera. You are now ready to make your first exposure. To develop the film, pull the

Scientific Data Recording Instrumentation Utilizing Polaroid Film

Acoustic holography equipment: creates a three-dimensional graphic representation (hologram) of the material under study, using ultrasonics as the tool. The hologram is made directly on film.

Computerized axial tomography equipment (CAT scanning): creates a cross-sectional representation of the patient using x-rays. This medical diagnostic device produces its CAT image on a CRT display, which is photographed.

High-speed (streak/framing) cameras: take pictures of an event at a rate equal to 7,000,000 or more frames per second. Data is recorded directly onto film.

Interferometers: measure surface integrity by generating a fringe pattern contour map of the surface in question, using light as the tool. The fringe pattern is focused directly onto the film to record it.

Oscilloscope cameras: take pictures of electronically generated luminous phosphor traces directly from a cathode ray tube (CRT) display.

Photomacrography equipment: photographs a subject with a simple camera system with one lens, usually from 1:1 to magnifications of 25x.

Photomicrography equipment: photographs through a microscope, using the microscope optics generally with no camera lens at all.

Radiographic (x-ray) equipment: determines the internal structure of an object using x-rays. The data can be represented on a CRT or can be exposed directly onto the film.

Scanning electron microscope (SEM): creates an image giving an almost three-dimensional perspective of the subject matter by the scattering and absorption of electron beams. SEMs are capable of magnifications of over 300,000x, and resolution of up to 30 Angstroms. The graphic representation of the item under surveillance is produced on a CRT.

Spectrographic equipment: analyzes the chemical nature of a substance or surface by evaluating its spectra. The representation of the spectra is usually photographed from a CRT display.

Thermographic scanning equipment: produces a graphic representation of the heat profile of a subject on a CRT display.

white tab out. This brings the negative material around to the back of the pack and mates it with the print receiver material. Next, grip the yellow tab at the center and pull it out straight all the way out of the camera. After allowing it to develop the recommended time, quickly separate the print from the rest of the paper by starting at one corner near the tab end and peeling it away. For best results, follow the instructions packed with the film.

Polaroid 4″ x 5″ is sheet film for use in sheet-film holders such as the Polaroid #545 and the older Polaroid Model 500. These holders fit into any standard viewcamera back designed for sheet-film holders. There are also specialty cameras designed for scientific, industrial, and medical applications that will accept Polaroid 4″ x 5″ film. Complete instructions for use are supplied with the film.

SX-70 film is the first truly one-step material ever developed. There is nothing to peel apart and no waste material. It comes in ten exposure packs that include a wafer-thin battery that operates the camera. At present, only cameras designed specifically for this film can use it. Adapter backs for medium-format and viewcameras are not available. To use this film, just slide the film pack into the camera and close the door.

Kodak manufactures one instant film—PR-10—for use in Kodak instant cameras, and in the PR-10 film back which can be used with any camera that accepts Graflok accessories. The film is also a one-step system with no waste. The principal difference between PR-10 and SX-70 film is that PR-10 uses organic dyes and a horizontal format whereas SX-70 film has metallic dyes and a vertical format.

Defects: Studies have shown that most problems with instant pictures are the result of improper film handling by the user. With roll and pack films, the most common problem is dirty rollers, which can produce streaks, spots, and a variety of other interesting patterns. A frequent problem with roll and pack film is improper tab pull—too fast, too slow, or at an angle.

Hold film packs by the edges when you load them. Squeezing the pack can cause part of the SX-70 picture to disappear. If an SX-70 camera does not eject the film cover or the film, the battery may be weak or dead. As a general rule, it's a good idea to use SX-70 film soon after purchase. Letting it sit in the camera just gives the battery time to die and the result is lost film.

Instant Black-and-White Films

ASA 3000 films: These incredibly fast films are ideal for making low-light hand-held photos and for getting extreme depth of field in brightly lighted situations. Although the grain is more apparent than with slower instant films, image quality is reasonably good and perfectly adequate for same-size reproduction in magazines or newspapers. It is a good choice for photojournalists working with a medium-format press camera or Polaroid Reporter Camera. Use it whenever extremely small apertures or very high shutter speeds are required.

Type 107 pack film, Type 47 roll film, and Type 57 4″ x 5″ film are the classic, high-speed Polaroid films for general available-light photography and such special applications as high-speed motion analysis, crystallography and oscillography. After the prints are peeled away from the developing packet, they require coating using a coater supplied with the film. Seven or eight overlapping strokes with medium pressure does it. If the plastic-impregnated coater has been used a few times, then press down to squeeze some out before stroking it over the print. Coat all the way to the edges and keep the coater clean. These prints must be coated or they will deteriorate rapidly.

The negative material is designed to be thrown away. Using special conservation techniques, some forensic laboratories can salvage the paper negatives, but the result is an inferior image suitable only for documentation purposes.

Type 667 and Type 87 Coaterless films are ideal for public relations photos and other applications such as photojournalism where speed and convenience outweigh cost. The smooth hard surface that appears automatically requires no extra coating. This is a real boon for those legions of photographers who have difficulty using Polaroid film coaters.

Positive/negative film: This film provides both a high-quality print and an extremely fine-grain negative with a resolution of 150 lines/mm that can be used to make reproduction-quality prints or enlargements up to 25X without objectionable graininess or loss of detail.

The exposure that produces a good print with this film generally produces an underexposed negative. Most photographers feel that to get a good negative from Type 55 P/N, the 4″ x 5″ film, you need to give an extra one- to two-stop exposure. Some photographers feel that the exposure that produces a good print with Type 665 P/N pack film also produces a printable negative; others prefer to give the negative one stop more exposure.

After you take the picture, peel apart the print and negative. The print should be coated. The negative has a black chemical layer over it that must be bathed away by soaking in a mild solution of sodium sulfite, available in most

photo stores, and water (16 ounces sodium sulfite per 3½ quarts of water). A hardening solution that gives the negative a bit more durability can be made by mixing 1 ounce (30 grams) potassium alum, and 3 ounces (90 grams) sodium sulfite in a quart of water. Polaroid sells a bucket to hold the negatives. You can store up to eight per bucket, because it is designed so that the negatives do not touch. If you use a hardening solution, liquid-tight plastic containers are more convenient, because they do not spill. Select a container that holds the negatives rigidly in place so that they do not scratch one another. Let the negatives soak at least one minute in a 12 percent sodium sulfite solution and 15 to 20 minutes in the hardening solution. You can keep the negatives soaking several days in sodium sulfite solution without harming them. Once back in the studio, wash the negatives for about five minutes in constantly running water. For this, you can use the Polaroid bucket, cut film holders in a tank, or cut film developing tank, or hold the negatives under running water from the faucet.

The contrast range of P/N film is about seven stops from detailed black to detailed white. It has a speed of about ASA 50, but you may want to adjust this up or down as you try for either a good negative or a good print.

Transparency films: Type 46 L is an 800 ASA-equivalent roll film that produces a continuous tone transparency in two minutes. Type 146 L is a high-contrast transparency roll film with an ASA equivalent of 200. The slides should be dunked in a Dippit hardening bath after they have dried. This bath is available from Polaroid.

The 3¼" x 4" format is the lantern slide size, used in large auditorium projectors. One slide can also be cut up into four 35mm-size slides and bound in standard 2" x 2" mounts. This could be useful if you wanted to photograph black-and-white prints for presentation in a 35mm-slide show.

By varying exposure, a variety of densities can be achieved. The resulting transparencies can then be rephotographed in various combinations on a light box to yield posterization and bas-relief effects in either color or black and white. (See Chapter 10.)

High-contrast film: Type 51 is a 4" x 5" sheet film with a daylight speed of 320 and a tungsten speed of 125. It produces intense blacks and clean whites. It is designed for making copies of line artwork, recording scientific data, and for special graphic and artistic applications such as tone separation and silhouetting.

Medium-speed films: Type 52 is a 4" x 5" sheet film with a speed of 400 ASA that produces detailed prints with a wide tonal range. The prints may be copied and enlarged up to three times with reasonably good results. Type 42 roll film (3¼" x 4¼" format) and Type 32 (2¼" x 3¼" format) are 200 ASA general-purpose roll films that yield pictures with good detail, fine grain and fairly wide tonal range.

Recording films: Type 410 is a high-contrast roll film with a speed of 10,000 ASA. It is designed for making oscilloscope trace recordings and other high-speed or low-light applications. Type 084 is a 3000 ASA pack film with medium contrast that is especially designed for CRT recording applications.

Instant Color Films

Polacolor 2, an improved version of the original Polacolor Land Film, uses the same fade-resistant metallic dyes found in SX-70 film. Available in both pack-and sheet-film versions, this film produces rich, saturated colors and an extremely fine-grained image. Its pictorial qualities are legend, and Polacolor 2 originals hang on the walls of museums throughout the world. Its applications range from advertising and industrial photography to legal documentation and portraiture.

This film is balanced for average daylight, about 5500 K, and its speed is 80 ASA (20 DIN). Since processing time and temperature affect the color balance of the film, it should be processed according to the instructions packed with each film. The accompanying chart provides a rundown on the current Polacolor 2 films and their applications.

Selection and control of lighting is important because Polacolor 2 is capable of recording only a narrow brightness range. Polaroid recommends a detailed highlight to detailed shadow ratio of no more than 1:12. This means that there should be no more than 3½ f/stops difference between the darkest and lightest areas in which you expect to get detail and rich color. For portraits, keep the main- to fill-light ratio on the face about 2:1 or approximately 1 f/stop difference between fully lighted highlight and shadow portions of the face.

Controlling color saturation with Polacolor 2: The color quality of the Polacolor 2 image can be manipulated by changing development time and using color-compensating filters. The subtle variations in color saturation and warmth or coldness can sometimes make the difference between a simple document of a flower or face and an original that vibrates with that magical quality that we sometimes call art.

When a Polacolor 2 print is developed according to the time and temperature recommendations supplied with the film, the result is the most natural appearing

POLACOLOR 2

Film Type	Format	Applications
58 film packet, single exposure, (10 per box)	4″ x 5″	For use with any camera that accepts a Polaroid sheet film back. Polaroid 4x5 Land film holder, also called a Polaroid sheet film back.
108 film pack, 8 exposures	3¼″ x 4¼″	For use with any Polaroid Land pack film back for a medium-format camera and in Polaroid and pack film cameras, CU-5 cameras, and instruments equipped with a pack film adapter.
668 film pack, 8 exposures	3¼″ x 4¼″	Designed specifically for use in ID camera, passport camera and miniportrait cameras. Gives optimum flesh tones with electronic flash.
808 separate negative and positive units, single exposure (10 per box)	8″ x 10″	For use with Polaroid 8x10 Land film holder and Polaroid 8x10 land film processor. Can be used with standard 8x10 view camera.
SX-70 SX-70 film pack, 10 exposures		For use with any SX-70 film camera, including SX-70, Sonar One Step and Pronto! models.
PR-10 PR-10 film pack 10 exposures		For use with any camera designed for PR-10 film pack, including Kodak EK-4, EK-6 and PR-10 Graflok back accessory.

image of which the film is capable. But the developing process can be altered.

Under normal developing conditions, the three layers of dye-linked molecules migrate in marching order—yellow, magenta, and last of all cyan. When the print is stripped from the negative, development is stopped, and the three color layers balance.

If the print is stripped away early, the cyan layer will not have completed migration from the negative to the print and the result will be a warm, magenta cast. If the development time is allowed to continue past that recommended, the print begins to take on a cyan cast and at the same time the overall color saturation of the print increases.

To get maximum color saturation without a cyan cast, use a red or magenta color-compensating filter and increase development time up to 100 percent of that recommended in the film instructions. Try starting with CC20M or CC20R, 90-second development at 68° F, and an additional ⅓ stop exposure to compensate for the filter density. Some photographers have also had luck using a CC30M or CC30R filter and a two-minute development. Stronger filtration tends to hold back other colors that are needed for a rich, full spectrum.

Extended development is particularly effective in late afternoon sunlight. Natural light indoors is also suitable, although you may want to decrease development time slightly. Each lighting situation will require slightly different developing times. Shade or indoor window light is naturally cool. If you use a magenta or red filter and extended development, the time required will be less than it would be for warm sunlight.

In shade, you can also skip filtration entirely and underdevelop

slightly to get a warmer tone.

SX-70 film: Designed for use in Polaroid SX-70, Pronto!, One-Step and Berkey Wizard cameras, it yields ten exposures per pack. The original version took about five minutes to develop and the emulsion remained soft for a half hour or so. The most recent version develops in about one minute and the emulsion hardens quickly.

Experimentally minded photographers discovered that the soft emulsion could be manipulated by pushing at it with a stylus, a spoon handle, or even an old dental tool. By pushing the emulsion around as it hardens, a variety of abstract patterns can be achieved. But it is harder to do now than it was at first, because the film hardens more quickly.

Other tricks have also been done with this film. For example, you can record a microwave pattern by exposing the film to some solid color and then putting it briefly in a microwave oven. But do not leave it in the oven too long. The microwaves will excite the metallic dyes and the film packet could explode.

PR-10 film: This film for Kodak instant cameras produces rectan-

gular color prints. The current improved version of this film begins to show an image in about 30 seconds and a judgment about exposure can be made in about a minute and a half. Overall print size, including the border is 3¹³⁄₁₆″ x 4″. The actual image size within the borders is 2⅝″ x 3⁹⁄₁₆″. To promote proper development when the temperature drops below 60° F, put the prints in a warm place, such as an inside pocket, and leave them there during development. Otherwise your prints may appear too light. When temperatures approach 100° F, you may have to lighten exposure somewhat to keep the prints from becoming too dark. PR-10 prints look lighter in direct sunlight than they do under normal room lighting.

Each picture is a sealed unit that contains a caustic fluid that can cause alkali burn. If you tear or puncture the picture unit, the fluid may leak out. If it gets on your skin, just wash it off. If it gets in your eyes, immediately flush with plenty of water and get medical attention. Eventually the chemistry dries, so with old prints, tears and punctures should not be a problem.

6
FILM TRANSPORT AND SHUTTER ACCESSORIES

The trick to loading a 35mm camera so that the film will not slip as you advance it is to make sure the sprocket teeth engage the perforations on both sides of the film. Use your finger tips to feel the teeth as they come through the holes. Then close the camera back and advance the film three frames.

This chapter is concerned primarily with film-handling technique and accessories such as motor drives, autowinders and special film backs that make it possible to use more kinds of film with greater ease than ever before. It also includes information on shutter accessories such as cable releases, intervalometers, and remote control devices that make it possible to expose and advance film without actually touching the camera.

FILM LOADING

Not all the film-loading tricks are covered in camera instruction manuals. Although the sections that follow on 35mm- and medium-format camera loading will not replace your instruction manual, they will supplement it with a few simple techniques that make film loading faster and more positive.

There is also a section on loading your own 35mm magazines. Bulk film for the load-em-yourself-

ers is half the price of factory-loaded 35mm magazines, so the payoff is substantial if you shoot a lot of film.

Loading a 35mm Camera

The easiest way to load a 35mm camera is to drop the magazine into the camera, lock it in place by pushing the rewind shaft down, then draw the tongue of film across the camera, and insert the film into the take-up spindle. If the film has a tendency to slip out of the take-up spindle when you operate the film advance, help the film along with your fingers, guiding it so that the sprocket teeth engage the perforations on the edge of the film. Keep the film winding onto the take-up spindle until the perforations on both the top and bottom of the film have engaged the sprocket teeth. Make sure the teeth are properly engaged by using your fingers to feel the teeth as they come up through the sprocket holes. Next, close the camera back and make two blank exposures. The next time you advance the film, you should be able to make exposure number one.

Unloading 35mm Film

Most 35mm cameras have a button on the bottom that you must press before you can rewind film. Cameras with autowinders and motor drives sometimes have a lever on the motor that will press this button when the motor is attached so that you can rewind film without removing the motor. Large motor-drive units have automatic rewind.

When you rewind by turning a rewind crank, a sudden release of tension on the crank signals that the film is no longer on the take-up spindle. At this point you can open the camera back safely, although most photographers prefer to give the crank three or four extra turns to make sure the film is rewound completely into the

You should develop a system that lets you distinguish exposed from unexposed rolls. The roll at left is unexposed. The roll in the middle has been partly exposed, then rewound and removed from the camera. A crease in the tongue indicates that it has been exposed. The number of exposures made are written in ink on the tongue. The roll at right has been fully rewound into the magazine to indicate complete exposure.

magazine. If you leave a tongue of film protruding from the magazine, crease it sharply as an indication that the roll has been exposed.

To change film in mid-roll and salvage the unexposed portion of the film, note the number of exposures made, then rewind until you feel the film release from the take-up shaft. Remove the film from the camera and write the number of exposures made on the tongue. When you are ready to reload this magazine, load normally, then with a lens cap on and using a high shutter speed, advance the film through the camera until the film counter indicates one more exposure than the number written on the tongue of the film.

Jammed film: If the film jams and you cannot rewind the film, take the camera into a dark room or put it into a changing bag, open it, and pull out the film by hand. If you are lucky, you may be able to get the rewind crank into operation again. If not, roll up the film and find some light-tight container for it. Your best bet is to keep it in a spare film magazine, described in the following section. If you put it into an empty film can, keep the can in an inside pocket of your jacket, gadget bag, or purse. You can wrap the film can in a dark cloth for extra protection.

Opened camera back: If you accidentally open the camera back before you have rewound the film, close the back immediately. Film is reasonably opaque, and if you are quick about closing the back, you may be able to salvage most of the shots on the roll, because the top layer of film on the take-up spindle will absorb most of the light.

How to Load Your Own 35mm Magazines

Bulk 35mm film is available in 50- and 100-foot rolls that cost less than half what you would pay for a similar amount of factory-loaded film in 135 magazines. If you shoot fewer than 20 rolls per year of any one film type, then you are better off sticking with the prepackaged magazines. If you are one of those photographers who runs through ten or more rolls of Plus-X or Tri-X every month, read on. You may want to consider loading your own.

The accompanying illustrations show the basic steps for loading by hand and with a film loader. A film loader is best, and you will probably save enough with your first 100-foot roll to pay for the loader.

The standard load lengths are 12, 20, 24, and 36 exposures. A 36-exposure load is about 4 feet, which means you can get up to 25 36-exposure loads from a 100-foot roll of bulk film. Do not exceed 36 exposures per magazine. If you go over 36, the film may be damaged by squeezing and you will have extra frames that will not fit on a standard contact sheet or in a standard negative preserver page.

You can buy empty magazines in most photo stores and some brands of black-and-white film, such as Ilford, come in reusable magazines. Kodak magazines can not be reused. Do not try to get too much mileage out of your magazines. Keep the light traps clean, and if a magazine scratches your film or leaks light, throw it away.

Make labels for magazines so that you can keep track of the film type. A piece of masking tape will do. You can write on it with any pen. A piece of Scotch Magic Transparent Tape over the masking tape will keep the ink from rubbing off. If you keep bulk film in your film loader, label the loader as well.

Keep loaded magazines in a plastic bag or in plastic film cans until ready for use. After exposure, put the magazines back into a sealed container until you are ready to have them processed. Do not let reusable magazines lie loose in your pocket, gadget bag, or purse. The light traps will pick up grit, and the next time you use the magazine, it could scratch your film. Keep empty magazines stored in a dust-tight plastic box or bag.

You can clean the light traps of your magazines with a small vacuum cleaner or a blast from a can of Dust Off. You can lift off grit by pressing the sticky side of a piece of tape against the felt.

Loading 120 and 220 Film

Most sophisticated medium-format SLR's take film inserts or have detachable backs. The film is

Bulk 35mm film comes on a spool in 50- and 100-foot lengths. The film is sealed in a plastic or foil pouch inside a tape-sealed film can. Open the can only in total darkness. Save the can, pouch and tape in case you want to put the film back into the can at some point.

This is a typical bulk film loader, with the cover off to show the film path. The emulsion side always winds inward, so that it faces the core of a roll or film spool. It has a natural curl in the right direction. That's how you can tell which side is which.

A reusable 35mm magazine has three parts, an outer shell with light trap, a spindle, and a removable top.

Before you begin bulk loading, make sure the light trap in the cassette is clean. You can either blast it with "canned air" or use a piece of transparent tape to pick up grit and lint from the felt trap. Dirty light traps scratch film.

Attach the film to the spindle with a two-inch length of tape.

Press about half an inch of tape on one side of the film, wrap the tape around the spindle, and press the remaining half inch onto the other side of the film. If you hold the film so that it feeds from the bulk roll on your right to the spindle on your left, then the end of the spindle that protrudes from the cassette will be toward you.

Slide the spindle into the cassette and seal the top. Most reloadable cassettes have a twist-on top.

Put the cassette into the film loader, close it up, and turn the film-loader crank to wind the film into the cassette.

Some loaders have an audible click, approximately one per frame, so that you can count off the number of frames on the roll. Do not wind on more than 36 exposures.

Remove the loaded cassette from the film loader and cut the film so that a squared off end protrudes from the loader.

Draw out the end of film that protrudes from the cassette until you have about three or four inches of film. Cut this into a tongue shape, as shown. Cut between the sprocket holes, not into them.

Label the cassette with the film type. You can make the label with a small piece of masking tape.

loaded onto a special holder or insert that fits into the back of the camera, or you may load the back itself.

The trick to loading a detachable back or film insert is to keep the dark side of the leader positioned so that it will face the lens when the insert or back is fitted to the camera. Place the roll into the film chamber of the back or insert and draw the leader across the pressure plate with the black side out. The tongue of the leader goes into a spool in the take-up chamber. Wind the film up until the arrows on the leader align with an index mark somewhere on the back or insert. At this point you can close the back or put in the insert and advance to the first frame.

To protect preloaded backs or inserts while they are in your gadget bag, keep them in plastic sandwich bags.

Twin-lens reflex cameras and backs with straight film paths load by keeping the black side of the film roll toward the lens. Advance the film until the arrow aligns with an index mark in the back. Close the back and advance to the first frame.

In addition to the large arrow that aligns with start marks in modern cameras, the paper backing on roll films contains three rows of numbers that can be seen through the red window in the back of some older roll-film cameras. When you advance film through a camera of this type, the first thing you see through the safe window is the outline of a hand. This indicates that the end of the film is just about to enter the negative area. From this point on, opening the camera or releasing the shutter will expose the film. After the hand comes a series of warning dots followed by "1," which indicates your first exposure.

Some cameras and old adapters that take the 4.5 x 6cm format pictures have two windows. Each number appears twice, once through each window. To get 16 exposures per 120 roll, make an exposure with the numbers in both positions.

CAMERA BACKS

Many of the better SLR systems include interchangeable camera backs. For the 35mm SLR, there are data backs, which imprint data into a corner of the film, and 250-exposure bulk-film backs. For medium-format SLRs there are Polaroid instant-film backs and bulk-film backs for 35mm, 46mm, and 70mm film rolls.

250-Exposure Backs

The 250-exposure bulk-film is used primarily for sports, audiovisual, surveillance, and scientific photography. Because it is bulky, it is used almost exclusively with tripod- or stand-mounted cameras.

To use a 250-exposure back, you must load bulk 35mm film into special cassettes that are made up of three parts—a spindle, an inner shell, and an outer shell. The inner and outer shells lock together with a twist to form a light-tight chamber for the film.

Although you could load the cassettes by hand, winding up 33 feet of film onto a spindle by hand is quite a job. A film winder greatly speeds the operation. A typical film winder holds both the roll of bulk film and the spindle. It can be preset for any desired

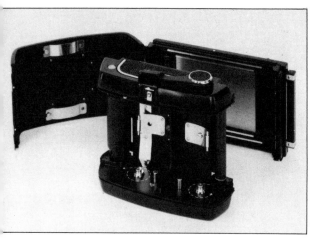

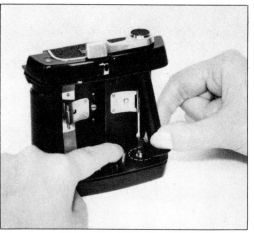

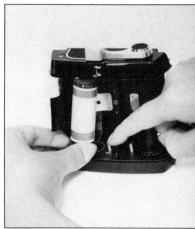

This sequence shows how to load a 120 or 220 film insert (bottom). The loaded insert goes into the camera back (top), which may be detachable, as with this Mamiya RB-67 equipment, or fixed. Most modern medium-format SLRs use the film insert system.

1. Insert an empty take-up spool into the take-up chamber. Any spool from a roll of 120 or 220 will serve.

2. Insert the film roll into the left-hand chamber. The name of the film, which appears in large letters on the paper leader, should be right-side up.

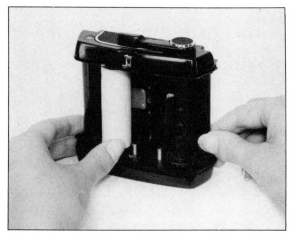

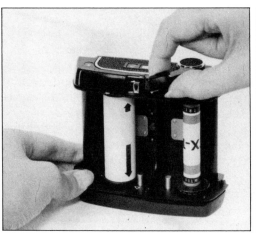

3. Draw the paper leader around the front of the insert and insert the tongue into the take-up spool. The black paper side of the leader should be facing outward, so that it will face the lens when the insert is placed into the back of the camera.

4. Use the wind lever or knob on the insert to wind the film up until the arrow on the paper leader aligns with a start mark on the insert. You are now ready to put the film insert into the camera back. If you have extra inserts, you can keep them preloaded in plastic sandwich bags.

The difference between exposed and unexposed rolls of 120 film is obvious. The word "EXPOSED" is printed on the paper backing and some manufacturers also use a different color paper at the end of the roll.

The various numbers on the paper backing of 120 film are used with cameras that have a small window on the back. Modern medium-format SLRs are completely light tight and film advance from one frame to the next is controlled mechanically by the film-wind mechanism. The arrows and numbers are still there for users of obsolete equipment.

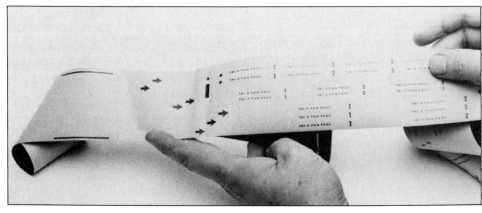

To seal a roll of exposed 120 or 220 film, bend back the black tab, lick the glued strip attached to the paper, and press down. Always seal the roll as soon as you take it out of the camera, before you load another roll. If you let it stay loose, it can unwind and get fogged.

Medium-format SLRs frequently have a dark slide in the back. Interlock mechanisms in many designs make it impossible to release the shutter unless the dark slide is removed. This same interlock makes it impossible to remove the back unless the dark slide is inserted. It's a safety feature that takes some getting used to.

Medium-format 120 and 220 roll film is often available in five-roll pro-packs. Each roll is individually sealed in a foil pouch, where it should be left until you are ready to load it into your camera. Individual pouches are identified by code letter only, so if you use more than one type of film, learn to identify the film type by code.

number of exposures up to 250.

There is no rewinding of bulk film. The loaded cassette is placed in the film chamber and the tongue goes into the spindle of a second cassette. The spindle goes into a pair of inner and outer shells that are locked together to make a take-up cassette, which goes into the take-up chamber. The take-up cassette is light-tight and is used to store exposed film until it is processed.

Processing bulk film requires special 250-exposure film reels, or a continuous processor. If you do not have a suitable processing system, make arrangements with a professional lab to do the processing for you.

Data Backs
A data back turns your camera into a tool for documenting the condition of people, places and things and for keeping track of

changes over a period of time. Among the manufacturers who offer data backs for some of their cameras are Canon, Minolta, Nikon, Olympus, and Pentax.

The typical data back contains a variable-power projection lamp that projects data onto the film at the same time you take your picture. The power of the lamp is controlled by an ASA dial on the back, which you should set to the

speed of the film you are using to prevent under- or overexposure of the data.

There are two popular types of data back. One lets you dial a set of numbers, such as the date or some coded combination of numbers and letters. The other projects the image of a watch or data plate into a corner of the film. Cameras specifically designed as data cameras, such as the Pentax Data MX, have a small shield plate built into one corner of the film aperture to keep a corner of the frame unexposed. The data is projected into this unexposed area. Cameras designed for general use project the data into the image area of the film. If you have a back of this type, try to compose so that you have a dark area in the lower right hand corner of the picture. The accompanying photo shows this type of composition used with a Minolta data back.

A data back is particularly useful for recording progress on construction projects, where the visual documentation can help resolve problems that may arise later in regard to penalty clauses, delays, schedules, and so on. The back can be used by doctors, dentists, and surgeons to record changes in pathology or the results of cosmetic work. It can be used to inventory property for insurance records, establish its condition, and record damage in the event of a loss. Use it to record water seepage in a basement, crop-growth patterns, traffic at an intersection, boat traffic in a marina, or even changes in your own body.

Polaroid Backs
The only Polaroid back for a 35mm SLR is the discontinued Nikon Speed Magny, which has an internal optical system that produces an exposure factor of about 18X. This means ASA 3000 film is being shot at an effective speed of ASA 170 with this system. The back can be used with either pack or sheet films, depending on the film holder, but only a few of the Nikon lenses will actually cover the entire format.

All other Polaroid backs are for use with either medium-format or large-format cameras. Most manufacturers of medium-format SLR's offer a Polaroid-pack film back as an accessory, and a number of the rangefinder press cameras will also accept Polaroid-pack film backs. Polaroid backs for a variety of medium-format cameras are also made by independent producers such as NPC Photo Division and Optical & Electronic Research, Inc. The format that you get with a Polaroid back will be determined by the format of the camera on which you put it, and with smaller formats, such as 4.5 x 6cm and 2¼" x 2¼" square, the size is so small that the originals are generally used only as test shots. P/N negatives in this size are quite satisfactory, however. Larger cameras, such as the Mamiya Press Universal and RB-67 provide a more usable format.

Backs for medium-format cameras are ordinarily pack-film backs. The roll-film type is currently available only for the Polaroid MP-4 camera, which is essentially a viewcamera. Sheet-film holders for Polaroid 4" x 5" film are technically not backs at all. They are special holders for use with cameras that accept standard 4" x 5" sheet-film holders.

There are a number of Polaroid-back cameras designed spe-

Data backs such as these examples from Minolta print a date or code number on the film.

cifically for scientific and commercial work. The group includes passport and portrait cameras and a variety of scientific instruments. For the curious, the accompanying chart gives a brief overview of scientific data-recording instrumentation that utilizes Polaroid film.

At the present time there is no accessory back for SX-70 film, possibly because the film must be exposed through the front, which would produce a mirror image unless the back contained a special mirror system like that used in SX-70 cameras.

Kodak PR-10 Back
Kodak manufactures a back for their PR-10 instant film. This back can be used on any camera that accepts Graflok accessories either directly or via a Graflok adapter. This limits its use to 4″ x 5″ view-cameras and a handful of press cameras. Most medium-format cameras do not accept Graflok accessories.

The Kodak instant back comes with an auxiliary groundglass focusing hood, which is necessary because the film is positioned about 1½ inches behind where it would be on all other film backs. The hood replaces the groundglass in the camera back. After focusing with the hood, you must remove the hood and replace it with the instant back. The system is designed for use with stationary cameras.

Medium-Format Bulk-Film Backs
Owners of medium-format SLRs are not restricted to using 120 or 220 roll film if there is a back available for long rolls. The most common long-roll size is 70mm, a film size that is also used in some aerial cameras. There are also backs available for some cameras that allow you to use 46mm- and 35mm-long rolls. Long rolls are used primarily by school and portrait photographers in situations where the camera can be mounted on a tripod or stand. Some backs will imprint a code on the film to aid the photographer in identifying subjects.

FILM TRANSPORT
Like electric can openers and dishwashers, autowinders and motor drives start out feeling like luxuries and end up seeming more like necessities. It wasn't too many years ago that photographers felt it was OK to advance film by turning a knob. If you wanted to advance the film quickly, you drew your thumb across the knob. Then the rapid advance lever took over and today all 35mm SLRs have a single-stroke advance lever. A skilled photographer can work one of these at speeds up to two frames per second, but the camera bounces around a lot. The motor drive has eliminated the bounce and made film advance smooth and effortless. If you haven't yet looked into automated film transport, you're in for a pleasant surprise.

Motor Drive and Autowinder Features
State of the art advances in motorized film transport have blurred the distinction between motor drives and autowinders. In general an autowinder is a light-duty device designed to move film through the camera at a maximum rate of two frames per second. It usually has a battery chamber as part of the unit, with no provision

This Polaroid back is designed for the medium-format RB-67 camera. If you have a medium-format camera that features interchangeable backs, you will probably be able to find a Polaroid back that fits, either from the distributor of your camera or from an independent manufacturer.

for separate power sources and occasionally no provision for remote operation.

A motor drive usually gives you a choice of power sources, can be operated by remote control, and will move film through the camera at maximum rates of two to nine frames per second, depending on the design.

This convenient distinction between autowinder and motor drive is not always followed by manufacturers when it comes time to describe the equipment in their catalogs. If your camera accepts either winder or motor and you are trying to decide which to buy, keep in mind that some manufacturers have units they call motor drives that actually work like autowinders and autowinders that behave more like motor drives.

Motor Drive Accessories
Most motor-drive systems offer a choice of power supplies and various remote-control systems.

The battery pack is usually a flat battery holder or NiCad battery pack that attaches to the base

This shot of construction work in progress is typical of the uses to which a data back is put. The date appears in white in the lower right-hand corner of the print. Note how the photographer composed so that the numbers appear in a fairly dark area of the image. If they had fallen on the light toned wood, they might have been harder to read. Photo courtesy of Minolta Co.

of the motor drive. Use it when you have a motor drive with hand grip attached and want a highly mobile camera.

The battery grip is usually a pistol grip that screws into the base of the motor drive, although in some designs, such as the Canon F-1, the unit serves as a hand grip at the side of the camera. A camera with a grip at the side is easier to put into a gadget bag than a camera with a pistol grip.

When used with today's lightweight cameras, a pistol grip battery holder may seem unnecessarily heavy. On the other hand, a pistol grip with shutter trigger provides extra stability for slow shutter speeds and telephoto work.

For remote operation, you can usually buy power cords that attach the battery pack or grip to the motor drive. This setup is useful when you have a tripod- or stand-mounted camera. It lets you work with the subject while you stand away from the camera and take pictures without touching the camera by using the trigger on the grip. This is particularly useful when you have a carefully focused and composed subject, or have precisely aligned the camera for extreme close-up or copy photography.

In cold weather, you can keep the battery pack or grip in your pocket. This keeps the batteries warm and extends battery life. In some systems, you can get a remote battery pack that serves the same function, but the typical remote battery holder does not have a trigger, whereas most battery grips and many battery packs do.

AC power supplies are ideal for audio-visual setups and laboratory work when the camera must be operated for long periods of time. They are primarily a tool for scientific and technical photographers. The better units of this type also function as interval timers for time-lapse studies. Some will even recharge your NiCad battery pack.

Other accessories commonly considered part of a motor-drive system are bulk-film backs, data backs, intervalometers, and wireless remote triggers, all of which are covered elsewhere in this chapter.

Buying Motor-Drive Accessories

Camera manufacturers are no better than automobile makers when it comes to interchangeability of accessory items. When a new model comes out, new accessories often come with it, and an intervalometer, battery grip, or remote cord for an old model may not fit the new one.

Unless the accessory is specifically designated in the dealer catalog or instruction book as fitting your model, do not buy it without checking further. The following are some of the more typical variations you are likely to run across:
1. Different body dimensions
2. Different coupling mechanisms
3. Different size accessory jacks
4. Different operating voltage
5. Different torque specifications

If you are buying used equipment directly from an individual owner, you can check compatibility by calling or writing the manufacturer's customer service department.

Manual Film Advance

The only problem with modern rapid-wind levers on 35mm cameras is the photographer's failure to completely advance the film with one stroke. It happens mostly with cameras that require a very long throw of the lever and the only remedy is practice.

If you have a camera with a very thin wind lever that feels uncomfortable, you might try looking for an enlarged thumb pad to slip over the wind lever. This accessory is a rarity because most modern cameras do not need it.

The film crank used to advance film in medium-format SLR and twin-lens reflex cameras is not a rapid system. For fast manual film advance, you need an accessory speed grip, which is available for many of the better roll-film SLR cameras. Two strokes are required to operate the wind lever on a speed grip. A one-stroke system is not used with 120-size film because the drag would be too heavy and could damage the film. Roll-film camera backs with a rapid-wind lever also require two or more strokes for film transport.

When you have the camera on a tripod, it is next to impossible to manually advance the film without making some slight change in camera position. As a safety factor, recheck focus and composition after each film advance. Holding the camera stable with one hand while you advance the film with the other also helps.

Motorized Photography Techniques

Motorized film transport is a primrose path that can lead to thousands of unnecessary shots. It is all too easy to respond to the excitement of the moment with a good subject and find you are burning up film faster than you ever thought possible.

Keeping the mode-selection switch on single frame, usually indicated by an "S," limits the number of shots you make, but it also prevents you from shooting in bursts when the action calls for it. If you learn to develop a light touch in the continuous-frame mode, you can shoot single shots or bursts at will.

The single-frame mode is most useful when you are using electronic-flash units that do not recycle fast enough to permit shooting continuous sequences. For photographing children, pets and

One makes it, one doesn't. These two five-shot sequences of white-water racers on the Esopus River were made at 2 frames per second using a motorized Nikon FM with 50mm lens and Tri-X film. A sequential study of form is only one of many possibilities that open up when you have motorized film transport.

In the sequence on this page, you can see how the racer manipulates the bow of his kayak so it passes beneath the gate pole. This is a legal maneuver that requires great skill.

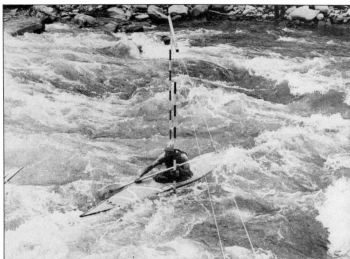

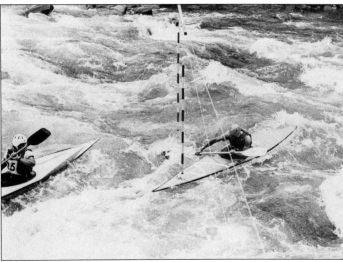

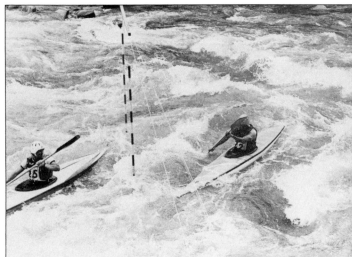

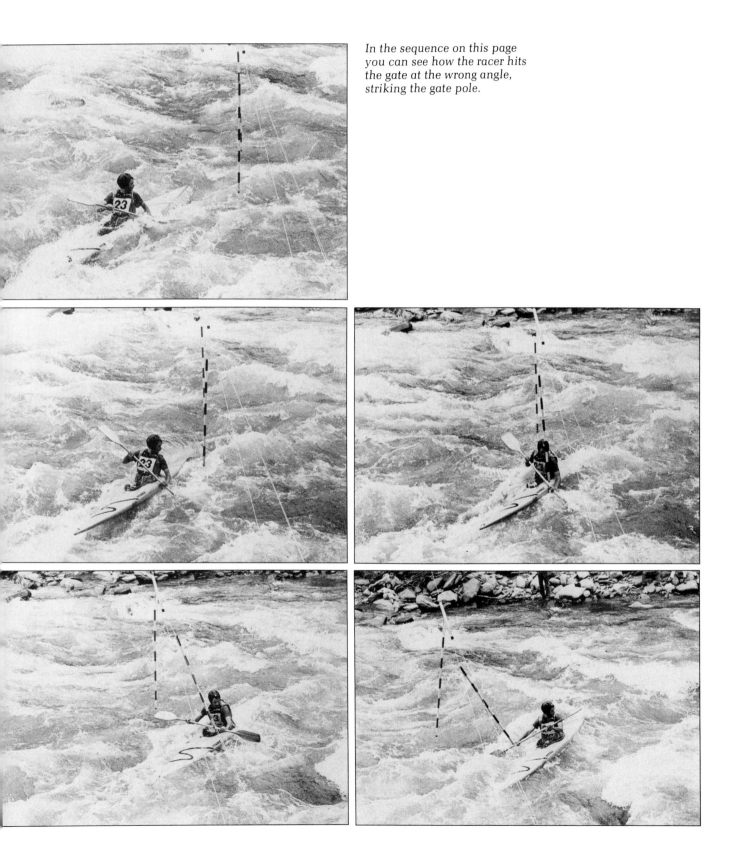

In the sequence on this page
you can see how the racer hits
the gate at the wrong angle,
striking the gate pole.

sports, a sequential mode is a better bet.

Portraits of children: The motorized camera with a remote trigger is the ideal tool for getting great portraits of kids. First, get the baby or young child comfortably and securely seated against some appropriate background. Put the camera on a tripod, focus and compose, allowing some room around your subject for movement. Now, with the camera triggered by long cable release or some other remote system, begin to work with the child to evoke reactions. As interesting expressions develop, press the release.

Sometimes it takes a bit of trickery to get the shot you want. For example, very young children just don't stare at flowers. If you want a shot of a kid looking with love at a flower, cup or any other object, try putting a jelly bean in it. To get a bright, alert look from a toddler, try rattling some pennies in a can, or quickly putting some shiny object within the child's reach but just outside the field of view of the lens.

Older children, from about age three on, will also respond to verbal encouragement, but don't expect them to follow directions. A spirit of play and a willingness to encourage playfulness in the child is the way to get those really big smiles that are a joy to parents and grandparents.

Portraits of pets: The techniques that work with kids can be adapted to photographing pets. A sudden, unfamiliar noise will attract the attention of most cats and dogs and give you a chance to capture an alert look. If your subject is a show dog, try to snap the shot at just that moment when the dog is showing his points to perfection.

Dancers and children at play: Today's lightweight, motorized cameras make it possible to use a wide-angle lens and work in close as you become involved in the play or dance activity itself. You can work holding the camera with one hand, and if you prefocus to some comfortable working range, such as three to ten feet, you can fire away without even worrying about focusing. The technique allows you to get physically involved with the action and to concentrate on timing, which is the key to good action shots. By becoming involved with the rhythm of an activity, you can anticipate the exact moments to trigger the camera. Once you have this technique working for you, good pictures just seem to happen naturally.

Sports action: When you work with a long lens at some distance from the action, try to anticipate movements and peak action. Keeping the camera in continuous operation during an end run or drive for a goal is no substitute for a precise sense of the action. Even at three or four frames per second, you are only taking tiny slices out of the duration of the action, so timing pays. And with only 36 exposures per roll, knowing what action is likely to be worth following can make a big difference. There is nothing more frustrating than burning up a roll of film on indifferent action only to find yourself loading up during the highlight of the game. If you know the end of a roll is coming up, and you see a lull in the action, you could be better off losing the last few frames on the roll and having a fresh load in the camera when the action starts up again.

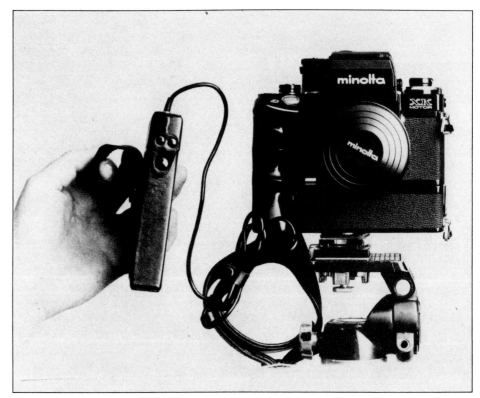

The external remote battery pack shown here is for cold weather use. You can keep it in an inside pocket and run the wires underneath your parka. The alternative is to keep your camera warm by holding it inside your coat and bring it out only when you are ready to shoot. Once batteries reach sub-zero temperature, they effectively cease to operate.

The plunger (top left) of this Vivitar cable release has a locking collar. If you turn the collar, the plunger will stay down when you press it. This position is used for time exposures when the shutter is set on "B." To release the plunger and close the shutter, turn the locking collar in the opposite direction. Some releases use a set screw to hold down the plunger, but the automatic locking-collar design is easier to use.

The tip of a standard Compur nipple cable release has two collars. Use the top collar to screw the tip into the cable release socket of the camera, then screw down the bottom collar to lock the release into the socket (below).

SHUTTER ACCESSORIES

Shutter accessories are indispensable to good photography. They let you make time exposures, work at a distance from the camera, trigger it automatically at preset intervals, or have the subject set it off. They include cable and wire releases, self-timers, intervalometers, and wireless remote-control devices.

Cable Releases

Every photographer needs at least one cable release with a locking mechanism for the plunger. It lets you make time exposure with the shutter set on "B," which is the only open shutter setting on most SLR cameras. Without the release, you have to keep your finger on the shutter, which inevitably introduces camera-shake blur into time exposures.

The typical cable release has a conical, threaded nipple, sometimes called a *Compur nipple*, that screws into the cable-release socket of your camera. Most 35mm SLRs have the socket located in the middle of the shutter button. Other camera types may have the cable-release socket on the lens itself or somewhere on the camera body.

If your camera does not accept a Compur nipple, you can probably find an adapter that will let you use this standard system. For example, Rowi sells a "Leica Cap" that permits Leica and Edixa cameras to use Compur nipple releases.

Cable releases are for use with manual shutter-release and film-advance systems. If you are working with a motorized camera, you will probably have to use a wire release, described in the following section.

Plunger-type cable releases generally consist of a piece of heavy wire wrapped in a flexible sheath with a nipple on one end and a plunger on the other. An important feature to look for in this type of release is a locking screw or ring that lets you lock the plunger down for long exposures. Some unlock with a twist, others by pressing down on the locking ring.

Extra long releases are usually air-operated (pneumatic). This type has a standard nipple with wire plunger on one end connected by a long air tube to an air bulb on the other end. The longer ones come on a reel that helps keep the tube from getting tangled.

An air release is very easy to operate. You can squeeze the bulb with your foot, your teeth, or any

A motor drive is a real help in candid photography because the camera is always set for the next shot. It lets you concentrate on timing and composition. This photo by Robb Smith was taken on Plus-X at 1/30 sec. with a 35mm lens.

convenient object. You can even put it under a board out of sight and step on the board to activate the release.

If the cable-release socket on your camera is not readily accessible, you can get a rigid cable-release extension that will stand out from the socket. Screw your regular cable release into the socket on the extension.

Some cable releases are designed to be used with a soft shutter release. The soft release screws into the cable-release socket in your shutter button and makes it

easier to put gentle pressure on the release. If you get this type, make sure the soft release will fit your camera.

Slow-Speed Timers

A slow-speed timer is used to make automatically timed exposures when your shutter is set to "B." For example, the Rowi Ultra Slow-Speed Timer will keep the shutter open for 2 to 32 seconds, depending on the setting. This timer screws directly into the shutter-release socket.

There are also slow-speed tim-

ers available that are attached to a cable or air release.

The use of a timer is generally more accurate than standing by with a watch while the shutter is held open with a locking-cable release. And it is a lot more convenient.

Timed Release

There are two types of timed-release accessory. One is the self-timer, a one-shot device that automatically triggers the shutter after a preset interval. The other is an interval timer, or intervalometer, that is used in conjunction with a motorized camera to make exposures at preset intervals.

The accessory self-timer is generally a spring-loaded device that presses the shutter automatically after some preset interval. You can use it in lieu of a cable release with a tripod-mounted camera or as a means of getting yourself into the picture. If your camera does not have a built-in self-timer, then this accessory is worth considering.

Putting yourself into family photos is more than vanity. Your camera is a tool for creating family history, and it is important to get yourself in the shots, particularly in family group portraits; no one should be left out because of operating the camera.

An intervalometer is used to activate a motorized camera at preset intervals ranging from seconds to hours, depending on the device. Some are attached to the camera via a power cord. Others attach directly to the motor drive. Since connections are not standardized, you should make sure the unit you plan to buy has a connecting cable available that is designed specifically for use with your camera model. On the other hand, an intervalometer is essentially nothing more than a clock attached to an electric switch. If you are handy, you could probably modify any intervalometer to work with any motorized camera that has a remote socket, or you could make your own interval timer.

The intervalometer is a tool for technical, industrial, and scientific photography. It is used to make recordings of oscilloscope patterns at preset intervals, to record rapid growth, and to make periodic records of an area or process.

Wire Release

The wire or "electronic" release is used with motor-driven cameras. One end plugs into the remote socket on the motor drive. The other end may simply be two terminals that you touch together when you want to activate the shutter or it may end in a button, which closes the circuit when you press it.

The type of release that has two terminals on the end can be lengthened by plugging the terminals into any household extension cord. To trip the release, short out the prongs or wires at the other end of the cord.

An electronic release can easily be worked into tripwire, trip board, and other triggering systems for subject-actuated photography. Any action that closes the circuit triggers the shutter.

The remote power supply with trigger release is another form of wire release, but in this case it also supplies the power for the motor drive.

Wireless Remote Control

For many years radio was the only practical remote wireless system, and it is still the only widely available method. But recently, infrared devices have been appearing that allow you to activate flash slaves, projectors, and motorized cameras with an infrared beam.

Radio control and infrared triggering devices are two-component systems. The receiver is attached to the remote socket of the motor drive. In order to use the unit, you need a connecting cord designed for your winder or motor, so check to see that the manufacturer of the unit you plan to buy has a cord for your camera. The transmitter has a trigger button. Press the button and you activate the camera, provided there is no interference with the radio or infrared beam.

One difficulty with using these devices professionally at large

Exposures at preset intervals are possible using a number of different camera systems. It's done using an intervalometer to automatically trigger a motorized camera. The device varies according to the manufacturer. Here, three different systems are shown (left to right). The Canon F-1 has a small interval timer that attaches to an accessory bracket on the motor. The Minolta has a timer that goes on an accessory shoe attachment and connects with the motor via a control cord. The Pentax ME system has a multi-purpose AC-powered unit.

For use with its F-1 SLR and power winder, Canon offers this wireless infrared remote trigger.

This Hawk remote system is widely used by professionals. The outfit consists of a radio transmitter, receiver, and power relay. Cords are available to connect the relay unit to most of the popular motor-drive cameras.

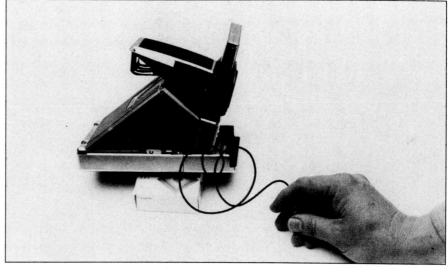

Whether you have a 35mm SLR with an autowinder or a motorized camera such as this Polaroid SX-70, you will probably need an electronic cable release. The one shown here is designed specifically for Polaroid SX-70 cameras.

This is a remote control cord for motorized Pentax cameras. The single connector attaches to the motor drive unit. To trigger the camera, all you do is touch the two probes on the other end of the cord together. This is the simplest, and most versatile, form of "electronic" cable release. For extra extension, just plug the two probes into a household extension cord and short out the prongs of the plug on the other end. But make sure some "helpful" assistant doesn't plug the cord into an electrical outlet. It could fuse the circuits of your motor into a metallic glob.

An external battery grip can be used as a remote release in some motor drive camera systems. It is convenient for studio and laboratory work.

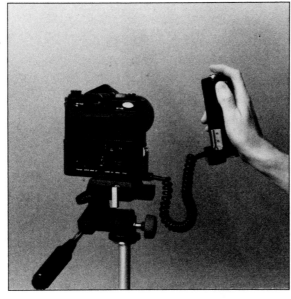

events is the possible presence of other photographers on the scene with similar equipment, which can trip all similarly equipped units in the area every time it is activated.

The typical radio control system has an operating range of about 250 feet and will operate at greater distances if there is a clear line of sight between transmitter and receiver. An infrared unit will operate in small rooms regardless of where the transmitter is pointed because the light will bounce off the ceiling and walls. Outdoors or in large auditoriums and long halls, the transmitter must be pointed directly at the infrared receiver. The maximum operating range for an infrared transmitter is in the neighborhood of 200 feet.

Radio and infrared triggering devices can be used to operate more than your camera. Any electronic device with a remote on/off socket can be connected to the receiver. Photographers sometimes use them to trigger flash units. One maker of an infrared device notes that you can use it to turn tape recorders on and off and activate automatic garage door openers.

7
CAMERA SUPPORT AND PROTECTION

No system is complete without some of those devices that help keep your camera stable and safe. Tripods and various tripod heads, straps, grips, chain and chest pods are only a few of the many options you have to improve stability. And to protect your equipment from the ravages of rain, dust, snow, sand, and travel, there are cases, gadget bags, and special housings.

CAMERA SUPPORTS

Camera supports range from a simple neck or wrist strap, through various grips and pods, to giant studio stands with built-in stairs. They all serve two basic functions: They hold the camera and they provide increased stability during long exposures.

Exposure Time

The single biggest cause of fuzzy pictures is camera shake caused by the use of slow shutter speeds and inadequate camera support.

Although there is no logical connection between shutter-speed numbers and focal-length numbers, it is a fact that the number of blurred photos due to cam-

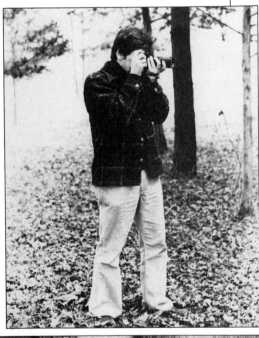
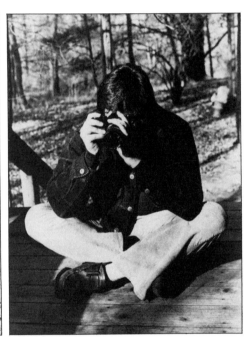

era shake rises dramatically when the shutter speed is less than twice the focal length of the lens. In other words, minimum speed for a normal 50mm lens would be 1/125 sec.; for a 28mm lens it would be 1/60 sec.; and for a 105mm lens, 1/250 sec.

Some professionals use an even higher factor when sharpness is critical and insist on 1/250 sec. for hand-held shots with a 50mm lens and 1/500 sec. with moderate telephotos.

Working in the other direction, some photographers brag about being able to hand-hold shots at 1/

15 sec. Of course, they only talk about the shots that "come out." Consistently sharp photos hand held at 1/30 sec. and slower are possible with a normal lens only if you use some additional body or camera support. You have to lean against a wall, rest your elbows on a table, use a pistol grip or a chest, belt or shoulder pod, or improvise some other support.

Slow-speed warning systems built into cameras usually light up at 1/30 sec. or slower, which is too late. If you have a normal lens on your camera, the critical speed is 1/60 sec. At 1/30 sec. you can do

all right with a wide-angle lens, but chances are half the shots you take with a normal lens will be blurred.

The key to sharp photos is to make camera support a habit. Begin by holding the camera correctly at normal and fast shutter speeds. Keep your elbows tucked against your torso and stand comfortably, muscles relaxed. Tense muscles vibrate and produce blur. Whenever possible, hold the camera with both hands. The camera base or lens can rest in the palm of your left hand while your right hand operates the film advance

It's important to hold a camera correctly. Ideally, your body should be relaxed, arms tucked gently against your ribs, feet a comfortable distance apart, the camera cradled in one hand while you use your other hand to release the shutter and operate the film advance.

In the sitting position, your elbows press against your legs to provide support.

You can always find a wall or post to lean against when your shutter speed falls below 1/125 sec.

If you press your camera back against a wall or other solid surface, you can even make time exposures. But you'll have to guess at composition. This method works best with moderate wide-angle lenses and print film. Later on you can crop the print to get the part of the scene you want.

A folded jacket makes an excellent support for long-lens or slow shutter speed photography. With still subjects, you can use the self-timer on the camera to avoid moving the camera when you release the shutter.

With your elbows resting on a table, car hood or fence rail, you can greatly improve your percentage of sharp photos when you hand-hold your camera used at slow shutter speeds.

Improvised supports are always at hand. Here, a pair of skis is pressed into service as a V lens support.

and shutter release.

Breath control is important at normal and moderately slow speeds. Do not press the shutter as you inhale, because your chest is expanding and your arms are moving. You can trigger the shutter as you exhale, but it's best to pause momentarily in your breathing just as you press the button. Do not hold your breath. That too causes camera shake.

For intermediate-speed exposures, use the camera strap as a tension support (see below), or use one of the more stable positions such as sitting, leaning or prone (shown in the accompanying photos), or use your camera with a grip, or improvise a support.

Camera Straps

Always use some sort of strap to keep the camera from falling. The one-inch-wide straps are comfortable if you carry the camera slung around your neck or over your shoulder, but the thin ones that come with the camera will also do.

Motion-Stopping Shutter Speeds (for normal lenses)

The table and formulas can also be used to find shutter speeds that will show a predictable amount of blur in moving subjects. If you use the next slower shutter speed, the amount of blur will double (about 1 mm or 1/25″) in an 8 x 10 print. If the speed called for in the table is 1/1000 second, and you give 1/30 second, the amount of blur will be about 12 mm or ½″. If you pan the camera to follow the subject, the background will be blurred by this amount, provided the direction of the action is across the camera field.

If the lens to be used is a wide-angle lens of about half the normal focal length, the next slower shutter speed than that given in the table should be used. If the lens is a telephoto of about twice the normal focal length, use the next faster shutter speed to get the same amount of blur.

Speed		Type of Motion	Distance from Camera		Direction of Motion		
Mi/Hr	Km/Hr		Ft	M	←OR→	OR	OR
5	8	Slow walk, hand work, sitting or standing people	12	4	1/500	1/250	1/125
			25	8	1/250	1/125	1/60
			50	16	1/125	1/60	1/30
			100	33	1/60	1/30	1/15
10	16	Fast walk, children and pets playing, horses walking, slow-moving vehicles	12	4	1/1000	1/500	1/250
			25	8	1/500	1/250	1/125
			50	16	1/250	1/125	1/60
			100	33	1/125	1/60	1/30
25	40	Running, sports, very active play, horses running, vehicles moving at a moderate speed	12	4	1/2000	1/1000	1/500
			25	8	1/1000	1/500	1/250
			50	16	1/500	1/250	1/125
			100	33	1/250	1/125	1/60
50	80	Fast-moving vehicles, birds flying, race horses running	25	8	1/2000	1/1000	1/500
			50	16	1/1000	1/500	1/250
			100	33	1/500	1/250	1/125
			200	66	1/250	1/125	1/60
100	160	Very fast-moving vehicles	25	8	—	1/2000	1/1000
			50	16	1/2000	1/1000	1/500
			100	33	1/1000	1/500	1/250
			200	66	1/500	1/250	1/125

Getting just the right degree of blur to emphasize a moving subject within a sharply rendered environment takes thought and a bit of luck. This photo was made on Plus-X at 1/250 sec. with a 50mm lens.

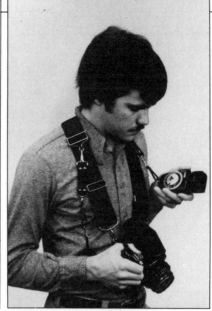

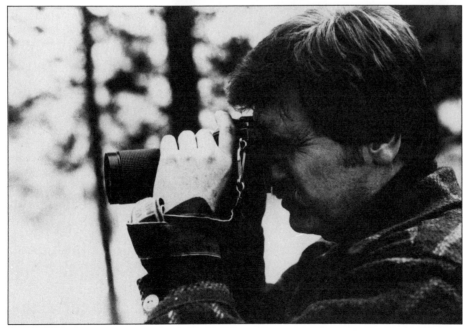

(Clockwise from left) When you carry a camera from a strap over your shoulder, let it hang so that the lens is to the rear. In this position, the lens is protected against accidental knocks and your arm can keep the camera tucked against your body.

The better camera straps provide an assortment of rings and hoods between strap and camera body. Starting at the top we see two split rings, a leather shock absorber, a spring-clip hook and swivel. The hook lets you remove the strap quickly when you want to mount the camera on a tripod. The rings and swivels ease tension and torque on the strap mount lugs, which protects the camera body.

A strap can do multi-duty as a carrier for film, light meter and other accessories, or even a second camera, depending on the accessory clips available for it. This is a two camera strap with accessories attached to the hooks designed for a second camera.

A neck strap becomes a wrist strap when you wrap it around your wrist a couple of times. This is a good way to secure your camera for candid photography. When you hold it down at your side it's inconspicuous; yet you can lift it to your eye and snap off a shot in a fraction of a second.

Most medium-format SLRs have studs for the camera strap. A spring clip on the strap snaps to the stud. The various rings found on light-weight 35mm SLRs are not used with most heavier cameras.

This is a heavy-duty wrist strap that helps ease the fatigue of carrying a large motor-driven camera for long periods of time. This one is specifically designed for use with the Minolta XL, which has a strap lug on the motor drive.

A camera grip like this one from Soligor can be taken on and off the camera with a twist of the lock lever. The accessory shoe tilts for bounce flash and a cable release in the grip allows you to trigger the camera with your right hand.

A heavy-duty grip, such as this one from Vivitar, proves its worth when you have a large portable flash attached to the shoe mount on the handle. Grips of this type are frequently used with medium-format cameras, which are boxy affairs that are hard to hold.

A pistol grip such as this one for the Pentax camera improves stability for slow-speed, hand-held exposures. Some photographers like it, some don't.

If you carry the camera slung from your shoulder, keep it tucked between your elbow and the bottom of your rib cage with the lens pointed toward your back. This is a semi-ready position where it will not swing and is well protected against accidental knocks. When it comes time to shoot, hold the camera with one hand and wrap the strap around your wrist a couple of times. A camera is relatively unobtrusive when you hold it casually in one hand at waist level. With practice, you can bring the camera up to eye level, snap off a shot, and drop it back down in less than a second. It's a good technique for candid and action photography when you work with only one camera.

One good way to carry a camera when you need to get at it in a hurry is on a strap around your neck. If you find that a dangling camera is uncomfortable, try adding a *camera clutch* to your strap. The clutch is an elastic that goes around your body and keeps the camera pressed against your chest. There is enough give in the clutch so that you can bring the camera up to your eye whenever you want. The difficulty with some clutches is that the buckles slip when the elastic stretches.

The *camera hitch*, which combines strap and clutch, is a more convenient system. The disadvantage to the camera hitch is that you end up with the camera strapped to your body in a very conspicuous way and, like a loud vest, it draws attention to itself.

If you are working with a heavy camera over a period of hours, the weight around your neck can be-

come oppressive. One answer is a *neck relief strap,* which has an extra strap that runs down the middle of your back to attach to your belt.

Two-camera straps let you keep two cameras at the ready simultaneously. They are useful if you want to shoot both color and black and white at the same time or want to cover fast-breaking actions with lenses of different focal length. Two-camera neck-relief straps are also available.

Straps with pockets for film cans let you get at your film without fumbling in a gadget bag. If you work with the camera slung around your neck, and don't run the strap across your arm as a tension support, then film cans in the strap can be convenient. If you carry the camera over your shoulder and wrap the strap around your wrist when it's time to shoot, the film cans will get in your way.

A **wrist strap** for a small camera is usually nothing more than a safety strap that screws into the tripod socket on the camera or clips to one of the D-rings to which a neck strap is normally attached. Wrist and hand straps for heavy, motor-driven cameras are more substantial. The best ones are padded and adjustable so that you can keep a heavy camera dangling from your hand for long periods of time with less fatigue. The wrist strap is fine as long as you are keeping the camera in active use, but you still need some other means of carrying the camera between times, and it's hard to get your hand into a wrist strap when you are in a hurry. A neck strap one inch wide or narrower is more versatile than a wrist strap because you can use it as a shoulder strap or, by making a couple of twists with it, turn it into a wrist strap in less time than it takes to slide your hand through the loop of a real one.

Camera Grips

A camera grip adds stability, particularly with heavy cameras. There are two basic styles, the side grip, which many manufacturers call a "hand grip," and the pistol grip. Of the two, the hand grip is probably the more popular because it also may serve as a platform for an electronic flash and its design lets you stow the camera in your gadget bag without removing the grip.

Hand grips for heavy cameras generally have an adjustable strap that goes over the back of your hand to keep the camera secure. A sturdy hand grip is particularly useful when you work with medium-format SLRs. If you are strictly a 35mm photographer, then you need an auxiliary hand grip only as a mount for an electronic flash.

Some photographers insist that a pistol grip gives them so much additional stability that they can take hand-held shots at speeds as slow as 1/15 sec. with a normal lens. But a pistol grip takes up more room in a gadget bag than most hand grips.

Triggers: Hand and pistol grips built for the motor-drive units usually have a trigger release in the grip itself. Grips designed for use with any camera may incorporate a cable-release trigger, like that found in the Vivitar hand grip, or they may be nothing more than a handle.

Improvised Supports

There is no need always to carry a tripod or other fancy camera support if in your mind you carry a repertoire of improvisations.

For very long exposures, set the camera on a table, shelf, chair, rock or log and use the self-timer to trigger the shutter. If you have a long lens on the camera, you can cushion it on a jacket or put a couple of books under it to keep the lens from tipping the camera.

You can also press the camera firmly against a wall or tree (see photo) and use either the shutter button or self-timer for long exposures. This method works best with normal and moderate wide-angle lenses because you have to estimate the field of view.

To keep the camera really steady, rest it on a bean bag. You can make one by filling a stocking with styrofoam beads. The flexible bean bag lets you tilt the camera up or down and will mold itself to irregular surfaces such as rocks and sloping car hoods to provide solid support.

To turn your neckstrap into a tension support for exposures of 1/125 sec. and slower with your normal lens, adjust its length so that when you stick your left hand through the strap, you can apply pressure by thrusting your wrist forward as you keep the pentaprism above the viewfinder eyepiece pressed to your eyebrow.

Tripods

Improvisations notwithstanding, if you are serious about taking good pictures, you need a good portable tripod. Look for one with an adjustable center column that is tall enough to bring the camera up to eye level when you use it. The legs should be solid when extended, with no wobble to them. The tripod head should be a pan-type with a tilting camera platform so you can make both vertical and horizontal shots. And the head or column should be reversible so that you can mount a camera between the legs of the tripod and use it as a copy stand. These and other tripod features are spotlighted in the accompanying photos.

Tripod heads: Since tripods do not usually come with instruction books, many tripod owners are unaware that the heads are generally interchangeable. Most portable tripods have removable

This Slik tripod has a number of desirable features, which are detailed in the accompanying photos. It has quick-lock legs with an accessory stud to which you can mount a camera or light. The interchangeable pan head contains a bubble level and a panoramic dial so that you can make sequential exposures and match up the resulting prints for a 360° view. The head can be tilted so you get a vertical format. The feet have rubber collars for use on tile and floors. The collars can be screwed back to reveal short spikes for use on turf and other soft surfaces. The leg struts can be adjusted so that you can lift a leg for support against a wall or tree, or adjust it in cramped or rocky terrain.

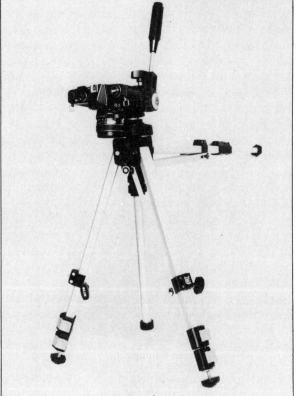

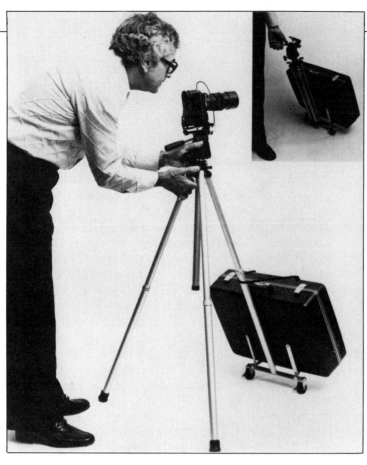

This unique Tri-Caddy from Welt/Safe-Lock is one answer to the problem of carrying heavy equipment.

A table-top tripod, such as this Minolta Mini Tripod TR-1, fits easily into a camera or tote bag.

This light-weight (1.5 pounds) tubular-legged Kenlock tripod from Smith-Victor comes with a vinyl carrying case and ball-and-socket head. It extends to 43″, not quite high enough for comfortable use by a tall person, but in the field, light-weight can be more important.

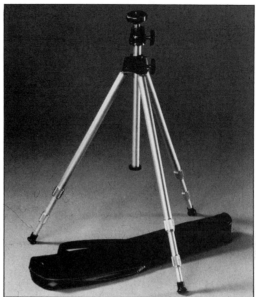

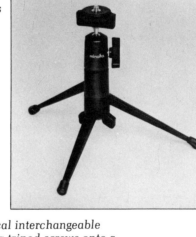

Some tripods have a removable head that you can screw onto the base of the column for low angle shots or copy work. This is a feature worth looking for when you shop for a tripod.

The typical interchangeable head for a tripod screws onto a standard ¼″ x 20 threaded stud. You could screw your camera directly onto this head stud, but don't try it. The stud is usually too long for your camera tripod socket, and if you screw your camera down hard, you could damage it.

This is the "Screw Ball," an adjustable ball socket that can be used in conjunction with the "Magna-Pod" (a super-strong cobalt-ceramic magnet accessory from New Ideas, Inc.), which you can put on the hood of a car, a refrigerator door, or any place where ferrous metals are present, without the need of a tripod or clamp.

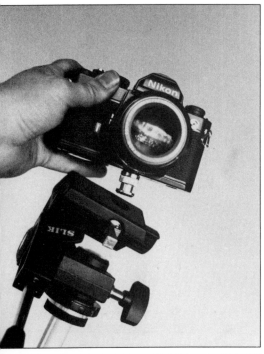

This Slik tripod head features a quick-mount system. A special stud comes with the head. The stud screws into the camera or lens tripod socket. To mount the camera, drop the stud into the tripod head and turn the locking lever. Extra studs are available.

This is a quick shoe from Perfected Photo Products. It consists of a Universal Tripod Quick Clamp and Universal Camera Adapt-a-Plate. Its large release lever makes it easy to use with both small and heavy cameras.

heads with a socket on the base for a standard ¼″ x 20″ or ⅜″ x 20″ (continental) screw. There are also a few tripods around that have heads that slip on over the center column and fasten with a locking collar.

Beware of tripods that do not have a camera head. The tripod head platform on the center column generally has a screw that will fit the tripod socket on your camera, but the screw length is frequently too long for the standard camera socket. If you screw the camera down hard onto that screw, you can damage your camera.

To remove a screw-on-type head, lock all rotating parts in place and turn the head counterclockwise.

The basic movements of a tripod head are the pan, in which the head rotates around the column; the tilt or vertical pan; and the vertical-platform tilt, which allows you to change the position of the camera from vertical to horizontal. The platform tilt is found in heads for still cameras. Heads for movie cameras have horizontal and vertical pan only.

The ball and socket head is the most basic. It permits movement of the camera in any direction and it locks in any position with the turn of a screw or lever. The large, heavy-duty types with big controls are efficient when rough, rapid adjustments are called for.

The pan head is slower working, but many photographers prefer it for still-camera photography because, in the better designs, you can individually lock each movement. This means you can adjust horizontal pan, vertical pan and camera tilt one at a time for precise framing.

The pan handle makes it easier to guide the head. The handle usually incorporates a twist lock. By turning the handle you can slow or lock either the horizontal or vertical pan or both, depending on the design. For still-camera work, a pan handle that locks only the vertical pan is the most convenient. There are also two-handle designs, in which one handle controls horizontal pan and the other vertical pan.

Fluid (viscous-damped) heads provide variable resistance that smooths out a panning movement in motion-picture photography. These heads can also be used for still photography, although most lack a tilting-camera platform, which makes them less versatile.

A "V" lens support is a fork in which you can rest a long zoom or telephoto lens. It allows smooth panning when you want to follow fast action on a playing field.

Vernier (macro-focus adjustment) heads allow precise vertical and horizontal adjustments of the camera position for macrophotography and copy work.

A low-angle post is a small camera platform used in place of a larger head for low-angle photography.

Tripod accessories range from side-arms and twin-camera platforms through weight bags to carrying straps and cases. None are necessary, but all are useful in specific situations.

An extension column allows you to extend the height of the center column. Some extension columns are designed so that they can be used alone as a monopod.

A leg platform mounts to a tripod leg. You can use it to hold either a camera or a light. A twin-camera platform is a bracket that allows you to mount two cameras on the tripod, one on either side of the tripod platform.

A side-arm extends out at a right angle from the center column. It is a useful studio accessory when you are photographing architectural models and other table-top subjects, because it lets you get the camera out where the

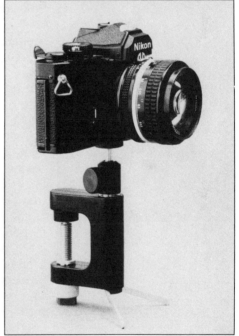

This gadget bag-size camera or lens pod from Rowi has multiple uses.

1. *Clamp to a shelf, or even a car-top carrier, as shown here.*

2. *Screw it into a fence post or dead tree.*

3. *Use it as a tiny table-top pod.*

Monopods, such as these two Kenlock models (center), are surprisingly versatile. A monopod is easier to carry than a tripod, you can use it in crowded situations when it would be difficult or impossible *to set up a tripod, and it provides adequate support for most low-light and long-lens photography. Outdoors it will double as a walking stick and in rough neighborhoods as a club.*

The gunstock or shoulder pod is your best bet when you want to do fast, hand-held camera work with very long lenses. You can trigger the camera with a cable release fitted into the handgrip in this Trigomatic model from Prinz.

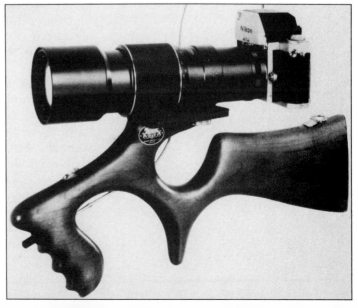

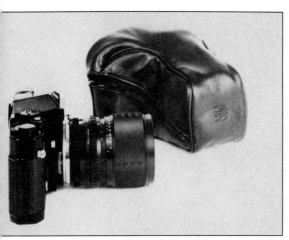

This pouch type camera case from Sigma is designed to hold the camera with a normal-range zoom lens or small telephoto attached. The soft case provides protection when the camera is carried in a gadget bag or stored on a shelf.

The soft lens pouch does not provide the protection of a hard case, but it's more convenient to use when you carry your equipment in a gadget bag or specialty pack.

legs of the tripod do not interfere with camera positioning. It performs a function similar to that of a rotating center column.

An accessory (weight) bag is designed to hang between the legs of a tripod. Failure to use a weight bag on a windy day has resulted in the smash up of more than one camera. A few rocks or bricks in a canvas sack or tote bag will do as a weight bag.

A shoulder strap is useful when you have to lug a lot of equipment around or hand carry the tripod a long way. A tripod case is useful when you travel.

Specialty Pods

Over the years inventive photographers have come up with everything from screw pods to ring and chain pods in a never ending effort to keep the camera steady at slow shutter speeds and hold it at odd angles.

Combination pods combine two or more pod types in one small device. One popular unit is a pistol grip with retracting legs that turn it into a table-top tripod. A clamp pod from Rowi has a small ball-and-socket head mounted on a C-clamp that can be attached to a table, chair leg, or shelf. Tiny retractable legs turn the device into a table-top pod. And for use in the field, there is a screw that you fit into a groove in the jaws of the clamp so you can screw the unit into a tree or fence post for nature photography.

A clamp pod is usually a C-clamp with a ball and socket head. A *tree pod* has a screw that you can screw into a tree stump or fence post for remote applications. A *car pod* is a clamp with padded jaws that can be mounted on the window or door of your car.

A chain pod is a five- or six-foot length of chain with an attachment screw that goes into the tripod mount on the camera. To use

a chain pod, stand on the loose end and pull upward to put tension on the chain. Like a monopod, the tensioned chain prevents vertical camera movement and permits hand-held shots at moderately slow speeds.

The shoulder pod or rifle-stock pod is a big help when you want to hand-hold long lenses. Designs for still-camera work usually incorporate a cable-release type trigger.

A unipod (monopod) is a long extension post that runs from the camera to the ground. By eliminating vertical camera movement, it allows you to use moderately slow shutter speeds, even with long lenses. Lightweight unipods that telescope to gadget-bag size are popular because they are easy to carry and can be a help in low-light situations.

A chest pod is a short extension tube that runs from the camera to your chest. It provides additional stability when you pull the camera toward you while you release the shutter. This means you have to hold your breath to keep the system steady, which is a big disadvantage when you want to keep the camera to your eye and capture fleeting gestures or expressions in portrait or action photography.

A belt pod is a short extension that runs between the camera and your belt. You get additional support by pressing down on the camera, just as you do with a unipod.

The ring pod is a large finger ring that screws into the tripod socket on your camera. It's a clumsy device at best.

Studio Pods and Platforms

Heavy-duty studio equipment is intended mainly for use with 4″ x 5″ and larger technical (view) cameras; it can also be drafted into service for medium-format and even 35mm camera work.

Manufacturers of this equipment make available a wide range of camera heads and accessories, including wheels, side-arms and clamps, and extension posts.

Among the more interesting pieces of equipment are the pedestal stand, which consists of a column mounted on a heavy base with casters, and a ladder pod, which looks like a folding step ladder with a camera platform on top so that you can get a view looking down on a set.

CASES AND GADGET BAGS

There is no uniform terminology in this area, but understanding cases and bags is easiest if you think of them as luggage. In general, cases are hard, bags are soft. Cases are designed mainly to provide protection, although you can work out of them. Bags are intended to make carrying equipment more convenient, although padded ones may also provide considerable protection.

Individual Camera and Lens Cases

The form-fitting camera case is sometimes called an eveready case, a misnomer if ever there was one. The typical case has a removable top, but the camera is firmly locked in the bottom with a screw that attaches to the tripod socket. These cases do provide some protection against dust, weather, and accidental knocks when you travel. They will do as camera protection when you are simply bringing a camera along, just in case something worth photographing turns up. For serious shooting they are a nuisance, because you must either let the top of the case dangle down below the camera or remove it, and then where do you put it? If you let the top dangle, it gets in the way when you turn the camera for a vertical format shot. And when it

comes time to rewind and reload, you have to remove the camera from the case anyway. When you go out with the intention of doing some concentrated picture taking, keep the camera, without case, in a gadget bag or at the ready on a neck or shoulder strap.

Lens and filter cases are more useful because they also protect the equipment when it is inside a gadget bag. Most lens cases have shoulder straps and with a little ingenuity you can also hang them from a web belt if you get the urge to take your camera on a nature photography or backpacking expedition.

There is little difference between round and square lens cases. The round ones roll if you put them on their sides, but they take up less room in a gadget bag. The square ones lie neatly on a shelf.

Belt cases: You will find a large variety of camera and lens cases designed to attach to your regular belt or to a web belt. Nature photographers frequently keep a selection of long lenses in cases suspended from a belt because in this position they are readily accessible and the weight is easier to carry when slung from the hips.

Gadget Bags

As soon as you begin to take picture-taking seriously, a gadget bag becomes indispensable.

When you shop for a gadget bag, avoid those that are nothing but flimsy vinyl, canvas, or nylon with no padding. Soft, unpadded bags are just purses, flight and shoulder totes renamed "gadget bags" to increase sales appeal. If you must use a case of this type, keep your lenses, filters and other accessories in individual hard or padded cases, or better yet, line the bag with inch-thick foam.

The best soft gadget bags are padded and have individually padded compartments inside for

camera bodies, lenses and other accessories. Some of the newer ones are made of heavy-duty nylon and inside have partitions held in by velcro tabs so that you can adjust the partitioning to suit your equipment.

Some camera manufacturers make excellent hard gadget bags with fitted compartments for special equipment mixes.

When you shop for a basic gadget bag, look for one that is lightweight and flexible, with a comfortable shoulder strap. It should be large enough to hold your regularly used accessories plus camera with lens, but not so large that it is cumbersome. A medium- or small-size bag is easiest to work out of.

You can get by with an inexpensive bag if you only carry lightweight equipment. If your total equipment load begins to run over ten pounds, you should investigate more expensive, heavy-duty bags. A good bag should give you years of service, so it's worth taking the time to shop for one you feel comfortable with.

Special-Purpose Bags

Waterproof flotation bags can be useful if you want to carry your equipment in a canoe or pack it into a swamp where your activities are likely to get it wet. On the other hand, if conditions are that bad, perhaps you should consider a rigid or flexible underwater housing or an underwater camera such as the Nikonos.

Lead pouches are now available to protect your film from airport x-ray machines. But what happens if the operator of the machine turns up the strength to see what's in the pouch? On the other hand, keeping your film in a lead foil pouch probably won't hurt and it might help, particularly if authorities refuse to take the time to hand-inspect the film or if you

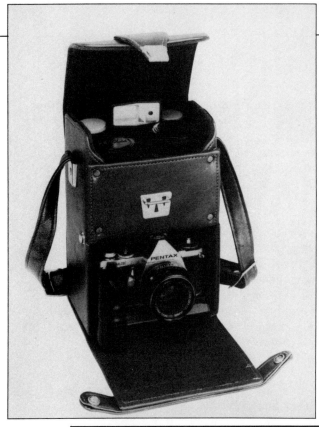

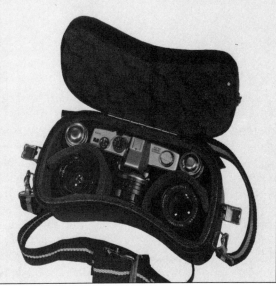

This hard case (left) is custom-fitted for the Pentax system. Cases like this are relatively expensive, but useful. This one can be opened from the top or side.

A high-quality case, such as this Kustom Traveler model from Kalt (above), provides plenty of padding inside and out to protect equipment. Gadget bags without padding or rigid panels for protection are really just modified tote bags.

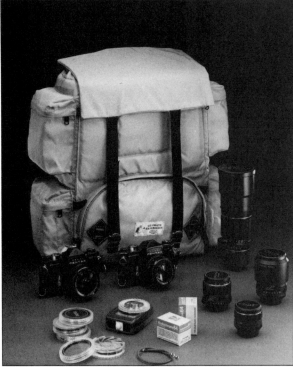

A camera backpack such as this from Ultimate Experience will carry a large selection of equipment in its padded compartments along with lunch or other gear. If you're into hiking and nature photography, check these out.

This is the Safari modular camera case (right) that will handle an SLR camera with almost any lens attached, including long telephotos and zooms. The case comes in sections so that you can customize it. It can be worn holster style from a belt or on a shoulder strap.

have your film stored in a suitcase that you have checked through. If you are only going through airport security twice, the machines in U.S. airports probably will not damage your film. If you know you will be going through four or five checks, then ask to have your film hand-inspected each time.

Camera back packs made of rugged, expedition-quality nylon with padded compartments are a recent innovation for the outdoor photographer. They are less convenient than a gadget bag when you try to work out of them in an actual photo session, but they win hands down when you have to schlep heavy equipment over hill and dale.

The fanny pack is a padded case modeled after the classic skiers' fanny pouch. It puts the weight on your hips and leaves your arms and shoulders free.

Heavy Duty Cases

Professionals use heavy-duty fiberglass, fiberboard, leather or metal cases to transport camera gear. Some models, such as the classic Zero Halliburton cases, have foam inserts that you can cut to the shape of your equipment. If you own this type of case, you can buy different inserts to accommodate different sets of equipment. Other designs have padded tops and bottoms with hard panels that slide in and out of grooves to form different size boxes in the interior for lenses, camera components, and flash units.

These cases are available in a range of sizes, but for day-in, day-out use, a fiberglass or metal one about the size of a one- or two-suiter suitcase is the most useful. It's large enough to hold several lenses, a couple of camera bodies and a flash unit but it's not so big that you will need help carrying it.

To help prevent theft, put a few strips of stick-on fluorescent strip-

ing or some very prominent decals on the outside of these cases so that you can recognize them at a glance. It could help in case someone tries to walk off with them in a baggage-claim area.

PROTECTIVE HOUSINGS

Foul-Weather Protection

Rain, snow, spray, dust and sand can all damage a camera, particularly when they are driven by a brisk wind. One easy way to protect your camera under these conditions is to put a Skylight or clear filter on the lens. Then cut a lens-size hole in the bottom of a large plastic food storage bag and tape the edges of the hole to the rim of the filter, which seals the lens. You can put your hands through the bag opening to operate the camera, or, if there is a lot of sand and dust blowing around, you can seal the bag and operate the camera controls from outside the bag.

A flexible underwater housing is even more versatile than a plastic bag, but it is a lot more expensive and you may not always have it with you.

If you do not want to mess with a plastic bag, you can always shoot from beneath an umbrella in rainy weather. A little misting won't hurt your camera so long as you wipe it off with a towel as soon as you get into a dry area.

Do not confuse rainwater with salt spray, which is highly corrosive. Always protect your camera if there is any chance it will come into contact with salt water.

Underwater Housings

You can buy underwater housings for almost any camera made from a company such as Ikalite. If your local camera dealer does not know much about underwater photography, check with the dive shops in your region.

An underwater housing is a

sealed unit. A typical underwater housing will let you bring your camera down to about 300 feet. A system of gears allows you to operate the focus, film advance and shutter release from controls on the outside of the housing. Although fairly heavy out of water, they are featherweights underwater, and lighter cameras may even be buoyant. The better designs permit use of through-the-lens viewing and focusing, although use of the finder is limited due to the depth of your diving mask. If you have a Nikon F, FTn or F2 series, Ikalite housings will let you use the Nikon Action Sports Finder, which gives you corner-to-corner reflex viewing even through a mask. For full-screen viewing with the Canon F-1, use the speedfinder with a housing that has a speedfinder back.

In the typical housing design, the lens protrudes into an interchangeable port. A standard port for a 35mm camera housing is generally used with 35mm and 50mm lenses. For wide-angle lenses, use a dome port. The best ones are optical lenses that compensate for the difference in refraction index between air and water and improve color saturation and definition. A macro port is for use with moderate-telephoto lenses and with normal lenses when you extend them to provide up to one-half life-size images. For longer lens extensions, extension ports are available.

The underwater housing is usually the basis for a system that can include flash brackets, underwater housings for a variety of flash units, underwater flash guns, underwater halogen lamps, and meter housings.

Flexible housings look like heavy plastic bags with built-in gloves. Most designs have a maximum operating depth of about 30 feet. They provide first-class protection from salt water spray if

you want to take your camera with you on a sailboat or get wide-angle close-ups of surfers and swimmers.

Operating Precautions for Underwater Housings

Water does not damage the housing, but the camera inside can be hurt by any kind of moisture, and seawater is particularly corrosive.

When you release the back cover of the housing after use, wipe it down with a towel or cloth so that no water falls onto the camera. When you finish using the camera, wipe it with a dry, salt-free cloth.

O-rings, which are used to seal lens ports and housings, have a limited useful life, so be prepared to change them occasionally. It is a good policy to check them out each time you use the housing. Stretch the O-rings out fully to make sure that there are no cuts or worn places and grease the O-rings before each use. Under high pressures underwater, even a single grain of sand may cause a leak, so keep the rings clean.

Here are some routine maintenance procedures:

1. After each use in seawater, immerse the housing in fresh water to wash it.

2. To remove all salt contamination, particularly from behind grips and other nooks and crannies, wash under a jet of high pressure water from a faucet.

3. Remove the camera only after you have completely dried the housing.

4. Wipe down the housing inside and out with a dry cloth to remove dust and grit.

5. Thoroughly check the O-rings once again, grease if necessary, and replace them in their grooves, where you can leave them for storage.

6. Clean the connecting joint screw thread between the main and front housings. If the unit has

not been used for some time, recheck before using it again.

When you transport the camera and housing by car, boat, and so on, keep them separately wrapped. If you ship the housing by air, keep it unclamped. If some units are left clamped, low pressure at high altitude can cause a vacuum inside the housing that can make it difficult or impossible to remove the rear cover once you have the unit on the ground.

This is an underwater housing designed for the Pentax 6x7 medium-format SLR.

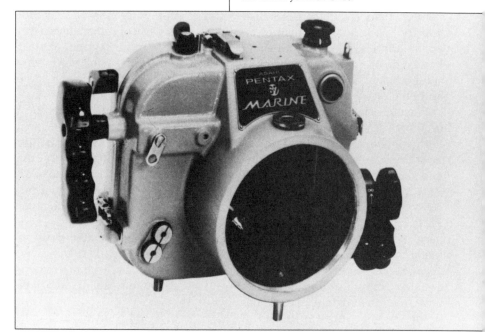

Here are a group of underwater housings from Ikelite.

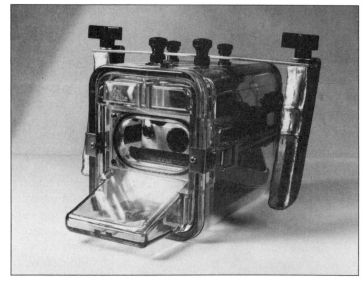

Housing for a twin-lens reflex camera.

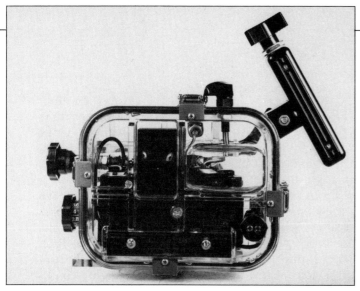

*Rear view of housing showing
SLR with speed finder.*

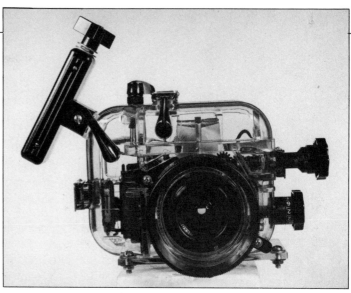

*Front view of 35mm SLR
camera housing.*

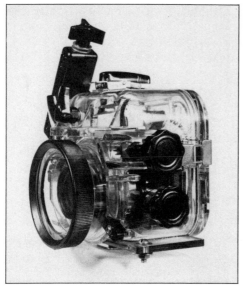

*Housing for a Polaroid
SX-70 camera.*

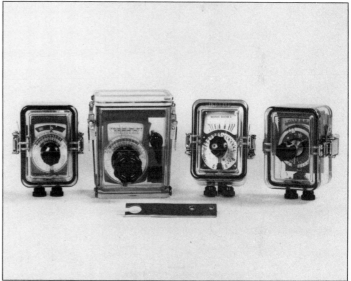

*Housings for a variety of light
meters.*

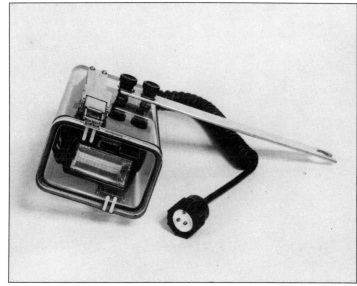

*Housing for a small portable
electronic flash.*

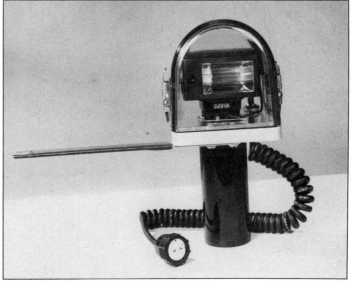

*Housing for a handle-mount
electronic flash.*

8 LIGHTING EQUIPMENT

If you have an interesting subject, then nine times out of ten it is the quality of the lighting that makes or breaks a photo. Outdoors, you can partially control the quality of light by making effective use of daylight conditions, by using artificial lights, and reflectors, by moving your subject around, and by patiently waiting until the light on your subject is right. Indoors, you can exercise complete control using lights, diffusers, reflectors, barndoors, and other devices.

Getting started with artificial lighting is not expensive. It's true that a large professional studio may have an investment of $20,000 or more tied up in lighting equipment, but if you are inventive, you can get a do-everything tungsten light set-up for less than $100, and a starter outfit for under $25.

There are two basic types of photographic lighting: continuous, which usually means daylight, photofloods, halogen lamps and fluorescent lights; and discontinuous, which means either electronic or bulb flash. There is no conflict between these two types and most photographers routinely use both. For example, nothing beats electronic flash when it comes to taking shots of people under low-light conditions in bars, at parties, in nightclubs, and so on. But for photographing still life subjects, coins, stamps, or room settings, photofloods or halogen lamps are a better choice.

FLASH PHOTOGRAPHY

Today when you say "flash," most photographers think of electronic flash. Among serious amateurs and professionals, bulb flash went the way of the dodo years ago, and

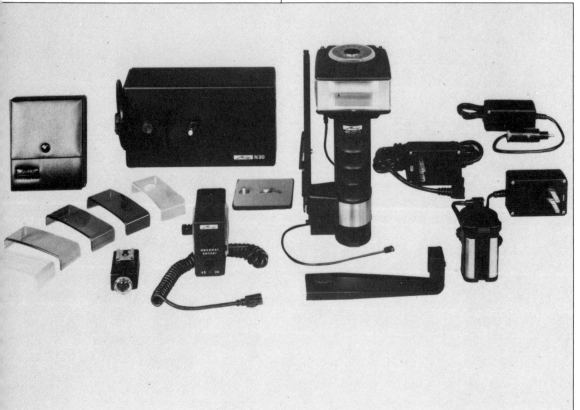

Top-of-the-line flash units, such as this handle-mount Metz 45CT-1, are fully automatic and are the heart of an accessory system. In addition to the basic unit, which offers a choice of five automatic f/stops, this system includes color filters, remote sensor, AC adaptor so the unit can be operated on household current, extra long p.c. cords, NiCad battery pack, and compartment case. Other system-flash makers such as Vivitar and Sunpak offer similar versatility for their flash units.

even in the area of the pocket and instant camera, electronic flash is rapidly taking over the functions performed by flash cubes, flash bars, and flipflash arrays.

The trend today in electronic flash is toward automatic units that are capable of calculating the exposure for you and dedicated units that are designed to work with one specific camera, such as a Nikon EM, Minolta XD-11, Canon AE-1, Olympus OM-2, and so on, calculating exposure automatically, setting the flash synch speed, and performing other functions that used to require thought on the part of the photographer.

Many of the larger automatic and dedicated units are powerful, capable of performing a wide range of amateur and professional tasks. On the other hand, you still see photographers walking around with battery packs slung over their shoulders. These high-voltage battery-pack systems deliver a lot of light, hundreds of flashes between rechargings, and some even accept interchangeable reflectors. It was units of this type that gave rise to the term "strobe."

Studio flash systems are more powerful yet. The simplest studio flash is a head with a self-contained condenser system that plugs into a standard household outlet or into a high-voltage battery pack. More complex units have flash heads that plug into a separate AC power pack. These units are strictly professional because of their high cost, but they are a delight to use.

Portable Electronic Flash
A small electronic-flash unit is the ideal light source for photographing people under low-light conditions. These flash guns consist of a flash tube in a permanent reflector and a capacitor system, which holds the enormous charge needed to create an electronic spark in the flash tube. The least expensive are tiny units weighing only a few ounces that have a fixed light output. To use these units, you have to calculate exposure using a guide number, as explained in the section on flash exposure. The low cost is attractive, but for a few bucks more you can get an automatic or dedicated unit, which is a much better bet for general use.

The smaller portable units, and all dedicated units, are designed to mount on the hot shoe of your camera. The hot shoe is a combination accessory mount and electrical contact that synchronizes the flash with the shutter. Mounting a flash on the hot shoe is convenient, but it has several disadvantages. First, when the flash is your main light, then you get flat frontal lighting, sharp shadows,

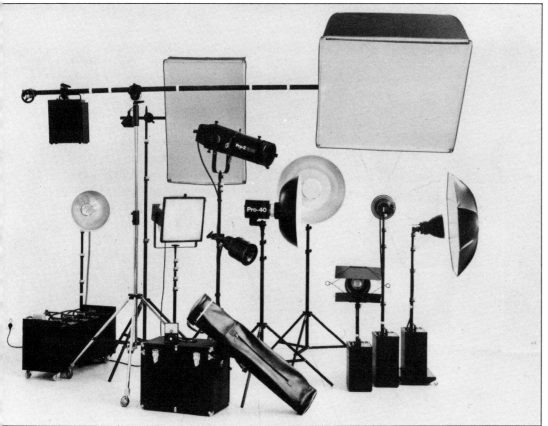

Manufacturers of studio flash equipment offer a spectacular array of accessories, including light stands, a variety of interchangeable reflectors, diffusors and bounce light systems, power packs, spots, cases and other paraphernalia. The system shown here is marketed by the Hershey division of Leedal. Ascor, Balcar, Bowens, and Broncolor are just a few of the many other studio flash systems that are well known among professional photographers.

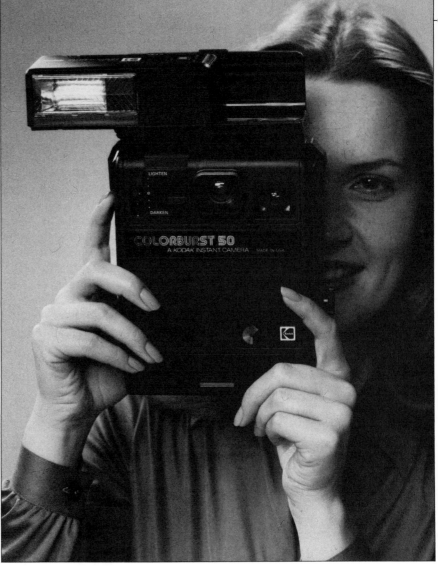

This light-weight shoe-mount flash from Metz has a tilting flash head and accessory remote sensor for use when the flash is off camera.

On a per shot basis, electronic flash is about 1,500 percent cheaper than flip flash or bar flash, which is why many photographers are in the market for an electronic unit that can be used with their instant picture or pocket camera. The simple electronic units generally have to be removed from the camera for normal daylight exposure. This Kodak Model C flash designed for the Colorburst 50 instant camera is more sophisticated. It can be left on the camera at all times without affecting the normal exposure program. The unit is actuated by sliding the reflector component to the side.

This unique handle-mount autoflash from Hitacon has two

flash heads. The more powerful upper head tilts for bounce light while the lower head remains fixed to provide a modeling light. Designed for use on or off camera, it will cover the field of view of a 28mm lens.

If you do underwater photography, you have two options available. First, you may be able to purchase a special underwater housing for your flash. Second, you can buy a flash designed for underwater operation, such as this Toshiba TM-1, shown here attached to a Nikonos underwater camera from Nikon.

These two portable units from Braun incorporate a textured reflector to soften the light without recourse to bounce or diffusion techniques.

and sometimes your subjects come out with red eyes, which happens when your subject looks directly into the lens and the flash bounces off the retina of the eye and back into the lens. (Red eyes will not happen as long as your subject does not look directly into the lens.) Second, the larger units are clumsy and put the camera off balance when you mount them on the hot shoe. (The solution to this is to use the larger units on a flash bracket attached to your camera.)

The classic "potato masher" (handle flash gun) design consists of flash head and condenser unit mounted on a battery grip handle. A p.c. (push-connector) cord synchronizes the unit with the camera shutter. Ordinarily, you use the unit on a bracket that attaches with a screw to the tripod socket on the base of your camera. The battery handle doubles as a camera grip. These flash guns are available in both automatic and manual designs.

All the better self-contained portable units have flash heads that swivel up and down and some rotate as well. This lets you use bounce flash. In the better automatic designs, the sensor is mounted below the head, so that you can aim it at the subject while you have the flash head aimed at some reflector such as a wall or ceiling.

Automatic flash: An automatic-flash system contains a light sensor and thyristor circuit that automatically shuts off the flash when sufficient light has been put out for the exposure. This happens with incredible rapidity. The flash duration may be anywhere from 1/1000 sec. at full output to 1/50,000 sec. at minimum duration. At its highest speed, an autoflash is easily capable of stopping a rifle bullet in mid-trajectory.

Even the smallest autoflash units will give automatic expo-

sures over distances of about 2 to 20 feet. Larger units provide considerably greater range. The limits of the autoflash depend on the power of the unit, the f/stop you select, and the film speed. The simplest units give you one f/stop option for each film speed. More expensive units may give anywhere from three to six f/stop possibilities for each film speed, and each f/stop will let you cover a slightly different auto-exposure range.

Another useful feature found in the better automatic-flash units is a remote sensor. You can mount the sensor on the camera hot shoe and the flash on an extension bracket or stand and be sure that the exposure is being read from the camera position. A power cord connects the sensor with the flash.

To use an automatic flash, set the ISO/ASA of the film on the calculator dial. If the dial has a fractional power setting, set the index to "1" (full power). Next, refer to the calculator dial and select an f/stop that will give you the distance range you want to work with. Then set the sensor to that range, either by turning a dial on the sensor itself or by adjusting a lever or selector switch somewhere on the unit. Set the selected f/stop on your camera lens and the camera shutter to the flash synch speed.

The sensor must be pointed at the subject. Most automatic units have tilting heads, and this is an important feature to look for because it gives you bounce-flash capability. There are a few small units that do not have a tilt head, which means that you have to use them on manual if you tilt the unit toward a ceiling or some other bounce reflector.

When you operate an automatic flash unit on manual, you get the full flash duration, unless there is a variable-power option, and must

base exposure on the guide-number system.

If you want to be certain of getting the top speed the flash can deliver so that you can stop a splash of water or a bursting balloon, then you have to trick the sensor. One method is to tape a short piece of optical fiber tubing between the sensor eye and the front of the flash. This pipes light directly into the sensor. Make tests to find the correct exposure.

Dedicated-flash units make on-camera flash photography so simple it is almost impossible to make a mistake. In the most modern designs, when the flash is on and fully charged, it automatically sets the shutter speed. By automatically setting the synch speed, the dedicated unit eliminates those sets of half-blank pictures that happen when you accidentally use a high shutter speed with a focal-plane camera. On the other hand, it prevents you from combining a slow, ambient light exposure with a flash exposure. If you want to make shots of this type, you can defeat the auto system by putting a piece of tape over the speed-switch contact on the hot shoe. (Canon has one flash with a built-in switch that cuts out the speed synch circuit for 1/30 sec. and slower exposures.)

If you try to take a photo while the flash is still recharging, the system will revert to the preset mode for non-flash operation. When it is fully charged, it will automatically go back to X-synch.

To use a dedicated flash off camera, you need a special synch that will tie in the various special circuits. New Ideas makes the Duo-Sync cords for this purpose. They work with any standard hot-shoe flash unit as well. They can be combined for use with two off-camera dedicated units or linked together to form a ten-foot-long, off-camera, automatic-flash cord.

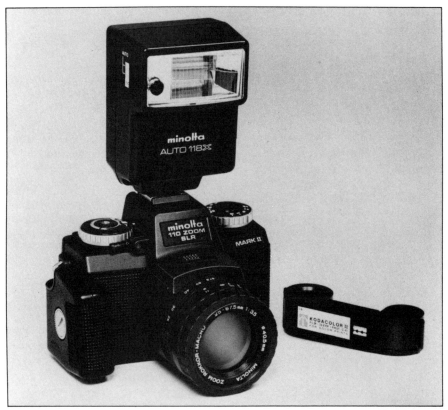

A small, dedicated flash unit is an ideal first flash for owners of cameras that will accept a dedicated unit. Shown here is the Minolta Auto Electroflash 118X on the tiny Minolta 110 Zoom SLR Mark II. The 110 film cartridge beside the camera gives you an idea of the actual size of this mini-outfit.

This camera has an accessory hot shoe that slides on over the film rewind knob. This is a clever way to incorporate a hot shoe on a camera that has interchangeable viewfinders.

Synchronization: Portable electronic-flash units either synch through the hot shoe or attach to the X-synch terminal of your camera via a p.c. cord. Units in which p.c.-cord synch is your only option should have detachable cords. Avoid the small units with permanent p.c. cords, because when the cord goes, so does the unit. Units that offer both hot-shoe and p.c.-synch systems give you an advantage because they can be used easily on or off the camera.

Power sources: The typical portable unit uses 9V or 1.5V AA batteries, and manufacturers with a systems approach to flash will offer a number of power alternatives. For example, you can get NiCad battery packs for most of the better units and a number of manufacturers also make rapid rechargers.

Another power option is the external-battery pack. Low-voltage battery packs, such as the Vivitar LVP-2, work with 1.5V D cells. They improve flash-recycling time and provide more flashes per pack than the built-in packs. High-voltage battery packs, described in the following section on high-voltage flash, can be used with an ordinary portable unit, if you have a high-voltage battery adapter for the power circuit.

Recycling time is the length of time it takes to fully recharge the capacitor that stores the energy for the flash. Most units have a small ready light that glows when the unit reaches about 80 per cent of full charge. Small non-automatic units powered by two or four AA batteries may take 12 to 15 seconds to recycle. The better units will recycle in three to five seconds with fresh batteries, but as the batteries grow weaker, recycling time increases.

When you use an automatic flash with close subjects, the unit may be able to recycle several

times a second, so you could actually use it with a motor-driven camera set for continuous operation. The high-speed recycling occurs because the flash uses only a small fraction of its charge for each flash. But with subjects at normal distances, you have to pause between shots.

If you fire a flash that is not fully charged, you will not get full light output and your shot will be underexposed. This happens more often than most photographers like to admit, because in the excitement of working with a subject, it is all too easy to forget to look at the ready light. A two-second pause after the light goes on will usually insure a full charge. A dedicated-flash unit solves this problem for you, because the camera reverts automatically to the manual mode when the unit is not fully charged.

Long-Distance Flash

Popular rumor to the contrary, you can take flash photos from the audience at sports events, stage shows and concerts, but you need some special equipment to do it. Bulb flash systems such as flash cubes, flash bars, and flipflash arrays won't do a thing for you beyond 14 feet, and the average portable electronic flash for adjustable cameras won't handle much beyond 30 feet. To get greater distance, you need either a very powerful flash or a light-condensing system for the flash head.

For example, owners of the Metz can now buy an accessory condenser device called a televorsatz that extends the effective range of the unit to several hundred feet with ISO/ASA 400 film and a fast lens. Several flash guns have a zoom head with wide-angle, normal, and telephoto positions, so that you can adjust beam coverage to suit the angle of view of your lens, and in

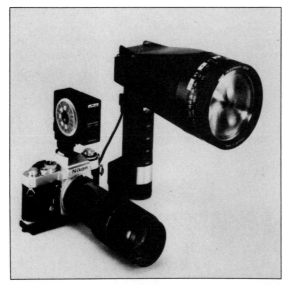

This unique tele-extender for long-distance flash consists of a Fresnel lens in a housing that slips on over the head of the Mitz 45CT-1 handle-mount flash. A remote sensor on the camera hot-shoe is required for autoflash operation, because the large housing covers the sensor eye on the flash. With ISO/ASA 800 film and the lens set to f/2.8, you can make flash photos of subjects up to 250 feet away.

This Vivitar flash features a variable-position lens so that you can adjust the beam spread for use with wide-angle, normal or telephoto camera lenses. Most manufacturers refer to this feature as "zoom flash."

the tele position, significantly increase the distance range available. If you are interested in long-distance flash, then the tele-light system should be an important consideration in your choice of a flash unit.

Professional photographers working in conjunction with sports arenas and auditoriums sometimes take another route. They get permission to have the electricians set up an array of studio flash heads along with the reg-

ular lighting for the event and use radio control or infrared to synchronize the flash. But this is an expensive way to go, and it may be that the new light-focusing accessories for the better portable flash units will make it unnecessary even for the pro.

High-Voltage Portable Flash

Flash units designed for use with 510-volt battery packs are regularly used by photojournalists, wedding and portrait photogra-

phers, and by photographers specializing in commercial and industrial work. In terms of light output, these systems deliver as much as, or more often more light than the best self-contained units.

There are two general types of high-voltage units, those with a self-contained condenser and those without. Units that have a condenser, which is usually located in a grip handle, can be powered by any 510V DC system. Units without a condenser must be powered by battery or power packs that contain a condenser unit to store energy for the flash. Condenser power packs are sometimes called "flash generators" to distinguish them from simple battery systems.

The big advantage to high-voltage systems is rapid recycling time and more shots per charge or per battery. The disadvantages are cost, extra weight, and the need to carry one more item slung over your shoulder.

Rechargeable NiCad batteries are available for high-voltage units. In some designs, such as the Graflite 250 rechargeable or Lumedyne Bye Dry, the battery is put into an over-the-shoulder pack. In others, such as the Hershey system, it goes into the flash gun itself, turning it into a self-contained portable flash.

The 510V dry cell delivers the most power—up to 1000 full-power shots—and has the fastest recycling time. On the negative side, it is expensive, nonrechargeable, has a short shelf life if not used, and it can leak and corrode.

Some manufacturers recommend the sealed lead-acid battery because it recharges quickly, will take up to 500 recharges, has a long shelf life, is not subject to deep discharge or memory problems, and is completely sealed. At current price ratios, one $150 lead-acid battery will deliver the same number of shots as $1000

worth of 510V dry cells.

Store high-voltage batteries in a sealed bag in the refrigerator when not in use. Rechargeable batteries should be fully recharged periodically for longest life.

In addition to battery power, most high-voltage units can be operated on standard household AC power using an AC adapter.

Hershey, Graflex, and other manufacturers of high-voltage units also make a range of adapters and accessories, including slave units, for their flash guns. Although these were some of the first electronic-flash designs to gain widespread acceptance, they have kept pace with technological developments, and their top-of-the-line units provide such options as automatic exposure, variable power, and variable beam width (zoom). Since many of the top-of-the-line lightweight units from Metz, Sunpak, Vivitar, and others can be operated from high-voltage battery packs, the distinction between high- and low-voltage power systems has blurred. The obvious conclusion is that with today's technology, you can have the best of everything when you buy a portable flash with high light output.

Ring Flash

A ring flash has a flash tube that encircles the camera lens. These devices are often AC-powered, although most can also be operated from battery packs. The ring flash is basically a close-up flash that is used to surround small subjects with even light. The effect works as long as the subject is smaller than the diameter of the circular-flash tube.

Ring flash is occasionally used by fashion photographers as fill light. It creates round highlights, but in most shots the effect is hardly noticeable, and you could get the same thing using an Air-

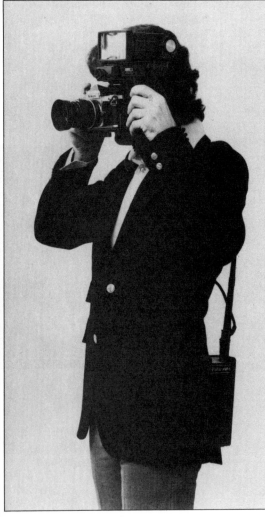

Over-the-shoulder 510V battery packs are often preferred by photojournalists and wedding photographers who need the faster recycling time and increased number of flashes that these power sources provide. The pack shown here is connected via high-voltage adapter to the Vivitar 365 flash.

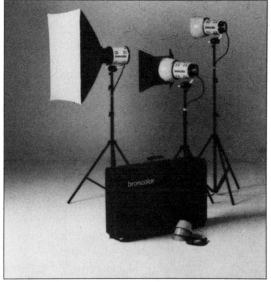

This is a front view of an Ascor CD 1200 studio light. In the center is a tungsten-halogen modeling light. This is surrounded by the flash tube. The outer rim of light is a reflection of the modeling light. Both flash tube and modeling light are replaceable.

This lightweight portable studio flash system from Broncolor consists of three self-contained flash heads, stands, and collapsible diffuser/reflectors. Outfits of this type are used mainly for location portraiture, which includes making yearbook photos, executive portraits, and small group portraits.

This Unitron ringlight can be operated either by battery or off a standard household outlet. It is designed specifically for close-up work, such as making catalog photos of jewelry or coin collections and medical or dental photography.

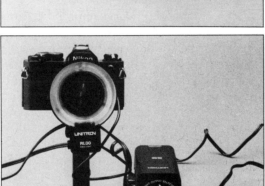

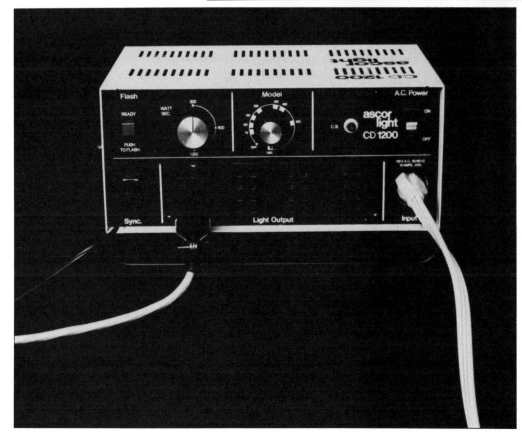

This Ascor Light CD 1200 is a studio power pack capable of putting out up to 1,200 watts of power and firing four flash heads simultaneously. On top in the top row of controls there is a large combination ready-to-flash light and test button, a three-position dial that lets you select 300, 600 or 1,200 watt seconds of power, a continuously variable dimmer switch for the modeling light, circuit breaker, and on-off switch. On the bottom is a socket for a standard two-prong camera synch cord, four multi-pin sockets for power cords that connect to flash heads (one of which is in use in this photo), and a socket for a heavy-duty grounded electric cord that plugs into any household electrical outlet. Units of this type are designed for heavy-duty professional use without overheating.

Diffuser on your regular flash unit. (See section on Practical Lighting Techniques.)

Studio Flash Units

Professional studio flash is worth knowing about, even if you do not plan to buy right now. You never know when your needs may change, and it's always worth knowing what you could get if you wanted to invest the money.

Self-contained flash heads such as the Hershey Prolite or Bowens Monolite consist of a lamp housing, flash tube, modeling lamp, condenser and power cords for AC or DC (high-voltage battery) operation. These all-purpose studio units are normally used on a lightstand, but they are light enough to carry on location. Some have provision for interchangeable reflectors. Most have an umbrella bracket either permanently attached or available as an accessory. Power runs from about 100 watt-seconds to 400 watt-seconds with trial ASA 100 guide numbers from about 125 to 340, depending on the reflector and the unit. The combination of moderate cost, high power, light weight, and an accompanying system of reflectors and other accessories has made these units quite popular among photographers who work mainly with 35mm- and medium-format cameras.

If you are a pro who also works with viewcameras or large sets, then you need more power than the self-contained unit will provide.

The Ascor CD 1200 pictured here is a typical studio power-pack and flash system of the type commonly purchased by professional commercial and fashion photographers. Balcar and Broncolor are two other well-known makers of studio units, and there are many others.

The heart of the system is the power pack, which works off standard household electrical outlets. Flash heads consisting of a light head containing an electronic-flash tube and a tungsten-halogen modeling light are purchased separately. They connect by power cord to the power pack, which may be capable of handling four or more at one time.

The amount of light you get from a flash head depends on the maximum power that it is designed to accept, on the reflector that you attach to the head, and on the amount of power it actually receives from the power pack. If you have a 1200-watt-second power pack and use four heads, each head will get 300-watt-seconds of power. If you use two heads, each will get 600-watt-seconds, and if you use one, it will get the full 1200-watt-seconds of power. This is called *symmetrical distribution*.

Asymmetrical distribution is a system that lets you dial in different amounts of power to the different heads to adjust lighting ratios.

Some power packs, including the one shown here, have a *variable-power control* that lets you cut down the amount of power delivered by the pack. This lets you use wider *f*/stops at closer flash-to-subject distances. A separate control lets you vary the power of the modeling-light circuit so you can keep the modeling-lamp brightness matched to the output of the power pack.

In this type of studio system, the camera-synch cord, or a slave, plugs into the power pack, which triggers all the heads simultaneously when you press the shutter button on your camera.

Among the accessories you might get for a system like this would be wide-angle, standard, and narrow-beam reflectors, a focusing spot, a projector spot that allows you to project a slide or shadow pattern or focus a small,

powerful beam into a tiny area, giant stand-mounted diffusers, and lightweight portable diffusers that attach to one of the standard reflectors.

Young photographers starting out in commercial or fashion work often equip themselves with a 1200-watt-second power pack, one flash head with standard reflector, a lightstand, and an umbrella diffuser/reflector or a large portable diffuser that gives a 3' x 3' square diffusion surface. Additional equipment is added as work comes in and finances permit.

When you use studio flash units, it is sometimes possible to base exposures on reflected or incident readings taken from the modeling lights. But most photographers prefer to use a flash meter.

Of the more than 10,000 photo dealers in the United States, fewer than 100 stock a good line of professional studio equipment and accessories, and these dealers are located in major population centers such as New York, Los Angeles, Chicago, Boston, and San Francisco. If you want to familiarize yourself with equipment of this type, your best course is to check the ads in a professional photo magazine such as *Photomethods*, and write to the manufacturers for literature. The manufacturers can also give you the names of dealers in your region that carry their equipment.

Bulb Flash

Flash bulbs and flash cubes are considered amateur equipment in most of the Western nations, but in developing countries you still run into portrait photographers and photojournalists using bulb flash for professional work.

Flash cubes, flash bars, and flip flash are all intended for use with subjects from about four to ten feet from the camera. The cost per flash is quite high, so if you plan

to do much photography with a pocket or instant camera, it will pay to invest in a small electronic flash designed for use with your camera. These units have about the same power output as a flash cube or flash bar. Each flash-bulb type has a different base, so if you want to replace it with electronic flash, specify flip flash, magicube, flash cube or flash bar base.

If you have occasion to use flash bulbs with an adjustable camera, check your camera instruction manual for the proper shutter synchronization. With focal-plane (FP) shutter cameras, M-synch bulbs usually synch at 1/30 sec. or slower; FP bulbs will synch at higher speeds.

Chances are your 35mm SLR has a FP shutter, but if you own a 35mm camera with a noninterchangeable lens or a medium-format camera, then it probably has a leaf shutter built into the lens. A leaf shutter will synch with electronic and bulb flash at any speed, but when you use speeds faster than 1/250 sec., open up one half to one f/stop to compensate for a light loss due to the leaf-shutter design.

There are four traditional flash-bulb bases. The glass groove is found on the peanut-sized AG-1 flash bulbs, which are customarily used with a 2″ polished reflector. With adjustable cameras, use either X or F synchronization at speeds up to 1/60 sec. or use M synchronization at any shutter speed.

M-28, M3B and M-3 bulbs have a miniature base. Use X or F synch at speeds up to 1/60 sec., FP setting up to 1/125 sec., or M synch at any speed.

The classic flash bulb for photojournalism before the days of electronic flash had a bayonet base. In this group you find the GE Nos. 5 and 5b and Sylvania 25B and 25 bulbs. Designed primarily for cameras with M synch, they

The flashbar is used with Polaroid instant cameras, 10 shots to the bar. It's a good system to use when you make only occasional use of flash. But if you take a lot of indoor pictures, then consider getting an electronic flash designed for the camera model you own.

The Kodak instant camera uses flip flash, eight shots per flash array.

This two-part adapter from Hitacon lets you use just about any small shoe-mount flash with a Polaroid SX-70 film camera. The bracket with hot-shoe attaches to the base of the camera. The adapter fits into the socket for the bar flash and connects via p.c. cord with the flash. Use only with flash units that have ASA 100 guide number of less than 50.

can also be used at X or F synch at 1/30 sec. or slower. The 6B, FP-26B and FP-26 are for focal-plane synch only, and can be used at any speed with focal-plane shutter cameras.

There is one situation in which flash bulb may still prove superior to electronic flash, and that is when you must go on location and light an extremely large hall, ballroom, or building with flash. You could of course walk around with an electronic flash in your hand and try to paint the entire subject with multiple flashes, and many pros today choose just this option. But some feel flash bulb is the better way because you can scatter lightweight, inexpensive bulb flash units hither and yon, synch them with a unit such as the Bowens Multiflash, and take the shot with one enormous blast of motion-stopping light.

For this application, you would use medium-screw base bulbs such as the Sylvania 2B, 3B, 3, or Press 40 and a camera that provides M or S synchronization.

Exposure for bulb flash is normally figured using guide numbers. The blue bulbs are for use with daylight-type color film, and no filter is needed. Clear bulbs are a bit warm for daylight film but fine for black and white.

Never fire a bulb flash close to a person's face. Although it does not happen often, bulbs have been known to explode, and the flying glass could cause serious damage.

Some old timers used to improve the flash-base contact by wetting it with their finger when they loaded the flash gun. This works for awhile, but then the spit corrodes the terminals and ruins the flash gun.

Light-Output Comparisons

The light output of a portable electronic flash unit, or a bulb flash gun with reflector,. is obvious from its guide number, and

you can make direct comparisons between one unit and another. Naturally, if you have a unit with a lens that zooms from wide angle to telephoto, or that will accept telephoto and wide-angle lenses, then the guide number applies only to the normal position. In the wide-angle mode, the guide number will be lower, and in the telephoto or narrow-beam mode it will be higher.

Units with built-in reflectors, a sweeping category that includes all but a small handful of studio and high-voltage designs, may also have light output specified in BCPS units (beam candlepower seconds) and these numbers can be compared directly.

Specifications for some studio-flash systems specify the power output in watt seconds. These ratings do not tell you how much light you will actually get from the system, since the power pack is frequently driving several flash heads with different tube efficiencies and different reflectors, but they do give you a ballpark estimate of what you can expect. In general, anything under 400-watt-seconds is in the semi-portable or portable class. When you get a power pack that delivers 1200- or 1500-watt-seconds, you are dealing with enough power to work several flash heads and light a standard commercial set. Large 4000- and 6000-watt-second packs are used in studios that specialize in large subjects such as furniture groupings, automobiles, or airplanes.

Exposure

The easiest way to get correct flash exposure is to use an automatic or dedicated flash unit in the autoflash mode. As long as the sensor is pointed at the subject and you have the ASA and autoflash aperture set correctly, you will get resonably good exposure. The pitfalls here are the same as

those encountered with any reflected light reading (see Chapter 9): exceptionally dark subjects may be overexposed and very light subjects may be underexposed. But in general autoflash works amazingly well.

If you do not use automatic flash, then a flash meter is your best way to find consistently good exposures. (See Chapter 9 for details.)

Guide numbers: The guide-number system of figuring flash exposures gives you the equivalent of an incident-light exposure. You can use it with non-automatic flash units and with auto-flash units set on manual. To find the correct f/stop divide the guide number by the flash-to-subject distance (not the camera-to-subject distance).

For example, if the flash guide number for ISO/ASA 100 film is 80 and your flash-to-subject distance is 10 feet, the correct f/stop is f/8 (80 ÷ 10 = 8).

If you need to know what distance will let you use a particular f/stop, then divide the guide number by the f/stop to get the distance.

Guide numbers vary from unit to unit, and depend on the electrical power, flash-tube design, and reflector design. Most manufacturers are fairly honest about assigning guide numbers to their units, but if your unit does not seem to be delivering as much light as you would expect, assume the manufacturer fudged a bit and try using a lower guide number.

Guide numbers include a factor for light bounced from walls, ceilings, and other reflectors in an average indoor environment. Outdoors, and in very large rooms, you should open up an extra stop to compensate for the lack of reflected light.

Many manufacturers give only one guide number for a flash unit and leave it to you to calculate

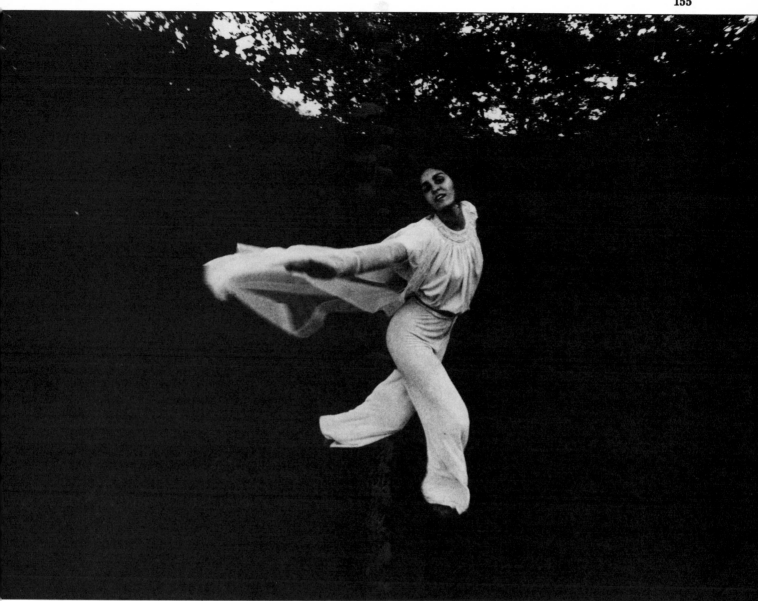

When you use flash outdoors in daylight you can get a wide range of effects by varying the ratio between flash and ambient light. In the photo on the left an f/stop was selected that underexposed the grass and trees by about 1½ stops. The combination of ambient light, slow shutter speed and flash created the blur/stop-motion effect. In the photo on the top the foliage was underexposed by about 3½ stops. A Vivitar automatic flash on the camera correctly exposed the dancer Karen Abrams. Both photos were made with 18mm ultra-wide-angle lens on Plus-X. Similar darkening effects could have been achieved by using No. 25 (Red) and No. 29 (Dark Red) filters, but the tonal values in the dancer's face would have been distorted. Photos by Robb Smith.

Guide Number Multiplying Factors

(For Higher Exposure Index Ratings)

Times Faster	Multiply Guide Number By
2	1.4
2.5	1.6
3	1.7
4	2.0
5	2.2
6	2.4
7.5	2.7
8	2.8
10	3.2
12	3.5
16	4.0
32	5.5

To find the guide number for a higher film speed, divide the lower into the higher to obtain the ''times faster'' number. Multiply the known guide number by the number in the righthand column. Note that manufacturers tend to rate guide numbers for black-and-white films more generously than for color films to take advantage of the black-and-white printing latitude.

other guide numbers. In the past, Kodachrome was the universal standard and guide numbers were based on ISO/ASA 25 film. The trend today is to give a guide number for ISO/ASA 100 film. To calculate guide numbers for faster films, multiply the guide number by 1.4 (the square root of 2) for each doubling of film speed. To calculate a guide number for slower films, divide the guide number by 1.4 for each halving of film speed.

For example, if the guide number for an ISO/ASA 100 film is 80 and you want to get a guide number for Kodacolor 400 (ISO/ASA 400) multiply 80 x 1.4 x 1.4 = 80 x 2 = G.N. 160. To get a guide number for Kodachrome 25, divide 80 by 2 (G.N. 80 ÷ 1.4 ÷ 1.4 = 40).

Flash and daylight exposures: Flash outdoors can do a lot to im-

prove your photos of people and animals. Candid wedding and portrait photographers use it as a routine technique, which is one reason these pros can get such pleasing results.

Base your exposure on the main light. If your subject is in sunlight and you are using the flash to fill in the shadows, then the main light will be the sun. The technique used in this case is called *synchro-sunlight flash*. The flash is usually used on camera or mounted near the camera position. To find the correct flash exposure, find the correct f/stop to use for a properly exposed photo by sunlight at the flash synch speed. For example, if your flash synch speed is 1/60 sec. and you

are using Kodachrome 64, then the correct f/stop for a sidelighted subject will probably be in the neighborhood of f/11 (open up ½ to 1 stop from f/16). If you are on manual and have to calculate, divide the flash-guide number by your f/stop to find the flash-to-subject distance that will balance the exposure.

If you have an automatic flash, set the ASA on the flash to twice the film speed to get a pleasing flash-to-sunlight ratio and don't worry about calculations.

When you use a simple pocket or instant camera to take portraits of people in direct sunlight, you can almost always improve the results by using flash on the camera. No adjustments are required.

Trial Guide Numbers For Electronic Flash

ASA Film Speed For Daylight	BCPS Output of Electronic Flash Unit									
	350	500	700	1000	1400	2000	2800	4000	5600	8000
10	13	16	18	22	26	32	35	45	55	65
12	14	18	20	24	28	35	40	50	60	70
16	17	20	24	28	32	40	50	55	65	80
20	18	22	26	32	35	45	55	65	75	90
25	20	24	30	35	40	50	60	70	85	100
32	24	28	32	40	50	55	65	80	95	110
40	26	32	35	45	55	65	75	90	110	130
50	30	35	40	50	60	70	85	100	120	140
64	32	40	45	55	65	80	95	110	130	160
80	35	45	55	65	75	90	110	130	150	180
100	40	50	60	70	85	100	120	140	170	200
125	45	55	65	80	95	110	130	160	190	220
160	55	65	75	90	110	130	150	180	210	250
200	60	70	85	100	120	140	170	200	240	280
250	65	80	95	110	130	160	190	220	260	320
320	75	90	110	130	150	180	210	250	300	360
400	85	100	120	140	170	200	240	280	340	400
500	95	110	130	160	190	220	260	320	370	450
650	110	130	150	180	210	260	300	360	430	510
800	120	140	170	200	240	280	330	400	470	560
1000	130	160	190	220	260	320	380	450	530	630
1250	150	180	210	250	300	350	420	500	600	700
1600	170	200	240	280	340	400	480	560	670	800

To find the guide number of any film when you have only the BCPS rating of the flash unit, read down the nearest BCPS column and read across the ASA film speed column for the particular film; the guide number will be at the intersection of the vertical and horizontal rows. Where you have a guide number for a flash unit stated in terms of certain film—often Kodachrome II—read across the film-speed column until the stated guide number is reached; then read up to the top figure, which will be the BCPS output for that unit. Thereafter, guide numbers for other films can be found by the first method. Courtesy, Eastman Kodak Company.

If you wait until dusk or sunset to make your flash-on-camera portraits, you should be able to get a deep purple sky or a rich sunset in back of your subject. This is an easy shot to take and it always seems to impress people.

On an overcast day, or when your subject is in open shade, you can use off-camera flash as a key light and the diffuse daylight as fill. If you use a flash in manual mode, find the correct daylight exposure and then find a flash-to-subject distance that will let you close down one stop from the day-light-only exposure. With an automatic flash unit, close down one stop from the daylight exposure and set the sensor accordingly. This will give you a 2:1 flash-to-daylight fill ratio.

Exposure with multiple flash is almost as simple as exposure with a single unit. Only your main and fill lights affect exposure, and the compensation required will always be less than one f/stop. This is so little that photographers working in black and white often ignore the fill light entirely and base exposure only on the main light. But if you do color work, you should close down ⅓ to ½ stop for the fill.

Let's assume that you have two flash units of equal power and want to use a standard two-light setup for a portrait. The basic exposure will be that of your main (key) light, which you place at about a 45° angle between the camera and your subject. At this point, part of your subject's face is in shadow. Next, you add the fill light, which will probably be at the camera position, where it will contribute about ½ stop to the exposure. This assumes that your fill light is at about the same camera-to-subject distance as your main light. If the fill is further away, or if you diffuse it, then you may need to compensate by only a quarter stop.

Standard Photo Lamp Specifications

ANSI Lamp Code	Description	Voltage	Watts	Bulb Dia., Inches	Base	Filament	Rated Aver. Life (Hours)	Max. Overall Lgth., Inch.	Approx. Initial Lumens	Approx. Color Temp. °K
BBA	No. 1—Inside Frost	115-120	250	2⅝	Medium	C-9	3	4¹⁵⁄₁₆	8,500	3400
BCA	No. B1—Blue—Inside Frost	115-120	250	2⅝	Medium	C-9	3	4¹⁵⁄₁₆	5,000	4800
BHH	Movie Light	120	100	1⅜	D.C. Bay	CC-2V	15	2⅜	2,000	3200
BNF	Movie Light	115-125	75	1⅜	D.C. Bay	CC-2V	25	2⅜	1,300	2900
DMS	Clear	115-120	500	2½	Medium	C-13	50	5½	13,200	3200
DMX	Clear	115-120	500	2½	Med. Prefocus	C-13	50	5¾	13,200	3200
DPT	Clear	115-120	1000	2½	Mogul	C-13	50	9¹⁄₁₆	28,000	3200
DPW	Clear	115-120	1000	2½	Mogul Prefocus	C-13	50	9½	28,000	3200
DXR/ DXS	No. 4—Inside Frost	115-120	1000	4⅜	Mogul	C-9	10	9⅜	31,000	3400
DXT	No. B4—Blue—Inside Frost	115-120	1000	4⅜	Mogul	C-9	10	9⅜	19,200	4800
EBV	No. 2—Inside Frost	115-120	500	3⅛	Medium	C-9	6	6¹⁵⁄₁₆	17,000	3400
EBW	No. B2—Blue—Inside Frost	115-120	500	3⅛	Medium	C-9	6	6¹⁵⁄₁₆	10,500	4800
ECA	Inside Frost	120	250	2⅞	Medium	C-9	20	6	6,500	3200
ECT	Inside Frost	120	500	3⅛	Medium	C-9	60	6¹⁵⁄₁₆	13,650	3200
ECV	Inside Frost	120	1000	5	Mogul	C-7A	60	9¾	26,500	3200

If you use two flash units in the same position to get a stronger main light, base your exposure on the stronger of the two units. Adding a second unit of equal power will increase the amount of light on the subject by one f/stop. This is the maximum increase you can get using a second flash. If you add a third flash, you only get an extra half stop, or a total light increase of 3X.

CONTINUOUS LIGHTS

Continuous-light sources for photography include everything from arc lamps to lightbulbs, all of which are fine when you shoot black-and-white film, but there are only a few sources that are really suitable for color work, and

those are the ones most photographers rely on for general work.

Flood Lamps

Beginning photographers and students often opt for photo lamps because they are inexpensive and efficient. You can get three or four clamp-on lights with 250-watt and 500-watt bulbs for under $25 and improvise lightstands, or use inexpensive portable stands. This is a good route to follow. You can always go for more expensive equipment later.

Lightbulbs contain a tungsten filament that heats up and produces light when you run an electric current through it. Bulbs for household use are generally sold by watts, which is fine when you are dealing with 40-, 75- or 100-

watt medium screw-base bulbs, which are all standard. It does not work so well when you begin to deal with photographic lights, which are available in different color temperatures as well as in different strengths.

Bulbs specifically designed for photography have ANSI (American National Standards Institute) or ASA designations, and you can save yourself a lot of trouble if you ask for bulbs by code rather than trying to explain to a sales clerk what you want in general terms. For your convenience, some of these codes are given in the accompanying charts.

Photofloods: One of the first

photographic bulbs to gain general acceptance was the photoflood, a 3400 K bulb that matches the color balance of Kodachrome 40 and most "Type A" movie films. Under the original code system, which is still in use, wattage was indicated by a number.

A No. 1 (BBA) flood is 250 watts, a No. 2 (EBV) flood is 500 watts. These both have standard, medium-screw bases, which screw into any standard household lightbulb socket. The No. 4 flood (DXR/DXS) is a 1000-watt bulb with a mogul base, which is a large-screw base that screws into the special mogul socket used in some heavy-duty lighting

equipment.

Tungsten lamps: Photo lights that operate at 3200 K are often referred to as studio floods or "tungsten" lights. This really doesn't make much sense, because all photo lights are used in studios and most bulb types have a tungsten filament. On the other hand, as long as the largest film manufacturer in the world makes Ektachrome 160 Tungsten, the lights that match might as well be called "Tungsten."

The two most useful lights in this category are the 250-watt ECA and the 500-watt ECT bulb, both of which have a medium-screw base and are ordinarily

Although often sold as components in inexpensive photo lights, paper-insulated sockets are potentially hazardous when used with hot photo lamps. The wires in this socket were fused and the insulator charred when it was used in conjunction with a bullet reflector and a 500-watt photoflood.

These are three of the most commonly used screw-base photo lamps. On the left is a mogul-base bulb, which must be used in a mogul socket found in lights designed for high-wattage bulbs. In the middle is a 500 watt bulb and on the right is a 250 watt bulb. Since every reflector is designed for use with a bulb that puts the filament at its focal point, you should try to use bulbs recommended by the manufacturer. Size does make a difference.

used in conjunction with a reflector. The 1000-watt ECV has a mogul base.

In general, 3200 K floods have a longer life than 3400 K floods (see chart for comparisons), so if the difference between Kodachrome 40 and Ektachrome 160 is not significant to you, then the 3200 K Tungsten lamps are a better buy.

If you are just beginning to build a lighting inventory, you are probably better off with floods, which are inexpensive. Tungsten halogen lamps (see below) are unquestionably superior, but a three- or four-light system will cost you several hundred dollars, and you can get similar results for less than $25 using floods in clamp-on sockets with cheap aluminum reflectors. To keep color quality up to snuff, discard the flood when it begins to darken noticeably or when it reaches three-quarters of its rated life.

Reflector floods (R-type bulbs) have built-in reflectors. They are available in a variety of color temperatures and are frequently called *movielights*. They are popular for general photographic work because they do not have to be used with a separate reflector and you can screw them into any standard lamp socket.

If you work with Ektachrome 160 Tungsten, consider buying a few DXH (R-32) reflector floods, which have a color temperature of 3200 K and a life of about 15 hours. You can operate up to four of these 375-watt R-bulbs on an average household circuit.

The BFA is a 375-watt reflector flood with a color temperature of 3400 K and a life of about four hours. You can use it with Kodachrome 40 and most movie films.

If you are looking for the longest possible lamp life, try the 300-watt DWD, a 2800 K bulb with a 2000-hour life. For proper color balance with color films, you will have to use a light-balancing filter

Reflector Flood Lamp Specifications

ANSI Lamp Code	Description, Beam Spread	Voltage	Watts	Bulb Dia., Inches	Base	Filament	Aver. Rated Life (Hours)	Max. Overall Length, Inches	Approx. Initial Candle-power	Approx. Color Temp. °K
BDK	Medium Beam—30°—Inside Frost	120	100	1¾	D.C. Bay	CC-2V	4	2¾	3,200	3400
BEP	Medium Beam—20° x 30°— Inside Frost	115-120	300	3¾	Medium	C-9	4	5¼	11,000	3400
BFA	Medium Beam—20° x 30°— Inside Frost	115-120	375	5	Medium	C-7A	4	6⅝	12,000	3400
DAN	Medium Beam—25°—Inside Frost	115-120	200		Medium		4		3,500	3400
DWE	Quartzline—Medium Beam	120	650	4½	Screw Terminal	CC-6	100	2½	24,000	3200
DWH/ DWJ	Medium Beam—25° x 35°— Cinema Light	6.3	100	4½	Screw Terminal	C-6	3	2¾	6,500	3400
DXB	RSP-2—20° Beam—Inside Frost	115-120	500	5	Medium	CC-2V	6	6⅝	38,000	3400
DXC	RFL-2—90° Beam—Inside Frost	115-120	500	5	Medium	C-9	6	6⅝	5,500	3400
DXE	Flood Beam—90°—Inside Frost	125	500	5	Medium	C-9	6	6⅝	6,500	3400
DXK	Quartzline—Medium Beam—30° x 40°	120	650	4½	Ferrule Contact	CC-6	30	2⅜	30,000	3400
DZR	Medium Beam—20° x 30°	120	250	4½	2-Prong	CC-6	4	3	18,000	3400
EAH	Flood Beam—90°—Inside Frost	220-240	500	5	Medium	C-9	6	6⅝	5,000	3400
EAL	Reflector lamp	120	500	5	Medium	CC-2V	15	6⅝	6,800	3200
EBR	Medium Beam—40°—Inside Frost	115-120	375	3¾	Medium	CC-6	4	5¼	14,000	3400
FAE	Medium-Wide Beam—38°—Inside Frost	115-120	550		Medium		—		18,000	3400
FAY	Quartzline—Daylight—Medium Beam—15° x 25°	120	650	4½	Ferrule Contact	CC-6	30	2⅜	35,000	5000
FBE	Quartzline—Daylight—Medium Beam—15° x 25°	120	650	4½	Screw Terminal	CC-6	30	2½	35,000	5000
FBJ	Quartzline—Daylight—Medium Beam—15° x 25°	120	650	4½	Ferrule Contact	CC-6	30	2⅜	75,000	3400
FBO	Quartzline—Spot Beam—15° x 22°	120	650	4½	Screw Terminal	CC-6	30	2½	75,000	3400
FCW	Quartzline—Wide Beam—70°	120	650	4½	Ferrule Contact	CC-6	100	2⅜	9,000	3200
FCX	Quartzline—Medium Beam—30° x 40°	120	650	4½	Ferrule Contact	CC-6	100	2⅜	24,000	3200
FGK	Quartzline—Medium Beam—30° x 40°	120	650	4½	Screw Terminal	CC-6	30	2½	24,000	5000
FGR/ FBM	Medium Beam—20° x 30°	120	250	4½	2-Prong	CC-6	4	3	18,000	3400
FGS/ DWA	Medium Beam—20° x 30°	120	250	4½	Ferrule Contact	CC-6	4	2⅜	18,000	3400

with this lamp. (See Chapter 4.) Do not confuse this bulb with the DXC, another R-40 bulb that has only a six-hour life.

The FAE is a popular 550-watt movielight (3400 K).

Blue flood lamps have a color temperature of 4800 K, which is slightly warm for use with daylight-type film. Photographers who want to show how an interior room setting looks when the lights are on will use these lamps to replace ordinary lightbulbs in all the lighting fixtures and then rely on either daylight or more often electronic flash for overall illumination. The resulting color quality is pleasing and the lights have a warm, natural look.

If you want to get daylight-quality light with blue floods, you use an 82A light-balancing filter on your camera lens. (See Chapter 4.)

Tungsten-halogen lamps are more expensive than floods, but they usually have a longer life and they do not change color with age, which is why they are in universal use on movie and TV sets and in the studios of commercial photographers. These lamps are available in a variety of color temperatures. There are a few medium and mogul screw-base halogen lamps, but most have a two-pin or recessed single-contact base and must be used in special lamps designed to take the extreme heat these bulbs generate.

When halogen lamps were introduced, they were manufactured from quartz and contained an atmosphere of inert gas and iodine. At that time they were called quartz-iodine or simply quartz lights, and you still hear the name used. But today, with new developments in lamp technology, material such as Vycor is used to replace the quartz, and other gasses in the halogen family are used. So the accepted name for these lamps is *tungsten-halogen*, or simply *halogen*.

Normal floods discolor with age because the tungsten in the filament evaporates and condenses on the inside surface of the bulb. Halogen lamps do not discolor because the bulb is extremely hot, which prevents condensation. When the tungsten particles evaporate, they combine chemically with halogen gas and are redeposited on the filament, at which point the halogen gas is released and ready to combine again. This cycle continues throughout the life of the bulb and a constant color temperature is maintained.

Fluorescent Lights

The recent introduction of full-spectrum fluorescents such as the Vita-Lite is creating a small revolution in continuous photographic lighting, because these lights produce daylight-quality illumination. Like all fluorescents, they are cool to the touch and yield far more light per watt than lightbulbs.

These full-spectrum lights are now used in some copying systems. They are still not widely used in offices and public buildings because they are more expensive than the traditional fluorescents, which produce a green or blue cast with most color films. On the other hand, recent behavior studies indicate that workers are more productive and healthier in offices lighted by full-spectrum fluorescents, so a change is in the

This portable quartz (tungsten-halogen) lighting kit from Smith-Victor is typical of the kits purchased by commercial photographers who regularly photograph room settings, architectural models, products and other still subjects. The entire kit, including stands and case, weighs only 14 pounds. Electronic flash equipment providing similar lighting would be much heavier and bulkier.

Subjects with lights lend themselves to unusual interpretations. One trick is to photograph the lights themselves using a 1 sec. exposure and moving the camera to create a pattern. Another is to combine a time exposure of the lights with a blast of light from an electronic flash so that you get a lighted subject plus light patterns.

On-camera flash is an ideal source of fill-in light for studies of flowers and other natural subjects. On the far right is a straight shot without fill. A Vivitar automatic flash was used to spotlight the flowers in the shot on the right. Photos by Julie Lomoe-Smith.

The soft sharp/unsharp quality of this photo was produced by making eight exposures of the subject on the same frame of film with a hand-held camera. Exposure was metered through the lens and the lens was then stopped down three extra stops to permit eight shots.

The usual method of photographing fireworks is to set the camera on a tripod, use the exposure guide (see page 155) to determine f/stop, and leave the shutter open during several bursts. Here, an alternative multiple-exposure method was used. The exposure guide was used to determine f/stop, but then a series of multiple exposures at 1/30 sec. each were made on the same frame so that the bursts piled up like a star nebula.

This photo (top left) of lower Manhattan was taken from the back of the Staten Island Ferry using a 28mm wide-angle lens, which created the feeling of depth that gives impact to this photo.

Right, a 35mm lens was used to emphasize the effect of pollution on a beach in Puerto Rico. The good depth of field provided by the moderate wide-angle lens also contributes to the impact.

Often the quality of light on your subject is more important the the lens chosen. Both these shots were made with a normal lens. In the case of the ice and leaves, a shaft of low winter sunlight turns the commonplace into something unusual. The model is backlighted and photographed from a low angle to take advantage of the sky as a background.

When you want to photograph an inaccessible subject, such as this gargoyle perched high on an ivy-covered wall, nothing beats a zoom lens. This was taken with on Ektachrome 400, which was a big help in the existing low-light situation, with a Vivitar 100–200mm zoom lens.

This simulated dogfight at the Old Rheinbeck Aerodrome was taken using a Sigma 500mm mirror lens and Ektachrome 400 film. The lens was light enough to hand hold and follow the action.

The trick to photographing snowflakes or raindrops is to use flash. Here, a time exposure was made of the overall scene. An electronic flash stopped the snowflakes.

Sometimes special cropping will rescue an apparently damaged shot. The photo of a dress rehearsal of Aida was the last on a roll and only took up half the frame. The processor mounted it in a half frame slide mount and saved the shot.

Although this shot (top right) looks filtered, it wasn't. Sometimes unusual lighting conditions such as an exceptionally red sunset combine with a film's inherent response to color to produce a unique result. The film was Focal 400, a private label film.

Tungsten type films are ideal for early evening and night-time photography. Blues, such as the blue of a sky are intensified, fluorescent lights tend to produce green, but subjects such as the balloons lighted by carnival flood lights appear normal.

A 200mm lens was used to frame these painters at work. The lines of the stacks are roughly parallel with the sides of the frame because the photographer made his shot from a window that was level with the painters.

These painters are making a trompe l'oeil facade on the plain brick wall of a New York City building. A 135mm lens was used through the window of a near-by building to capture the unusual situation.

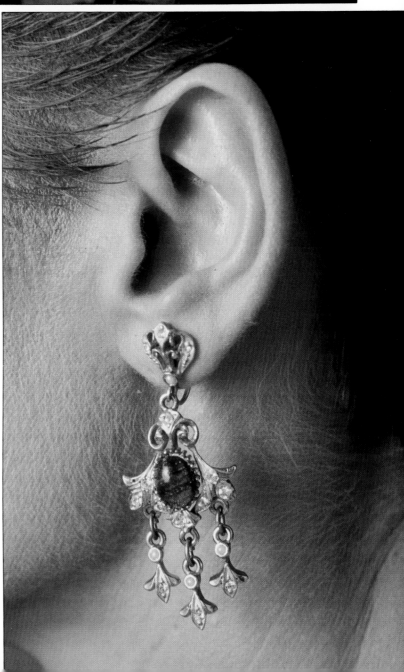

Photos like this are surprisingly hard to get. This is the best from a sequence of seven taken with a motorized Nikon FM. All the others had something wrong. Without the aid of the motor drive, which lets the photographer concentrate on the subject, coming up with a good photo would have been even harder.

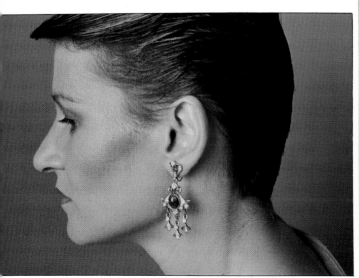

When you want to get detail in a small subject, the close-focusing limits of your normal lens can be frustrating. One simple solution is a +4 close-up lens, which was used here to get a close-up of the earring.

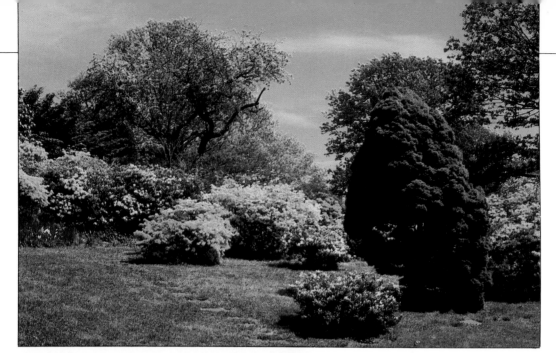

If you compare the Ektachrome infrared version of this shot, taken through a Yellow No. 15 filter, with the normal rendition on Kodachrome you can see many of the standard infrared effects. Green grass becomes red, blue sky turns turquoise, red flowers, surprisingly, come out yellow-green.

This dramatic shot was taken on Ektachrome infrared film through an 18mm lens with a built-in No. 25 (red) filter.

making and the world of photography will benefit.

The output of a fluorescent light tube varies at the rate of 60 cycles per second, so if you use fluorescents for copy work or still photography and seem to be getting uneven illumination, try using a shutter speed of 1/30 sec. or slower, which will allow the light to complete its full cycle.

Projector Lamps

Slide projectors usually have a color temperature in the neighborhood of 3200 K, which makes them suitable for use with tungsten film. The beam of focused light from a projector makes a good spotlight, and when you light a subject with 3200 K floods or halogen lamps, you can combine your subject with a projected slide for endlessly varied effects.

Lamp Design Considerations

Sockets: The standard lightbulb socket intended for general household lighting has a paper insulator and a metal shell. Sockets of this type are frequently sold as inexpensive photo lights, usually with a clamp attached. They are suitable for use with household lightbulbs up to about 300 watts, provided the lamp is well ventilated, but when you try to use them with photolamps, the intense heat these special bulbs generate chars the paper insulator. If you must use sockets of this type, inspect them every time you use them, and if you see deep brown char around the edges of the insulator, throw the socket away. (But keep the clamps, ball adapters, and reflectors.)

The best socket for photolamps is either ceramic or phenolic resin. The phenolic (usually brown plastic) sockets cost more than the traditional sockets, but they will take up to 600-volt lamps and stand up better to heat. Lamp heads for the big mogul-base 1000-watt photofloods usually have ceramic sockets.

Heat ventilation: Photofloods are override lamps. This means they generate more light and more heat than ordinary lightbulbs of similar wattage. A well-designed photo lamp will be vented to dissipate the heat (see accompanying photo). Even a simple clamp light should have a wooden handle on the end of the socket so you do not burn your fingers on the socket or reflector. Although they will do in a pinch, lamps that consist of nothing more than a clamp, socket, and reflector should not really be considered photo lamps.

This well-designed flood light has a toggle switch and handle mounted to the rear of the unit, which makes it easy to turn on and off and easy to position. If you do a lot of studio work with hot lights, you'll appreciate this feature on an intermediate priced unit.

A typical clamp light with battered aluminum reflector. These lights are OK for casual work, but once you turn it on you need a pot holder to adjust it or turn it off without burning your fingers. Cheap reflectors often give an uneven beam spread. The typical ten-inch reflector should not be used with bulbs stronger than 250 watts. Larger 500 watt bulbs put the filament in the wrong position relative to the focal point of the reflector.

Inexpensive lights are much easier to use if they have a wooden handle attached to the socket. These units are often sold with spring clamps attached. To use the lamp in

the studio, remove the spring clamp and attach the light to a ball adapter on top of a light stand.

This Smith-Victor 16" reflector lighting unit for use with photo lamps contains a mogul screw base porcelain socket, ventilation for cool operation and a swivel mount for easy positioning. The etched aluminum reflector provides soft, evenly diffused light when used with the correct bulbs. It is an option for the serious photographer who has outgrown cheap aluminum reflectors, but does not want to invest in more expensive tungsten-halogen lighting fixtures.

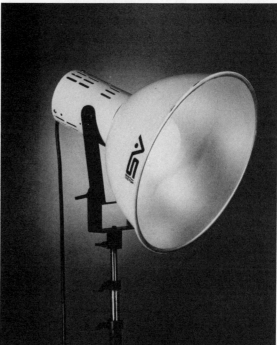

Circuit Loads

You can only draw a limited amount of power from a circuit before a fuse blows or the circuit breaker trips. The average household circuit provides 15 amps of current or 1800 watts of power. Appliance circuits in kitchens, and circuits in some studio and other installations will handle 20 amps. To figure out how many watts of power you can draw from a circuit before it blows, multiply the amperage of the circuit by the voltage, which is usually 120. Add up the total wattage of the light you want to put on the circuit and stop when you reach the power maximum of the circuit.

A typical 15 amp circuit will safely handle three 500-watt bulbs, one 1000-watt plus one 500-watt bulb, six 250-watt bulbs, and so on, assuming that you do not have anything else operating off the circuit.

You can find the amperage of a circuit by looking at the fuse or circuit breaker. If you do not know which outlets are on which circuit, switch the circuit breaker off and see which outlets go dead or which lights and appliances stop working. If you cannot find the fuse- or circuit-breaker box, or don't want to fool with it, assume you can get away with about 1000 watts of lighting per circuit. Avoid using the same outlet a refrigerator or other heavy-duty appliance is plugged into. If a fuse blows or a circuit breaker trips, you are drawing too much power and will have to redistribute your power drain. One way is to run a heavy-duty extension cord from some other place in the building or apartment so that you get a different circuit.

LIGHTING HARDWARE

This section covers lightstands, brackets, stand adapters, clamps, and all the other paraphernalia that lets you position lights where you want them. Most of the items covered are used for both continuous and electronic flash lights.

Stands and Clamps

Lightstands are essential for studio work. A single stand can run from under $10 to more than $100, with most falling somewhere in between. The typical collapsible stand is a lightweight affair with a telescoping center column that ends in a post, which is usually ⅜" or ½" thick, although some professional stand systems may use thicker columns. To attach a light to the stand, you need an adapter. Some lights come with built-in stand adapters, such as that on the base of the Smith-Victor light shown in the accompanying photo. An adapter of this type will fit on any lightstand. Amateur units often come with a ball adapter (see photo).

Some columns are held in place with set screws. Others, such as the Ascor lightstands, have quick-release locks that prevent slippage and are easy to adjust. If you are mounting studio flash heads, then a positive locking system is a big plus. There is nothing more unnerving than having a set screw suddenly give way, letting a center column plummet into itself when you have a flash head worth a couple of hundred dollars mounted on top. On the other hand, if all you have on top is a $7.95 light socket on a ball adapter, then the set-screw type should hold well enough.

A really good lightstand is also sturdy. It will not collapse when you accidentally knock into it. A lightweight stand can pose problems in this respect.

If you only do an occasional studio setup, you do not need to invest in lightstands. A tripod will hold a light. And if you are in a mood to improvise, you can always fill a bucket with sand or gravel, put a six- or seven-foot plant stake into it, and use a light mounted on a spring clamp. (If anyone asks, tell them the buckets of sand double as fire extinguishers, and you have to use them to meet the fire code.)

Stand adapters are used to attach the light to the stand. One typical adapter is a sleeve with a ¼" x 20 screw stud on top. The sleeve fits over the top of a ½" or ⅜" stand and is held in place with a set screw. Onto the stud you can screw a ball adapter or an accessory shoe adapter for flash units. For flash units that have only hot-shoe synchronization, there are hot-shoe adapters to which you can attach a slave unit.

The accompanying photos show some typical stand-adapter-light combinations. After a few years of accumulating studio equipment, you can develop a large collection of stand adapters that, with a little ingenuity, will let you mount almost any light ever made.

A boom is a long arm that you attach to a lightstand using a rotating bracket. One end of the boom takes an adapter for a light and the other end has a counterweight. Booms are used to position lights directly above a subject but out of view of the lens.

Flash Brackets

Flash brackets are used to hold a flash unit on a light stand or on a camera. The simplest bracket is nothing more than a side grip with an accessory shoe or band clamp that holds the flash. You can use this arrangement when you have a shoe-mount flash and a camera that does not accept shoe-mount accessories.

Potato masher-shaped units with a battery grip generally come with a camera bracket and some, such as the Metz 45-CT1 and Sunpak 611, have quick release mounts so you can remove the

This is a typical collection of adapters for use with light-weight stands sold for amateur use. On the top, from left to right, is a stand top adapter with standard ¼" x 20 stud into which you can screw any ball adapter that has a socket. The swivel clamp, salvaged from a clamp light, lets you attach a second ball adapter, or as here, an accessory shoe with ball. The bottom row contains a light socket clamp, double ball adapter, and small clamp for attaching a ball adapter to a spring clamp.

Unless you have an expensive system of permanent lighting tracks built into your studio ceiling—and even successful professionals can seldom afford that—then you will need one or two booms to hold lights directly above your subject. The boom has a weight on one end to balance the weight of the lamp on the other. It slides into a swivel bracket that slips over the top of your lamp stand. With a small light on the end of the boom, it is sometimes called a hair-light, following usage popularized by portrait photographers.

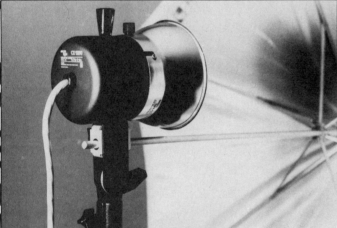

This system of mounting an umbrella reflector/diffuser offers the ultimate in convenience. The Ascor flash head comes with its own stand adapter/umbrella bracket. The shaft of the umbrella slides into a hole in the bracket where it is held in place with a set screw controlled by a large knob. The umbrella tilt can be locked in any position and the flash is always correctly aligned.

This medium-weight Ascor light stand for professional use features snap-lock height adjustment of the telescoping center column. Good snap locks make adjustment fast and positive. If you are planning to invest in expensive lighting equipment, plan to buy good light stands at the same time.

This heavy-duty studio stand from Smith-Victor has a roller base, which is a real convenience when you are adjusting large lights such as this 16" professional unit.

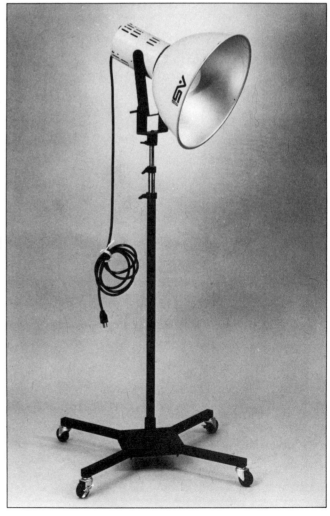

There are many ways that a flash can be attached to an umbrella reflector or to a diffuser. The only requirement is that you aim the flash along the axis of the umbrella or at the center of the diffuser. Here are a few of the many options available.

1. In this set-up, two portable handle-mount units are mounted in tandem on a bracket attached to a light stand.

2. Two small portable units are mounted on an extension bracket in conjunction with a small umbrella. This is a portable setup for hand-held portraits and group photos at wedding receptions, in work settings, and at other locations where the photographer has to remain mobile.

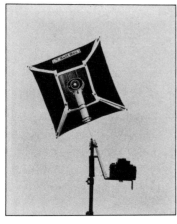

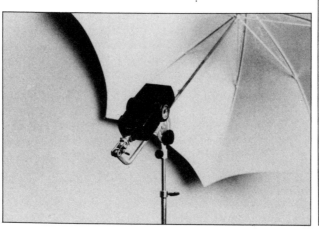

3. In this unusual arrangement, a Soff-Box diffuser designed for use with portable flash units is mounted on the flash. A special bracket attached the flash to the camera and the whole system is mounted on a heavy-duty light stand. This is a good setup for pet and child portraiture when you have a motor-driven camera and a remote switch. It lets you pre-focus, then concentrate on working with the child or pet to elicit reactions. The arrangement can also be taken off the stand and used for hand-held camera work.

4. This Testrite umbrella came with a screw-on ball adapter. A small ball-adapter clamp (salvaged from an old clamp light) connects the ball on the umbrella shaft to the shoe-mount ball adapter, which was purchased separately. The flash slides into the shoe. A setup like this is best used with relatively light-weight units. Note how the flash has been aligned with the shaft of the umbrella.

5. This Siegelite Mark III flash bracket looks cumbersome but balances well. Adapters are available from the manufacturer so that you can mount just about any type of flash, including handle-type units. The extension post telescopes into the handle and the handle pivots so that you can change the flash position to provide either side lighting for candid portraits or balanced lighting for two or more persons.

flash from the bracket with the push of a button.

The handgrip or battery grip puts the flash to the side of the camera and slightly above. Its advantage is that the slight displacement helps to prevent red-eye and to improve modeling.

A flash extension bracket such as the Siegelite gives significantly better flash-to-subject angles. These units are good for head-and-shoulder portraits of one or two people. By placing the extension arm so that it holds the flash high and to one side, you can get 45° lighting. If you attach a piece of black paper to the flash head, you can prevent light spill onto a background, which will give you a dark background for candid portraits at wedding receptions and family gatherings. If you place the extension so that it holds the flash high above the camera, you can get a balanced light for photographing two people, one to either side of the flash, and for groups. If you are interested in photographing people, a bracket like this can be a big help, and in professional situations it can even take the place of an assistant for routine candid portraiture.

An umbrella bracket is used to attach a flash to the shaft of an umbrella reflector. Self-contained heads for studio use often have a combination umbrella bracket and stand adapter permanently mounted to the base of the unit. Others have an umbrella bracket available as an accessory. Manufacturers of photo umbrellas, such as Larson Enterprises, have a whole system of brackets available so that you can attach high-voltage and portable units to the shaft and direct the light along the central axis.

Testrite offers an umbrella with a ball adapter to which you can attach a shoe mount or clamp.

You also need a bracket to attach the umbrella to the light stand. Often the flash bracket also serves this function, but in some systems, such as the Testrite, a separate stand adapter is supplied with the umbrella. Stand adapters for umbrellas tilt up and down so you can aim the light where you want it.

Backgrounds
A good background is hard to find. The problem is not with old canards about trees appearing to grow out of subjects' heads: you have to really work to get that effect. The difficulty more often lies in the presence of distracting background elements—bits of cars, telephone poles, the corner of a house, a wall filled with pictures, household clutter, and so on. Instead of providing a field against which the subject appears to advantage, the poor background presents confusion.

Professional portrait photographers often eliminate all problems by relying on painted backgrounds, which are available from companies such as Larson. A typical painted background is light in the middle, darker toward the edges to simulate the effect of a well placed background light, and usually offers some tonal variety. Popular colors are blue, brown, and greenish brown. The small 42" size is used for head-and-shoulder or three-quarter portraits; the 5' x 7' and 7' x 8' sizes are used for full-figure shots. There are also painted backgrounds that depict scenes, such as a landscape viewed through a window. A scenic background like this is next to impossible to achieve naturally because of the difference between indoor and outdoor illumination, so when the painted version is used, the results are special, something the portrait client could not take himself.

Commercial photographers doing fashion, advertising, and product photography frequently rely on seamless background paper, which comes in long rolls nine feet wide. The most useful are rolls of black or white seamless. Pearl gray, brown, and blue make good backgrounds for color work.

There are several popular systems available for holding background paper. Polecats are metal poles with spring-loaded tops that press against ceiling and floor. Brackets on the poles support a bar that holds the roll of paper. Timber-Toppers are spring-loaded tops for 2" x 3" lumber, which you can cut to size to fit any room. There are also free-standing background stands that consist of two tripod-type lightstands with a bar running between them. These are more often used for painted and cloth backgrounds than for seamless paper. Professional studios specializing in product photography will often have large holders that take several rolls of paper at the same time.

But there is no need to invest in a special stand to use seamless paper or a painted backdrop. A ten foot length of ½" conduit, available from any electrical supply company, makes an excellent holder. You can drill holes in each end, run lightweight eye bolts through, and hang the pipe from hooks screwed into the ceiling joists (see photo).

A roll of white seamless is a good investment for any serious photographer because the paper has multiple uses. You can cut pieces off and use them for reflectors. You can even use the paper as a projection screen.

As you use seamless, it begins to develop stains, tears and holes. When a section gets worn, just cut it off with a utility knife and unroll more paper. When the paper is not in use, keep it rolled up. A couple of strips of masking tape

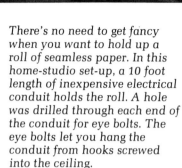

There's no need to get fancy when you want to hold up a roll of seamless paper. In this home-studio set-up, a 10 foot length of inexpensive electrical conduit holds the roll. A hole was drilled through each end of the conduit for eye bolts. The eye bolts let you hang the conduit from hooks screwed into the ceiling.

An overcast sky makes an ideal seamless background. This photo was made through a 35mm moderate-wide angle lens and with the camera held close to the ground. This technique minimized background detail and made maximum use of the sky area. The subject is a piece of playground equipment in Port Townsend, Washington.

will hold the edges so that they do not unroll.

Seamless will eliminate the joint between floor and wall if you unroll enough of it. If you place people or objects on the paper itself, and are careful about your lighting, they will appear to float in space.

Improvised backgrounds: Here are some tips for finding and using backgrounds that you discover on the scene.

Foliage makes a good background for color work, but avoid it for black-and-white portraiture. If you must use foliage as a background for black and white, have your subject wear very light clothing and decrease exposure ½ stop or have them wear very dark clothing and increase exposure ½ stop.

The sky is always a good backdrop. Use filters to darken it if required.

To eliminate distracting backgrounds, smooth out brick walls and other surfaces, use your widest f/stop and place your subject at sufficient distance from the background, so that it will blur.

You can use the fall-off in intensity of electronic flash to create a dark background in any low-light environment, indoors or out. Any medium- to dark-colored object or area that is more than four times the flash-to-subject distance will not receive enough light from direct flash to register on the film.

Cloth makes an excellent background. For a smooth, white background, try a bed sheet. Blankets make good colored backdrops. Velour is an ideal background material for small subjects.

Primary Reflectors

A primary reflector is used to contain and shape the beam of light from a flood or electronic flash. The standard reflector for floods and flash units with interchangeable reflectors is a round, parabolic design with about 60° of light coverage. Portable flash units in the normal mode generally have a rectangular reflector that provides 60° horizontal and 45° vertical coverage, which is slightly wider than the field of view of a normal lens.

The physical size of the reflector is unimportant. What counts is the relationship between the bulb filament and the focal point of the reflector. A reflector for a tiny, 1000-watt halogen bulb may be only four inches in diameter and a reflector for a 1000-watt mogul-base flood lamp could measure 10½ inches across, yet both could yield the same coverage.

When you buy reflectors from a manufacturer that offers an extensive system, then the manufacturer's literature will specify the coverage. If you want to be certain of getting a wide-angle or narrow-beam reflector, check the specifications before you buy. Size is not a good guide to coverage.

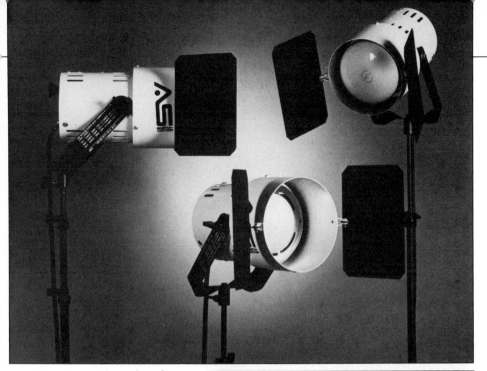

Barn doors are used to shape the beam of light as it emerges from the reflector. They are used to stop the light from spilling onto shiny surfaces just out of view of the lens and to cast portions of the subject into darkness for modeling effects.

Studio photography of still subjects leaves endless scope for improvisation. This set-up illustrates a number of common expedients. The table is a sheet of plywood resting on saw horses. The background is a sheet of white seamless paper. Diffuse illumination is provided by a flash on a boom directed through a translucent photo umbrella. A sheet of white seamless paper tacked to the wall provides additional bounced illumination.

You can further shape the beam of light by using accessories that attach to the reflector. *Barndoors* are opaque panels that block off part of the light. A *snoot* is a cone with a hole in the narrow end where the light emerges. It gives a spotlight effect. A *grid* partially diffuses the light.

For portable electronic-flash units, many manufacturers offer a slip-on, *wide-angle diffuser* so you can use the unit with wide-angle lenses or off camera with a reasonable margin of error when you aim the flash at the subject.

PRACTICAL LIGHTING TECHNIQUES

What Lights Do

When you try to talk about what lights do, you have to resort to a vocabulary drawn from a dozen different sciences and arts and use words that already have numerous meanings. Even experienced photographers sometimes find this confusing. The purpose of this section is to sort through this mishmash of terms and explain how the effects these words describe relate to the light sources, lighting setups, and miscellaneous accessories that you use to create them.

The key light is customarily a strong light such as the sun, a photoflood, or an electronic flash. It casts the shadows that serve to delineate the form of the subject. When the sun is functioning as a key light, it is often spoken of as *working* on a subject. A shaft of sunlight in a forest may work on an interesting bit of wood or rock formation for only a few moments. On the other hand, an isolated building may have the sun working on it all day with new variations of texture and form appearing hour after hour as the sun arcs through the sky. Good landscape and architectural photographers try to anticipate what the sun will do and may return to the same subject many times over a period of hours, days or weeks to catch the sun working on it in different ways.

In the studio, there are a whole set of terms that refer to the position of the key light, which in portraiture is often called the *modeling light. Front lighting* is created by placing the light at the camera position. On-camera flash, when the camera is at the sitter's head level, produces a *flat front lighting.* It's called *flat* because there are almost no shadows in the face. When the front light is higher than the head, it produces a small shadow beneath the nose and eye sockets. This is sometimes referred to as *glamour lighting.* It is used frequently in fashion photography, where professional make-up artists are hired to make up the models. The make-up job

creates the form that the lights do not. You can get glamour lighting by mounting any portable flash unit on a bracket that holds it above the camera (see Lighting Hardware), but you will need some additional fill lighting, as explained below, in order to get a smooth look.

Three-quarter lighting, also called *forty-five degree lighting,* is created when you position the key light at about a 45° angle from an imaginary line drawn between you and your subject. This is the standard position for portrait lighting. Adjust the height of the light so that the shadows in the eye sockets do not come below the upper lid.

In **Rembrandt lighting,** you place the key light to one side and slightly behind your subject, so that the light spills around one small area along the edges of the face and clothing.

Side or **hatchet lighting** is light that is positioned at a 90° angle to the line between camera and subject. When your subject faces the camera directly, it splits the face neatly into light and dark halves.

When the key light is directly above the subject, the result is *top lighting.* The sun around midday in summer is a top light. It gives an interesting texture effect to some walls, but with people, it puts the eyesockets in deep shadow, which is an ugly look at best.

When the key light is placed directly behind the subject, anywhere between 11 and 1 o'clock, you have backlighting. This key light position is used mainly for product photography, because it seems to create a dramatic context for commonplace items. It is also used for low-key effects, in which the subject appears to be in shadow, and silhouettes.

The *main light* in a scene is the light on which exposure is based. It is usually the key light, but in backlighted situations, it may be the fill light. When photowriters discuss the main light, assume they mean the key light unless they specify otherwise.

A *fill light* is used to fill in the shadows cast by the key light. It is the second most important light in any lighting arrangement, because it is the fill light that lets you capture detail and color in

A key light, placed slightly above and to one side of the face, is used to simulate sunlight in traditional portraiture. The shadows delineate bone structure and create mood.

In this low-key (dark subject) rendition, general illumination was provided by a light bounced from a low ceiling. The highlight in the hair was produced by a hair light hanging on a boom above the subject.

When you place the main light slightly above head height and aim it directly at the model's face, you get a flat effect, but the edge contour of the face is well delineated. This is a lighting favored by both wedding and fashion photographers because it produces negatives with good color quality and, in black-and-white work, with even tonalities that are easy to manipulate in the darkroom.

Here you see two versions of the same negative, one printed for normal facial tone, the other printed for high contrast to eliminate tonal variations in the face and create a high-key (light subject) effect.

shadow areas. In a standard studio-portrait setup, the fill is usually placed at the camera position, although it may also be a light bounced off a ceiling, wall, or other reflector.

Supplementary lights are used to add texture, brilliance, shine, subject-background separation, and other effects to a photo. A *hair light* is a small light on a boom that hangs over the subject's head and adds more sheen to a hairdo than you can ever get from shampoo. An *edge light* is a light placed to the side or behind a subject to light up the edge of a form. Placed behind a sitter's head, it can turn an afro into a halo. A *background light* lights up the background. *Spot lights* are sometimes used as supplementary lighting to bring out recessed areas in a subject with complex shapes.

From Hard to Soft
When photographers speak of a *hard* or *sharp light*, they mean one that casts sharp shadows. Direct sunlight is a hard light. So is any tiny point-source of light, or any light in which the rays are either parallel (collimated) or focused, such as the light from a spot light or a slide projector. In recent years, some photographers have been calling these light sources *specular*, although technically it's a misuse of the word.

The typical photographic light source is moderately hard. This is as true of photofloods in reflectors as it is of portable electronic-flash units. They cast shadows with hard edges. This is fine for objects with interesting texture, but it does nothing for the subtle beauty of rounded forms such as cheeks, lips, and free-form sculpture.

Soft light is a diffuse light. The rays are scattered, and the light seems to wrap around three-dimensional forms, creating the soft, delicate transitions from

This is the characteristic beam pattern for most portable electronic flash units now being sold. The coverage is adequate for normal lenses.

The addition of the simple Air-Diffuser increases the angle of illumination significantly and requires an exposure increase of only ½ f/stop.

The Air-Brella spreads the angle of illumination to the point where it can be used with a 21mm lens on a 35mm camera or a 40mm lens on a 6x4.5 cm format camera. On the other hand, it requires an exposure increase of 2 to 3 f/ stops. A true umbrella reflector creates even greater coverage. This test series was done by lighting consultant George Ward using Polaroid film.

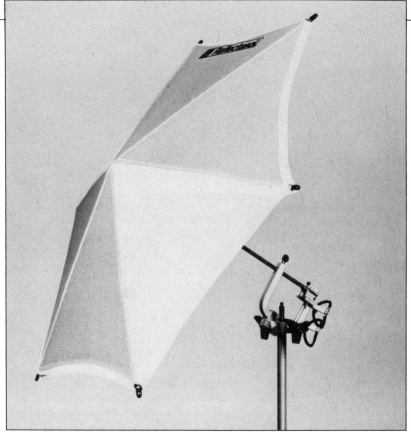

A 32" soft white umbrella with bracket for attaching a portable flash unit, such as this Reflectasol Hex Kit, is a good choice for your first general-purpose photo umbrella. You can always get additional umbrellas as your techniques become more sophisticated.

Keep your photo umbrellas clean by storing them in a case when they are not in use. Each umbrella should be kept in the plastic case in which it is packed when you buy it. Over-the-shoulder bags are available for carrying several umbrellas to a location.

The *Air-Diffuser from New Ideas Inc.*, demonstrated here by Peter Gowland, is an inflatable diffuser for portable electronic flash units. Outdoors it provides a softening effect when electronic flash is used for close-up portraits. In the studio, it can be used to soften a fill-in or key light.

This bounce reflector is designed for use with Vivitar flash units. It consists of a white card clipped into a metal frame that slips on over the head of the flash. It provides a softer, more diffuse light than direct flash. In an emergency, you can fashion your own bounce reflector using a sheet of typing paper and some masking tape to hold it on the flash.

These synchro-sunlight photos (top row) were made by Glamour photographer Peter Gowland using an Air-Diffuser on his flash to soften the fill-in light.

In these studio photos (bottom row) by Peter Gowland, an 11-inch plastic Air-Diffuser on a small flash was used as an additional light next to the camera, on the opposite from his 72-inch Reflectasol Umbrella, to soften the effect of the fill-in light. (If you want to duplicate the windblown hair effect, use a large fan.)

light to shade. Under extreme conditions, such as the light from a heavily overcast sky, there are no shadows at all because the cloud cover acts as an enormous, extremely dense diffuser for the harsh rays of the sun, and the entire sky becomes a light source. This is a flat light that does not reveal form or texture. In contrast, a light overcast produces a combination of direct and diffuse light that is usually quite pleasing. Under these conditions, you get soft, luminous shadows and gently rounded forms with some texture. This is the lighting condition that photographers most often try to simulate using a combination of direct and diffuse lights and bounce-light reflectors in the studio.

The ability to control diffuse light is crucial to effective studio photography, and manufacturers of lighting equipment are quite aware of this. You can get everything from giant reflector/diffusers containing more than 80 square feet of cloth to brackets that hold an 8″ x 10″ white card at an angle over a portable flash unit, and the range between contains a seemingly endless variety of umbrellas and diffusers in different sizes, shapes, and colors. All this inevitably seems like total confusion to the beginner, and you don't have to look hard to find a lot of pros who aren't so sure about it either.

There are two basic methods of diffusing light. The first is to put a translucent material such as white plastic or silk between the light and the subject. The second is to bounce the light off a matte surface.

When you beam light through a diffuser such as a white silk umbrella, the light scatters as it goes through. The amount of diffusion you get using this method depends on both the thickness of the diffuser and its size relative to the subject. A moderately thin diffuser, such as a single layer of silk or a thin white umbrella, will scatter some of the light and let some pass directly, giving a slight modeling effect. A double or triple layer of silk will scatter almost all the light, producing a very flat effect.

When the diffuser is larger than the subject, the light will wrap around the subject, filling in nooks and crannies with soft light. That is why fashion photographers like large diffusers, such as the Soff Box shown in the accompanying photo, or umbrellas in the four- to six-foot diameter class. When you photograph small subjects, you do not need all that diffuse area, so you can go with a smaller diffuser, such as the ones that clamp directly onto a light's reflector.

For fill light in portraiture and fashion work, a smaller diffuser is also effective. For example, the Air-Diffuser, which is about the size of a person's head (see photo and caption), can be used to soften a portable electronic flash just enough to give a pleasing look to the fill light on the face. (The 8″ x 10″ white card used as a reflector fills a similar function, as does the small portable umbrella.)

Tracing paper makes an ideal diffuser for all types of studio work. You can buy it in sizes ranging from a small, 8½″ x 11″ pad to rolls that are four feet wide and 50- or 100-feet long. You can buy it wherever drafting supplies are sold; the good quality types are sometimes known as visualizing paper. To make a large sheet from several small sheets, use Scotch Magic Transparent Tape. Tracing paper is so light you can hang it up anywhere using masking tape. Hang it from the ceiling, from a light boom, from a frame cut out of strips of cardboard. As a safety precaution, always keep tracing paper at least seven or eight inches from any hot floodlight or halogen lamp.

The diffuser should be large enough to cover the beam from the lamp. This means that you would use a relatively small sheet at one foot from the source and a larger sheet with more distant sources. A diffuser used independently of the light source is sometimes called a *scrim*.

You can also buy special diffusing material called Kodapak from professional photo supply houses. You pay more for it than you would for tracing paper and you use it in the same way.

Reflectors: Light bounced from a matte surface such as a wall or ceiling or piece of white cardboard is also diffuse, and for this reason makes an excellent fill light.

Professional photographers often use umbrella reflectors, which are literally umbrellas made of white or metallized fabric. Umbrella reflectors are usually attached to the lighting unit, but they can also be used as independent reflectors that bounce light into dark areas of the subject. Umbrella reflectors are portable and efficient. The typical umbrella shape is hexagonal, although there are also square designs. Some can be used both behind the light as a reflector or in front of the light as a diffuser.

Large square and rectangular reflectors that mount on collapsible stands are available from a number of lighting equipment manufacturers. These reflectors are usually positioned so that the bounced light creates luminous shadows.

White reflectors produce a diffuse, colorless light. Metallic reflectors produce a somewhat harder light that some photographers prefer. Gold-color reflectors add warmth to light from a blue sky, to light from a skylight or north-facing window, and to light

Diffusers for portable and studio flash units are available in a wide range of sizes. A variety of clamping devices available from manufacturers allow you to clamp them to various units. Shown below is a collection of Soff-Box reflector diffusers from Larson. These collapsible units consist of a metalized fabric reflector stretched on a wire frame with a silk diffuser covering the front. The fabric reflector concentrates the light, so there is less light loss than you experience when you use a soft-white umbrella as a diffuser.

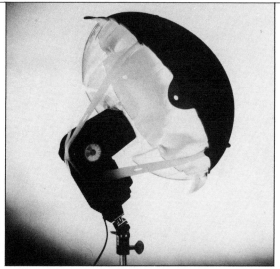

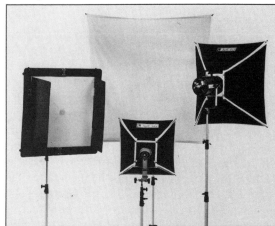

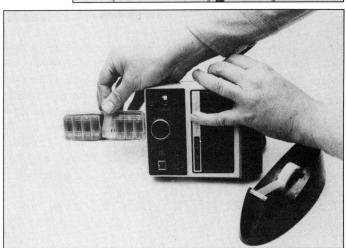

To diffuse the light from a bar or flip flash array, put one or more layers of transparent tape on the flash. For colored light effects, you can try coloring the tape with marker pens.

Some inexpensive gadgets turn out to be invaluable. Attached to the camera strap lug of this camera is a p.c. tension relief device for use when you are using a p.c. synch cord to trigger an off-camera flash. The p.c. cord threads into slots in a strip of plastic, which then takes up the weight of the cord and prevents the connector from falling out of the synch terminal when you move the camera.

The Air-Brella (top) is a collapsible, parabolic plastic balloon that deflates for storage and blows up with a few puffs of air when you want to use it.

Black reflectors, or more correctly black screens, are used in outdoor portraiture to absorb unwanted light from light sources and reflectors in the environment. This portable shade can be a surprisingly effective modeling device. The screen shown here is a professional accessory. For experimentation or occasional use, you can make your own by stretching a piece of black cloth on a frame or painting a piece of cardboard matte black.

from electronic flash. Blue reflectors are used to correct tungsten lights for daylight film when you want to combine floods with daylight or electronic flash.

Black reflectors are really portable shade. They are used to block out light from primary and reflected sources so that you can get improved modeling of rounded forms such as faces. For example, you might use one or two black reflectors outdoors to create a partial tent for a photo portrait subject. By blocking out overhead sun, the light would come from the side. A second black reflector might be used to absorb colored light bounced from a colored surface such as a nearby brick wall or green foliage.

Any handy surface will serve as a reflector, but remember that if you bounce light off a colored surface, the light will be colored and that will record on the film. A red wall used as a reflector will produce a reddish cast; a beige wall will give a faint brownish tinge; and if you make portraits of light-skinned subjects in the cool shade of a spreading oak tree in full leaf, the light bouncing off grass and foliage will produce people with pale green skin.

Large sheets of white paper or matt board make excellent reflectors. You can use bulldog or large spring clips to attach them to lightstands or use masking tape to hang them from walls, ceilings, shelves, and booms. Projection screens also work well. For a slightly harsher light, try crumpled aluminum taped to a sheet of cardboard. And for a highly directional reflector, try a mirror or use a piece of mylar taped to cardboard.

Multiple-Flash Arrangements
When you use more than one self-contained electronic-flash unit, there are two ways to synchronize the units so that they all flash at the same time. First, you can use camera-synch (p.c.) cords that connect with two or more flash heads. With dedicated flash, you must use special synchronization cords, such as the Duo-Sync Cord. In either case, the multiple-cord option results in an inconvenient tangle of cords.

Most photographers prefer to rely on slave-triggering units for multiple flash. The slave is a switch that closes in response to the flash from a unit that is synchronized with your camera. Response is so fast that it is instantaneous so far as the camera-synchronization system is concerned. Depending on the flash, a slave will either plug directly into the unit or attach via p.c. cord.

An infrared-slave system such as the one from Broncolor is the latest wrinkle for professionals. It completely eliminates the need for synch cords, which is a real advantage in commercial studios where you find a lot of people working around the set. The IR-slave system consists of a transmitter that mounts to the camera hot shoe and sends out a burst of infrared light when you press the shutter button. The infrared light triggers the slave attached to the flash.

Radio-transmission systems are also available to trigger multiple-flash arrangements.

Multiple flash setups are a snap with professional units that have built-in tungsten-halogen lamps called "modeling lights," which duplicate the effect of the flash, although at much lower levels of illumination. What you see is what you'll get. In better designs, such as the Ascor Light CD 1200, the power of the modeling light can be adjusted to match the power of the flash, so that it is possible to take an exposure reading of the light from the modeling lamps and multiply that by a predetermined factor to find the flash exposure.

If you want to use two or more portable flash units in a multi-light setup, then previewing the effect is tricky. One solution is to set up a small, R-type reflector flood on a bracket just above the flash and aimed so that its light beam roughly duplicates that of the flash. Spiratone sells a light for this purpose that attaches to an accessory clip on the top of its flash units. It is also possible to tape a small flashlight to each unit, but the light is relatively weak and the beam pattern is significantly different from that of the electronic flash.

Of course, you can usually estimate the effect of multiple lights. Let's say you have two units of equal strength. If you are bouncing the fill light from an umbrella or shooting it through a diffuser, then assume the diffuser will absorb about 1½ to 2 stops. If this is the case, then putting the key at the same light-to-subject distance as the fill will produce a 4:1 ratio. To get a 2:1 ratio, multiply the fill-to-subject distance by 1.4 to find the distance at which to set the key light.

If both key and fill are undiffused, multiply the key-light-to-subject distance by 1.4 to find the subject-to-fill-in-light distance for a 2:1 lighting ratio and by 2 to get a 4:1 ratio.

The key to figuring lighting ratios based on distance is the factor 1.4. Each time you increase the distance by 1.4, you cut in half the amount of light reaching the subject. If you want to avoid calculations altogether, use the f/stop scale, as a guide to placing lights of equal strength. For example, if your key light is 4 feet from the subject and you want a 2:1 key-to-fill ratio, then place the fill at 5.6 feet. To get a 4:1 ratio, place the fill at 8 feet.

Painting with light is a multiple-flash technique using one

flash unit. It can only be done in a darkened room or outdoors at night. The trick is to put the camera on a tripod and lock the shutter open. With a 35mm SLR you can do this by setting the shutter to ''B'' and using a locking-cable release. Set leaf-shutter lenses to ''T.'' Next walk around your subject making flashes with the flash test button of your unit or by shorting the p.c. with a paper clip. Try to estimate the coverage of the flash beam and aim for a slight overlap between flashes. Use the same flash-to-subject distance for each flash, and base exposure on that distance, or use an automatic flash. Keep your body positioned so that you do not get silhouetted by the flash.

Taking Advantage of Natural Light

Each type of light offers a range of picture-taking possibilities, and no light quality is inherently any better than any other. The classic situation for ideal picture taking is midmorning or midafternoon on a sunny day, with a blue sky that contains just a few clouds for pictorial effect. In fact, this ideal is nothing more than one picture, a scenic shot perhaps containing mountains in the distance, a lake with a lone fisherman in the middle ground, and a bush or over-

Late afternoon sunlight coming through a window brought out the textures that make this still-life composition interesting. Film: Agfa Isopan 24 (an ASA 200 pan film); normal lens on a 4″ x 5″ view camera.

hanging branches in the foreground. The lighting will be too harsh for portraiture, and to photograph small subjects such as flowers you will probably want to use a reflector or flash to fill in the dense shadows. As that sunny day moves toward noon, shadows get smaller and sharper, the contrast far exceeding the latitude of most films. With the exception of postcard shots—and you have to be in just the right place for those—this is a difficult light with which to work.

To take portraits or candid shots of people on a sunny day, try to get your subjects in open shade or even into the enclosed shadow of a porch or north window light.

For color photography, times when there is a light haze, just enough to soften the light but not so much that the shadows disappear, provide ideal lighting ratios for shadow and highlight portions of the subject. You may want to warm this light slightly by using an 81A filter, which some Japanese manufacturers call the "cloudy-day" filter.

A dull, overcast day need not be a photographic disaster if you are ready to take advantage of that soft, diffuse light. It is ideal for photographing shiny objects and glassware. It is also a very good light for general black-and-white work, and if you happen to have zeroed in your filtration with color films, or if you use flash as a key light, it can be a fine light for portraiture.

Another way to take advantage of an overcast sky is to think of it as a pearl-gray backdrop. To make the best use of it, you may have to keep the camera low and shoot upwards, so that your subjects are framed against the sky. The distortion produced by this upward angle of view is tricky to use effectively, but when you get it to work for you, the result is often an outstanding picture.

Early morning and late afternoon summer sunlight, and winter sunlight generally, are good for black-and-white landscape photography, particularly in wasteland areas and among rocks. The dense shadows and well-delineated contours produced by the sidelighting offer endless possibilities for interesting composition and give you a fine opportunity to relax and immerse your mind in the visual dynamics of

Direct sunlight working on these ropes created the picture. Earlier or later in the day, or on an overcast day, the photo would not have worked because it depends on stark contrast between light and ark. Film: Tri-X; 35mm lens on a 35mm SLR. Photo by Robb Smith.

nature.

From late afternoon on, till the sun sets, a mixed-lighting situation occurs in which subjects illuminated by the sun become bronzed while everything in shadow is illuminated by the sky and takes on a bluish hue. This is not a good time for natural-light portraiture because skin takes on a ruddy hue in the sunlight and a cyanotic look in shadow or backlight. On the other hand, it is a fine light for dramatic cityscapes in color or black-and-white and can be used for outdoor product photography.

There is a period of time after the sun sets, usually a half hour or so, when the intensity of sky light on buildings matches the intensity of interior lights. At this time of fleeting balance, cities and buildings seem to open up for the camera. You can photograph a house so that the sky is a deep purple blue, the details of the exterior are visible, and the tungsten- or fluorescent-lighted interior seen through the windows is properly exposed.

Night shots are tricky. If there are no artificial lights in the scene, then the quality of shots will vary from murky gloom to a daylight appearance, depending on your exposure, and shadows cast by the moon may become indistinguishable from shadows cast by the sun if you are shooting black and white. In color the results are bluish because the light on the scene is skylight.

Night shots containing streetlights are difficult because of the enormous contrast between the ambient light and patches of artificial light from windows and streetlights. If you expose for the overall scene, the artificially-lighted portions will be overexposed. One frequently successful trick is to expose for subjects illuminated by a streetlight, and let everything else fall where it will on the exposure scale.

Filtered Light
You can put a filter over any light source to create a wide range of effects. It's done all the time in stage lighting and studio photography, and it's easy to do in the photo studio.

Theatrical supply companies sell sheets of colored acetate called *gels* that you can use over continuous lights, but as long as you do not get the plastic too close to the light, any colored plastic will do. You can pick it up in art and plastic supply stores.

Smith-Victor makes an accessory-filter holder for lightstands, but it's easy enough to make your own clip-on filter holder. Get two bulldog clips, put a bolt through the hole in the clip, and bend a piece of coat hanger to serve as a frame that will attach to the bolts. Use tape to attach the plastic to the frame.

Electronic-flash systems sometimes have filter sets that slip into the unit. The amber filter will usually balance the light for use with tungsten film. The other colors are used for special effects.

By using a filter on both flash and camera, it is possible to create an exotically colored background for a normal-looking color subject. This is easiest when you use a variable-color or variable-color-density filter.

Look at your subject through both a variable-color filter and a flash filter of the opposite color. Rotate the variable-color filter until you find a point at which the subject appears normal. Use the colored flash as your main light on the subject. The variable-color filter on the camera will add its color to the background, such as a sky or street scene, but will be neutralized in those areas where light from the flash dominates. Bracket exposures and try varying the color combinations.

9
EXPOSURE METERS

The majority of SLR cameras sold today have through-the-lens exposure-metering systems that efficiently displace the need for hand-held, reflected-light meters in most situations. On the other hand, there are things your in-camera meter can not do, such as flash-and-incident-light metering, and it is a clumsy tool at best when you use it to make small-area (spot) measurements.

Your in-camera meter makes full-scene, reflected-light readings, or in some few cases it may meter the center spot in your viewfinder. In either case, it can be easily fooled by very contrasty subjects, giving too little exposure in response to an overly bright background, or too much in response to small, bright subjects in a large, dark surrounding. These are only a few of the many good reasons for owning a good hand-held exposure meter. Others may flash to mind as you skim through the sections on meter functions and metering techniques.

Meter Functions

You can still buy meters that perform only one function, such as a spot or flash reading. But today most photographers with a yen to supplement their through-the-lens camera meter are opting for one of the remarkable combination meters with a do-everything accessory system. Here are some of the basic functions and accessories that you should consider when you shop for a meter.

Reflected-light readings are measurements of the light reflected from a subject. Your in-camera meter does this, so look for a meter that will give you more than a simple reflected-light reading.

A spot meter or spot attachment gives you a reflected-light reading of a small area that may measure from 10° to 1°, depending on the meter design. The typical spot-metering device has a viewfinder with a substantially larger viewing area than the metering spot. An area in the center of the finder

is marked out to show the area actually metered. Small-area measurements are especially useful in very contrasty lighting situations.

An incident meter, or a meter with an incident attachment, gives a measurement of light falling on the subject. A hemisphere that looks like a small ping-pong ball covers the sensor. When you point it toward the camera, the hemisphere substitutes for a three-dimensional subject. The size of the sphere is unimportant. It may be an inch or more in diameter and designed to bayonet onto a rotating head or it may be a tiny diffuser that slides over the sensor for incident readings and slides out of the way for reflected readings.

An ND hemisphere is a neutral-density dome that replaces the standard hemisphere for readings in extraordinarily bright light.

An integrating disc is a flat-disc diffuser that can replace the hemisphere on some meters. The disc

is used to measure light on flat copy and to establish lighting ratios by pointing the sensor first at the fill light then at the key light. It is also used to make scientific measurements of illuminance.

A spot reader, sometimes called an enlarger mask, is an accessory that turns your meter into an enlarging meter. It can also be

Serious photographers demand a lot from hand-held exposure meters, and with the latest meter systems, they get it. The basic meter, which usually provides both incident and reflected readings, can be supplemented with a variety of accessories for specialized types of readings. The system shown here is based on the Vivitar LX meter. Attachments, from left to right, are a rotating incident light head, 1° spot reader with through-the-lens sighting, and microscope attachment. Other manufacturers of top quality meter systems are Gossen, Spectra, Minolta, Calcu-Light and Seconic, to mention just a few.

Snow always fools the built-in meter of an automatic camera. The "AUTO" photo was taken using through-the-lens metering. It is underexposed by about 2½ stops. The "MAN" photo was made using a best guess exposure, which turned out to be just about right.

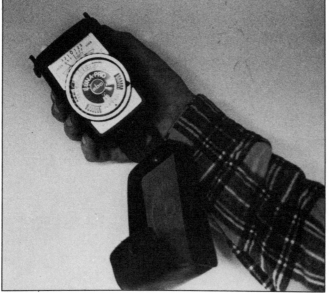

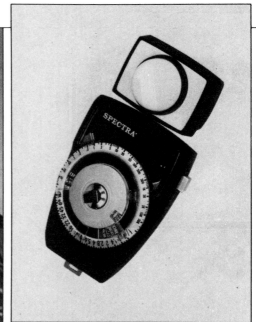

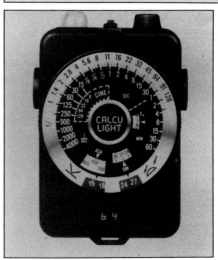

The Luna-Pro SBC is a popular professional light meter that provides reflected or incident readings and a nul-metering dial. A large system of accessories is available for this meter, including spot reading and flash metering attachments.

The Spectra Pro II is an all-purpose silicon cell meter with a large rotating head for incident light readings. The principal advantage of the rotating head is that you can hold the meter away from your body to avoid light kickback from a light-colored shirt and still read the meter dial. It was developed in response to the

needs of Hollywood cameramen who seem to favor light-colored clothing. The rotating head is an important feature only in those meters that have the sensor parallel with the face.

This digital exposure meter from Calcu-Light provides both incident and reflected readings. To use it, you have to transfer the digital value to the meter dial. Note the reflected light symbol to the left and incident symbol to the right, indicating in which window you should place the light value. The dial has large, easy-to-read numbers similar to those on the old Weston Master V meter.

used in conjunction with controlled light sources for black-and-white densitometry.

A fiber-optics probe allows you to make small-area readings in otherwise inaccessible locations. It is used mainly in still life and close-up work. Reflected- and incident-light types are available.

A groundglass probe is a device that allows you to make readings directly from a groundglass or focusing screen. It measures a wider area than the fiber-optics probe.

A microscope adapter lets you take readings through a microscope, telescope, or other optical device with an eyepiece tube.

A flash meter, or flash-metering accessory, makes an incident reading of flash illumination. A

simple type measures only flash. A more complex design may permit incident- and reflected-light readings of electronic or bulb-flash or continuous illumination or combinations of them using a variety of attachments.

An incident/reflected-average reading is a combined incident- and reflected-light reading that the meter averages out to a single reading. It is used with unusually light or dark subjects on the assumption that the deficiencies of the reflected and incident readings will cancel each other out. The standard compensating factors found in the section on technique produce a similar result. It is not a significant type of reading and most meters will not do it.

Light Meter Features

In addition to the existence of an accessory system to expand meter functions, there are several special features that you should consider when you shop for a meter.

Sensors: There are four photo cells used in today's meters, each with its pros and cons. The classic is the silenium cell, which produces a small current when struck by light. Silenium meters require no batteries and are good performers under bright-lighting conditions. They are not sensitive enough for use under very low-light conditions.

The CdS (Cadmium Sulfide) cell produces a resistance to a flow of electricity when struck by light. CdS meters can be ex-

tremely sensitive and they are frequently used in cameras. But they have a memory, which means that if you meter a very bright light source and then try to immediately meter a dim subject, the resistance created by the bright source will be retained and influence the reading. The effect can last from a few seconds to 10 minutes or more, depending on the disparity between the bright and dim sources. CdS meters are also notoriously slow to respond to very low light.

The silicon blue cell is the high-speed successor to the CdS cell. Silicon blue meters are capable of enormous metering ranges and a good one such as the Luna Pro SBC or the Spectra Combi II can give nearly instantaneous readings of everything from bright sunlight to almost total darkness. They have no memory.

The gallium arsenide cell is even more sensitive than the Silicon blue cell and it is extremely fast. For example, a meter of this type in the Nikon FM has three LED's in the finder to indicate under- correct, and overexposure. If you point the camera at a TV screen and activate the meter, all three diodes seem to light up. Actually, the meter is so fast it is reading both the bright TV scan lines and the dark intervals between them and the diodes are blinking so fast they seem on all the time.

The selenium meter is still fine for daylight photography and emotionally you may prefer it because it is solar powered. It is an excellent back-up meter for cold-weather use. But practically, indoors or in warm weather, you are better off with a silicon blue cell meter with its incredible sensitivity and high-speed response.

The light-measuring range of a meter can be stated in several ways. If you are not familiar with scientific measures of illuminance, then the range in minutes or hours that appears on the calculator dial is your best clue. A really sensitive meter such as the Spectra Combi II, Luna Pro SBC or Minolta Auto Meter II will give exposure times from 1/4000 sec. or faster to several hours.

Most photographic exposures, even outdoors at night, are less than one minute, so any meter that gives readings of a half hour or more with ASA 100-125 film has all the range you are ever likely to need.

The meter face is important. Dials with big numbers are easiest to use, particularly in low light. The classic meter face has a swinging needle that points to a light-value number. To get a recommended exposure, you have to transfer this number to the calculator dial, which then gives you a range of f/stop–shutter-speed combinations to choose from. A modern variation on this type is the face of the Calcu-Light 1, which gives a digital readout of the light value.

In the null-needle system used on the Luna Pro SBC, you take a reading by turning the calculator dial until the needle rests in the center of the meter window. The calculator provides the f/stop–shutter-speed range automatically. A three-stop range on either side of the "0" point lets you move the meter around to various parts of the scene to find its brightness range.

With some of the new digital flash meters, you set both ASA and shutter speed and it gives you a digital readout of the f/stop. By turning the shutter-speed dial, you can get a range of f/stop–shutter-speed combinations when you use one of these meters for measurement of continuous-light sources such as daylight or flood lights.

Light Meter Scales

F/stops: Most meters are calibrated in 1/3 f/stop increments with numerical indications at full stops. The accompanying table gives the complete f/stop scale in 1/3 stops from f/0.7 to f/128. Since most lenses have click-stops only at full and half stops, you must either estimate 1/3 stop increments or use the nearest full or half stop.

Shutter speeds: The speeds shown may range from several hours to as fast as 1/8000 sec. Seconds are often shown with a small slash to the left of each number to indicate that it is a fraction. Seconds usually have no identifying mark. Minutes may have a small "m" following each number and hours are sometimes represented by an "h." Often the difference between fractions of a second and full seconds and minutes is shown by putting them on a different color background. Silver for one, black or red for the other are common. Make a mental note of which is which on your meter. It will help you avoid mistakes.

Exposure-value (EV) numbers have no practical value for most camera owners. They are for use with cameras that have a special interlock on which you set the EV number. Once the interlock is set, changing the shutter speed or the f/stop adjusts the other automatically to keep exposure constant. The difference between consecutive EV numbers is one stop, but the EV depends on both the light level measured and the speed of the film, so you cannot use EV numbers as constants to indicate light level unless you use the special technique described below.

Illuminance measurements: Illuminance is the scientific name for the measurement of incident light. The common unit of illuminance in the United States is the footcandle, although the international lux and dekalux (lux times

EV/Lux/Footcandle Equivalents

Set meter to ASA 50. Use a flat disc diffuser to make an incident reading of the light source.

EV	Lux	Fc
−5	0.17	.016
−4	0.35	.032
−3	0.7	.065
−2	1.4	.13
−1	2.8	.26
0	5.5	.5
1	11	1
2	22	2
3	44	4
4	88	8
5	175	16
6	350	32
7	700	65
8	1400	130
9	2800	260
10	5500	500
11	11000	1000
12	22000	2000
13	44000	4000
14	88000	8000
15	175000	16000
16	350000	32000

10) are also widely used. Since a dekalux is approximately equal to a footcandle, some meters have a footcandle/dekalux scale.

To find illuminance using an EV scale, put a flat-disc diffuser on your meter, set the ASA scale to 50, and read the value of the incident light. The accompanying table shows how this reading translates to lux and footcandle (dekalux) units.

Cine scales are calibrated in frames per second. Use the f/stop value that aligns with the number of frames per second you are using.

ASA/DIN (ISO) scales: You probably cannot buy a box of film in the United States that does not have an ASA rating on it, but elsewhere, you may find other scales in use. The DIN (Deutsche Industrie Norm) is a logarithmic scale in which each increase of three equals one doubling of the film speed. It is the second part of an ISO designation. If you happen to run across film with speed in Russian GOST numbers, use them as though they were ASA numbers.

GOST units are 9/10 of ASA units and the difference is not worth worrying about. BSI arithmetic and ASA numbers are the same.

If you collect old light meters you may also run across such obsolete scales as H & D, Weston, G-E, Scheiner, ASA Additive Speed Value System, Watkins, Wynne, and Chapman-Jones. To get a setting for use on an old Weston meter that has the original calculator dial, multiply the ASA number of the film by four-fifths. To convert BSI log (Scheiner) numbers to DIN, subtract ten from the BSI log number. If you are not a collector, leave these flea-market specials alone.

An exposure-factor (EF) scale programs the calculator dial for exposure factors. If your meter has one of these scales, keep it set to "1" when you are not using it.

EXPOSURE-MEASUREMENT TECHNIQUES

Before you can feel comfortable using an exposure meter, you need some standards. In color work, the right exposure is one that produces reasonably accurate color values in the main subject. If your subject is a person, then you will go after good flesh tones, possibly with the aid of an incident light exposure reading. If your subject is an object or landscape, then you may choose to go after accurate color in the lighter areas, which is the traditional wisdom, or decrease exposure some to get more highly saturated mid-level colors.

In black-and-white work, the standard scene is one that contains a full range of brightness values from ultra black and detailed black through the shadow, mid-level and light tones to detailed white and pure white. The standard exposure is one that will give you a negative from which you can print this nine-stop scale

on normal-contrast printing paper and at the same time get mid-level tones such as flesh, grass, and wood that are neither too light nor too dark.

In practice, getting good exposure is a lot easier than it sounds in theory. The real trick is to know when to believe your meter and when to modify the readings.

Incident-Light Reading

Incident-light readings are relatively foolproof in conventional photographic situations, and when correct flesh tones are important, you just can't get a better reading. It works because the hemisphere simulates a three-dimensional subject such as a face and integrates the effect of all the different lights on the subject.

To make an incident reading, hold the meter so that the light falling on it is the same as that falling on the subject and point the hemisphere directly toward the camera. That's all there is to it. When you take a reading for a portrait, for example, hold the meter in front of your subject's face. Try to hold it, or swivel the head, so the sensor is not picking up light bounced off your shirt and you are not casting a shadow on it.

If you can't get close to your subject, stand between your subject and the camera and hold the meter so that the light on it is the same as the light on your subject when you point the hemisphere at the camera.

Limitations of incident metering: The meter gives you the best exposure for an average subject, one that reflects about 18 percent of the light falling on it, and for subjects such as faces that fall within a stop on either side of the average. Very dark subjects generally have to be given extra exposure to bring up the detail rendition. If flesh tones are prominent along with the darks in the scene, then try an extra ½

stop. If the entire subject is dark —a black cat on a brown velvet pillow, for example—open up a full stop from the metered exposure.

Very light subjects should be given less exposure if you want to hold subtle details, particularly in transparencies. If you have important flesh tones in the scene—a bride in a white dress against a white backdrop, say—then you can get away with closing down about ½ stop without darkening the face too much. If you are photographing an albino pig in a bathtub, close down a full stop from the metered exposure.

Incident/reflected-average method: If your meter also makes reflected-light readings, or you have a through-the-lens meter in your camera, and you are dealing with an unusually light or dark subject, you can take both a reflected- and an incident-light reading and use an exposure midway between the two.

Reflected-Light Readings
To make the classic reflected-light reading, stand at the camera position and point the meter toward the subject. That's all there is to it, and almost no one does it anymore. A through-the-lens reading is better because it reads only the scene imaged by the lens. If you must make a large-area reading with a hand-held meter, tilt it down slightly so that it does not read the sky. You do not have this problem with most in-camera meters because they are weighted to compensate for excess brightness along the top area of the frame.

Small-area (spot) readings: Small-area, reflected-light measurements can be quite accurate, but they have to be interpreted. You can make spot readings by holding your meter close to the area you want to measure, by using a spot-metering accessory for your meter, or by using a spot

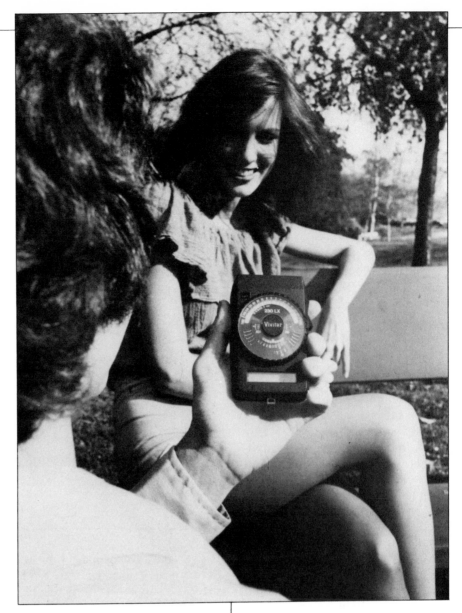

meter.

To use the through-the-lens meter in your camera as a spot meter, first stand at the point from which you plan to take the picture and focus, then without changing focus walk toward your subject until the area you want to meter fills the frame. Do not refocus at the close distance, because if you do the meter will compensate for the extra-lens extension required for close focusing.

There are two standard ways to use spot measurements, the highlight-shadow average method and the key-tone method.

To find a highlight-shadow average exposure, take a reading of the brightest area in which you want to reproduce some detail and remember, or write down, the

A reflected light reading is made by pointing the meter at the subject, but contrasty scenes such as this are tricky. In this situation, the photographer's best bet would be to move in close and take a reading of the model's face. (Photo courtesy of Vivitar.)

f/stop. Next, take a reading of the deepest shadow in which you want to reproduce detail. Then take an average halfway between the two readings. If you want to be sure of getting the full range, then the difference between the two readings should not exceed 4 *f*/stops for color films or 7 *f*/stops for black-and-white films.

This is a good method for landscape and architectural photography. You can also use it in product and commercial photography as a means of adjusting lighting ratios by moving lights or reflectors.

To find a key-tone exposure, take a reading from some evenly toned, important subject area. If you want that area to come out about the same density as a gray card, then use the reading unmodified. If you want it to come out about the same tone as a light-skinned face or a concrete building in overcast light, open up a stop. If you want it to come out like light-gray concrete, light skin in diffuse light, or a pale bright color, then open up two stops. If you are metering from weathered wood, stone, light foliage, or sunburned skin in sunlight, leave the reading alone. If you are reading for average dark foliage, dark stone, or shadow in landscapes, close down one stop.

The substitute-subject reading is a variation of the key-tone method. You take a reflected-light reading from your hand, holding it so that the light falling on your hand is the same as that falling on the subject. The general rule for light skin is to open up one stop, but every hand varies. To get a personal factor, compare the reading from your hand with that from a gray card.

Gray-Card Readings

An 18 percent gray card such as the Kodak Neutral Test Card is the poor man's incident-light meter.

The Gray Scale

Percent Reflectance	Exposure Zone	Subject Step Range Definition	Commonly Photographed Subjects in the Sun
—	9	Specular Highlights	Light Sources, Specular Reflections from Shiny Surfaces
80	8	Diffuse Highlights	Whitest Clouds, Whitest Snow, Bright White Paint
40	7	Light Tones	Light Caucasion Skin, Dry White Sand, New Unfinished Wood, Light Blue Sky, Dusty Dirt, Lemons, White Paint
20	6	Medium Light Tones	Caucasian Skin, Wet White Sand, Medium Dry Earth, Red Brick, Weathered Wood, Deep Blue Sky, Light Grass and Foliage, Oranges
18	5	Middle Gray	KODAK Neutral Test Card (gray side)
10	4	Medium Dark Tones	Black Skin, Medium to Dark Grass and Foliage, Dry Dark Earth, Dark Tree Trunks
5	3	Dark Tones	Black Fresh-Turned Earth, Very Black Skin, Dark Clothes
2.5	2	Very Dark Tones	Moist Black Objects, Very Dark Clothes
1.3	1	Black	Blackest Objects
0.6		Deep Black	Black Velvet
—	0	Deepest Black	Blackest Objects in Shadow

If you take care in manipulating the card as you make your readings, you can get accurate results.

To use the card with studio lights, hold the card straight up and down, close to and in front of your subject, and facing halfway between the camera and the main light. Make the light reading of the gray side of the card with your reflected-light meter or camera lens not more than 6 inches away. Do not allow your shadow or that of the meter to affect the reading.

If the light is too dim to get a good reading with your meter, try reading the white side of the card, which reflects five times as much light as the gray side. Divide the shutter speed recommendation on the meter by 5 or open up 2⅓ *f*/ stops to get a standard exposure.

If the subject is unusually dark, open up ½ to 1 *f*/stop. If the subject is unusually light, close down ½ to 1 *f*/stop.

For copy work or close-up photography, put the card in place of the subject and take a through-the-lens reading directly from the card.

The gray card is essentially an indoor device, so when you use it outdoors, you have to make some compensations. Hold the card in the usual way, straight up and down with the gray side facing halfway between the sun and your camera and make your meter reading as usual with the meter not more than 6 inches from the card, or fill the frame with the card if you use a through-the-lens meter. Then compensate. Use a lens opening one-half stop larger than the meter indicates for a frontlighted scene and open up one and one-half stops for a side-lighted close-up scene. If your subject is in shade, or the day is overcast, or your subject is back-lighted, hold the card straight up

The current state of the art in flash meters is represented by this Minolta Flash Meter III, a multi-function meter with liquid crystal display (LCD) that provides flash, ambient light, and ambient plus flash readings. As with most flash meters, you dial in the shutter speed and it gives you a readout of the f/stop to use. Note the p.c. socket on the bottom of the meter. That's for your flash synch cord. Pressing a button on the meter will fire the flash and give you a reading.

Exposure for high-contrast subjects at a distance from the camera are tricky. A spot meter might have helped, in this instance, but a best guess exposure for spotlighted circus acts worked out almost as well. 1/250 sec. at f/3.5 with ISO/ASA 400 Tri-X film; 200mm lens. Photo by Robb Smith.

and down with the gray side facing directly toward the camera. No exposure compensation is required for open shade or overcast lighting. For a backlighted close-up, close down ½ f/stop. For a backlighted subject at medium distance with a sunlit background, close down one and one-half stops if you want to get any detail in the background.

Flash Meters

Flash meters are usually incident meters. There are two types. The dedicated-function type usually measures only the flash. To use it, you have to null the meter by adjusting it for the level of ambient light in the environment. Then when you make a test flash, the meter reads the additional light and gives you an f/stop based on the flash alone.

A multi-purpose flash meter such as the Minolta Digital Flash Meter II will do a lot more for you. A good system flash meter can take a cumulative reading of several flashes and add in any ambient light in the scene so that you

Lighting Ratio Table

Stops Difference	Lighting Ratio	Stops Difference	Lighting Ratio	Stops Difference	Lighting Ratio
⅔	1.5:1	2	4:1	3⅓	10:1
1	2:1	2⅓	5:1	3⅔	13:1
1⅓	2.5:1	2⅔	6:1	4	16:1
1⅔	3:1	3	8:1	5	32:1

A 3:1 ratio is generally considered appropriate for color photography, while for black-and-white photography the ratio may vary from 3:1 to as high as 8:1. Reflectors may be used to lower the ratio. Diffuse white reflectors such as cloth or paper must be relatively close to the subject to have an appreciable effect, whereas aluminum foil reflectors can be used at a greater distance.

Exposure and Development Under Different Brightness Ranges

The following table is a guide for exposure and development under different brightness ranges.

	Brightness Range (approx.)	Exposure	Stops	Development Factor
Misty Landscapes	1:10	1/3 X	Under 1½	2 X or 100% Over
Distant Views	1:20	1/3 X	Under 1½	1.5 X or 50% Over
Street Scenes (diffuse light)	1:40	1/2 X	Under 1	1.2 X or 20% Over
Summer Landscapes	1:100	Normal	Normal	Normal
Back Light (Natural)	1:250	2 X	Over 1	.8 X or 20% Decrease
Interiors	1:500	4 X	Over 2	.7 X or 30% Decrease
Interiors (Sun)	1:000	6 X	Over 2½	.6 X or 40% Decrease

Note: Increase or decrease in development factor applies to optimum development times as listed in Ethol film development charts.

can get an accurate reading of the total exposure with multiple-light setups. It will take either incident- or reflected-light readings of either flash or continuous lighting, including studio floods and daylight. If you have a studio- or off-camera flash arrangement, you can put the flash p.c. cord into the meter, press a button, and trigger the flash.

To determine light fall-off on a set illuminated by flash, walk around the set and make test flashes at various points. This will let you determine the coverage you will get of subjects separated in depth and of moving subjects.

Educated-Guess Exposures

If your only meter is the one in the camera, there will be times when an educated guess is preferable to a metered exposure. For example, an ultra-wide-angle or fish-eye lens used outdoors often takes in too much sky, or even the sun,

and a through-the-lens reading results in severe underexposure. Or your meter may be going on the fritz. You should know when a meter reading is way out of line and be able to correct it.

The rule of thumb for an educated-guess exposure is based on a frontlighted subject in direct sunlight at noon on a summer day. Under these conditions, set your lens at f/16 and use a shutter-speed number that is equal to the ASA of your film. This is sometimes called the 1-over-ASA method. For example, on a sunny summer day, you would shoot Plus-X (ISO/ASA 125) at 1/125 sec. at f/16. If your subject is side-lighted, then you need to bring in additional shadow detail by opening up ½ to 1 f/stop. For lightly overcast conditions when you can still see some shadow patterns on the ground, try f/8. For heavy overcast and subjects in open shade illuminated only by blue

skylight, try f/5.6. In winter give an extra ½ stop to compensate for the lowered angle of the sun.

This general guide assumes that you are in the mid-latitudes at sea level. As you near the equator or climb high in the mountains, sunlight can be from one to two and one-half stops brighter.

Situation guides: There are times when the subject cannot be properly metered with the equipment you have. For example, when you go to a play or to the circus, the contrast between background and brilliantly lighted performers can be too great to give you a correct reflected-light reading. And subjects such as fireworks or Christmas tree lights are just about impossible to meter. Under these conditions, you can use the accompanying table of existing-light exposures, which is based on exposure guides published by Kodak.

Contrast, Tone and Color Control

In color photography, you can control contrast by changing film to suit the conditions or by using reflectors, scrims and artificial lights, indoors or out. If you shoot black-and-white film, you have the additional option of varying exposure and development to increase or lower contrast.

Subject contrast is the brightness range between shadow and highlight areas. Given normal development and printing procedures, most black-and-white films will handle a seven-stop brightness range from detailed white to detailed black. Anything outside these limits either burns in as a detail-less black or disappears into the white of the paper. On average, color films handle a four-stop range.

In black-and-white photography you can lower the contrast of a film to accommodate subjects with a very long brightness range by increasing exposure one stop

and decreasing development time about 25 per cent. You can increase film contrast and give added snap to very flat (low-contrast) subjects by underexposing one stop and increasing film development time 50 percent.

If you become interested in the mechanics of tone control, then you may want to make your own tests. Procedures are outlined in books such as *The New Zone System Manual* published by Morgan & Morgan, Inc., and in literature supplied by manufacturers of developers. A typical range of exposure and development variations is given in the accompanying chart from Ethol Chemicals.

Lighting contrast is the ratio of the illumination produced by the key light plus fill light to that produced by the fill light alone. It is used in product, fashion, and portrait photography to establish optimum lighting conditions and is measured with an incident-light meter or with the aid of a gray card. For color films, the ratio is usually from one-half stop to two and one-half stops. For black-and-white films, the difference may be anywhere from one to four stops.

The additional texture and depth that it is desirable to have in both shadows and highlights is created by the subject contrast. When you want to be certain that you will achieve both a pleasing portrait or product shot and a full-scale photo, measure both lighting and subject contrast. Use the results as a guide for adjusting your lights and reflectors.

This photo was originally meant as a visual comment of the quality of food affordable by graduate students. If your subject is dinnerware on a porcelain sink, or any white subject on a white background, it's tricky to meter. If you use an incident light reading, close down one stop from the metered reading. If you have only a through-the-lens meter, then open up one stop for shots like this. Photo by Robb Smith.

An airplane against the sky will always fool a reflected light meter. This photo was taken through a Vivitar 100-200mm zoom lens with a No. 15 (yellow) filter to darken the sky. Exposure was based on a best guess. Then the photographer opened up the lens one more stop to compensate for the fact that the undercarriage of the plane was in shadow and an additional stop and a half to compensate for the filter. Tri-X, 1/500 sec. at f/5.6. A straight through-the-lens meter reading would have been underexposed by several stops.

This portrait was taken in open shade using a reflected light reading. A camera's built-in meter comes through with flying colors in situations like this.

Existing Light Exposures

Existing Light Categories

A. Skyline 10 minutes after sundown; neon and other brightly lighted signs; bright spotlit subjects at ice shows, circuses, and stage shows.

B. Brightly lit theater and nightclub districts; burning buildings and campfire flames; night football, baseball, race-tracks; floodlit ice-show subjects; interiors with bright fluorescent lights; boxing and wrestling events; ground displays of fireworks; store windows.

C. Bright downtown streets; basketball, hockey, bowling events; average white-lit stage events; hospital nurseries; color TV with black-and-white film or color film without a filter; floodlit circus subjects.

D. Fairs and amusement parks; amusement park and carnival rides; bright home interiors; inside swimming pools (above water); color TV with daylight color film and CC40R filter with slide films. (Do not use filter with Kodacolor 400.) (Use ⅛ sec. with focal-plane shutters; 1/30 sec. or longer with blade shutters.)

E. Church interiors (tungsten illumination); average home interiors at night; school stage and auditorium events; subjects lit by campfires.

F. Car traffic (give time exposure long enough to record light patterns); indoor and outdoor (night) Christmas tree lights; candlelit close-ups; illuminated fountains; floodlit buildings; subjects lit by streetlights; aerial displays of fireworks (use time exposure to capture several bursts).

G. Lightning (use time exposure to capture several bursts).

H. Floodlit dark-colored factory buildings.

I. Niagara Falls lit by white lights; distant skyline views of lighted buildings at night.

J. Niagara Falls lit by light-colored lights.

K. Niagara Falls lit by dark-colored lights.

L. Full-moonlit snowscapes.

M. Full-moonlit landscapes.

N. Full-moonlit close-ups and medium distant subjects.

Existing Light Exposure Chart

A	B	C	D	E	F	G	H	I	J	K	L	M	N	ASA
1/125 f/8-11	1/125 f/5.6-8	1/125 f/4-5.6	1/125 f/2.8-4	1/60 f/2.8-4	1/30 f/2.8-4	3.5 sec. f/22	1/4 f/4-5.6	1/2 f/4-5.6	1 sec. f/4-5.6	6 sec. f/8	6 sec. f/5.6	6 sec. f/4	12 sec. f/4	1600
1/250 f/5.6	1/250 f/4	1/250 f/2.8	1/125 f/2.8	1/60 f/2.8	1/30 f/2.8	4 sec. f/22	1/4 f/4	1/2 f/4	1 sec. f/4	4 sec. f/5.6	8 sec. f/5.6	8 sec. f/4	16 sec. f/4	1250
1/250 f/4-5.6	1/250 f/2.8-4	1/125 f/2.8-4	1/60 f/2.8-4	1/30 f/2.8-4	1/15 f/2.8-4	5 sec. f/22-4	1/4 f/2.8-4	1 sec. f/4-5.6	2 sec. f/4-5.6	4 sec. f/4-5.6	8 sec. f/4-5.6	16 sec. f/4-5.6	32 sec. f/4-5.6	1000
1/250 f/4-5.6	1/250 f/2.8-4	1/125 f/2.8-4	1/60 f/2.8-4	1/30 f/2.8-4	1/15 f/2.8-4	6 sec. f/22	1/4 f/2.8-4	1 sec. f/4-5.6	2 sec. f/4-5.6	4 sec. f/4-5.6	8 sec. f/4-5.6	16 sec. f/4-5.6	32 sec. f/4-5.6	800
1/250 f/2.8-4	1/125 f/2.8-4	1/60 f/2.8-4	1/30 f/2.8-4	1/15 f/2.8-4	1/8 f/2.8-4	6 sec. f/16	1 sec. f/4-5.6	2 sec. f/4-5.6	4 sec. f/4-5.6	8 sec. f/4-5.6	16 sec. f/4-5.6	32 sec. f/4-5.6	1 min. f/4-5.6	400
1/250 f/2.8	1/125 f/2.8	1/60 f/2.8	1/30 f/2.8	1/15 f/2.8	1/8 f/2.8	4 sec. f/11	1 sec. f/4	2 sec. f/4	4 sec. f/4	8 sec. f/4	16 sec. f/4	32 sec. f/4	1 min. f/4	320
1/125 f/2.8-4	1/60 f/2.8-4	1/30 f/2.8-4	1/15 f/2.8-4	1/8 f/2.4-8	1/2 f/4-5.6	5 sec. f/11	2 sec. f/4-5.6	4 sec. f/4-5.6	8 sec. f/4-5.6	16 sec. f/4-5.6	32 sec. f/4-5.6	1 min. f/4-5.6	2 min. f/4-5.6	250
1/125 f/2.8-4	1/60 f/2.8-4	1/30 f/2.8-4	1/15 f/2.8-4	1/8 f/2.8-4	1/2 f/4-5.6	5 sec. f/11	2 sec. f/4-5.6	4 sec. f/4-5.6	8 sec. f/4-5.6	16 sec. f/4-5.6	32 sec. f/4-5.6	1 min. f/4-5.6	2 min. f/4-5.6	250
1/125 f/2.8	1/60 f/2.8	1/30 f/2.8	1/15 f/2.8	1/8 f/2.8	1/2 f/4	4 sec. f/8	2 sec. f/4	4 sec. f/4	8 sec. f/4	16 sec. f/4	32 sec. f/4	1 min. f/4	2 min. f/4	160
1/125 f/2-2.8	1/60 f/2-2.8	1/30 f/2-2.8	1/15 f/2-2.8	1/8 f/2-2.8	1/2 f/2.8-4	5 sec. f/8	2 sec. f/2.8-4	4 sec. f/2.8-4	8 sec. f/2.8-4	16 sec. f/2.8-4	32 sec. f/2.8-4	1 min. f/2.8-4	2 min. f/2.8-4	125
1/125 f/2-2.8	1/60 f/2-2.8	1/30 f/2-2.8	1/15 f/2-2.8	1/8 f/2-2.8	1/2 f/2.8-4	6 sec. f/8	2 sec. f/2.8-4	4 sec. f/2.8-4	8 sec. f/2.8-4	16 sec. f/2.8-4	32 sec. f/2.8-4	1 min. f/2.8-4	2 min. f/2.8-4	100
1/125 f/2	1/60 f/2	1/30 f/2	1/15 f/2	1/8 f/2	1/2 f/2.8	4 sec. f/5.6	2 sec. f/2.8	4 sec. f/2.8	8 sec. f/2.8	16 sec. f/2.8	32 sec. f/2.8	1 min. f/2.8	2 min. f/2.8	80
1/60 f/2-2.8	1/30 f/2-2.8	1/15 f/2-2.8	1/8 f/2-2.8	1/2 f/2.8-4	1 sec. f/2.8-4	5 sec. f/5.6	4 sec. f/2.8-4	8 sec. f/2.8-4	16 sec. f/2.8-4	32 sec. f/2.8-4	1 min. f/2.8-4	2 min. f/2.8-4	4 min. f/2.8-4	64
1/60 f/2	1/30 f/2	1/15 f/2	1/8 f/2	1/2 f/2.8	1 sec. f/2.8	4 sec. f/4	4 sec. f/2.8	8 sec. f/2.8	16 sec. f/2.8	32 sec. f/2.8	1 min. f/2.8	2 min. f/2.8	4 min. f/2.8	40
1/30 f/2-2.8	1/15 f/2-2.8	1/8 f/2-2.8	1/2 f/2.8-4	1 sec. f/2.8-4	2 sec. f/2.8-4	5 sec. f/4	10 sec. f/4	20 sec. f/4	40 sec. f/4	1 min. f/4	2 min. f/4	4 min. f/4	8 min. f/4	32
1/30 f/2-2.8	1/15 f/2-2.8	1/8 f/2-2.8	1/2 f/2.8-4	3 sec. f/5.6	6 sec. f/5.6	6 sec. f/4	12 sec. f/4	24 sec. f/4	48 sec. f/4	2 min. f/4	4 min. f/4	8 min. f/4	16 min. f/4	25

10
CLOSE-UP AND DUPLICATING EQUIPMENT

If you have a modern SLR you can probably use your normal lens and fill the frame with a sheet of typing paper at close-focusing distances. If you have one of the close-focusing zooms, then you can probably get closer than that. This is all the close-up capability you need for most copy work, but if you want the special thrill of exploring the magic world of the very small, of filling the frame with a postage stamp, or of making slide duplicates and variations, then you need some special equipment.

CLOSE-UP EQUIPMENT

When you focus on progressively closer subjects, you extend the distance between the lens and the film, usually by turning a focusing ring on the lens. Once you reach the close-focusing limits of the lens itself, you can get closer either by putting extension tubes or a bellows between the lens and your camera or by attaching an auxiliary close-up lens to the front of your regular lens.

Close-Up Lenses

An auxiliary close-up lens takes up no more room in your gadget bag than a filter, but it significantly extends the close-focusing range of your camera. These lenses are available in various strengths ranging from +1 to +10. Some manufacturers are selling close-up lens kits containing +1,

Close-up lenses such as this are your best way to enter the world of the very small. The tiny arrow on the rim of this Tiffen No. 2 lens should point away from the lens, toward your subject. Close-up lenses in +2, +3 and +4 diopter strengths are the most useful for SLR photography. No exposure compensation is needed.

Extension tubes take up where close-up lenses leave off. This is a set of automatic tubes from Nikon. When you use extension tubes you will either have to rely on through-the-lens metering or calculate an exposure compensation.

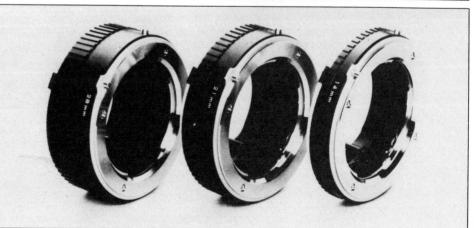

Close-Up Lenses With Still Cameras

Close-up Lens (diopters)	Footage Setting on Camera	Inches from Subject to Close-Up Lens	Area Seen by Lens (inches)*				
			45mm Lens 24 x 36mm Negative	50mm Lens 24 x 36mm Negative	50mm Lens 28 x 40mm Negative	75mm Lens 2¼ x 2¼ in. Negative	100mm Lens 2¼ x 3¼ in. Negative
+1	Inf.	38¾	20½ x 31	18⅝ x 28	21⅞ x 31¼	30 x 30	22⅛ x 32
	50	37		17¾ x 26⅝	20½ x 29¼	28 x 28	21 x 30¼
	25	34¾		16⅝ x 25	19¼ x 27½	26⅛ x 26⅛	19⅝ x 28⅜
	"FIXED"	33¾		16 x 24	18¾ x 26¾	25½ x 25½	19 x 27½
	15	32⅜		15⅜ x 23	17⅞ x 25½	24½ x 24½	18¾ x 27⅛
	10	29⅝	15½ x 23	14 x 21	16⅝ x 23½	22 x 22	16⅝ x 23⅝
	8	27⅞		13⅛ x 19¾	15⅛ x 21⅝	20½ x 20½	15¼ x 22⅛
	6	25½		11⅞ x 17⅞	13¾ x 19⅝	18⅝ x 18⅝	13¾ x 19⅞
	5	23¾	12½ x 18	11 x 16⅝	12¾ x 18¼	17⅛ x 17⅛	12¾ x 18⅜
	4	21⅝		10 x 15	11½ x 16½	15⅜ x 15⅜	11⅜ x 16⅜
	3½	20⅜	10¼ x15½	9¼ x 14	10¾ x 15⅜	14⅜ x 14⅜	10½ x 15¼
+2	Inf.	19½	10½ x 14⅞	9⅜ x 14	10⅞ x 15½	14¾ x 14¾	11⅛ x 16⅛
	50	19⅛		9⅛ x 13⅝	10½ x 15⅛	14⅜ x 14⅜	10¾ x 15⅝
	25	18½		8⅞ x 13¼	10¼ x 14½	13⅞ x 13⅞	10⅜ x 15
	"FIXED"	18		8⅝ x 12⅞	10 x 14¼	13½ x 13½	10⅛ x 14⅝
	15	17¾		8½ x 12¾	9⅞ x 14	13⅛ x 13⅛	9⅞ x 14⅜
	10	16⅞	8½ x 12¼	8 x 12	9¼ x 13¼	12½ x 12½	9⅜ x 14
	8	16⅜		7¾ x 11½	8⅞ x 12¾	12 x 12	8⅞ x 12⅞
	6	15½		7¼ x 10⅞	8⅜ x 12	11¼ x 11¼	8⅜ x 12
	5	14⅞	7⅜ x 10½	6⅞ x 10⅜	8 x 11½	10¾ x 10¾	7⅞ x 11⅜
	4	14		6½ x 9⅝	7½ x 10¾	10 x 10	7¼ x 10½
	3½	13⅜	6¼ x 9⅛	6⅛ x 9¼	7⅛ x 10⅛	8⅞ x 8⅞	6⅞ x 10
+3	Inf.	13	6⅛ x 9¼	6¼ x 9⅜	7¼ x 10⅜	9⅞ x 9⅞	7½ x 10¾
	50	12⅞		6⅛ x 9¼	7⅛ x 10¼	9⅝ x 9⅝	7¼ x 10½
	25	12½		5⅞ x 8⅞	6⅞ x 9⅞	9⅜ x 9⅜	7⅛ x 10¼
	"FIXED"	12⅜		5⅞ x 8⅞	6⅞ x 9¾	9¼ x 9¼	7 x 10
	15	12¼		5¾ x 8¾	6¾ x 9⅝	9⅛ x 9⅛	6⅞ x 9⅞
	10	11⅞	6 x 8⅞	5⅝ x 8⅜	6½ x 9¼	8¾ x 8¾	6½ x 9½
	8	11½		5⅜ x 8⅛	6¼ x 8⅞	8⅜ x 8⅜	6⅜ x 9⅛
	6	11⅛		5⅛ x 7⅞	6 x 8⅝	8 x 8	6 x 8⅝
	5	10¾	5½ x 8	4⅞ x 7½	5¾ x 8¼	7¾ x 7¾	5¾ x 8¼
	4	10⅜		4¾ x 7⅛	5½ x 7⅞	7⅜ x 7⅜	5⅝ x 7¾
	3½	10	5⅛ x 7½	4½ x 6⅞	5¼ x 7½	7 x 7	5¼ x 7½
+4	Inf.	9⅞	5¼ x 7½	4⅝ x 7	5½ x 7¾	7⅜ x 7⅜	5⅝ x 8⅛
	"FIXED"	9½		4½ x 6⅝	5⅛ x 7½	7 x 7	5⅝ x 7¾
	3½	8	4 x 6	3⅝ x 5⅜	4⅛ x 6	5½ x 5½	4⅛ x 6
+5	Inf.	7⅞	4 x 6	3¾ x 5⅝	4¼ x 6¼	5⅞ x 5⅞	4½ x 6½
	"FIXED"	7⅝		3½ x 5⅜	4⅛ x 6	5⅝ x 5⅝	4¼ x 6⅛
	3½	6½	3¼ x 4⅝	3 x 4⅜	3½ x 4⅞	4½ x 4½	3⅞ x 4¾
+6	Inf.	6½	3¼ x 4⅞	3 x 4⅝	3⅝ x 5⅛	4⅞ x 4⅞	3¾ x 5⅜
	"FIXED"	6⅜		3 x 4⅜	3⅜ x 4⅞	4¾ x 4¾	3⅝ x 5¼
	3½	5⅝	2¾ x 4⅛	2½ x 3¾	3 x 4¼	3⅞ x 3⅞	2⅞ x 4¼
+8	Inf.	5⅛	2½ x 3¾	2¼ x 3⅜			
	4	4⅝	2¼ x 3¼	2 x 3			
+10	Inf.	4¼	2⅛ x 3⅛	1⅞ x 2¾			
	4	4	1⅞ x 2⅝	1⅝ x 2½			

*Data is approximate. The area seen by lens depends in part on the separation between supplementary and camera lenses. All focal lengths given are considered average.
Information courtesy of Tiffen Manufacturing Corp.

+2, and +3, or +4 lenses. The kit gives you quite a range because close-up lenses can be used either singly or in combination, but if you want just one lens for general close-up capability, a +3 or +4 lens is probably the most versatile.

The size of the image you get depends on the power of the close-up lens and the focal length of the lens you put it on. To get an idea of what a close-up lens will do for you, look at the accompanying chart, which gives the area covered by close-up lenses of various strengths. As a rule of thumb, if you double the focal length of your prime lens, you double the image size with any given close-up lens.

To use a close-up lens, attach it so that the convex (bowed-out) side is pointing toward the subject. Some lenses have a small arrow on the rim to indicate which side goes out. If you use a close-up lens in conjunction with a filter, put the lens on first, then the filter. (With very strong close-up lenses, the outward bow is so large you usually have to put them on last.)

To get into the realm of life-size and macro images, where magnifications are larger than life-size on the film, you need bellows. All the better designs combine the bellows focusing rail with a focusing stage that moves the entire camera-bellows-lens assembly back and forth for easy focusing.

If you have a lens hood, you should use it, particularly when you have nearby flood lights. The convex element is a catch-all for stray light coming in from the sides, and the resulting flare can severely degrade image quality.

Use a fairly small f/stop such as f/8 or f/11 to eliminate any slight unsharpness that may be caused by residual spherical aberration. And if you can, use the camera on a tripod or copy stand. If you hand-hold, use a shutter speed at least four times the focal length of the lens.

You can focus most easily by moving the camera back and forth. If you have the camera on a tripod or copy stand, you can fine-focus by turning the focusing ring on the lens.

To use a close-up lens with a rangefinder or fixed-focus camera, you will have to measure the distance between the front of the close-up lens and your subject. Set your camera lens at one of the distances given in the accompanying tables and use the lens-to-subject distance given for the close-up lens strength you are using. If you use two or more close-up lenses together, add up their strengths to get the combined strength.

To simplify measurement, use a piece of cardboard cut to the right length. If you make the width of the cardboard equal to the horizontal coverage with a particular close-up lens, then you can use the cardboard to help center the image.

There is no exposure factor when you use a close-up lens.

Variable close-up lenses are multi-element systems that allow you to change power by, in effect, zooming. If you do a lot of close-up work, variable magnification may be a useful option, but for occasional close-ups, one or two single-element lenses are all you really need.

Extension Tubes

An extension tube is a tube that goes between the lens and the camera. These tubes are frequently sold in sets so that you can use them singly or in combination to get a variety of image magnifications. In general, extension tubes are used to cover the range of images from about one-tenth life-size to life-size on the film.

Both automatic and non-automatic types are available. If you decide to go the extension-tube route, then automatic tubes are a real convenience because they let you retain the automatic functions of the lens- and the camera-metering system.

If you have the inexpensive, non-automatic types, then you must stop the lens down manually to the taking aperture each time you meter or make an exposure. At long extensions, the light is dim when you stop down, and reading your through-the-lens meter can be tricky. It is usually not a problem with cameras that have silicon blue or gallium arsenide meters. CdS meters, on the other hand, may be too insensitive to respond or may take several minutes to respond fully.

In theory, extension tubes should give you slightly better image quality than close-up lenses because you are not adding any lens elements to the optical system. But in practice, the difference may not be worth the added bother of taking the lens off the camera, putting the tube or tubes on, and then putting on the lens. And if you do not have a through-the-lens metering system, then the work of figuring out exposure factors may be enough in itself to tip the scales in favor of the auxiliary close-up lens.

When you put an extension tube between the lens and the camera, use through-the-lens metering or compensate for the ex-

tension by giving added exposure as explained in the upcoming exposure section.

Bellows

When you use a bellows between your normal lens and the camera, you can get continuously variable magnification from about life-size to about three times life-size on the film. This range covers objects such as small stamps, gemstones, many types of insect, and slide duplicates. A bellows lets you do true macrophotography, which is the next step beyond the range covered by extension tubes and auxiliary close-up lenses.

Bellows are available in both automatic and non-automatic versions. The automatic types let you retain the automatic features of the lens with the aid of a dual cable release when you use the lens in its normal position. Of course, if you reverse the lens to get the ultimate in image quality, then you are back to manual stop-down picture taking.

Focusing rail: Some bellows have a built-in focusing rail that moves the entire camera-bellows-lens assembly back and forth. This is a convenient feature because in the macro range, moving the camera is the only practical way to make a major focusing movement. It lets you preset the bellows extension for magnification and then make focusing movements without changing image size.

Accessory focusing rails that can be used with any light-weight camera-bellows or camera–extension-tube assembly are also available.

Scales: Some bellows have scales that show magnification or lens extension with normal and macro lenses. These scales provide scientific accuracy and can be used to calculate exposure compensations, but they have no practical use in run-of-the-mill

macro work where you rely on visual determination of image size and through-the-lens exposure metering.

Reproduction Ratio

Technically, close-up photography extends from about one-tenth life-size down to life-size on the film. Life-size photography is just that: the images are life-size on the film. Macrophotography covers the range from just larger than life to about ten times life-size on the negative. For larger images, the camera is usually attached to a microscope using a microscope adapter.

When you enter the realm of close-up and macro work, you may want to begin thinking in terms of reproduction ratio, which is also called *scale* or *magnification*, rather than in terms of how close you are to your subject.

Technically, *scale* is the ratio of the size of the image on the film to the size of the original subject. For example, if the scale is 1:5, then the image on the film is one-fifth life-size. If the scale is 1:1, then the image is life-size.

When the image on the film becomes greater than life-size, it's called *magnification* rather than scale. If the ratio is 2:1, for example, the magnification is 2X, or twice life-size on the film.

When you use extension tubes, you can find the reproduction ratio with the lens focused to infinity if you divide the tube length by the focal length of the lens. For example, if you use a 10mm extension tube with a 50mm lens, the reproduction ratio is 1:5 or 1/5X. When the tube is the same length as the focal length of the lens, the ratio is 1:1 or life-size. You will get some additional magnification if you turn the focusing collar on the lens to the closest focusing distance.

To find magnification with a bellows, divide the bellows exten-

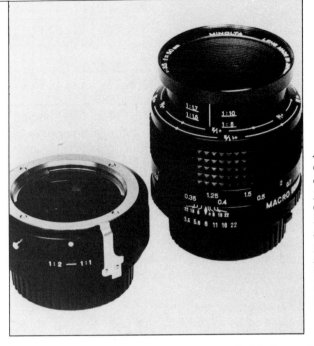

A macro lens, such as this example from Minolta, is computed for close-up photography, although it will also produce excellent images in the normal range of ⅒ life-size to infinity. The lens alone provides about ½ life-size magnification. An extension tube that comes with the lens lets you focus down to life-size on the negative.

sion by the focal length of the lens.

To find the reproduction ratio using your 35mm SLR viewfinder, place a millimeter ruler next to the subject, focus sharply and read the length of the scale. If you place the ruler horizontally, divide 36 by the number of millimeters you see in the finder. If you place the ruler vertically, divide 24 by the viewfinder reading.

Lens Selection

For close-ups as large as life-size on the film, you can expect reasonably good results if you stop down your normal lens to f/8 or smaller, particularly with three-dimensional subjects. Flat subjects will naturally come out better when you use a flat-field lens, but if you do not own one, it should not be a cause for concern.

When you get into the macro range, then you can usually improve image quality slightly by reversing the lens using a reverse adapter. In so doing you lose the automatic function of most lenses, so many photographers prefer to use the lens in its normal position anyway, particularly if the reason for taking the close-up is experimentation or simple record keeping.

A typical macro lens is a flat-field lens designed to produce high-quality images from infinity focus all the way down to life-size on the negative. As with a normal lens you can improve quality slightly if you reverse it when you work in the macro range where images are larger than life.

There are macro lenses, usually moderate wide angles, that are designed specifically to be used with a bellows to produce images life-size and larger on the film. Do not reverse these lenses.

To get the largest image possible using your extension tubes or bellows, try using a 35mm or 28mm wide-angle lens. In theory you could get an even bigger image with even shorter lenses, but most of these are retrofocus designs, and to get a life-size image on the film, you might find that the subject would have to be inside the lens.

If you need to increase the distance between the front of the lens and your subject to get sufficient room to place lights or reflectors, then try using a moderate telephoto lens. You need twice as much extension with a 100mm lens as you would with a 50mm lens to get the same size close-up image on the film, but the longer lens also gives you twice as much lens-to-subject distance.

Exposure

Accessory close-up lenses require no exposure compensation. When you use extension tubes or bellows, your best bet is to use continuous lighting and through-the-lens metering. For a really accurate reading, use a gray card in place of your subject. Just remember to compensate for reciprocity failure when exposures are longer than one second. (See Chapter 5.)

If you use a hand-held meter, then you will have to compensate for any additional lens extension. The accompanying table gives exposure factors and increases in $f/$ stops that you can use with reproduction ratios from 1:20 through 10X.

If you know the magnification, you can calculate the correct exposure for hand-held meters and flash using the following formula:

Actual Exposure Time = Meter-indicated exposure × (magnification + 1)2

If the actual exposure time is longer than one second, then add on any time required to compensate for reciprocity failure and filtration.

It really is easier to use through-the-lens metering, but unless you have a very sensitive in-camera meter, you are going to have a problem with accurate exposure measurements with long bellows extensions, because you have to stop down to take the reading. One way to get around this is to measure at full aperture, then calculate a new exposure time based on the number of $f/$ stops you stop down. For example, if your reading was 1/15 sec. at $f/1.4$ and you wanted to stop down to $f/11$ to get maximum depth of field, then your taking exposure would be four seconds. (Multiply the shutter speed by two for each stop; $1/15 \times 2 = 1/8 \times 2 = 1/4 \times 2 = 1/2 \times 2 = 1 \times 2 = 2 \times 2 = 4$.)

Exposure with flash: If you use flash, your easiest route is to set the flash on manual and use a flash meter to calculate exposure. Then open up the number of extra stops required for the reproduction ratio you are using. If you do not have a flash meter, you can measure the flash-to-subject distance, calculate the $f/$stop by dividing the guide number by the flash-to-subject distance, and open up according to the reproduction ratio you are using.

Lighting

The lighting used for tiny three-dimensional subjects is essentially the same as that used for normal-size subjects. The only difference is that you can use much smaller light sources. Instead of a big 500-watt studio flood, you can get away with 75-watt and 100-watt bulbs and high-intensity desk lamps. Just remember to filter (see Chapter 3) if you use color film.

For diffusion, use sheets of tracing paper. A couple of sheets of tracing paper taped together and made into a cylinder make a perfect light tent for maximum diffusion.

You can improvise diffuse reflectors out of white cardboard or typing paper. For a more directional reflector, use crumpled aluminum foil taped to a piece of cardboard, or a small mirror. You can prop up reflectors with books or even bits of modeling clay.

The standard lighting arrangement for rounded subjects is a key light at about a 45° angle and a fill light placed near the camera position. The key should be stronger than the fill. You can accomplish this by using bulbs of different strength or using the key light closer to the subject than the fill light. If you use a single electronic flash, you can prop up a white card to one side of the subject for fill-in illumination. These and other lighting arrangements are demonstrated in the accompanying illustrations.

Don't neglect the possibilities of natural outdoor lighting for close-up work. Open shade and overcast skylight are both good, even sources of shadowless illumination that will save you the bother of setting up artificial lighting. If you use color film, an 81C filter will eliminate the bluish cast.

Close-Up Technique

Here are a few tricks that make it easier to get consistently sharp, accurately focused photos in the close-up and macro ranges.

Focus. Move the camera or the subject for rough focus. To fine

Exposure Factor Table*

Magnification	Exposure Factor	Increase in f/Stops
1/12X	1.17X	¼
1/8X	1.27X	⅓
1/5X	1.44X	½
1/4X	1.56X	⅔
1/2.5X	1.96X	1
1/2X	2.25X	1⅕**
1/1.5X	2.78X	1½
1/1.3X	3.31X	1⅔
1X	4X	2
1.2X	4.8X	2⅓
1.4X	5.8X	2½
1.6X	6.8X	2⅖
1.8X	7.9X	3
2X	9X	3⅓
2.2X	10.2X	3⅓
2.4X	11.6X	3⅗
2.6X	13X	3⅘
2.8X	14.5X	3⅘
3X	16X	4
3.5X	20X	4⅓
4X	25X	4⅘
4.5X	30X	5
5X	36X	5⅕
5.5X	42X	5⅗
6X	49X	5⅗
6.5X	56X	5⅘
7X	64X	6
7.5X	72X	6⅕
8X	81X	6⅖
8.5X	90X	6½
9X	100X	6⅘

*The beginner can get by working with just two points on this table. At 1/2 life size, increase exposure about 1 stop. When the image is life-size on the film, increase exposure 2 stops.
**Round off to 1 stop. 1/5 stop is barely noticeable and impossible to set accurately on a normal lens.

When you take close-up photos, there is often no way to tell how large the original subject was. When you take photos for documentation purposes, including a ruler in the shot will give an accurate guide to scale. If precise measurement is not important, then a familiar coin or even a finger tip included in the picture will provide scale. If you have trouble controlling glare from a plastic or metal ruler, try a wooden ruler.

A right-angle finder is a useful accessory for copystand work. It is shown here in a Pentax portable copystand set-up.

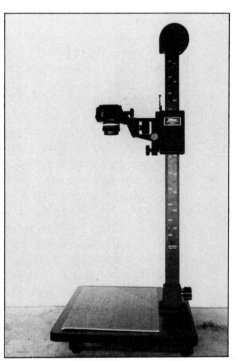

Copystands are available in a variety of configurations. The durable Nikon stand has a head that rides up and down the column on a spring. Magnification ratios on the column facilitate rapid adjustments for laboratory work with the Medical Nikkor lens. The Minolta stand features a tubular column and adjustable arm. The four-leg copypod from Pentax is for use in document copying. Its lightweight and collapsible legs make it ideal for work in libraries. Similar pods are available from other camera manufacturers.

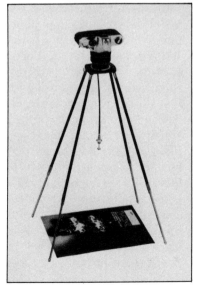

focus, use the focusing ring on the lens in the close-up range or change bellows extension in the macro range. If you have a focusing rail, you can use that for all focusing movements.

When you have the camera mounted on a copy stand, and are working in the macro range, you can move the subject by putting it on a macro focusing stage, which is like a miniature jack that moves the subject up and down at the turn of a knob. You can also change subject height by putting scrap wood, boxes, or for really fine adjustment a stack of typing paper under the subject.

Viewfinder aids such as an eyepiece magnifier or magnifying finder also help. If you do a lot of macro work at very high magnifications, and your camera has interchangeable focusing screens, consider a cross-hair screen.

Stability: The greater the magnification, the greater the need for a rock-steady camera. In the close-up range, you can get away with hand-held camera work if you use electronic flash as your primary light source. In the macro range, tiny changes in camera location make significant changes in the plane of sharp focus, so tripod- or copy-stand mounting is essential for consistent work.

It is easy to improvise a setup for close-up and copy photography if you have a tripod.

If you do a lot of document copying, you may want to consider one of the four-leg stands that attach to the accessory mount on the lens and position the camera directly above the work (see photo). This device is portable enough to bring with you to a library; on the other hand, film is considerably more expensive than electrostatic machine copies, so think twice before you decide to use your camera in place of the Xerox machine.

Copy stands usually have a head that rides up and down a vertical column. Some stands also have lights attached, which is convenient but unnecessary. Those with four lights are theoretically able to provide more even illumination over large drawings and documents than those with two lights, but if your interest is in photographing small objects such as coins, stamps or belt buckles, there is no advantage to a four-light setup. If you do a lot of close-up and copy work, then a copy stand is a worthwhile investment because the head, in the better designs, keeps the camera parallel with the baseboard, which means the camera will always be aligned properly with the material you want to photograph. When you use a tripod for copy work, you are faced with a tedious job of alignment every time you set it up.

Use a self-timer or cable release when you have the camera mounted on a tripod or copy stand. If you hand-hold, then a rifle-stock type shoulder pod with built-in trigger or a pistol grip with trigger will improve your batting average.

Shutter speed/f-stop selection: If you hand-hold the camera, use a fast film and the highest shutter speed you can get away with. There is a trade-off here, because the traditional wisdom also advises you to use the smallest f/stop you can manage. The answer is a compromise, and you should experiment to find your own limits. But to start, try keeping your shutter speed at 1/500 sec. or faster and let the f/stop go where it must. If you have a good lens, chances are using a wider f/stop won't have much effect on your results, whereas using a slower shutter speed is almost certain to introduce some blur into the system.

When you have your camera mounted on a solid tripod or copy stand, shutter speed is less important, but there is one caveat. Some cameras have a mirror that introduces vibration into the system when it snaps up. In general, this vibration is significant only at speeds in the 1/15 sec. to 1/2 sec. range. If you think this speed range is giving you trouble, avoid it, or lock up the mirror if your camera has that feature.

Backgrounds

A good background should provide a field that makes the subject stand out clearly. In black-and-white photography, white, black and pearl-gray are frequently chosen. In color close-ups, any color that works well with the subject will do, although red, green, and black seem to be the most popular.

For indoor work, velour makes an excellent background material because it dampens down hot spots. Black velour comes out deep black, which is why it is a good choice when you are photographing jewelry. You can also use paper, which is available in just about any color you can think of, but the fibers in paper have a distinct pattern that is often undesirable in an extreme close-up and in macro shots.

If you want to put an object into a setting, you can lay it on top of a photo or drawing. You can also prop up a sheet of glass between two books and lay your subject on that. Whatever you put under the glass becomes the background. To get an abstract background, try using crumpled foil. By varying the glass-to-background distance, you can control the degree to which the background will be out of focus.

Outdoors, out-of-focus leaves, twigs, and flowers may serve as a background, but there are times when colored cardboard will im-

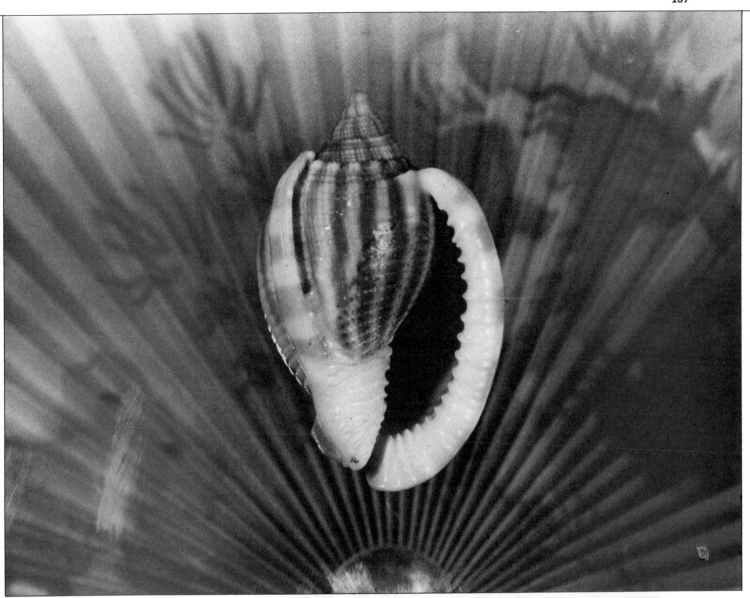

Both photos were taken using a +2 close-up lens on a 200mm telephoto. The shell was placed on a sheet of plate glass that was propped up on books. The background is a Chinese fan placed underneath the glass. Two lights, one on either side of the subject, were diffused with sheets of tracing paper to dampen glare on the shell. The difference in background sharpness between the two photos is the difference between f/4 and f/16.

This sequence was taken using a bellows to provide progressively greater magnification, beginning with an image that is approximately life-size.

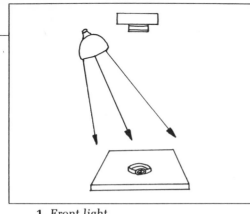

1. Front light

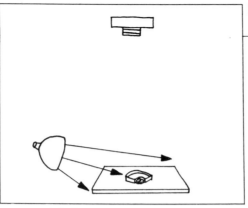

2. Side light

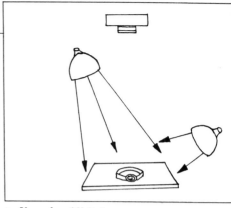

3. Key plus fill light

4. Diffuse light

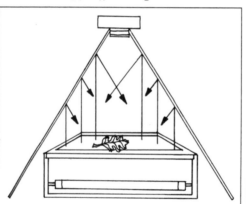

5. Strongly diffused light

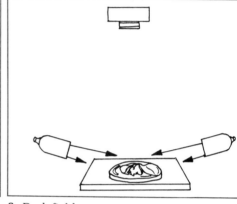

6. Dark field

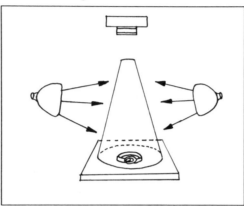

7. Transmitted light

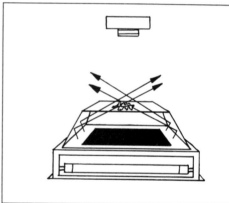

8. Transmitted light plus reflected fill

9. Transmitted light with dark background

Close-up lighting techniques

1. Front light. Use a ring flash or place the light source close to the axis of the lens. The effect is soft, shadowless illumination that penetrates cavities, contours and indentations. Avoid frontal light with shiny objects, because it causes unwanted reflections.

2. Side light. Place the light so that it strikes the subject from a raking angle. This light creates distinct shadows, similar to those created in a rocky landscape by a late afternoon sun. It brings out texture and surface detail.

3. Key plus fill light. Use a strong light at an angle to create shadows and texture. Then use a weaker light, or a reflector, above the subject to lighten up the shadows. The set-up is similar to that used on a larger scale for portraits.

4. Diffuse light. Faint, soft shadows are useful for shiny objects that have deep cavities and indentations. You can get diffuse light by bouncing your main light from a white card or sheet of typing paper. Or you can put a sheet of tracing paper in front of your light.

5. Strongly diffused light. To get virtually shadowless illumination, surround your subject with a cone made out of two sheets of tracing paper taped together. The camera lens pokes through the narrow end of the cone. Shine your lights on the sides of the cone, above the subject.

6. Dark field illumination. Use two spotlights, one on either side of the subject at a low, oblique angle. The flat surfaces will appear dark while the elevations and depressions will appear light. The effect is just the reverse of front light. Dark field illumination is useful for photographing coins, medals and other flat, shiny objects with designs or inscriptions on the surface.

7. Transmitted light. Use a light box to illuminate the subject from behind.

8. Transmitted light plus fill. Use a cone of white paper or aluminum foil over the light box. This produces a diffuse, shadowless illumination. If you prefer, you can use a light above the subject for fill.

9. Transmitted light with dark background. Use a sheet of plastic or glass to lift your subject a few inches above the light box. Put a small square of black paper or cloth in the light box to serve as a background. A white cardboard box, open at top and bottom, holds the glass and acts as a reflector. Important details in translucent or transparent subjects are seen as bright areas against a dark background. Diagrams by Julie Lomoe-Smith.

prove on nature. Even if you don't use cardboard as a background, it can serve as a windbreak, so it never hurts to have some with you when you are out in the field photographing bugs and flowers.

Handling 3-D Subjects

You sometimes need a bit of ingenuity to get the right view of a tiny, irregularly shaped subject. Jewelry can often be set in a jewelry box. You can fashion props out of bits of paper or cardboard, and if you use the same material for the background, the prop will disappear. For props at points out of view of the camera lens, modeling clay works well.

Live specimens are better photographed with electronic flash, because hot tungsten and halogen lights can damage tiny living things. Flash is cool and gives you the added benefit of being able to stop action.

If you are trying to photograph insects in their natural environment, try the action-field method in which you prefocus on an area and take your picture when the subject moves into the preestablished area of sharp focus. To make a portable-action field, decide on a suitable lens-to-subject distance and image ratio. Draw the field to life-size scale on a piece of graph paper and bend a piece of wire to fit the shape. Mount the frame at the end of a strip of wood lath. At the other end of the lath, mount the camera using a ¼″ x 20″ bolt. The distance between frame and lens should be set to give a sharp image when the lens is focused to infinity. When you use the frame, anything inside it will be sharp. You can use it in conjunction with one or two light-weight flash units mounted on a bracket that attaches to the front of your lens. If you have the whole outfit mounted on a shoulder (gun-stock) support, you will be able to hunt moving subjects.

At night you can search out insects using a flashlight with a yellow filter over the lens. Most insects do not see the yellow light, so they will be unaware of your presence. If it's bright enough, the light will also allow you to focus through the lens.

Copying Technique

Flat subjects are easiest to photograph if you have them lying flat. If your subject has a tendency to curl and the back is unimportant, then you can hold it down with double-sticky (double-sided) tape or even a piece of transparent tape folded over. If the edges won't show in the photo, you can use weights to hold them down.

You can pin or tape flat copy to a bulletin board, hardboard or plywood panel, but the pins always cast shadows. On the other hand, you have to use the tape carefully to avoid damaging your original.

Professional copy houses often use a vacuum table to hold work flat. This table has a hollow surface with hundreds of tiny holes in it. A pump sucks the air from inside the table top and air pressure holds the copy flat. If you do a lot of copy work but don't want to foot the bill for a commercial unit, you could make a hollow table top from plywood or sheet metal, drill holes in the top, and cut out a port in the side for a vacuum cleaner hose. It's been done.

Lighting for copy work: When you want to copy flat documents, try to get your lighting even. If you use four lights, place two on each side of the work at about a 45° angle from the surface. Keep the light-to-subject distance the same for each light. Large items may require three or more lights on each side. You can also use lights at top and bottom of the piece, but that's not usually necessary.

If you have an incident meter,

you can use it to check the evenness of the illumination. Another method is to hold up a card in the center of the work. The shadow density on each side of the card should be the same. Your finger or a pencil will also do for a quick check.

To reduce glare on silk-screen (serigraph) prints and paintings, you can use a polarizing filter over the lens. To eliminate glare, use polarizers over the lights as well and align them so they are at right angles to the polarizer on the lens. This is the crossed-polarizer technique. It allows you to use texture lighting without producing hot glare spots on the surface of oil paintings and to photograph items under glass.

To emphasize the texture of a painting, use a raking sidelight at about a 10° angle from the surface as your key light, and then use a diffuse frontal light as fill.

SLIDE DUPLICATES

Equipment

The easiest way to make a slide duplicate is to project the slide onto a matte screen, or onto a piece of matt board or wallboard painted flat white, and photograph it using Ektachrome 160 Tungsten. You could also use a daylight type film and an 80A filter on your camera lens. Quality is reasonably good so long as you use a matte surface to project the slide on. Do not use a beaded screen, which produces a slightly granular and uneven image. Use your through-the-lens meter or any hand-held meter to determine exposure.

If you own a bellows, then you should be able to get a slide-copying attachment for it. The copy attachment consists of a slide holder with a diffusing screen behind it. Some attachments must be used at a fixed distance from

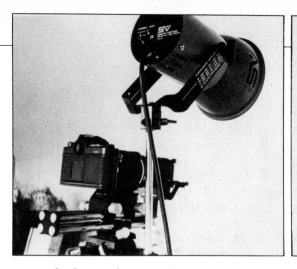

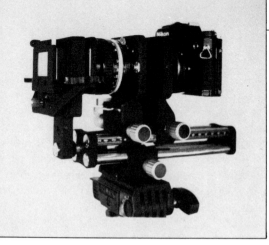

This basic slide-copying system consists of a Nikon with autobellows, normal lens, and copy attachment. If you are in a hurry you can point the diffuser directly at a photofloor or studio flood, use a film balanced for the light source, and make your copies. But illumination will be a bit more even if you shine your flood at a white card or flat white wall and aim your diffuser at that.

the lens, others can be adjusted so that you can crop the image if desired.

You can shine lights directly at the diffuser, or for more even illumination, you can shine them at a sheet of white paper and use the paper as your light source.

Another slide-duplicating device that you might consider consists of a flat-field macro lens in an extended barrel for 1:1 and larger magnifications and a slide holder. A system of this type is the Spiratone Vario-Dupliscope II, which can also be gotten with an electronic-flash unit and a scale calibrated to give consistent exposure.

If you already own a copy stand and bellows, then you might consider getting a slide-duplicating illuminator. The illuminator is essentially a ventilated box with one or two weak bulbs to light up the slide for viewing and focusing, and one or two 3200 K tungsten bulbs to light the slide during the exposure. The less expensive single-bulb style is adequate for 35mm slide copying. If you work with larger transparencies, then you need the two-bulb type.

If you use a photolamp (3400 K) or tungsten bulb (3200 K) in one of these units, discard it if the bulb becomes noticeably dark or when you have used it for about three-quarters of its rated life. If you use it too long, you will get a color shift toward the red end of the spectrum. Halogen lamps do not have this problem.

You can make your own illuminator with ease if you have a diffuser that gives you even illumination without creating a color cast. One good diffuser is a 4″ x 5″ or 5″ x 7″ sheet of Kodak Flashed Opal Glass. To make a simple illuminator, cut a slide-size hole in a sheet of scrap plywood or hardboard. Lay the diffuser over the hole and tape it down. You can lay the board across the legs of a stool, between two chairs, or across two sawhorses. Put a 250-watt tungsten bulb (3200 K) or photoflood (3400 K) at least a foot below the diffuser. You can mount your camera, with bellows, on a tripod above the slide. To eliminate stray light from around the edges of the slide, use a mask cut out of black paper.

If you want to get fancier, you can make a box to hold the light and the diffuser. The box should be vented and you will need to put a piece of heat-absorbing glass between the light source and the diffuser.

Large-volume photofinishers still use tungsten lights for mass-production slide duplicating, but labs specializing in audio-visual work frequently prefer to use units such as the Bowens Illumitran or the Radmar Dupe-Pro with built-in flash illumination, which is desirable in slide duplicating because it lowers contrast. These instruments combine copy stand and slide illuminator in one unit and the fancier models offer variable-illumination control. Some come with an SLR camera body, bellows and macro lens; others will accept any camera and bellows. They are a good investment for the small lab and for commercial photographers who do a lot of AV (audio-visual) work because they are almost as easy to operate as an office copy machine.

If you want slide-duplicating capability to make occasional extra slides or as a creative tool that will let you make black-and-white or color negatives from your favorite slides or play with colorful derivations using filters and infrared-film stocks, then you do not need a fancy duplicating setup. A duplicating attachment

Depth of Field

Depth of field depends on image magnification. If depth of field is not sufficient to reproduce enough of the subject in sharp focus, you might be better off to try a lower magnification in order to gain more overall sharpness. Remember that the main purpose of photomacrography is generally to give you as much useful information as possible, and not just to give you the largest possible image.

Magnification	f/16		f/22		f/32	
	Inches	cm	Inches	cm	Inches	cm
1:1	.32	.81	.44	1.12	.64	1.63
2X	.12	.32	.17	.42	.24	.61
3X	.07	.18	.10	.25	.14	.36
5X	.03	.09	.05	.13	.08	.20
8X	.02	.06	.03	.08	.05	.11

for your bellows, an inexpensive slide-duplication illuminator, or an improvised illuminator should be more than adequate.

Film Selection

Kodak now has two 35mm films designed specifically for slide duplicating. Ektachrome Slide Duplicating Film 5071 is intended for 3200 K tungsten illumination. It has an ISO/ASA 4 designation. If your meter will not go down to ISO/ASA 4, then set it for ISO/ASA 32 and increase (open up) the meter-indicated exposure by 3 stops. This film gives optimum results when exposed to tungsten light, such as that in a typical enlarger lamp or slide-duplicating illuminator for exposure times in the neighborhood of one second. It can be used with daylight or electronic flash if you use a conversion filter, but the short exposures do not produce the best results.

For duplicating with electronic-flash light sources use Kodak SE (short-exposure) duplicating film SO-366. The film has improved response at short exposure times and is balanced for daylight and electronic flash.

If like many photographers you make your slide duplicates using whatever color film you happen to have in the camera or on the shelf, your results should be OK for all but the most critical applications. If the original and the duplicate are made on the same film types, contrast build-up will be exaggerated, so you might try to avoid that situation by putting the original and the dupe on different stocks, or lower contrast by flashing, as explained below.

Of all the general-purpose slide films, Kodachrome 25 makes the best dupes when you use daylight or electronic flash. For tungsten light, use Ektachrome 160 Tungsten, and for photolights (3400 K) use Kodachrome 40.

To lower contrast, flash each frame. You do this by giving the film two exposures at the f/stop–shutter-speed combination that you would use for a normal duplicate. Make the first through an ND 2 filter, which has 2 percent transmittance. The second is of the slide itself. Naturally you can only do this if your camera can make double exposures.

Lighting

Your best light source is one that matches the color balance of the film you are using. If you are using a daylight film, then use electronic flash, if you use a tungsten film, use tungsten (3200 K) lights, and if you use Kodachrome 40, use photofloods (3400 K).

Filtration

Critical slide-duplicating methods adopted by professionals in the AV field call for careful filtration using CC filters to balance the dye characteristics of the original with the characteristics of the duplicating film, corrective filtration for batch-to-batch emulsion variations, as specified by instructions that come on the film cartons, and filtration to correct for deficiencies in the original. Data on critical filtration procedures for use with slide duplicating film is available from Kodak.

Filtration in non-professional slide duplicating is usually limited to the use of filters to make major color shifts. For example, you might want to get a sunset effect using an Orange No. 15, or No. 85 conversion, or 81EF light-balancing filter. Or you might want to try correcting the yellowish cast of a slide made on daylight film in tungsten light by using an 80A conversion filter, even though the results won't be perfect.

When you use filters in slide duplicating, put them between the slide and the light source. In this position they do not interfere with the optical path of the image, which means you can use inexpensive CP filters, used in enlargers, rather than expensive CC filters. You can also use colored acetate in a rainbow of color variations for special effects.

For example, you could copy a black-and-white negative onto a standard black-and-white film such as Panatomic X, which will produce a positive, and then recopy that onto color-slide film using colored acetate between the slide and the light source. And there is nothing to stop you from assembling sandwiches made from several images, taping them together, and duplicating those, with or without special filtration. The permutations and combinations of copying for special effects are endless.

Exposure

To calculate exposure for slide duping with continuous light sources use your through-the-lens meter. If you use a hand-held reflected light meter, hold it right up to the surface of the slide to read the light coming through.

To calculate exposure with electronic flash, put the flash on manual and calculate the f/stop by dividing the guide number by the distance between the flash and the slide. Then open up 1½ to 2 f/ stops to compensate for light absorbed by the diffuser. You can get an exact factor for the diffuser by measuring a continuous-light source, or piece of brightly lighted white paper, and then taking the measurement again with the diffuser in front of the meter cell. The difference between the two is the amount to open up to compensate for the diffuser. If you use filters, remember to compute in the filter factor as well.

11 PRESENTATION AND STORAGE

No print or slide is complete until it is on display or resting securely in a retrievable storage system. So much attention gets paid to the tools and techniques of picture taking, that the results of all this activity sometimes get no more than a short shrift. The photos so painstakingly created are surveyed once, then left to languish unseen on a shelf or in the dusty back regions of bureau drawers.

To really enjoy picture taking, you need to be able to do something with the results. Just letting a picture collection build up chaotically is a sure way to take the fun out of photography. One of the great pleasures of making pictures is seeing your best prints on display, either in a slide show, or on the wall of your home, or in an exhibit. Prints or slides not being used should be safely stored in some way that lets you get at them when you want to.

SLIDES

When you get a box of slides back from the processing lab, you need some way to look at them so that you can edit out the ones you want to keep, and you need somewhere to put them so that you can get at the ones you want without having to go through the whole box every time you want to look at one slide.

For the initial viewing and editing, you will want either a hand viewer or, better yet, a slide projector with stack loader. To show slides to a group, you need a projector and screen. And to store slides, you should have something better than the boxes they come in from the lab.

The following sections give a rundown on all the paraphernalia involved in slide viewing and storage.

Slide Viewers

The simplest viewer is a folding type that takes one slide at a time. To use it, hold the viewer up to the light and look through the magnifying eyepiece at the slide.

The next step up is an illuminated viewer. Press the slide into a slot in the back of the viewer and a light goes on. You look at the slide through a Fresnel lens that serves as the "viewing screen." (There is no actual projection involved.) Viewers of this type provide anywhere from 2X to 12X magnification of the slide. In practice, you need at least 4X

A static neutralizer, anti-static brush or anti-static cloth is a useful accessory when you are mounting your own slides between glass or printing negatives in the darkroom. Film has a negative charge that attracts dust which is positively charged. When you give the film a temporary positive charge with an anti-static device, it repels dust.

A blast of inert gas will clear off most of the dust and other particles that inevitably gather on the surface of slides.

magnification to get a realistic idea of what a slide contains, and you need even more enlargement before you can begin to make critical evaluations of quality.

Viewers with push-pull changers that accept a stack of up to 36 slides at a time are useful for preliminary sorting and editing when you do not want to take the time to set up a projector or look at the slides on a light box with a magnifying glass.

Projection viewers are rear-screen projection systems that use mirrors to increase the length of the optical path and have a built-in screen that provides an image large enough to let you critically evaluate slides. These viewers are also used for small-group audio-visual presentations. Some models are convertible so they can be used as standard projectors. Manual and automatic types are available.

Light Boxes and Slide Sorters
A light box has a flat, translucent top on which you can lay out your transparencies. Incandescent or fluorescent bulbs inside the box provide illumination. A slide sorter is a light box that tilts up-ward like an easel so that you can examine slides without bending over. Horizontal strips on the sorter hold the slides in place.

A light box or slide sorter makes it easy to compare one slide with another and set up a slide show. Trying to put together a show using your projector is tricky, because you cannot directly compare one slide with another.

Inexpensive slide sorters are available that do not provide totally standard illumination but which are more than adequate for most applications.

This illuminated viewer accepts one slide at a time. A flashlight bulb powered by AA batteries illuminates the slide, which you view through a Fresnel lens that serves as the "screen." Color quality is poor —too reddish—and the image size is too small to see details, but a viewer of this type does let you review selected slides without setting up a projector.

This Pana-Vue automatic viewer will let you quickly run through a whole box of slides. It can be powered by batteries or an AC adapter. Like all viewers, the image is small and the color too warm, but there is no denying its convenience.

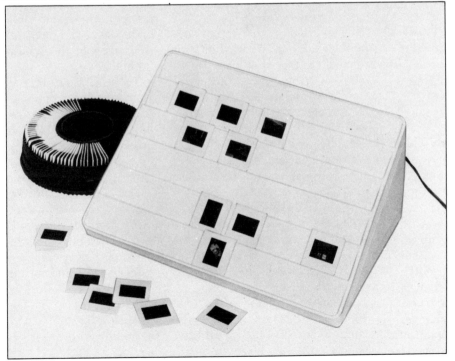

This is the Kustom Slide Sorter from Kalt. Table-model slide sorters make it easy to put together a slide show. Use a magnifier to get a detailed look at each slide.

To improvise a light box, stretch a clear plastic drop cloth on a frame and lay it across two chairs. A storm window will also do. Tape a large sheet of tracing paper on the underside of the plastic or glass to diffuse the light. On the floor between the chairs, put a table lamp without its shade or a floodlight reflector with a 100-watt bulb. Leave several inches between bulb and paper to avoid scorching.

A light box or slide editor for critical applications should have a color temperature of 5000 K and a color-rendering index (CRI) of more than 90. Boxes that meet these specifications are expensive but they provide a standard for color evaluation that is important whenever color is being evaluated critically. They are essential for commercial work and should be available to students wherever photography is taught.

To examine slides laid out on a light box or editor, you need a magnifying glass. The most common one for 35mm slides is an 8X magnifier. The 10X thread counter is a bit too strong and anything less than 6X does not provide adequate enlargement. Low-power magnifying and reading glasses are useful only for viewing medium-format slides.

Slide Projectors

Here is what to look for in a good slide projector:

Automatic slide changer. This is a system that advances the slides at the push of a button. An additional fillip that really is not very useful is a timer that changes slides automatically at preset intervals. A semi-automatic projector will take a tray of slides, but you have to manually push-pull a slide-feed mechanism to advance the slides. Today you can buy a projector with automatic changer and remote function for about the same price. Projectors that must be fed one or two slides at a time are outmoded manual designs that take the fun out of showing your slides.

Tray styles are not too important, but they are not interchangeable. The popular Carousel projectors use a round tray that lies flat on the projector and feeds slides into the changer mechanism by gravity. The vertical-rotary tray is used in Sawyer's, Wards, Sears, Hanimex, and other systems. This style is based on the use of a mechanical arm to feed slides in and out of the projector. The Universal straight tray can also be used with vertical-tray projectors. Both Carousel- and vertical-tray styles accept stack loaders so that you can show a stack of slides just as it comes from the box.

The slide cube used with the Bell & Howell system is basically a modified stack loader. The cubes can be used for storage and take up significantly less room than round or straight trays.

A number of projectors made in Europe use the European straight tray, which depends on a mechanical-feed system similar to projectors using rotary trays.

Any automatic projector can jam if you try to show slides in damaged cardboard mounts; however, you may find it harder to unjam a mechanical-feed system.

A remote cord lets you stand away from the projector, at the screen, for example, and change slides with the push of a button. Some cordless remote units that use an infrared beam to change slides are also available.

A bulb-saver switch is a dimmer that lets you increase bulb life up to four times, from 25 hours to 100 hours for example, while reducing the brightness on the screen about 30 percent. If the projector does not have this switch, check into the possibility of buying different-strength bulbs for it.

You can save significantly on bulb replacement costs if you use a long-life, low-brightness bulb whenever you can get away with it. These bulbs are adequate in moderate-size, darkened rooms. For medium-size rooms and wherever there is a low but significant level of ambient light, use the standard bulb. For large rooms and conditions where there is a lot of ambient light, use a high-brightness bulb.

Remember that brightest is not always best. In a dark room, a too bright image looks chalky and it's hard on the eyes.

A zoom lens gives you some flexibility in adjusting the image to the screen size, but a unifocal 4″ or 5″ lens is also adequate for most situations. To get a bigger image, use a wide-angle lens, such as a 3″ lens with the 35mm format. To fill the screen from the back of a large room, use a long lens.

Format: The "standard" slide projector is the 2X2, which projects slides in 2″ x 2″ square mounts. This is the standard size mount for 35mm, 127, 126 (instamatic), half-frame, and super-slide sizes. The only difference is the shape of the window in the mount.

To project 110-size slides, you need a 110-slide projector or 2X2 adapters, which are special mounts that hold 110 (30mm) mounted slides.

Projectors designated 2¼″ are actually designed to hold slides in 2¾″ square mounts. This size is used for 2¼″ square and 6 x 4.5cm transparencies. Rollei and Kindermann have projectors in this size.

Lantern-slide projectors are used in large auditoriums to project 3¼″ x 4″ lantern slides and transparencies in lantern-slide mounts.

A slide editor that lets you pull a slide out of the projection gate is

Small rear projection screens such as this model from Porter Camera are good for small group presentations when you do not want to have the projector interfere with the audience. The projector you see here is a horizontal tray model of the type manufactured by Kodak.

These two vertical tray projectors from Hanimex, one with pop-up slide editor, are typical of the "rotary tray" style.

This Tiffen Slide/Synch recorder with built-in dissolve allows you to program narration and dissolve rate for multi-media showings. Two projectors are necessary for dissolves with this unit. A system of this type allows even a novice to make a smooth, professional slide show. Once you've tried it, you may never be satisfied with a single-projector show again.
and taped in place, as was the f/stop, because it was too dark to see the numbers on the lens. The 24mm lens had a wider angle of view than the flash, and this was deliberately used to create a vignetting effect. The black background is the result of light falloff, as is the tonal modulation toward the center. Film: Panatomic-X.

useful if you happen to have a slide in the wrong way or want to pull out selected slides from a stack or tray. But it is by no means a necessary feature.

Automatic focus is a big plus for a projector. The heat of the projector lamp causes slides to bow or "pop" after a few seconds in the projector gate. When you refocus to compensate, the next slide in will be out of focus. Manual focus means constant focus adjustment. The auto-focus system makes these adjustments for you and it does not add significantly to the cost of most projectors.

Other buying points are a retractable cord; a preview screen or light that lets you see the next slide coming up; a switch that turns the room lights off automatically when you turn the projector on; a blind that makes the screen go dark when there is no slide in the gate; a tilt adjustment so that you can angle the lens upward; a

quiet cooling fan; and a style that goes with your hi-fi, TV, and other audio-visual system components.

Projection Screens
If you are running through your slides to review and edit them, any white wall or even a large piece of white paper will do as a screen. (If you show your slides against a colored surface, such as a light beige wall, the images will take on the tint of the wall, so white is a better choice.)

If you do not want to invest in a screen, then you can make your own out of a sheet of tempered hardboard by giving it a couple of coats of flat white paint.

But if you are serious about showing your slides, or use them for audio-visual presentations, then a screen is important. There are four basic types: matte, beaded, lenticular, and rear projection.

The matte screen has a smooth,

non-gloss surface that diffuses available light evenly over a wide area. Picture brightness is considerably less than with other surfaces, but it remains uniform over wide-viewing angles. It is the preferred surface for use with multiple projectors, and because it exhibits no visible grain, it is the surface to use when you want to make copies of projected slides. Any stray light degrades image brightness and contrast on a matte screen.

Metallic (silver)-lenticular surfaces tend to intensify colors. Screens with this surface perform better than others in rooms that cannot be darkened. It has a viewing area similar to that of a matte screen and brightness comparable to a beaded screen.

Glass-beaded surfaces are about three times brighter than a matte white surface but the audience has to be seated within a narrower viewing area (see below). They provide excellent color

quality in a normally darkened room and yield a sharp image that is relatively free from grain.

Rear-projection screens let you view the image through the screen. These screens are frequently used in self-contained systems that include projector and a small viewing-screen in one portable unit. They are used for sales and real estate presentations, small group-training programs, and counter-top displays.

Large rear-projection screens that can double as front-projection screens are also available. They are used principally for audio-visual presentations.

You can buy rear-projection material by the foot or yard, and stretch it on a frame for special setups. The screen can also be used as a diffuser for artificial lights in a photo studio.

Special-purpose screens: *Chalkboard screens* are usually white enamel boards that you can write on with grease pencil. A *high-gain screen*, such as the Kodak Ektalite, produces over six times the brightness of a lenticular screen so that you can show slides with the lights on, but it has a relatively narrow viewing cone.

Viewing cone: The ideal position from which to view a projected image depends on the screen size and type. The seats nearest the screen should not be closer than twice the long dimension of the picture; the rear seats should not be farther than six times the long dimension of the picture.

Think of the audience as being seated within a cone-shaped area with the projector at the center of the wide back end of the cone and the screen at the narrow front end. To get the optimum-viewing cone for lenticular and matte screens, put a 24mm lens on your 35mm SLR, stand at the screen, and center the projector in the finder. The angle of view of the lens just about covers the optimum-seating area. Any seating outside this area will give a distorted view of the image on the screen. For a glass-beaded screen, restrict the seating cone to the area covered by a normal lens.

Showing Slides

The proper position for a slide in the projector is reversed left to right, as you look at it from behind the projector, and upside down.

To avoid confusion, when you first get a box of slides back from the processor, orient each slide so that when you hold it up to a light it is right-side up and reads correctly left to right. Put a small mark or stick-on dot in the lower left-hand corner.

Tray loading: Assume you are standing behind the projector. Hold the tray in the same position it takes on the projector, flat for Carousel models, vertical for rotary trays, and so on. Turn each slide so that the mark or dot is in the upper right-hand corner and slide it into the tray. That's all there is to it.

A black slide is a piece of two-inch square cardboard or an unexposed, mounted slide, or a thin piece of black paper in a snap-together mount. Use them to begin and end a slide show if your projector does not have a built-in blind. It eliminates the glaring white screen that is an irritating way to begin or end a show.

Sound: You can use a tape recorder to supply background music, and if you have a mixer, you can prerecord both narration and music. A pencil tap can serve as an unobtrusive cue that tells you when to change slides.

A programmer couples a projector to a tape recorder. While you record music and narration in the normal way, you press a button on the programmer to change the slides. In playback, the slides change automatically at the proper times. Some programmers will also serve as a mixer that lets you control volume for narration and background music.

Slide/tape synchronizers generally work in conjunction with a stereo tape recorder. Narration and music are taped on one track and played through the speaker system; slide-advance signals are taped on the other track and fed into the sound synchronizer, which relays them to the projector.

Dissolve units let you blend the image from one projector into the image from another so that the picture seems to dissolve from one shot to the next. To do it you need two or more projectors with remote-slide advance and a dissolve unit compatible with your projectors. The dissolve unit dims the light in one projector while bringing up the light in the other. Dissolves work best when you have slides of about equal density and simple shapes or colors that flow naturally into one another.

There are dissolve units that incorporate a tape recorder for cassette tapes and permit either manual or automatic slide changing and dissolve programming. The more features you get, the more you pay. Training programs, sales presentations and slide lectures benefit from dissolve and sound programming and the use may justify the cost. These units are not for casual home use.

Slide Mounts

When you get your slides back from the processor, they are in temporary cardboard mounts. These mounts are fine for slides that you do not project more than half a dozen times.

If you give slide lectures, use slides as part of sales or training programs, or send slides to publishers, then you should bind them in permanent plastic, fiber,

or metal bindings that include a cover glass to protect the delicate surface of the film.

Snap-together metal or plastic bindings such as the Gepe Mounts are the easiest to use, because they provide a mask and cover glass in one unit. Just slip the edges of the film into the tabs inside the mount and press the two halves together. There are also snap-together mounts without cover glass. They are a big improvement over cardboard and significantly cheaper than mounts with cover glass.

Snap-together bindings have two disadvantages. First, they are a little thicker than cardboard so some projectors will not accept them. Second, they are relatively expensive.

The Kodak system consists of a sandwich made up of the film in a thin paper matt sandwiched between two thin sheets of cover glass that you slide into a thin metal binder. To use this system, tape the top edge of the slide to the mask with a small piece of transparent tape. Place the mask between two clean sheets of cover glass, and slip the entire sandwich, top first, into the metal binder. When turned upside down for projection, the open end of the binder is on top. The advantage to this is that you can use different masks for special effects.

Special mounts and masks: You can get cardboard slide mounts and masks with windows in the shape of hearts, stars, keyholes, circles, and so on. The judicious use of these devices may save otherwise unacceptable shots or heighten the effect of a slide program.

Masks with multiple openings can be used when you want to combine images in one slide. Cut the film to fit and tape it to the mask with a small piece of transparent tape along the top edge.

Mounts with built-in colored gels are available for correcting color or adding color casts for special effects.

Die-cut slide mounts with apertures in the shape of stars, diamonds, hearts and so on can add variety to a slide show and crop out unwanted clutter around the edges of the image.

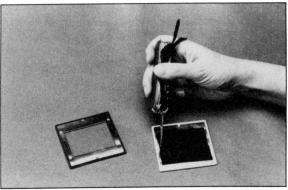

To mount a slide in the glass Gepe mount, slide the transparency into the slots inside the front half of the mount, dull side facing the glass. Then press the back half of the mount into the front half. This system is a bit more expensive than some others, but it's fast and provides complete protection for the slide.

Plastic pages with individual pockets for slides are an ideal way to store slides. This is a page of inventory slides used in the Ziff-Davis book Shoot the Works.

Not every photo will be a prize winner, but it's fun to try. These entries were displayed at the Dutchess County Fair in New York State. Photos to be entered in contests should be mounted ready for hanging and have all pertinent data, such as the title, and your name and address, written on the back.

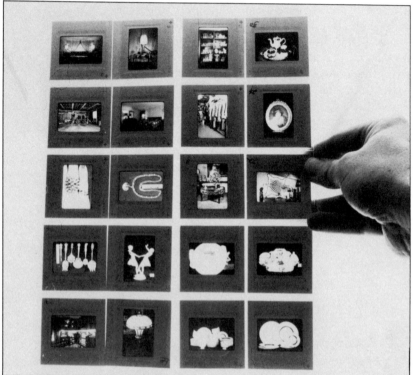

A desk-top storage/display system, such as this Gepe Picture Box, is a convenient way to organize family photos. This one will hold over 400 photos and features a *compartment underneath with a small drawer to hold negatives so that you can find them when you want to make a reprint.*

You can crop a poorly composed slide by using a mask or mount with a smaller opening or by cutting your own mask to fit.

Slide Storage

Far too many slides end up knocking about in unmarked boxes, just as they came from the processor. At some point, the sooner the better, they should be transferred into a permanent storage system.

Some photographers organize their slides into shows and keep each show stored in a slide tray or cube. This is fine for small collections, but larger collections require storage boxes or file pages. The typical slide-storage box has individual compartments for each slide. This is a nuisance because

slides have to be put in and taken out one at a time. Other box types will accept a stack of slides, but again to view individual slides you have to either handle them one at a time or run them through your projector using a stack loader.

Today, more and more photographers are storing slides in see-through file pages with individual pockets for 20 or 24 slides. To find a slide, just hold the page up to the light and glance over the array. For close examination of a slide without removing it from the page, use an 8X magnifier.

There are three types of plastic page: flexible vinyl with one matte surface; clear flexible vinyl; and stiff plastic. The matte surface acts as a diffuser and lets you view the slides against any convenient light source, but the surface grain is apparent if you use a magnifier to view the slides. The clear pages are for use with a light box.

Flexible pages are readily available in most photo outlets. Their main disadvantage is that it is sometimes hard to get the slides in and out of the pockets and cardboard mounts are often bent in the process. Flexible pages are usually hole-punched for storage in three-ring binders.

Stiff plastic pages, such as the Leedal Journal System, hold slides by the edges so that you can pop them in and out easily. A cover keeps each page safe and the entire unit is referred to as a "cassette."

PRINTS

The way you should handle a print depends to a large extent on the way you use it. Prints for display should be mounted, and if feasible, framed. Family snapshots should be kept in an album, or together in an envelope till you find some free time to select out the ones you want for albums. Prints intended for fine-arts collections should be given archival treatment, which involves the use of acid-free mounting materials and special, non-reactive storage containers. (If you have difficulty getting archival materials locally from photo or art supply stores, you can order them from Light Impressions, 131 Gould Street, Rochester, New York 14610.)

The negatives should be stored in negative preservers and keyed to a contact sheet or duplicate set of prints so that you can get at the images you want easily.

Mounting

There are three ways to mount a print: you can use glue, which is called wet mounting; you can use an adhesive sheet that's sticky on both sides; or you can dry-mount using special adhesive tissue and a hot press.

Wet mounting: The easiest method is to use a few dabs of a glue such as Kodak Rapid Mounting Cement along the top edge of the print. This method works well for conventional paper prints. Use only glues specially formulated for photo mounting. Do not use rubber cement, which bleeds through and yellows prints after a couple of years. Do not use glue with prints on RC (resin-coated) paper.

Mural-size prints on conventional paper (not RC paper) can be mounted using wallpaper paste, or better yet, printer's padding compound. Tempered hardboard makes the best mounting board.

Here are the steps for wet mounting a big print on tempered hardboard or heavy cardboard. (For extra strength, attach the board to a wooden frame.)

1. Coat the board front and back with a solution of padding compound diluted 1:1 with water or use any standard sizing. Countersink any nail heads. If there are any dents, holes or other imperfections in the board, fill with plastic wood and sand flush.

2. Soak the print in clean water until it is limp, then lay the print flat and sponge away surplus water from both sides.

3. Use a paint roller to apply an even coating of full-strength padding compound or wallpaper paste to the mount.

4. Lift the print by the corners and lay it in position on the mount. You will probably need the help of an assistant for this.

5. Use a damp sponge or squeegee to press the print into contact with the mount. Sponge away any traces of adhesive that remain on the print surface.

6. Trim off the overlapping paper with a single-edge razor blade or a sharp utility knife. If you prefer, you can miter the corners of the print and stick the overlap to the back of the mount.

7. To equalize stress as the wet-mounted print shrinks, wet-mount to the back of the mount a sheet of photographic paper or heavy kraft paper of about the same weight as the print. Make sure that the grain of the backing sheet runs in the same direction as that of the mounted print.

If you want to mount murals directly on a wall, wash it thoroughly, fill all holes with spackeling compound, sand smooth, and apply two coats of wallboard sizing. When the second coat is dry, apply a gelatin sizing made of 8 oz. clear gelatin (food quality) to two quarts of water at 100° F (38° C). Use this solution before it cools because gelatin solution sets as a jelly. You can also use the gelatin sizing as an adhesive. This allows you to remove the mural if you get tired of it. Do not use padding compound, which is extremely hard to get off once it dries.

If the mural has more than one section, you will have to splice

If a photo is worth enlarging as a print, it deserves to be mounted. If you use good-quality (acid-free) mount board, it will protect the photo for years. Photo courtesy of Falcon Photo Products.

This cardboard box with holes in the back is actually a photo mount. These ready-made mounts are ideal for home use.

To hang a mounted print on a wall, use a paper clip. Bend it to approximately the shape shown here and attach it to the top center of the mount with a piece of packaging tape. You can hang it on any picture hook, or even on a push pin.

the pieces together. The easiest is a butt joint. To make this joint, register the image where the two prints overlap, then using a steel straight edge as a guide, trim both prints simultaneously with a utility knife. Soak the first section for two minutes and wet-mount it. Soak the second section for two minutes and mount it so that the edges of the prints butt together and the image matches. Next, cover the whole area of the picture with a damp cloth, except for a strip six inches wide on either side of the splice. The uncovered

part dries first so the joints are not pulled apart as the rest of the paper shrinks. When the uncovered parts are dry, remove the cloth and let the rest of the print dry normally.

The adhesive sheet is a relatively new mounting method, and while you probably should not use it for prints that you want to last 100 years, it is more than adequate for prints used as decoration. To mount a print, peel away the paper on one side of an adhesive card and lay the print on it. Next trim away the edges using a utility knife and straight edge or a print trimmer. Peel away the paper on the reverse side, center the print on your mount board and press down. You can use a print roller to press it down, or you can cover the print with a clean sheet of paper and use your fist to rub it down.

Dry mounting: The advantages of dry mounting have been recognized for many years by photographers, artists, collectors, and museums. The method is clean, quick, and does not warp the materials to be mounted. If you expect your prints to last for the next 100 years, dry-mount them on archival mounting board.

The disadvantage to dry mounting is that it requires a special dry-mount press, which is expensive, and a tacking iron, which is relatively inexpensive, in addition to the dry-mount tissue or adhesive, which is cheap.

Here is a summary of the materials and equipment you will need for dry mounting:

1. A dry-mount (softbed) press
2. Tacking iron
3. Ademco Archival Drymount Tissue, Seal Fusion 4000 Dry Mount Adhesive, Kodak Drymounting Tissue Type 2, or any standard dry-mount tissue.
4. Temperature-indicator strips (optional)
5. Kraft paper or silicone-release paper

There are two types of dry-mount press, hardbed and softbed. Softbed presses, such as the popular Seal models, lock down with a lever action. They are capable of applying moderate pressure and can be used with a variety of special tissues and laminates. Hardbed presses such as those made by Admeco are screw-type presses capable of exerting enormous pressure. Significantly more expensive than softbed presses, they are used mainly for commercial applications and are sometimes referred to as *laminating presses*. A softbed press is adequate for most photographic applications.

Dry-mount tissue is a resin-impregnated tissue that goes between the print and the mount. When heated, the resin melts, creating a firm bond. Once mounted, it is difficult or impossible to remove the print if conventional tissue has been used, although you can sometimes get a print on conventional paper to come away from the board by putting it in a very hot press. Don't try this with resin coated (RC) paper because you may melt the print surface. If you think you will probably want to remove the print later, select a tissue or adhesive designed to be removable.

There are two recent advances in tissues that you should know about if you are interested in print preservation. First, Ademco has introduced an archival dry-mount tissue specially formulated to provide maximum protection for prints sold as fine art to collectors and institutions. You can remove the print by immersing it in cold water. Second, Seal offers Fusion 4000 Dry Mount Adhesive that has no paper core and will bond to almost any surface, is self-trimming, so it can be used to mount even complex shapes, and is removable.

The temperature of a good dry-mount press is thermostatically controlled, but the thermostats are not always accurate. You can accurately determine the proper heat setting by using temperature-indicator strips. For RC prints, use the lowest possible temperature. Ademco tissues mount at 175° F (80° C) and Seal Fusion 4000 at 195° F (91° C); Kodak Dry Mounting Tissue Type 2 mounts at about 180° F. All are suitable for both conventional and resin-coated papers.

A silicone-treated release paper is used to protect the platen (pressure plate) during dry-mount operations, but a sheet of kraft paper or even a thin matt board will also work. Manufacturers of dry-mount equipment recommend a cover sheet or overlay foil to protect the surface of glossy resin-coated prints.

The complete sandwich that goes into the press consists of the mount board, dry-mount tissue or adhesive, print, cover sheet (overlay foil) if the print is resin coated, and release paper (kraft or silicone-treated).

To attach the tissue or adhesive to the print, lay the print face down and lay the tissue over the back of the print. The tissue should completely cover the print. Fix it in place by making an X in the middle with a tacking iron. If you do not have a tacking iron, you can use a corner of the heated press (not recommended by manufacturers) or a household iron. Next, trim the print on all four sides. Center the print on the mount, then lift one corner and tack the tissue to the mount. This prevents if from moving in relation to the mount.

Exact time in the press varies, so follow the recommendations that come with the tissue or adhesive. If you use a heavy kraft or

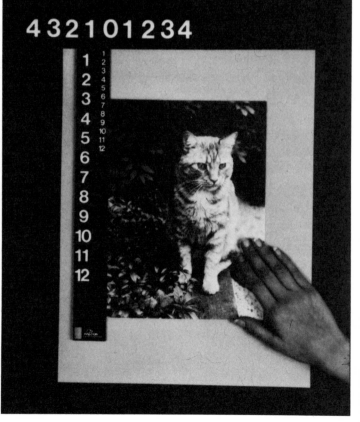

A print trimmer of one sort or another is an invaluable accessory for every serious photographer. This light-duty model from Falcon incorporates a single-edge, replaceable razor blade; if you use it according to instructions, you never have to worry about slicing your fingers as you trim a print. More expensive rotary blade trimmers offer similar safety features. Print trimmers should never be used to cut mount board and other heavy or thick materials. Always trim one print at a time.

This special T square from Falcon makes it a snap to center prints on a mount.

1. First, place the print on the top right-hand corner of the mount and place the print positioner so the number readings along the top of the T on the left edge of the print and left edge of the mount board are the same.

2. Next, slide the print flush against the positioner and down to the bottom of the mount board. Note the number reading on the left-hand scale for the top of the print.

3. Finally, slide the print up so its top numerical reading on the right aligns with the number on the right-hand scale that corresponds with the number you got at step two. The print is now centered.

card in place of release paper, it may take a bit longer.

Cloth mounting: Once you own a dry-mount press, you can do more with it than just dry-mount prints. Chartex is a specially treated cloth-backing material that bonds to a photo, map or drawing.

Laminating is the process of putting a clear plastic coating on a print. You can heat laminate with a dry-mount press using a laminating material such as Seal-Lamin, or you can laminate using adhesive-coated plastic sheets. Wallet-size prints should be laminated on both sides for protection. Prints mounted on wood and used as coasters, table tops, or wall decorations can be laminated to make them impervious to spills, airborne pollutants, and sticky fingers. To turn a photo into a placemat, mount it to Chartex and then laminate the front.

Unmounted prints should be laminated on both sides. You can trim the lamination material flush with the edge of the print if you use a heat-seal type. Adhesive types should have a small rim around the edge to provide additional adhesion.

Canvas mounting is available from some custom labs. The process involves mounting the face of the print to a laminating surface, stripping away the back of the print, and then mounting the laminated surface of the print onto canvas under high pressure in a hardbed press. The texture of the canvas will show through and the material can be stretched on a frame as though it were a painting.

Selecting a Mount

There are many kinds of mount board available, but if you want your prints to stay at their best for 10, 20 or 100 years, use only acid-free mounting board. You will sometimes find it called con-

servation board or museum mounting board. Or you can mount your prints to discarded but archivally processed prints.

Once you have mounted the print, you can leave the mount whole to give a border or trim the mount flush with the edge of the print. You can give flush-trimmed prints, or prints on black mounting board, a finishing touch by running a black felt pen along the thin edge of the cardboard or print where it has been cut.

Photographic prints are traditionally mounted on either white or cream (ivory) colored board to emphasize the blacks or on a flat, black board that emphasizes high lights and color saturation. Brown-toned graphics are generally mounted on ivory colored board.

If you want a fancier presentation, you can mount the print on a tinted underlay, which shows as a border around the print and then mount the underlay on mounting board.

There are an enormous number of special mounts available. There are postcards with peel-away adhesive surfaces to which you can mount a resin-coated or single-weight print; presentation folders that have corners to hold the print in place in front of an oval, square or rectangular window; Christmas card mounts; and mounts you can hang on a wall.

Photo albums: The pages of a photo album are another type of mount. You can attach the prints to the pages using Kodak Rapid Photo Mounting Cement along the top edge or using stick-on picture corners. Albums with pre-gummed pages covered by pull-away plastic covers are less satisfactory because the system is messy. Albums with individual clear plastic pockets for each print work well, but there is no place to write comments except on the back of the print itself.

Postcards with adhesive backs are an easy way to send a photo to a relative or friend. This example is from Porter's Camera, which also sells a postcard-size rubber stamp that lets you turn any photo into a postcard. Spiratone offers postcard printing paper for the darkroom do-it-yourselfer.

Greeting folders, such as these from Porter's Camera, have die-cut openings into which you can slip 3½" x 5" or 4" x 5" borderless photos.

Aluminum section frames in black, silver or gold are put together with small L brackets and set screws. For best results use plastic rather than picture glass. Metal and glass are antagonistic and glass breaks easily in a metal frame. (Glass does not break in aluminum windows because it is shielded from the metal by caulking.)

Wall brackets such as these from Falcon are a quick and easy way to hang up border or flush-mounted prints. The bracket can be fastened to a wall with self-stick adhesive strips or screws. Rollers in each bracket minimize damage to prints and mounts. To protect the surface of the print, sandwich it with a sheet of clear plastic. Picture glass is less desirable. If you must use picture glass with mounts like this, bind the edges of the glass with tape for safety. Never use unprotected glass.

Photo albums are the best place for those prints that document family history—the baby photos, family reunion shots, picnic fun, parties, friends, and relatives. If you are in the habit of shooting slides, don't neglect to have some prints made for the family albums. Those albums may be the only family history your grandchildren and ensuing generations will ever know. Good ones are a priceless legacy.

Matts

A matt is a piece of heavy paper or cardboard called *matt board* that serves as a protective border for a print. The matt has a cutout window for the print. Some frame makers customarily cut the window about ⅛ inch smaller in all dimensions than the print so that the edges of the print do not show. But careful photographers often compose right to the edge of the frame and sign their name beneath the print. Matts for prints in this category should have a window that is ¼"–½" larger than the print and allows the mount to show through as a floating border. If you have a print professionally framed, specify the treatment you want.

You can easily cut your own matts using a metal T-square or straight edge and a razor-blade utility knife or matt cutter. When you use a utility knife on heavy matt or mounting board, you will find it is easier to make several light strokes using a straight edge as a guide rather than to try one heavy stroke.

The window of a matt is customarily beveled so that it does not cast a shadow on the work. Making a beveled cut with a knife requires a steady hand and a practiced eye. If you are going to be making several matts, get a Dexter matt cutter. This inexpensive tool makes matt cutting a cinch.

When you measure a matt for cutting, make your pencil marks on the back of the matt and cut through from back to front. Use scrap matt board or heavy cardboard under the matt to protect the knife blade and the surface of the table when you make your cut. If you use a matt cutter, adjust the blade length so that it protrudes just enough to cut through the thickness of the matt board.

Use linen tape as a hinge to attach the matt to the mount board. This tape, along with other matting and mounting supplies is available in art supply stores.

Framing

There is something sad about seeing good prints displayed on warped cardboard mounts. A good print deserves a good presentation, and it deserves the protection only a frame can provide.

If you stick to standard-size matts, then you can select from a large variety of ready-made frames. For example, plastic box frames are available in 5" x 7", 8" x 10", 11" x 14", 14" x 18", and 16" x 20" sizes. In this style, a clear molded plastic box fits over a slightly smaller cardboard box that holds your print firmly against the front surface.

Aluminum section frames are available in standard sizes up to 24" x 30". They fit together with small angle braces that are held in place by screws. You can use either glass or plastic in these frames, but plastic is a better bet because glass tends to break easily in a metal frame. For important color prints, use UF-3 Ultra-Violet Filtering Plexiglass.

Frameless frames are adjustable clamps that hold a sandwich of glass and foam-core mounting board as a unit. They are suitable only for temporary displays.

Wood frames are available in endless variety and are the best option when you want to use glass to protect the print.

Photofinishers have a number of very simple frames that they make available at a reasonable price when you order enlargements. Technically, these should probably be called mounts or print holders rather than frames since they are fragile and do not contain a cover glass or plastic. They have the virtue of giving the print a finished look for display at reasonable cost.

Three-dimensional mount boards, such as the Falcon Photo Showcase Mounts, are cardboard boxes about an inch thick in standard-print sizes. The mounts come with an adhesive sheet for mounting the prints and you can hang them with any picture hook.

How to make wood frames: Frame-making is a craft. If you are only displaying a handful of prints, or if you are not handy with tools, you are probably better off sticking with ready-made frames, or having a professional frame-maker do the work. But if you feel comfortable with woodworking tools and have some time to spare, then frame-making can be fun.

To begin, you need some way to make mitered (45° angle) cuts for the corners. The easiest way to get perfect miter cuts is to use a power-miter box, radial-arm saw, or a top-quality hand miter box with solid metal guides that hold the saw firmly in place on both sides of the piece. Inexpensive wood miter boxes are hard to use and often result in poor cuts. If

Standard Sizes For Picture Glass	
8" x 10"	20" x 24"
9" x 12"	22" x 28"
11" x 14"	24" x 30"
14" x 18"	26" x 32"
16" x 20"	28" x 38"
18" x 24"	30" x 40"

you have to go the inexpensive route, try one of the new, plastic miter boxes, which may be a little easier to use.

If you miter by hand, you need a backsaw at least 16 inches long. Anything shorter is hard to use. Backsaws up to 24 inches long are not uncommon in professional framing shops.

Mark your measurements on the wood and cut away the lines when you make your cuts. If you cut to one side or the other of the measuring lines, you change the dimensions of the frame.

Make your measurements from the inside of the rabbet. The rabbet dimensions should be ⅛" higher and wider than your matt or mount size. This leeway gives room for expansion and shrinkage due to temperature and humidity changes. The correct size will be a loose fit, but not so loose that you can see the edges of the matt or glass when you look at it from the front.

To join the frame sides you will need a vise or, in a pinch, a C-clamp, so that you can keep the pieces from moving when you drive the nails. Put some leather scraps on the jaws of the vise or clamp to act as pads that will help prevent your marring the frame. Use light or moderate pressure on the clamps.

Use a general-purpose glue such as Elmer's White Glue or Elmer's Carpenter's Glue.

Nail size is determined by the size of the molding. For ½" moldings, use No. 17 or 18 wire brads ¾" or 1" long. For 1½" moldings, use fourpenny finishing nails.

To join the corners, drill pilot holes for your nails, apply glue, and tap home the nails. Corner clamps, available in many hardware stores, help ensure a stronger bond, but they are not necessary.

Use picture glass, which is thinner and clearer than window glass. Non-glare glass can also be used, but it diffuses the light and makes the image look slightly softer than it actually is. Reserve the use of non-glare glass for those rare situations where glare makes it difficult to see the image from a normal viewing position.

You can cut glass yourself, take the frames to a glazier and have them fitted with panes, or make your frames to conform to the standard sizes in which glass is usually available.

Plastic is considerably more expensive than glass, but if you want to retard fading of color prints, use UF-3 Plexiglass, which absorbs ultraviolet. Its slightly yellowish tinge is not objectionable for most applications.

If you want to leave the frame natural, you can wax it with a paste wax or put a couple of very thin coats of urethane varnish on it. Rub the varnish lightly with steel wool between coats. Basswood with its straight grain makes a particularly good natural frame. Or you can stain the frame and when the stain dries, apply wax or varnish.

Print and Negative Storage

Prints that are not pasted in albums or on display generally wind up stacked wherever the photographer can find room, and finally after years of mistreatment, they get thrown out. In most cases it's no great loss because the majority of those prints should never have been stored in the first place.

Prints that you consider good should be treated as fragile, valuable objects. Here's the archival treatment:

1. Mount the print on the back of another archivally processed print or on acid-free board. Protect the surface of the print with acid-free interleaving tissue. If it has a matt, the matt should be acid-free and the linen tape used to hinge the matt to the mount should be acid-free.

2. While any box will do for temporary storage, short term has a way of becoming long term without anyone noticing. Your best protection is to keep prints in print-storage boxes that are specially designed for long-term storage.

3. If you ship a group of prints, you can use a Fiberbilt print-shipping case, which has heavy-gauge steel corners and straps to keep the case from springing open. These cases are available in different sizes and depths, but most photographers use the 5" deep models in 11" x 14", 14" x 17", and 16" x 20" dimensions.

Keep black-and-white and color negatives in plastic negative preservers. You can use glassine envelopes, but see-through negative preserver pages let you find individual shots more quickly. The number of 35mm frames you can store in a preserver varies from 25 to 42, depending on the design. Most 35mm photographers prefer the type that holds six or seven strips, six frames long. Those designed to hold strips five frames long are a little less convenient when you shoot 36 exposures per roll because you end up with an extra frame and no place to put it. But if you have your film developed commercially, it may be returned in five-frame strips. Negative preservers are also available for 120, 4 x 5, 5 x 7, and 8 x 10 sizes.

There are two preserver styles: one has a wrap-around folder for file date; the other is hole-punched for a three-ring binder. If you choose the hole-punched design, you can hole-punch your contact sheets and file them in a three-ring binder with the negatives. If you use the wrap-around

design, you should use a code to key the preserver to the contact sheet, which will be filed separately. For wrap-around styles, you can get stackable file boxes made of chemically inert paper to preserve negative life.

The easiest code to use when you key a contact sheet or envelope of proof prints to the negative preserver is to use the date you develop the roll or the date you get it back from the processor. If you get back several rolls on the same day, then use letters—A, B, etc.—after the date to identify individual rolls.

When you get prints back from a mass-production photofinisher, they come in a two-pouch envelope called a "kangaroo." Remove the negatives from the kangaroo and put them in a wrap-around-

folder-type negative preserver. File a set of prints in an envelope keyed to the preserver. If you want to maintain complete sets of proof prints, take advantage of the low price that many photofinishers give when you order two prints of each frame at the time you have the roll processed.

You can write on the back of conventional prints with a soft pencil. To write on film or plastic negative files, use an all-surface marker pen. If you use a stamp on the back of your prints, get special fast-drying ink. Conventional stamp ink can bleed through to the front of RC paper. You can write on the back of RC prints with a special RC marker pen that contains ink specifically formulated for the RC surface.

Photographic art shapes the environment in an innovative model room display created by Richard Ryan, A.S.I.D., for Bloomingdale's main store in Manhattan. Ryan worked closely with the design project's co-sponsor, Eastman Kodak Company, to convey a positive and dramatic statement about photographic art's versatility as a design medium. You can have your own mural-size blow-ups done by labs that specialize in work of this sort. Check the Yellow Pages and call around to find one that will do it for you. To get a grainy effect, select photos done on pushed Ektachrome 400 or High-Speed Recording Film. To minimize grain, use photos taken on Kodachrome or a slow black-and-white film such as Panatomic-X.

Glossary

This section provides working definitions for some of the terms that photographers most often find confusing. For more information on these and other photographic terms, check the index for page references.

adapter: A device that lets you attach one component to another. The adapters most frequently used in photography are light-stand adapters that allow you to mount a light on the stand, filter adapters that let you use filters of various sizes with a single lens, and lens mount adapters that let you use a lens on a camera for which it was not designed.

ANSI: American National Standards Institute, a national organization that sets industry standards for everything from film speed to lightbulbs.

aperture: The lens opening through which light enters an optical instrument. In a camera lens opening, the area is usually adjustable by an iris diaphragm or stop. The size of the aperture is defined by the f/number or f/stop, which is the ratio of the focal length of the lens to the effective aperture. The larger the f/number set on the lens, the smaller the opening.

ASA: The old abbreviation for ANSI (American National Standards Institute). Among photographers, the term "ASA" is generally used to refer to film speed. Slow films are in the ASA 25 to 32 range; medium-speed films cluster in the ASA 64 to 125 range; and high-speed films run from ASA 200 on up. Each time the ASA is doubled, the sensitivity of the film is doubled. ASA numbers are the ones you set on most light meters, but today ISO numbers are replacing ASA numbers. The first half of the ISO number is identical to the ASA number and is the one to set on your meter.

automatic flash: An electronic flash unit containing a light sensor that automatically determines the correct exposure.

carbon arc lamp: A powerful light source used in sports arenas and on movie and TV sets. It has a quality similar to daylight.

color compensating filters: A group of pure-color filters available in primary (red, blue, green) and secondary (yellow, cyan, magenta) colors and in a range of densities. They are used to fine-tune color quality.

color temperature: The proportion of red to blue in a light source. It is measured in degrees Kelvin and is used to indicate the color quality of photographic lights. The lower the color temperature, the redder the light. Daylight has a temperature of about 5500 K; a No. 1 photoflood is 3400 K; studio (tungsten) bulbs and most slide projectors are 3200 K. The standard light for viewing color slides on a light box is 5000 K.

color temperature meter: A meter that measures the proportion of red to blue in a light source and provides filter recommendations.

conversion filter: A filter that makes a major change in color quality and allows you to get correct color with a film designed for light of a significantly different color temperature from the light you are using. For example, an 85A conversion filter balances daylight film for use with 3200 K studio floods.

dedicated flash: An electronic flash unit containing special circuits that couple with the electronic circuitry in certain cameras. A dedicated flash unit makes correct exposure practically a sure thing.

depth of field: The zone of apparently sharp focus. It varies with focusing distance to which the lens is set, the focal length of the lens, and the f/stop selected.

DIN speed: A film speed standard laid down by the German standards organization (Deutscher Normenausschuss). The scale is logarithmic, the speed being doubled for every increase of three in the DIN speed value.

E.I.: Exposure Index. Use it just as you would an ASA number. When a film speed is given as an exposure index number, it means the speed rating was achieved using a method not specified by the American National Standards Institute or the International Standards Organization.

electronic flash: A device that produces a strong burst of light by means of an electronic spark inside a flash tube. Electronic flash units are available in a wide range of sizes and strengths. They are an ideal light source for hand-held camera work, indoors or out.

f/number: See f/stop.

f/stop: The ratio between aperture and focal length, usually expressed as an f/number. The lower the number, the wider the opening. Small f/stops, such as f/16, give great depth of field, but cut down the light entering the camera so that you need to use slower shutter speeds. Wide stops, such as f/2, give shallow depth of field but let you use faster shutter speeds.

fill-in light: Direct or reflected light used to fill in the shadows produced by the key light.

film: Any transparent material coated with a photosensitive emulsion. The "emulsion" of modern films actually consists of ultra-thin layers, each with a different function. Although referred to collectively as the "emulsion," chemically they are not an emulsion at all. These layers are usually deposited on a flexible, transparent plastic base. Film is available in a wide range of sizes and types.

film speed: A number indicating the relative sensitivity of the film to light. See ASA, ISO, ISO/ASA, DIN, E.I.

filter: In photography, a transparent or translucent material that absorbs some colors of light while passing others. Filters are used to achieve optimum color, correct tonal balance, create contrast, or yield special color effects.

flash: A brief burst of light, produced by an electronic spark inside a tube or by burning foil inside a flash bulb, flash cube, or flip flash array.

flash meter: A meter that measures the burst of light produced by a flash unit.

flood light: See photoflood.

focal length: The distance between the film plane in the camera and an optical point called the rear nodal point when a lens is focused to infinity. Experienced photographers think of the focal length of a lens in terms of the type of view it gives with a particular camera—wide-angle, normal, telephoto, and so on—and don't worry about the technical definition, which is relevant only to optical engineering problems.

forced processing: See push processing.

halogen lamp: See tungsten-halogen light.

ISO: International Standards Organiza-

tion. ISO film speed designations contain two parts, the first similar to ASA numbers, the second similar to DIN numbers or British Log speeds. For example, ISO 100/21° can be set on your light meter as ASA 100 or DIN 21.

ISO/ASA: An abbreviation used in this book to indicate that the film speed number given is the common ASA number and identical to the first half of the ISO number. For example, ISO/ASA 100 is ASA 100 or ISO 100/21°.

key light: The light that creates the primary highlights and shadows, which serve to model the subject and give it the appearance of roundness or depth.

lens flange: Lens mount.

light-balancing filter: A filter that makes a small change in color quality and allows you to eliminate minor reddish or bluish color casts.

macro lens: 1. A lens designed for both general photography and ultra close-up work. A true macro lens will yield close-ups as large as life-size on the film. 2. A close-focusing zoom lens. Despite the name, these lenses are not designed for macro photography.

macro photography: A body of photo techniques that produce images larger than life-size on the film.

main light: The primary light on a subject and usually the one on which exposure is based. See also key light.

open up: To open the aperture of a lens by setting it to a smaller f/number. For example, if you go from f/8 to f/5.6, you open up one f/stop.

p.c. cord: An electrical cord with a push connector on one end. It is used to synchronize a flash with the camera shutter when the flash is not mounted on a hot shoe or used with a slave trigger.

perspective: The illusion of depth in a flat photograph. It depends on the camera to subject distance, and not on the focal length of the lens.

photoflood: 1. Any lightbulb designed specifically for photography. 2. A 3400 K lightbulb that gives correct color quality with Kodachrome 40 and most color movie films.

push processing: A method of raising the effective speed of a film by extended development. Film processed in this manner is said to be "pushed."

slave: A remote trigger used to fire an off-camera flash in response to the burst of light from a flash or infrared or radio transmitter synchronized with the camera shutter.

stop down: To adjust the lens aperture to a smaller opening by going to a larger f/number. For example, when you go from f/5.6 to f/8, you stop down one stop.

studioflood: A 3200 K tungsten type lightbulb designed for use with Tungsten film such as Ektachrome 160.

three-color meter: A meter that measures the proportion of red, blue and green in a light source. These meters are preferred for photographic work.

tungsten-halogen light: A special, hot-burning light that contains halogen gas. Available in a wide range of color temperatures, these bulbs do not change color with age, which makes them a preferred light source for lighting photographic, TV and movie sets.

tungsten light: 1. Any lightbulb with a tungsten filament, including household lightbulbs, photofloods, and halogen lamps. 2. A 3200 K studioflood or halogen lamp designed for use with Ektachrome 160 slide film.

varifocal lens: A variable-focal-length lens that requires refocusing each time you change the focal length.

zone focusing: A focusing technique in which you preset the focus and the f/stop and restrict picture taking to subjects that fall within the resulting zone of sharp focus.

zoom lens: A continuously-variable-focal-length lens that maintains focus throughout its focal-length range. See also varifocal lens.

Index